PAINTING IN BRITAIN 1525 to 1975

John Sunderland

PAINTING IN BRITAIN
1525 to 1975

PHAIDON

PHAIDON PRESS LIMITED, *Littlegate House, St Ebbe's Street, Oxford*

First published 1976
©1976 by Phaidon Press Limited All rights reserved

ISBN 0 7148 1716 3

Filmset by BAS Printers Limited, Wallop, Hampshire
Printed in Italy by Amilcare Pizzi SpA, Milan

Contents

To MY MOTHER; to CLARE, who had to put up with a great deal whilst this book was being written; and to MICHAEL KITSON and ANITA BROOKNER, in appreciation of their gifts and patience as teachers.

Preface

A BRIEF GENERAL SURVEY such as this, covering over four hundred years of British art, could not have been written without recourse to the researches and publications of many scholars in more specialist fields of study and I can make little claim to original research, though many of the ideas and interpretations are my own. There are many books, articles and exhibition catalogues which I have consulted and which, in the absence of footnotes, I am unable to acknowledge. I hope that the writers of these works will forgive me for plundering their rich harvests. The brief bibliography at the end of this book, however, gives some idea of my indebtedness to the work of others. Any mistakes that may appear are my own.

One is inevitably open to criticism, in a book of this kind, for one's sins of omission, perhaps more than commission. I can only say that this short essay, already liberally peppered with names, might have become merely a list of them if I had included all the painters who could have been included. The same holds true for the choice of illustrations.

If this book had been written fifteen years ago, there would have been different emphases; written fifteen years hence, there might be many amendments. None the less, I have tried to achieve some degree of balance in the presentation of the material.

I would like to thank Helen Langdon, Catherine Gordon and Rosemary Treble for valuable assistance with the notes to the illustrations and the brief biographies. These biographies are arranged in alphabetical order after the Plates, with the notes to the illustrations entered under the relevant artists. Artists' dates are given in the text only when their work is not illustrated. A short anthology of observations on British art will be found after the Introduction. Keith Roberts has been a most sympathetic editor, encouraging or restraining me as the situation of the moment demanded.

Painting in Britain 1525 to 1975

THE REIGN OF HENRY VIII brought about many changes in religion and politics, and these changes were reflected in the arts. The pattern of painting in Britain was in many ways set for the next three centuries. Of the greatest significance was the virtual abolition of religious art and the new importance attached to portraiture. At the same time, for the next two hundred years all major developments in painting were effected by foreign artists working in Britain, coming mainly from the north of Europe and especially from the Netherlands.

The Reformation was a key factor. In 1531 the Convocation of Canterbury recognized Henry VIII as Supreme Head of the Church in England and by 1535 most of the old religious themes in art were denied to artists. Archbishop Cranmer and the Council under Edward VI ordered the clergy to remove all images which were objects of pilgrimage. The reign of Mary I (1553–8) was too short to stem the tide. Henry Machyn's diary of 24 August 1559 records that the Lord Mayor came to see two bonfires, 'of Mares and Johns and odur emages, ther they wher bornyd with gret wondur'. The 'Elizabethan Settlement' achieved a compromise solution, which gave some consolation, but not much, to the Roman Catholics. But the Reformation in England had more consequences for British art than the destruction of religious art and the banning of further religious painting. The Protestant country that England was becoming was suspicious of art, except in the form of portraiture, because it smacked of heresy and idolatry. This puritanical hostility towards art has remained an underlying obstacle to British painters right up until the twentieth century and it has blighted the ambitions of many throughout the whole period covered by this book.

Henry VIII realized that the image and power of the Crown could be asserted through portraiture particularly well. He put this to good effect by employing Holbein as his court painter. Holbein first came to England in 1526 and stayed for two years, living in the Chelsea home of Sir Thomas More. He had painted religious and secular pictures before in Basle, but his portrait style must have seemed little short of miraculous to English eyes. It was powerful and realistic, completely up-to-date in the Renaissance style of the court portrait and owing something to his knowledge of North Italian art. But it had a compelling sensitivity and delicacy that was all his own, as the portrait drawings now at Windsor demonstrate. His portrait of More, painted in 1527 (*Plates 2 and 4*), shows the mastery of this early style. The details of More's face, down to the stubble on the chin, are all included, yet the figure remains coherent and monumental. The bulky shape of More's body, as far as the calmly placed arms and hands, presents an almost 'touchable' physical presence. It is not surprising that the immediacy of Holbein's portraits has always struck the observer. When Erasmus saw the portrait group of More and his family, of which there exists a later altered version by Rowland Lockey in the National Portrait Gallery, he wrote to More that it was 'so completely successful that I should scarcely be able to see you better if I were with you'.

In 1537, five years after Holbein's second arrival in England (he was to stay until his death), Henry VIII commissioned him to paint a large portrait group on the wall of the Privy Chamber in the New Palace of Whitehall. It showed the king with his third wife, Jane Seymour, and his parents, Henry VII and Elizabeth of York. The painting was destroyed in the fire of 1698, but the cartoon, a huge drawing on paper with holes punched in it for transference of the design to the wall, survives in part and is now in the National Portrait Gallery (*Plate 3*). It shows the king three-quarter face, as does the exquisite portrait in the Thyssen Collection, Lugano, the only known painting of Henry VIII attributed with certainty to Holbein himself (*Plate 1*). The finished painting, now only known from a copy at Hampton Court made by Van Leemput in 1667, showed Henry VIII full-face. The original must have been an immensely powerful image, with the royal quartet appearing to float out into the hall. The figure of Henry VIII set the pattern for numerous copies and studio versions showing the king full-length, with legs confidently astride supporting the powerful body and the strong and cruel face.

Holbein's later work in England shows an increasing emphasis on linear design, the patterns in the rich jewelled clothes, and a tendency to flatten out the space in the composition and bring all the elements of the design right up to the picture surface; this is already evident in the Lugano portrait of Henry VIII (*Plate 1*). The accent on a flat and richly patterned surface was to become more apparent in English painting as the sixteenth century advanced, both in the work of Holbein's immediate followers (*Plates 5 and 6*), and especially in the portraits at the end of the century by such artists as George Gower and William Segar. It continued into the seventeenth century in the works of Robert Peake (*Plate 21*) and William Larkin (*Plate 16*), although by the second decade of the century the use of flat and rather abstract patterns had become old-fashioned.

It was not only through portraiture that Henry VIII and later Elizabeth I sought to impress their power and majesty on their subjects. Holbein did decorative work at the temporary Banqueting Hall at Greenwich in 1527, to celebrate a treaty with France, and was paid four shillings a day, the highest paid workman. A vast amount of decorative painting, often of a temporary nature in the first place, has disappeared. The monarch's Sergeant Painter, or official artist, for example, was responsible for the painting of coaches, furniture, banners, coats of arms, heraldic devices and so forth. It was only under Elizabeth that the functions of the Sergeant Painter were officially extended to cover royal portraiture. Henry VIII employed many craftsmen and artists for his great palace at Nonsuch, begun in 1538, which no longer survives. Many imported Italian artists worked on the palace, including little-known names like Toto del Nunziata, a Florentine.

The court masques came to be of especial importance in the reign of Elizabeth, although they were started under Henry VIII. These entertainments, which involved poetry, music and sculpture as well as painting, glorified and even attempted to deify the monarch. Sir Henry Lee was Elizabeth's pageant master and he organized two splendid 'tilts', reviving the days of feudal chivalry and jousting, at Woodstock in 1575 and at Ditchley, his own home, in 1592. The Ditchley portrait of Elizabeth, now

attributed to Marcus Gheeraerts, is possibly connected with the latter entertainment (*Plate 12*). It shows the queen, in hieratic majesty, standing on a map of England with a storm on the right behind her and the sun breaking through on the left. The partially decipherable verses on the picture seem to refer to Elizabeth as a 'prince of light', bringing peace to England after the storm of war and strife. The cult of Elizabeth as Virgin Queen is central to Edmund Spenser's *Faerie Queene*, but it is also shown in the portraits of her, such as the 'Ermine' portrait at Hatfield now attributed to William Segar and dated 1585. The picture of 1569 at Hampton Court, now thought to be by the Monogrammist HE, probably a Flemish artist, is another case of complex allegory (*Plate 7*). It shows the queen confounding Juno, Venus and Minerva. The implication is that she is superior to these goddesses of classical mythology as her reign is creating a new mythology of splendour and achievement.

The point is that art was made to serve a political and propagandist purpose, and it was closely bound up with the political facts of the Reformation and the emergence of the so-called 'modern' nation states during the sixteenth century all over Europe. In England, Henry VIII and later Elizabeth were not only heads of state, but also heads or governors of the Church. In order to justify their position, especially against the papacy, a new mythology of 'Empire' was devised, and this depended heavily on imperial theories stretching back to Constantine and beyond. It included not only the ideas of political statecraft put forward by Machiavelli, but also the notion of spiritual power, a justification of the monarch as head of the Church, suggesting that the Pope had usurped the power really belonging to the temporal emperor. It is expressed in part by John Foxe's *Acts and Monuments* of 1563, or *Foxe's Book of Martyrs*, which was placed in churches after 1570. The way in which art could help to propound this new mythology of monarchy, which came to be known in the Stuart period as the 'Divine Right of Kings', is obvious; by the power of the visual image. We find the idea expressed in Richard Haydocke's translation (1598) of Lomazzo's theoretical treatise on painting, *Trattato dell'arte della Pittura*, first published fourteen years earlier. 'Emperors above all other Kings and Princes should be endowed with majesty, and have a noble and grave air which conforms to their station in life . . . even though they be not naturally so in life.'

Returning to the artists working in England after the death of Holbein, we find that until the emergence of Hilliard in the late 1560s the scene was dominated by painters coming from abroad, mainly from the Netherlands. This, as already mentioned, is the prevailing pattern in British art until after the beginning of the eighteenth century. The occasional distinct English figure stands out, such as Hilliard or Dobson or Cooper, but on the whole painting depended on the importation of foreign styles, even though these styles were often modified to suit British tastes and conditions. All the artists working in England between 1540 and 1570 were influenced in one way or another by Holbein. John Bettes the Elder, who was working from about 1531 to his death before 1576, may have been a pupil, and his solid forms, as shown in the portrait of an unknown man in the Tate Gallery of 1545, suggest that he had fully understood Holbein's work. Master John, working in the 1540s, brought a stiffness but a sense of decorative pattern to his portrait of Lady Jane Grey of about the same date in the National Portrait

Gallery. Gerlach Flicke, a German from Osnabruck, was working in England from 1545 to his death in 1558. But it was the work of two Netherlandish painters, Eworth and Scrots, which, while still within the Holbein tradition, broke new ground. Hans Eworth came from Antwerp and his portrait of Lady Dacre, of about 1555 (*Plate 6*), shows him to be a follower of Holbein, but with an added intricacy and an ability to give his sitters a sense of personal identity, if not quirkiness. He also had a taste for complex Mannerist allegory in the vein of Jan van Scorel. His work is varied and always sensitive. William Scrots is another important figure. He came to England in 1545, succeeded Holbein as the king's painter on a high salary and introduced the grand full-length portrait of the type recently used by the painters to the Habsburg monarchy. His portrait of Henry Howard, Earl of Surrey, which contains Flemish allegorical figure decoration, exists in a number of versions, although all the extant ones may be variants of a lost original (*Plate 8*). The full-length was exceptional in England, even in the work of Holbein, and Scrots's models were almost certainly portraits by Jacob Seisenegger, whose full-length of the Emperor Charles v was painted in 1532. Another German artist, Christoph Amberger, may have influenced Eworth. Seisenegger and Amberger were, in their turn, dependent on the work of North Italian painters such as Moretto. The Scrots picture demonstrates two important points which are sometimes overlooked in relation to Tudor portraiture. It is a fully up-to-date portrait on a European model, by no means a provincial curiosity, and it shows a confident statesman, sumptuously dressed, elegantly holding his gloves and striking a stylish pose. He might have been depicted thus by Bronzino. Secondly, the problem of the different versions is revealing about the practice of portraiture in the sixteenth century. The normal practice, in the case of an important sitter, was for the artist to make a drawing from the life, for which he was often granted only one sitting, and this drawing was then used to paint from and sometimes, if it was large, pricked for transference to panel. The artist would then make an original picture, and the drawing could be reused, often by studio assistants, to produce further versions. Or the original picture would be copied by other artists, sometimes with variations in the composition. The notion of a painting as a unique and extremely precious object was not current, except in the work of particularly famous artists. Multiplication of portrait images, especially royal portraits, was very common, as we have seen in the case of Henry viii's portrait by Holbein. Queen Elizabeth carefully restricted portraits of herself and then sanctioned the favourite image which could be reproduced many times. When George Gower was her Sergeant Painter, in 1581, she decreed that no other painter was to be allowed to produce her portrait, 'excepting only one Nicholas Hilliard'.

With Nicholas Hilliard we come to the first English-born artist with a distinct artistic personality whose work was greatly prized in his own time as it is now, and whose reputation extended beyond Britain to the Continent (*Plates 9 and 10*). The son of an Exeter goldsmith, he practised the craft himself and probably created the Armada Jewel in the Victoria and Albert Museum. The delicacy of this work fits in well with his greatest contribution to British art, his painting of miniatures. Miniature painting, or limning, owes its origin to the illustrated manuscript. It was practised at the court of Henry viii by Luke Horenbout and also by Holbein during his second stay in England.

Hilliard himself wrote: 'Holbeans maner of limning I have ever imitated and howld it for the best.' Considering its tiny scale, the work of Hilliard is amazing for its freedom of technique, as well as its delicacy and the clear freshness of the colours.

His miniature of Queen Elizabeth done in 1572, now in the National Portrait Gallery, became a standard image and there are a number of versions of this composition in larger scale painting. Two beautiful examples associated with his name (in the National Portrait Gallery and the Walker Art Gallery, Liverpool) have a luminous quality, seemingly half-way between a rich jewel and a densely patterned Oriental carpet. Seen, as they would have been, glowing from the dark background of a panelled wall, they express all that is finest about Elizabethan portraiture and they are essentially English, standing apart from the European tradition. They have a Neo-Gothic quality and show a love of intricate linear pattern, a flat surface, and a decorative richness which appears again in British art in the work of Rossetti and Burne-Jones. They are the perfect equivalent of the feudal and chivalrous mythology which grew up about the court of Elizabeth. Hilliard rarely used shadows in his painting of the face, concentrating on line, colour and remarkably free brushstrokes. In his *Art of Limning*, written between 1598 and 1603, he tells how the queen wished herself to be portrayed. 'Her Majestie . . . therfor chose her place to sit in for that porposse in the open ally of a goodly garden, where no tree was neere, nor anye shadow at all, save that as the heaven is lighter then the earthe soe must that littel shadow that was from the earthe.'

Miniature painting was essentially a court art and it belonged especially to the court of Elizabeth, where dalliance and elaborate love games were an integral part of the highly sophisticated life of courtiers and their mistresses. The miniature was often a portrait of the loved one, encased in a jewelled locket, precious and intimate, to be studied and sighed over, worn next to the heart (*Plate 10*). But they also had a practical and political purpose. Being so small they were easily transportable, and portraits of Elizabeth were entrusted to ambassadors so that they could show the image of their sovereign in foreign courts or present them as gifts to foreign royalty.

Hilliard continued to work in the reign of James I and there are many miniatures of the new king attributed to him, but he had passed the zenith of his powers. The late Elizabethan style did not change suddenly and the same love of pattern and flat surface goes on, as it had done in the work of George Gower (working 1570–90) and William Segar (working 1580–1600), with painters such as Robert Peake (*Plate 21*) and William Larkin (*Plate 16*). Two artists whose work spanned the two centuries and whose style is more in line with contemporary Netherlandish painting were Marcus Gheeraerts the Younger (*Plate 12*) and his brother-in-law, the miniature painter, Isaac Oliver. Gheeraerts brought a greater realism to the treatment of the face, and his full-length of the Earl of Essex of about 1596 in the Duke of Bedford's collection has a solid and vital presence that looks forward to the work of Mytens. Like Isaac Oliver, he was probably influenced by the work of Frans Pourbus. Oliver, a pupil of Hilliard, was his rival by 1595, and he is a worthy successor (*Plate 11*). His colour is more subdued than Hilliard's and his work has a denser quality, with more use of shadow and modelling, more in line with Continental tradition. But by 1620 even the work of Gheeraerts and Oliver had

become old-fashioned. A new wave of Netherlandish artists appeared on the scene under the patronage of Henry, Prince of Wales, and James I's queen, Anne of Denmark, and they heralded a more dramatic and up-to-date style, which was to culminate in the English work of Van Dyck.

Before finally leaving the sixteenth century it may be worth considering some other aspects of painting. So far this book has been concerned almost entirely with court or Crown patronage. What of painting outside the court? Apart from portraiture there is little that survives. A certain amount of decorative painting exists, usually in a battered condition. This was mainly 'antique work' rather than figure painting, and is usually in the form of Renaissance grotesques in the manner of Raphael's painting in the Loggie in the Vatican, often interpreted with an overlay of Flemish Mannerism. Walls were usually panelled with wood and painted decoration was restricted to the ceilings and a horizontal band at the top of the walls. Tapestries and wall-hangings were on the whole more fashionable, and warm, than painted decoration. A good example of the latter which survives from the turn of the century is the grand staircase at Knole, with painted grotesques, strap-work and panels with some figure scenes executed in grisaille to imitate plasterwork (*Plate 17*).

As for portraits, many have not survived, or if they have only in dreadful condition. The wet, damp climate of England has not been kind to Tudor paintings, so many of which were done on wooden panels. Portraits have hung for centuries in cold damp passages, not particularly cherished, except as the faces of ancestors, and those that were cared for have often been overpainted or repaired so that hardly any of the original paintwork survives. Portraits were, none the less, of great importance to those of the nobility and gentry who needed to establish their legitimacy and ancient lineage to buttress their social status. They were also a reminder of the lives of great men and it is significant that the concept of the Renaissance portrait gallery was introduced into England in the sixteenth century. John, Lord Lumley, had a vast collection which is known in detail from the famous Lumley Inventory of 1590, where the whole of his collection at Nonsuch, Lumley Castle and his London house at Tower Hill is listed. Loyalty to the Crown could also be demonstrated by a portrait of the monarch and sometimes a set of portraits of kings and queens stretching back through the Middle Ages. At Hardwick, where the collection of paintings has remained virtually intact since the inventory of 1601, there is a series of thirteen royal portraits from Edward II onwards. The ideal place for portraits to be hung was the Tudor Long Gallery; this became longer and higher as the century advanced, thus becoming suitable for full-length portraits. A fine late example of these sets of full-length portraits is the series from Charlton, now at the Ranger's House, Blackheath and attributed to William Larkin (*Plate 16*). Their extrovert presence is a reminder of the self-confidence of the age in which they were painted. There are Long Galleries at Hatfield, Hardwick and Audley End, to mention the best known. On a more sombre note, the portrait acted as a *memento mori*; and in the late Elizabethan and Jacobean period it became a vehicle for the fashionable romantic melancholy which was affected by those of a poetic inclination.

Painting was regarded as a skilled craft, and paid accordingly. Hilliard charged

about three pounds for a head and shoulders in miniature, although in 1572–3 Sir Henry Sidney paid fourteen pounds, twelve shillings and sixpence for fourteen yards of velvet. Inventories of collections show that paintings were not valued particularly highly and artists' names were mentioned only if they were very famous. The identity of the sitter was usually far more important. Holbein was an exception. In the inventory for probate of Archbishop Parker's collection in 1575 Holbein's portrait of Archbishop Wareham was valued at five pounds, whereas most of the other paintings were put at between two and five shillings.

The concept of painting as a noble and intellectual pursuit, as well as a craft, surfaced in the sixteenth century, but only sporadically and in a limited circle. Indeed, even in the middle of the eighteenth century painters such as Hogarth were complaining that the artist was regarded as only at best a skilled craftsman. Hilliard, in his *Art of Limning*, advocated that, 'none should medle with limning but gentlemen alone'. The availability of such works as Castiglione's *Book of the Courtier* translated by Sir Thomas Hobie in 1561, and Richard Haydocke's translation of Lomazzo at the end of the century, did something to propagate the idea of the artist as potentially a man of intelligence, wit and independent judgement, but these advanced notions could only thrive in the atmosphere of an enlightened court where there was plenty of money available for the patronage of art (and Elizabeth's finances were always on the rocks). On the whole the nobility and gentry, as many later painters were to discover, were never especially interested in art, except in so far as it served a practical purpose. The Church, of course, was no longer a source of patronage. Not until the founding of the exhibiting societies by the painters themselves in the eighteenth century did the situation substantially change.

In the seventeenth century the court and the needs of royal propaganda still dominated the course of painting. James I and Charles I, with their notion of the 'Divinity that doth hedge a King', continued to employ artists to glorify their image and to uphold the power and authority of the Crown. But there was a new factor on the political scene; the increase of the power and ambitions of Parliament. This was allied to the Puritans' distrust of the monarch, uneasiness with the Roman Catholicism of Henrietta Maria, Charles I's consort (*Plate 18*), and a polarization of political attitudes which led to the Civil War, the execution of the king, and the Protectorate of Oliver Cromwell. Charles II and James II both attempted to redress the balance in favour of the Crown after the Restoration, Charles with tact, James with no tact at all; and this led to the 'Glorious' or 'Bloodless' Revolution of 1688, after which Parliament managed fully to assert its power and gain control of the purse-strings. By the beginning of the eighteenth century, with the arrival of the Hanoverian dynasty, Parliament had effectively broken the power of the Crown and a settled period of limited monarchy, or a 'mixed' constitution, had become established. In general terms the history of painting in Britain was bound to be affected by the constitutional struggles of the seventeenth century. Under James I the Elizabethan pattern was basically unchanged. By the end of the century patronage of art, though by no means lost to the monarch and the court,

was spread far more evenly through the upper sections of the community. We have only to look at the vast portrait practices of Lely and Kneller, catering for the aristocracy, the gentry and the merchant classes, to confirm this; and large building and decorative schemes were being carried out in country houses such as Burghley (*Plate 42*), Chatsworth and later Blenheim, largely independent of the court.

The late Elizabethan style of portraiture was finally banished at court by the arrival of a new wave of Netherlandish artists, amongst whom were Paul van Somer, who came to London late in 1616, and Daniel Mytens, who was in England by 1618. The advent of this new up-to-date Netherlandish style was due to the enlightened patronage of Anne of Denmark, James I's queen, who died in 1617, and Thomas Howard, Earl of Arundel (*Plate 13*). Henry, Prince of Wales, Charles's elder brother, who died in 1612, was also an active supporter of the arts, and his collection of pictures, together with that of Anne of Denmark, passed to Charles. The most significant artist in the revival of the arts at this time was not a painter, but the architect, draughtsman and connoisseur, Inigo Jones (1573–1652). His work for the court masques after 1605, his buildings at Greenwich and Whitehall, his appreciation and enthusiasm for classical and Italian art, which he knew at first hand, all combined to create a climate of artistic awareness which almost amounts to an English Renaissance. At the same time large and important collections of works of art were being built up by adherents to the court. Thomas Howard, Earl of Arundel, formed a discriminating collection at Arundel House. He was in Italy in 1613–14 with Inigo Jones, buying classical statues and marbles which he displayed in his Long Gallery overlooking the Thames (*Plate 13*). He was the first to patronize Mytens. George Villiers, later Duke of Buckingham (*Plate 24*), favourite of James I and companion to Charles I, assembled a huge collection of Renaissance pictures in record time. When Rubens was in London in 1629 he wrote; 'When it comes to fine pictures by the hands of first class masters, I have never seen such a large number in one place as in the royal palace and the gallery of the late Duke of Buckingham.' Most important of all was the collection built up by Charles himself, 'a most excellent judge and a great lover of paintings, carvings, gravings, and many other ingenuities.' When Charles and Buckingham went to Spain in 1623 to woo the Infanta, Philip IV presented the prince with Titian's *Venus of the Pardo*, now in the Louvre. Charles acquired the Raphael Cartoons in the same year, and after 1625 the collection of the impoverished Duke of Mantua, including Mantegna's *Triumph of Caesar*. It would be difficult to overemphasize the importance of the royal collection for the history of painting in England in the seventeenth century, and indeed beyond. Although Charles's collection was largely sold off by Parliament after the Civil War, more as a result of economic need than active inconoclasm, fairly successful attempts were made under the Restoration to buy back as much as possible. The collection contained works by northern artists and living artists such as Caravaggio, but it was the Venetian school, and especially the Titians, for instance the portrait of Charles V, which were of paramount significance. They were studied by a generation of artists including Mytens and Dobson, as well as Van Dyck, and they left their impress upon British portraiture right down to Gainsborough, Reynolds, Lawrence and even Sargent.

The impact of Charles I's collection is first noticeable in the portraiture of Mytens, who worked for the Crown in the 1620s. In 1625 he received payment for a copy of 'Titian's great Venus', and it may be that the subtle colour scheme of grey, silver and blue in his magnificent and well-known portrait of the first Duke of Hamilton (in the family collection) is due to his knowledge of Titian. Mytens's portraits of Charles I may look stiff and old-fashioned beside those of Van Dyck, but he did introduce a sense of realism and plasticity in his portraits which was new in England and which heralds the more Baroque drama of his famous successor. His figures are convincing, yet they do not relate entirely satisfactorily to their backgrounds, as can be seen in his portrait of Arundel (*Plate 13*). Mytens was totally eclipsed by the arrival of Van Dyck in 1632 and no certain English portraits by him are known after 1633.

The arrival of Anthony van Dyck in England was the crowning achievement of Charles I's artistic policy. He was immediately knighted, set up in a house at Blackfriars and granted an annual pension of £200. From then until his death in London in 1641 he held complete sway over royal portraiture. He worked almost exclusively for the court and his influence on British art was immense. His portrait compositions were widely circulated through Wenceslaus Hollar's series of etchings, which were published in 1641. Robert Walker, a portrait painter who worked for the Parliamentarians, adopted his poses with little variation. Later Lely and Kneller were both heavily dependent on his portrait style and he remained a dominating figure in British portraiture right through the eighteenth century, especially in the work of Gainsborough, and even in the nineteenth century. His English style is subtly different from his Flemish and Genoese periods, although it grew out of them. He gave to his English sitters a grace, refinement and elegance, managing to combine reticence with a certain underlying arrogance which has always stood as the hallmark of the British aristocracy. The double portrait of Lord Digby and Lord Russell (*Plates 23 and 25*) shows his style at its most sumptuous. In his portraits of Charles I these qualities have been married with a sense of brooding melancholy which has been interpreted by some as a premonition of his troubled end (*Plate 22*). On the other hand it could be seen as a rather more sophisticated version of the pose of poetic melancholy which has already been remarked upon in relation to late Elizabethan and Jacobean portraiture. Certainly in the National Gallery portrait of Charles on horseback the image of a spiritual St George is consciously advanced, whilst in the Louvre portrait of the king on the hunting field he seems to be seeing far beyond the day-to-day excitements of the chase. But however much Van Dyck's portraits of the king may have been interpreted in the light of succeeding history, the image has stood as the epitome of royal grace and reserved majesty.

Outside the mainstream of court art, we find a number of artists who to a greater or lesser extent adjusted to the presence of Van Dyck. The first of these was Cornelius Johnson, whose father had come to London as a Protestant refugee from Antwerp. He was closely associated with other Protestant artists from abroad, such as the Olivers, the Gheeraerts and the de Critzes, whose lives revolved around the Dutch Reformed Church in Austin Friars. Johnson did work for the court, but he was also patronized by more humble country families. His art has always been seen as essentially English,

reticent, sober and restrained (*Plate 32*). Without a strong artistic personality of his own, his works tend to reflect current fashions and he was affected considerably by Van Dyck after 1632. He worked a great deal in the pattern of the oval bust-length in a rectangular frame, where his sitters' heads rise hesitantly but with great human sensitivity from a delicate lace collar as if from some intricate leafy knoll. Two painters who worked in a more awkward style, reflecting possibly more of Mytens than of Van Dyck, were Gilbert Jackson (working 1622–40) and Edward Bower (*Plate 15*). It must also be remembered that an even older fashion, deriving from late Elizabethan and Jacobean models, was current outside the court right through until the middle of the century, as is shown by the continuing work of John de Critz I (1555–1641).

The Caroline Renaissance also produced a flowering of decorative painting which has never since been paralleled in England. Again, it was almost entirely the work of foreign artists who were seduced into coming to England by the king and the so-called 'Whitehall Group' of connoisseurs and patrons, like Arundel and Buckingham, or diplomats, like Sir Henry Wotton and Sir Dudley Carleton, whose duties abroad seemed to be as much concerned with artistic as political matters. Gerrit Honthorst came to England in 1628, Orazio Gentileschi in about 1626. The latter, with his daughter Artemisia as assistant, did decorative paintings for the hall at Inigo Jones's Queen's House, Greenwich, which are now at Marlborough House. But it is the Rubens ceiling at the Banqueting House, Whitehall, which still stands as the peak of achievement in Charles's reign (*Plates 26 and 27*). Covering the compartments on the ceiling of Jones's Palladian building, it glorifies the reign of James I, celebrating the Union of the Crowns of England and Scotland and the prosperity and peace to which James attached so much importance. It was, in fact, the peacefulness of England which partly attracted artists from a Continent torn by the strife of the Thirty Years War, as well as the magnificent royal collection. Rubens, diplomat and courtier as well as artist, wrote in 1629: 'This island, for example, seems to me to be a spectacle worthy of the interest of every gentleman, not only for the beauty of the countryside and the charm of the nation; not only for the splendour of the outward culture, which seems to be extreme, as of a people rich and happy in the lap of peace, but also for the incredible quantity of excellent pictures, statues and ancient inscriptions which are to be found in this court.' Rubens's landscape (*Plates 19 and 20*), in which Charles I, in the guise of St George, rescues Henrietta Maria, as the princess, also beautifully sums up this golden age of Caroline culture.

It was, of course, a fragile peace. The greatest artistic achievements of Charles's reign came in the 1630s, when the king was ruling without Parliament and was finding it increasingly difficult to raise money for his grandiose projects. When Charles was forced to recall Parliament in 1639 over the Scottish invasion, the die was cast and the Civil War followed hard on the heels of his inability to deal with the constitutional problems.

The Caroline court moved to Oxford; and surprisingly it was here between 1642 and 1646, almost in conditions of siege, that an English-born painter of great merit, William Dobson, painted some of the finest portraits ever painted by a British artist. His art is superficially Van Dyckian, but it has a native robustness that is quite individual, and he

profited immensely from his studies of Titian. His landscape backgrounds, his colouring and his broken and rather dry paint surface all point to a full understanding of Titian's technique. He painted the officers of the Cavalier army in a situation of war (*Plate 31*). They are bulky, embattled figures, not without elegance and the trappings of scholarship and learning, which Dobson may well have absorbed from his master, Francis Cleyn, but they have their backs to the wall. The art historian David Piper gives a nice comparison between Van Dyck and Dobson; 'It is . . . as though Van Dyck painted his sitters as members of the Dramatic Society, while Dobson shows them . . . as members of the Rugby Club.'

Inevitably the Civil War and the rule of Parliament and Cromwell saw a great reduction in patronage and artistic work, but it is by no means a completely fallow period. Wilton House was reconstructed for the 4th Earl of Pembroke after the fire of 1647/8, and here John Webb, Inigo Jones's assistant, created the magnificent Single and Double Cube Rooms. The painters who worked on the decoration, Edward Pierce, Matthew Gooderich, Emmanuel and possibly Thomas de Critz, sons of John de Critz, were not in the same class as Rubens. But the somewhat awkward style is none the less vigorous. It combines figurative work with a bulky Baroque form of Franco-Flemish cartouche decoration, and is typical of the Caroline court style on a more routine level below the high achievement of the Whitehall ceiling. It was even proposed, in 1651, to decorate Whitehall Palace with portraits and battlepieces illustrating the 'memorable achievements' of Parliament, but this came to nothing.

Under Cromwell there also flourished the miniaturist Samuel Cooper, who was one of England's greatest portraitists. In a few square inches he was capable of suggesting the mind and character of his subjects with a directness and absence of mannerism which makes one feel that one is actually talking with the sitter. 'For a Face', Richard Graham wrote in 1695, '. . . his *Talent* was so extraordinary, that . . . he was (at least) equal to the most famous *Italians*.' His portrait of Cromwell, 'warts and all' of course, has always been the accepted image of this complex man (*Plate 34*). The miniature as an art form continued to be popular during the seventeenth century. Charles I kept nearly eighty miniatures in his Cabinet Room at Whitehall, and in 1641 Sir Kenelm Digby wrote: 'Cavaliers are even more earnest to have their Mistresses' picture in limning than in a large draught wth. oyle colours.' Cooper himself, after the Restoration of 1660, was also kept busy painting fashionable beauties (*Plate 35*). In the latter half of the century, miniature copies were often made of the portraits of Lely and Kneller and this fashion carries on throughout the eighteenth century.

I have dwelt inevitably on the work of foreign artists and the importation of Continental styles and content in painting, and it may be worth redressing the balance a little by seeing the seventeenth century as the cradle of developments in British art which came to maturity in the eighteenth. At first, it may seem surprising that art in England, especially after the Restoration, did not follow more closely the pattern of Netherlandish and especially Dutch art. Both Holland and England were Protestant countries, with increasing wealth derived from trade and the opening up of new markets in the New World and the East. Yet England did not really adopt the genres of painting which were eagerly sought in the urban commercial environment of Holland,

especially genre scenes of everyday life characteristic of the work of Teniers, Steen, Brouwer, de Hooch, Terborch, Metsu or Vermeer. Nor in the seventeenth century did English patrons take to landscape to the same extent as did the Dutch. A partial explanation of this may be hinted at by a remark of John Evelyn, who said that in Holland people put their wealth into pictures, whilst Englishmen put their money in land. It is certainly the emphasis on land and property which goes a long way towards explaining the patronage of art in Britain in the eighteenth century, and the seventeenth century gives a foretaste of this. Dutch artists such as Claude de Jongh had some success in landscape in the reign of Charles I (*Plate 30*). Of seminal importance were the topographical landscape etchings of Wenceslaus Hollar, with their emphasis on actual places and buildings. After 1660 there is a growing taste for landscapes as overmantels to doors or inset into the panels of rooms. At Ham House in the 1670s, the Duke of Lauderdale employed painters like the Van de Veldes and Dirck van den Bergen to paint marines and landscapes in a decorative scheme which remains virtually unchanged to this day. Sometimes these landscapes are Italianate in the manner of Salvator Rosa or Gaspard Dughet. Pride in the possession of land and property is illustrated by paintings of animals by such artists as Francis Barlow, who painted a series of large pictures for Denzil Onslow's house at Pyrford which are now at Clandon Park, Surrey (*Plate 36*), and earlier in the century there were the vast paintings of horses at Welbeck traditionally attributed to Abraham van Diepenbeeck. At the end of the century, with the growing confidence of the landowning classes, the pace quickens, as is witnessed by the success of Jan Siberechts, Peter Tillemans, and, in the early eighteenth century, John Wootton. Their work is largely factual record, influenced by the Netherlandish tradition, cataloguing and itemizing the possessions of the great landowners in terms of land and livestock, and showing their love of country pursuits like hunting (*Plates 45, 46 and 47*).

After the Restoration, with the foundation of the Royal Society, there was a great interest and delight in ingenuity and inventiveness. The architect Christopher Wren is perhaps the most characteristic artistic figure in this upsurge of interest in mathematics and applied science, but we also find intellectual pleasure being expressed in the work of Dutch artists who practised elaborate '*trompe-l'oeil*' painting and very detailed still-life. Pepys was amazed at the drops on a flower painting by Verelst; 'It is worth', he wrote, 'going twenty miles to see it.' Such a relative diversity of genres reflects the wider based patronage which is a growing feature of British painting after the fall of Charles I.

At the end of October, 1661, an annual pension of £200 was granted to Peter Lely, 'as formerly to Van Dyck', on his appointment as 'Principal Painter' to Charles II. From then until Godfrey Kneller's death in 1723, British portraiture was dominated by these two men in succession. They were the first portraitists to have a huge clientele and vast studio practices. Both employed assistants, some to paint the draperies, some the backgrounds, some the flowers and still-lives in their portraits. Bainbrigg Buckeridge, chronicler of artists in England, wrote in 1706 of, 'John Baptist Gaspars, commonly called Lely's Baptist', whom he employed, 'to paint his postures, which he performed very well, and after his death he did the like for Mr. Riley and afterwards for Sir Godfry Kneller'. Their vast output accounts for the mediocre quality of much of the work

which came from their studios or which is assigned to them. Horace Walpole said of Kneller; 'Where he offered one picture to fame, he sacrificed twenty to lucre.' By 1670 Lely had arranged his available poses in numbered series. Kneller too had pattern book drawings of poses. They were often derived from Van Dyck, though more stiff and artificial; and these poses were taken over by followers such as Willem Wissing and Michael Dahl. Both Lely and Kneller catered for the same markets: ladies of the court (witness Lely's 'Windsor Beauties' and Kneller's 'Hampton Court Beauties'), admirals, the aristocracy, the country gentry, rich merchants, civic dignitaries, and the established professions. The dissemination of their portrait styles was aided not only by their conveyor belt productivity, but also through engravings, and especially the recently invented mezzotint process, which was particularly sympathetic to the reproduction of the tones of painting.

Peter Lely came to England in the 1640s and 'for some time followed the natural bent of his genius, and painted Landskip with small figures, as likewise historical compositions' (*Plate 38*), but he soon turned completely to portraiture, 'finding face painting more encouraged here', as Buckeridge tells us. His portraits, at least those done largely by himself at the height of his powers in the 1660s and 1670s (*Plate 37*), have a voluptuous, languishing air, a 'drowsy sweetness', with long heavy-lidded eyes and a horizontal emphasis to the composition, ideal for depicting the *déshabilée* shepherdess fashion current at court in the reign of Charles II. Godfrey Kneller's portraits are more upright, ordered and masculine. His direct style of painting the face *alla prima*, all at one sitting, produced a firm sense of character, best expressed in the series of 'Kit-Cat' portraits in the National Portrait Gallery. These were so called because they all depicted members of a Whig club which met at a tavern where the keeper, Christopher Cat, made delicious mutton pies known as 'Kit-cats'. The term also became associated with the size of the canvas, 36 × 28 in., a size previously used by Rembrandt, under whom Kneller may have studied in the early 1660s, but not common in England. Kneller's run-of-the-mill portraits have so detracted from his finest work that it is worth quoting a letter from C. R. Leslie to John Constable, written in 1823: 'I dined, yesterday, at the house built by Sir Godfrey Kneller, that man of wigs and drapery. On the staircase hung a beautiful portrait of Pope, by him. How unlike his usual efforts!' His portrait of Dryden, for firm characterization and spontaneous direct handling, is an example of what he could do at his best (*Plates 39 and 41*). There were many slavish imitators of Lely and Kneller, but two late seventeenth-century portraitists who have some individuality are Gerard Soest and Michael Wright. Soest is grave, restrained and unmannered (*Plate 40*). Wright (1617–after 1690), a widely travelled and learned man, shows in his work the kind of strictness combined with love of rich pattern which one might expect from a Scottish-trained artist considerably influenced by French elegance.

Aside from portraiture, the last half of the seventeenth century reflects the influence of Britain's two nearest neighbours, Holland and France. Despite wars, ties with Holland were close, even if competitive, and there was, as we have seen, a significant influx of Dutch craftsmen and painters. On a grander scale, the influence of France, and especially Louis XIV's palace at Versailles, made itself felt in decorative painting.

Alexander Pope, in his epistle to Lord Burlington of 1731, satirized the by then outmoded fashion;

> *On painted Ceilings you devoutly stare,*
> *Where sprawl the Saints of* Verrio *and* Laguerre.

Antonio Verrio, a southern Italian artist who later moved to France, was invited to England by Ralph Montagu in 1672. He brought to England an extrovert style of interior decoration which consisted of painting the ceiling, or indeed the whole room, as if it was a grand architectural structure open to the sky, where allegorical figures massed themselves on clouds, or glided behind painted balustrades and around columns. Verrio worked extensively for Charles II and James II at Windsor, where he had by 1678 completed fourteen ceilings, but when his Roman Catholicism made his presence at court unwelcome in 1688, he worked at Burghley for the 5th Earl of Exeter and his masterpiece is the Heaven Room there (*Plate 42*). The idea of apparently opening out the wall to the outside is at least as old as Mantegna's decorations in the Camera degli Sposi at Mantua, but Verrio's style is a compound of Italian and French seventeenth-century styles. Louis Laguerre (1663–1721), who followed him, was born at Versailles and was actually a godson of Louis XIV. His work was more classical than that of Verrio, as one would expect from a painter trained under Charles Lebrun, the mastermind of the Versailles decoration, and Laguerre's Saloon at Blenheim, painted for the Duke of Marlborough, is freely adapted from Lebrun's Escalier des Ambassadeurs at Versailles. By the end of the century, the Whig and indeed Tory grandees were flexing their political muscles and palatial decoration was an apt way of expressing their wealth and power.

Just after the turn of the century, Laguerre's position was threatened by the emergence of a thrusting and ambitious English-born decorative painter, James Thornhill. Working in the same tradition, he painted the Sabine Room at Chatsworth in 1706. Later he was to capture the plum commissions to decorate the Upper and Lower Halls at Greenwich (1707–25) and the interior of the dome in St Paul's (1715–17). His significance extends beyond his decorative painting to the fact that he was a native-born painter competing on equal terms with imported foreign artists; and during his lifetime there was a growing feeling expressed that patrons should, if possible, choose British artists. The beginnings of a national school are at least glimpsed, as opposed to the odd British artist standing out amongst a stream of foreign painters. Thornhill, of course, was still purveying an essentially international style, but his example was not lost on Hogarth, his son-in-law, nor on the national aspirations of such writers as Buckeridge or Jonathan Richardson, whose wishes for a coherent national school are echoed and re-echoed throughout the first half of the eighteenth century. Allied to this was the desire for a national academy of art; and then, wrote Buckeridge, 'we might see how high the English genius would soar'. Thornhill was the first English-born painter to be knighted, in 1720; and a later anecdote about the St Paul's commission, even if apocryphal, demonstrates the mood of the time. Archbishop Tenison, one of the trustees of St Paul's, is reputed to have said; 'I am no judge of painting, but on two articles I think I may insist: first that the painter employed be a

Protestant; and secondly that he be an Englishman.' So Thornhill triumphed over Pellegrini and Laguerre and won the commission. He also succeeded Kneller, in 1716, as head of the academy which the latter had founded in 1711, the first in the line of relatively informal academies or schools of art which culminated in the founding of the Royal Academy in 1768.

William Aglionby, in his *Painting Illustrated* of 1685, wrote; 'I have often wondered that we never produced an Historical Painter, Native of our own Soyl. . . . I cannot attribute this to anything but the little Encouragement it merits within this Nation, whose genius more particularly leads them to affect Face-Painting. . . . But our Nobility and Gentry are generally speaking no Judges, and therefore can be no Promoters of an Art that lies in all nice observations.' If this was true when it was written, it was also true, with the possible exception of Thornhill (*Plate 43*) and later Benjamin West (*Plate 93*), in the eighteenth century. It was a continual grumble amongst connoisseurs and some artists, such as Richardson, Reynolds and Barry (*Plate 91*), who wished to see High Art securely implanted in England. Given the political, social and economic condition of Britain, its Anglican religion and the ingrained puritanism of the British character, it is amazing that artists followed this stony path for so long. Hogarth painted the staircase of St Bartholomew's Hospital in London, free of charge, with religious paintings (1735–6) and later wrote: 'By the pother made about the grand stile thought [it] might serve as a specimen to shew that were there any inclination in England for Historical Painting such a first essay would Prove it more easily attainable than is imagined, but as religion the great promoter of this stile in other countries, in this rejected it.' It is surprising, though, that while History painting did not catch on in a society of country gentry and hard-headed merchants, the idea of High Art took so long to die. We can trace it through Reynolds's *Discourses* given to the students at the Royal Academy, through the manic outpourings of Benjamin Robert Haydon's diary, to the work of Watts, whose concern for high moral issues in art (*Plate 156*) found a more sympathetic response in a slightly bewildered Victorian public, none the less keen to be suitably edified.

A hankering after the grand style of the Italian Renaissance was, however, but one thread in a movement during the course of the eighteenth century towards a national school. As we have already seen, there was strong desire for academies of art where the latent English genius could be nurtured; and it was a hope that was realized, albeit in the muddled empirical way typical of British institutions. James Thornhill (*Plate 43*), who succeeded Kneller as governor of the latter's academy, founded his own school in 1724 in his house in St James's Street, Covent Garden. Louis Chéron and John Vanderbanck had started the St Martin's Lane Academy in 1720 and this was revived by Hogarth in 1734 on democratic principles: that is to say there was no structured constitution and all members had equal rights. Hogarth was particularly hostile to the idea of a state-run academy with elaborate rules and regulations on the French model. Most British artists drew at this informal academy, more in the nature of an artists' club, from the 1730s until the 1760s. Meanwhile there had been rumblings in favour of

a more formal body which could elevate the status of the artist in society. In 1755 there appeared a pamphlet entitled an 'Essay on the Necessity of a Royal Academy', and in the same year the Dilettanti Society tried unsuccessfully to found a school of art.

Connected with this was the need for a place where artists could exhibit their works to the public. It was a need which had been rather unsuccessfully fulfilled by the walls of the Foundling Hospital, started in 1739, for which British painters such as Hogarth, Hayman, Wilson and Gainsborough had produced paintings, and the Vauxhall pleasure gardens, opened in 1732, where works by English artists, especially Hayman (*Plate 53*), had adorned the supper-boxes and bosky alleys. The Society for the Encouragement of Arts, Manufactures and Commerce, founded by William Shipley in 1754, offered prizes, from the late 1750s, for different kinds of painting and drawing. This was a typically British venture, which found later echoes in the nineteenth century with the Government Schools of Design, whereby it was hoped to nourish the 'Useful Arts' so that British manufactures, commerce and invention could thrive in harmony with the fine arts. But the first really significant achievement, organized by the artists themselves, was the foundation in 1760 of the Society of Artists, which began to hold annual exhibitions open to the public; and in 1768 a breakaway group of artists from this society obtained royal approval for a Royal Academy, which would provide, not only annual exhibitions, but also a school of art, taking over from the St Martin's Lane Academy.

The Royal Academy succeeded from the start. It had the best artists, with Joshua Reynolds as president until his death in 1792; it secured royal patronage; it helped to raise the status of the artist and encouraged a sense of professional corporate identity amongst the members; and it gave to the work of English painters at the annual exhibitions a sense of national purpose and to their lives and careers a social cachet. Through its teaching, and especially through Reynolds's *Discourses*, it propagated ideas of High Art so beloved of the theorists and connoisseurs. For over a hundred years it was the established and cherished focus of the best British art, and even those it ill treated, such as Constable, remained faithful to it. The Pre-Raphaelites saw themselves as rebels against the sad state of English art in the middle of the nineteenth century, but they still exhibited at the Academy. It did not begin to falter as the centre of English artistic endeavour until the 1870s and 1880s.

But there was another side to the coin. The British have always been suspicious of organized bodies dispensing dogma and doctrine; and in the Romantic age the notion of individual genius, the idea of random sources of inspiration plucking the creative sensitivity like the breezes which move the strings of the Aeolian harp, was bound to cause some artists to dispute the value of an academy. Hogarth had been bluntly and unromantically hostile in the middle of the eighteenth century. William Blake, hardly surprisingly, was antagonistic. Benjamin Robert Haydon wrote of academies as 'Royal and Imperial hot-beds of commonplace'. It was felt by some that the Academy was the home of the 'establishment', which must be attacked; that it stifled creativity; that it purveyed mediocrity; that it levelled talent; that it broke the spirit of the true artist. But these were lonely and intermittent voices. On the whole the Royal Academy did not dispense dogma and doctrine. It managed to accommodate the eccentricities of Fuseli

(*Plates 87, 88 and 90*) and the genius of Turner (*Plates 104, 106, 107, 118 and 130*), and to retain their whole-hearted loyalty, as well as the more conventional excellence of Lawrence (*Plates 98 and 110*) and the wide popularity of Landseer (*Plate 124 and 129*).

The Royal Academy is so central to British art in the late eighteenth and nineteenth centuries that some of its wider implications, and the effects of some of its foundations that are apparent even today, should be clearly appreciated. It is somewhat paradoxical that the Academy was founded to celebrate and confirm the generally accepted doctrines of art which had been upheld by theorists going back to Alberti in the fifteenth century: the concept of a hierarchy of genres, of morally and intellectually ennobling art, of the ascendancy of History painting. In short, of all the notions of unity and harmony and idealization of nature which are synonymous with the 'Age of Reason' and an Augustan climate of opinion. The idea was succinctly stated by Jonathan Richardson (1665–1745) in his *Essay on the Theory of Painting* (1715), a much read work in the eighteenth century. 'A painter must raise his ideas beyond what he sees, and form a model of perfection in his own mind which is not to be found in reality, but yet such a one as is probable, and rational.' It was an Aristotelian concept, accepted by an aristocratic and elitist society. Yet the paradox is that this society was gradually breaking up and the Academy helped to steer the practice of art towards a more 'populist' approach. For the annual exhibitions were open to the public and the kind of paintings the artists produced became gradually dictated, not by some Olympian theorist such as Reynolds, but by what the public wanted. The painters had managed to free themselves in some measure from the shackles of conventional aristocratic patronage by founding the Academy so that they could paint what they wanted. But as the nineteenth century advanced they were subjected to a new taskmaster—the public who attended the exhibitions; and the people who bought pictures by living artists in the nineteenth century were mainly the commercially successful middle classes—the Manchester businessman—who wanted something sweet and sentimental (*Plate 177*), or anecdotal (*Plate 142*), or dreamily escapist (*Plate 153*) or stirringly patriotic (*Plate 169*). It is true he was prepared to be morally edified, but he did not want any of his basic ideas to be questioned; he did not want to be hectored or lectured, he wanted to be entertained, and in some cases sexually titillated with genteel pornography (*Plate 170*).

Another important effect of the freeing of the artist from his aristocratic patron was that he began to be more self-conscious about his role. What was he to do if he disagreed with the current climate of artistic opinion? Well, he could strike out on his own, and possibly starve, or he could collaborate with other like-minded souls and form a group, with the intention of imposing his own principles on his prospective clients. The idea of the 'movement' in art was gradually born. So we have the Pre-Raphaelites in England (*Plates 136–40 and 157*), as there had been the German Nazarenes on the Continent. Later there are more splinter groups: William Morris and his circle, the New English Art Club, the Camden Town Group, the Vorticists, the Seven and Five Society, Unit One. The 'isms' of art march on today with Pop art, Op art and beyond. The painter sees it as his function to lead thought, to be modern, to shape his own destiny and the course of art, to be *avant-garde*. In a word, we have fragmentation, the destruction of a unified concept of art and society.

But if in 1768 British art achieved a position of significant maturity, this was not apparent at the beginning of the century. 'We are now arrived', wrote Horace Walpole of the reign of George I (1714–27), 'at the period in which the arts were sunk to their lowest ebb in Britain.' Given a certain amount of hostility to the immediate past, this was substantially true. Portraiture was active, but it was on the whole a turgid ebbing out of the Kneller tradition which was not finally laid to rest until the 1750s. Largely responsible for this was the continuing use of drapery painters, notably Josef van Aken who worked in England from about 1720 until his death in 1749. Van Aken was responsible for the draperies and figures in many of the paintings of John Vanderbanck (1694–1739), Thomas Hudson (1701–79) and the early paintings of Allan Ramsay. An idea of the creative process in run-of-the-mill portraits can be gained from an account of the work of a little-known painter, Hamlet Winstanley, who had a large portrait practice in the north of England in the second quarter of the eighteenth century. He 'travelled about and drew pictures from the life in oil colours—often on small pieces of cloth, only the face; pasted them when sent to London on larger clothes'. In London Van Aken completed the portraits with that 'excellent, free, genteel and florid manner of pencilling, silks, satins, velvets, gold lace, etc.' Van Aken's draperies were much admired, but they do account for the fact that so many English portraits of this period look remarkably alike, with the same poses and the same rather metallic polished surface. In the late 1730s and 1740s, two Continental painters, Andrea Soldi (*Plate 71*) and Jean-Baptiste Vanloo (1684–1745), had great success in London with a crisper and more elegant version of Hudson's standard portraits, and it was not until the paintings of Allan Ramsay (*Plate 79*), after about 1750, that a breath of fresh air ruffled the dead surface and mannered poses of British portraiture.

Allan Ramsay, a Scottish painter, came to London in 1734. After his return from his first Italian visit he could write, in 1740; 'I have put all your Vanloos and Soldis and Ruscas to flight and now play the first fiddle myself.' Although he employed Van Aken at first, after 1750 he thought out original and natural poses for his sitters, as can be seen from his preparatory drawings. Instead of a polished 'licked' surface he introduced a softer finish with a quiet palette of pastel greys, blues and pinks which owes a good deal to his knowledge of contemporary French portraiture, especially the work of Nattier and Perroneau. In addition, as can be seen from his gentle portrait of Mrs Bruce of Arnot (*Plate 79*), instead of the artificial, brittle image of a Hudson, his portraits have that informal charm which we associate with the good breeding of the county families who were later immortalized in the novels of Jane Austen. His female portraits probably influenced those of Reynolds, and Walpole considered him to be ideally suited to paint women, just as Reynolds's strong point was in portraits of men.

Aside from portraiture, it is William Hogarth who dominates English art in the first half of the century. Yet he is a figure whose art is so original and challenging that he is isolated from his contemporaries. He was scornful of portraiture, although his *Captain Coram* and his *Archbishop Herring* (*Plate 72*) are masterpieces. His jingoism, his aggressive pragmatism, his bluntness, his harsh satire and journalistic eye, all place him not so much with the painters, as with the writers, especially Henry Fielding and Tobias Smollett. He created single-handed a new genre, the 'Modern Moral Subject', and

introduced the original practice of paintings and engravings in series, telling a story, such as the *Harlot's progress*, the *Rake's progress* and *Marriage à la mode* (*Plates 59 and 63*). Charles Lamb wrote of him; 'His graphic representations are indeed BOOKS: they have the teeming fruitful, suggestive meaning of *words*. Other pictures we look at—his prints we read.' Hogarth rejected the well-worn paths of English artists in portraiture or 'fiz-mongering' and forged a new way. He despised the paraphernalia of conventional patronage and poured scorn on the trade in dubious Old Master paintings, upsetting all the canons of good taste and connoisseurship laid down by Jonathan Richardson and his son. His real originality lies in the fact that he was able to support himself not through the sale of his paintings, nor through dependence on aristocratic patrons, but through the widespread sale of his engraved series, aided by the 1735 Engravers' Copyright Act which he helped to get passed through Parliament. 'Dealing with the public in general', he wrote in his *Autobiographical Notes*, 'I found was the most likely do provided I could strike the passions and by small sums from many by means of prints which I could Engrav from my Picture myself I could secure my Property to myself.' His dependence on the sale of engravings, from which he made a lot of money, can be compared to the way in which a writer depends on the sale of his books. It was a way of bypassing the existing structure of patronage. It was also prophetic. As the organization of society was beginning to change under new social and economic pressures, which culminated in the Industrial Revolution and the political reforms of the nineteenth century, so artists were forced to seek a different and much wider public for their works. When John Boydell commissioned his Shakespeare Gallery in the 1780s, it was through the sale of engravings after the paintings that he hoped to make his profit. A newspaper report of 1787 claimed: 'The plain truth is engravers are the principal employers of the painters of the present day (formerly Princes and the Nobility were the patrons!)'

Although in many ways Hogarth is a figure apart, who looks forwards, perhaps, to Dickens rather than to later painters, he was a leading exponent of one essentially British genre which flourished in the eighteenth century. This was the group portrait in little, or conversation piece. In the late 1720s and early 1730s he was attempting to make his living out of painting this kind of picture for an aristocratic clientele (*Plate 61*). In style and composition, the conversation piece owed much to the work of Watteau, and it has often been said that Philippe Mercier (about 1689–1760), who was painting group portraits in the 1720s, brought it to England. Bartholomew Dandridge (1691–1754), Charles Philips (1708–47) and Gawen Hamilton (1698–1737) also practised it. Hogarth sometimes introduces a note of comedy, as in his picture of *Lord Hervey and his friends* (*Plates 61 and 62*), though he retains the elegance and sensitivity of a painterly French manner. Gainsborough's *Heneage Lloyd and his sister* (*Plate 52*) emphasizes the landscape element and brings to the genre a wistful quality and a harmonious elegance, at times almost Mozartian in feeling, that somehow belies the Dutch sources of his early work. But it is in the work of Arthur Devis that the conversation piece is at its most English. His stiff doll-like figures, both down to earth and sensitive at the same time (*Plates 50 and 51*), reintroduce into English painting a quality of charm earlier found in the work of Cornelius Johnson (*Plate 32*). It may be that the gauche poses are due to the practice of painting figures from dressed-up dolls or

lay-figures, which may have been introduced into England by Hubert François Gravelot, who taught at the St Martin's Lane Academy in the 1740s and was one of Gainsborough's teachers. Later Johann Zoffany (*Plates 65 and 70*), George Stubbs (*Plate 66*), Francis Wheatley (1747–1801) and John Hamilton Mortimer painted group portraits of a similar kind in the 1760s, 1770s and 1780s.

The success of the conversation piece was one of those happy accidents which spring from the harmonious fusing of artistic development with social and economic factors. The early eighteenth century was a great building age. The aristocracy and country gentry were consolidating their wealth and status by establishing themselves in landed property, putting up villas and houses in the current Palladian style all over the country. On the whole these were relatively small-scale houses, and they needed pictures smaller in format than large full-lengths appropriate to grander mansions. The small conversation picture was ideal wall furniture for the dining room, the drawing room or the staircase, as the Devis portraits still at Uppark make clear. The group of family or friends, as well as being cheaper than large single portraits, expressed the sense of pride in property and family which the landed gentry felt.

The style and mood of the conversation piece owed a certain amount, as we have seen, to the work of Watteau. He came to England for about a year in 1720, and though his stay may not in itself have been very significant, for the next three decades the influence of French art is apparent in England. It was not the stern academic 'salon' art, nor the luscious sensuality of Boucher, but the informal intimate side of French art which affected English painters. This is found not only in the conversation pieces of Gainsborough (*Plate 52*), but in other branches of art which gave English artists some release from the tyranny of the portrait. Mercier painted some genre scenes which look forward to the 'fancy' pictures of Reynolds and Gainsborough and indirectly to the pastoral genre of Wheatley and Morland (1763–1804). There was also a growing market for illustrations to literature. Joseph Highmore (1692–1780) painted some delicate illustrations to Samuel Richardson's novel, *Pamela*. They are now in the Tate Gallery, the Fitzwilliam Museum, Cambridge, and the National Gallery of Victoria, Melbourne, Australia, and they express the softer side of the mid eighteenth century, its penchant for rather self-conscious tearfulness. Illustrated copies of Shakespeare began to appear, notably Hanmer's edition of 1744, with designs on the French model by Gravelot and Hayman. Francis Hayman's decorative paintings for Vauxhall show the influence of Watteau's *fêtes galantes* (*Plate 53*). In fact, there was in the middle of the eighteenth century a mutual exchange of artistic ideas between France and England. England adopted the light French Rococo manner, whilst France responded to the 'sensibility' of Richardson's novels and to a certain extent to the 'morality' of Hogarth.

But if there was a move towards softness, informality and a more natural manner away from the stiff artificiality of the Kneller tradition, there was also a development towards a new grand style in portraiture. Early examples of this are the more imposing portraits of Hogarth (*Plate 72*) and Ramsay, but it was Joshua Reynolds who really established the Grand Manner in England. Just after his return from his Italian tour he painted a portrait of his naval friend Commodore Keppel (1753; National Maritime Museum, Greenwich), which established his reputation as the leading British portrait

painter. It was not grand in the operatic manner of the French Baroque portraiture of Largillière. There were no agitated draperies and over life-size gestures. It was more solid and down to earth. Reynolds tried to weld on to the tradition of British portraiture the *gravitas* and compositional range and depth of the Renaissance art of Raphael and Michelangelo, combined with the rich colour of Venetian art. His portrait of the Prince of Wales (*Plate 77*) is another example of the rich senatorial style naturally appropriate to a royal portrait. Reynolds was continually conscious, perhaps over conscious, of the traditions of art; he saw his own work in relation to the great tradition of European painting and he saw himself as extending and enriching that tradition. Probably he had in mind the words of Jonathan Richardson, which he had read as a boy; 'And now I cannot forbear wishing that some younger painter than myself . . . would exert himself . . . in this single instance of attempting and hoping only to equal the greatest masters of whatsoever age, or nation.' Reynolds also felt himself to be responsible for the health and future development of British art, demanding that it should be a worthy successor to the art of the Italian Renaissance. Hence the *Discourses* and the presidency of the Royal Academy. And he was much admired and respected, not only by his contemporaries, but also by such later and apparently different artists as Turner and Constable, who were both, in their differing ways, concerned with producing work which took its place within a coherent and unified tradition, albeit a tradition that was susceptible to development and change. But, as I have suggested, this self-conscious concern for tradition was taking place just at the time when many factors were conspiring to destroy it.

This concern for traditional values in art, stretching back to the Renaissance and, beyond, to classical antiquity, is at the root of that essentially eighteenth-century phenomenon, the Grand Tour. A visit to Italy, usually by land through France and over the Alps, was considered an essential part of the education of a young aristocrat at least from the middle of the century onwards. It was also considered essential by many artists. At the beginning of the century, Joseph Addison wrote; 'There is certainly no Place in the World where a Man may Travel with greater Pleasure and Advantage than in Italy. One finds something more particular in the Face of the Country, and more astonishing in the Works of Nature, than can be met with in any other Part of Europe. It is the great School of Musick and Painting, and contains in it all the noblest Productions of Statuary and Architecture both Ancient and Modern.' But whilst a steady stream of young lords and young artists made the pilgrimage to Rome and Venice and Naples, the increasing wealth of England and declining patronage in Italy were attracting Italian artists to make the journey in the opposite direction. At the beginning of the century, with the demise of the grandiloquent Verrio, Laguerre and Thornhill tradition of decorative painting, a more informal and playful style of interior decoration was introduced within the austere Palladian exteriors by Sebastiano Ricci (*Plate 44*), Pellegrini and Amigoni. Antonio Canaletto came to England in 1746 and was in great demand for landscapes and views (*Plates 54, 56 and 57*). It was a combination of his influence and that of William van de Velde that accounts for the style of Samuel Scott: topographical accuracy and a fresh and breezy depiction of the English sky (*Plate 55*). Richard Wilson was a landscape painter who visited Italy and

whose spiritual home was there. The taste for seventeenth-century Italianate classical landscape was already, by the middle of the century, deeply embedded in the English consciousness, and the work of Claude and Rosa and Gaspard Dughet was well known in England both at first hand and through the pastiches of such artists as John Wootton and George Lambert. But what makes Wilson's work transcend that of a mere pasticheur is his understanding for and love of the light and air of Italy, combined with a buttery and fluent brushstroke which is, at its best, almost a quality that one can taste, like a fine pâté. It is not surprising that his *Arch at Kew* (*Plate 58*) was taken for many years as an Italian scene. When he painted more obviously British landscapes, such as his view of Tabley (*Plate 116*), it is true that he used a compositional structure derived from Claude, but it is the honesty of his depiction of the English atmosphere in its depth and distance which gives such a painting its quality, a quality that was admired by Turner and Constable and Ruskin.

The attraction of Italy and Italian art, both past and present, was significant for many painters, but for Thomas Gainsborough it meant nothing. Consciously unacademic, unlearned and will-o'-the-wisp in temperament, Gainsborough did certainly respond to the art of the past; to Van Dyck (*Plate 25*) in portraiture, to Ruysdael, Rubens (*Plate 20*), Wynants and Watteau in landscape, but he owed to these artists a personal debt that was not in any way self-conscious. He transformed his sources into a musical harmony of rhythm and pastoral mood that was completely individual. His technique was also original. He hatched and scratched in his middle and late periods (*Plates 75, 76, 97, and 100*) in a very personal manner that yet earned the admiration of Reynolds, although the latter did not recommend the practice to others. He praised Gainsborough for 'his manner of forming all the parts of his picture together; the whole going on at the same time, in the same manner as nature creates her works'. Gainsborough admired Reynolds in his turn, and was impressed by the 'variety' of Reynolds's portraits, the different poses and the ability of Reynolds to paint not only grand pictures (*Plate 77*), but also informal and intimate portraits (*Plate 78*) and perceptive studies of mind and character (*Plate 73*).

As is well known, Gainsborough preferred painting landscapes to the drudgery of portraiture. His early landscapes are precise and detailed in the Dutch seventeenth-century manner of Wynants, but gradually his technique became looser and more fluent, his compositions simpler and, in his last years, more monumental. We are told he brought into his studio stones, lumps of coal, broccoli and bits of vegetation, from which he constructed landscapes in miniature, painting them often in the evenings by candlelight. But this clearly artificial way of constructing his landscape compositions belies the great contribution of Gainsborough to English landscape painting. His originality lies in the fact that although he does not present literal truth to appearance (*Plate 101*), in the way that Constable attempted to do (*Plate 102*), he does provide a kind of emotional truth. His paintings of landscape create in the spectator the same mood of appreciation and contentment which he might feel on actually seeing a beautiful scene in nature; and it is this element of emotional involvement and the communication of a mood which makes Gainsborough such an important painter. Constable perceptively wrote of him; 'His object was to deliver a fine sentiment, and he has fully accomplished it.'

George Stubbs was like Gainsborough in the sense that he personally rejected Italy as the centre of culture, though he did visit the country and he did also have aspirations to be a 'history' painter. But in common with artists such as Wright of Derby he preferred to trust his own eye rather than the precepts of imposed theoretical art doctrine. His studies of the anatomy of the horse, published in 1766, and later his comparisons of the anatomy of man with that of the tiger and the fowl, which he was working on about 1800, demonstrate his belief in empirical scientific observation. Though he made his living by painting horses, sporting pictures and portraits for the aristocracy—paintings which are now regarded as his finest works—he was not entirely happy to work solely for such commissions. His original and experimental nature is shown by the enamel paintings he executed on large Wedgwood plaques, as well as by his detailed drawings done from dissections of horses—dissections which he personally carried out at a lonely farm in Lincolnshire. But he stands as the supreme exponent of the sporting conversation picture, celebrating an age in which man lived in harmony with his animals, admirably expressed by such a painting as *Lord and Lady Melbourne, Sir Ralph Milbanke and John Milbanke* (*Plate 66*).

What raises his work above that of a predecessor in horse painting, such as Wootton, is his fastidious sense of colour, the rhythms of his compositions, seen especially in his paintings of *Mares and foals* (*Plate 68*), which can be appreciated as abstract designs in their own right, and his cool undifferentiating observation of form, which, Chardin-like, can give the same breadth and monumentality to the depiction of a stable lad as to the most prized racehorse (*Plate 67*). These are the qualities which have made his art so much appreciated today, when formal and abstract values are especially admired. In his lifetime, though much sought after by patrons, his paintings were not considered, largely because of their subject matter, as belonging to the highest branches of art. Subsequently his reputation suffered an eclipse. In the early part of this century the grand portraits of Reynolds, Romney and Raeburn were the most prized eighteenth-century paintings. But now both the intrinsic quality of Stubbs's paintings, and the social life they depict, are admired above the pretensions of the Grand Manner.

The art of landscape is particularly associated with Britain, and in the eighteenth century developments were taking place which led up to the magnificently original work of Turner and Constable. It is, of course, easy, with the aid of historical hindsight, to select a pattern which shows a consistent evolution away from artificially constructed 'picture making' based on the classical landscape of Claude and the Poussins, towards a fresh and spontaneous response to the humble facts of the English natural scene. The true position is more complex, though it is true that as the century advanced we find more evidence of an attempt to depict the English landscape and the quality of the English light and atmosphere in a truthful way. The most obvious example of this is the development of the British watercolour school, with the work of such artists as John Robert Cozens (1752–99), Paul Sandby (1725/6–1809) and Thomas Girtin (1775–1802), although these lie outside the scope of this book. But we can equally cite examples from the second half of the century which undermine this theory of a

consistent progression towards greater naturalism. Edward Dayes, a watercolourist, in his *Essay on Painting* published in 1805, argued: 'The means most likely to enable us to acquire a knowledge in this art [landscape] are, first to study pictures, and then to resort to nature.' The most successful landscape painters in the second half of the eighteenth century were those artists who idealized nature in the manner of Claude. For example George Barret (1732?–84), though his views are more particularized than those of Wilson and more influenced by the Dutch landscape tradition, or Jacob More (*Plate 82*), who spent most of his working life in Italy. We find Gainsborough writing to Lord Hardwicke: 'With respect to real views from Nature in this country he has never seen any place that affords a subject equal to the poorest imitations of Gaspar [Dughet] or Claude.' On the other hand we find George Lambert producing, as early as 1733, a simple view of harvesting in an unspectacular rural setting (*Plate 49*), and Thomas Jones (*see Plate 85*) painting oil sketches from nature in his native Wales and in Naples.

What is of the greatest significance, however, is that as the century advanced, appreciation of British scenery grew. At the centre of this growing preoccupation with the delights of landscape was the 'Picturesque' movement. At the end of the seventeenth century, as we have seen, the landscape paintings of Claude, Gaspard Dughet and Salvator Rosa became popular. Their works were collected and admired. On the Grand Tour, visitors such as Thomas Gray and Horace Walpole enthused over the sublimity of the Alpine scenes through which they passed. Poets like James Thomson and John Dyer in the first half of the eighteenth century incorporated a great deal of landscape imagery into their poetry, often with reference, either explicit or implicit, to the paintings of these artists. In the second half of the century, largely due to the enthusiasm of William Gilpin (1724–1804), a country parson, schoolmaster and connoisseur of landscape, it became common for people to tour Britain in search of landscapes worthy of the brush of Claude or Salvator. They found that in the mountains of Wales and Scotland, or in the Wye valley, Britain had imposing and 'picturesque' scenery which could almost rival that of the Alps or Italy. Gilpin defined the picturesque in 1768 in his *Essay upon Prints* as 'expressive of that peculiar kind of beauty, which is agreeable in a picture'. Between 1768 and 1776 he travelled round Britain gathering material for a series of travel books, such as *Observations on the River Wye, Relative chiefly to Picturesque Beauty* published in 1792, which were concerned with this 'peculiar kind of beauty'.

We also find that in the Romantic period, that is the years from about 1750 to 1850, both in painting and in literature, landscape takes on a great wealth of meaning, emotional, intellectual and moral, which it had not previously carried. This is shown by the poetry of Wordsworth, and it is equally true of the work of Constable and Turner, and the paintings of such artists as Francis Danby and Samuel Palmer. Before this period the content in art had usually been restricted to the actions of the human figure, or to objects which carried symbolic or allegorical meaning. It was found in a noble, historical, biblical or mythological story. But in the Romantic period this content, though of a different kind, was often conveyed through the visual facts of landscape. It is found not only in the work of British artists, but also in the work of the Germans,

Philipp Otto Runge and Caspar David Friedrich, who sought to convey Christian and moral truths through the depiction of landscapes.

In a painting such as *The cornfield* (*Plate 102*), Constable wanted to show not only the ordinary landscape as he actually saw it, but to convey its particular emotional meaning for him, for this probably shows the lane down which he used to go to school in his 'careless boyhood'. In his paintings of the Stour valley he was celebrating the agricultural life, the labourers who worked in the fields and saw the changing seasons, the way in which the barges were managed and pulled by the horses. This had for him a moral significance, made more poignant by the fact that in the 1820s he saw the settled country upset by change and strife, the burning of hayricks in barns and workers demonstrating against poverty and unemployment. He wanted to recapture the harmonious agricultural life he had known in his youth. Turner, on a more cosmic and expansive canvas, depicted varying types of historical landscape, with works such as his engraved series, the *Liber Studiorum*. In his painting of *Ulysses deriding Polyphemus* (*Plate 107*) he even showed mythological figures themselves dissolving into the natural phenomena they were originally invented to symbolize. The giant Polyphemus is half human figure, half cloud. The horses of Apollo's chariot, now hardly visible in the painting, not only represent the rising sun, they are the fingers of the dawn; and sea nymphs that cluster round the bows of the ship take on the visual shape of the phosphorescent vapours of the sea, or vice versa. For Samuel Palmer, the Bible story shines forth from the hills and dells of the country round Shoreham in Kent, and the landscape becomes a gateway, a kind of entrance into a visionary poetic world (*Plate 115*). We find the same thing happening in the elegiac landscapes of Francis Danby, such as *An enchanted island* (*Plate 105*), though he is inspired by something vaguer than the Christian story, a sort of personal symbolism that resides in a fragile mood of evening stillness and which requires no reference outside the light and colour of the landscape itself.

So it was that landscape became a way of expressing varying Romantic moods, whereas at the beginning of the eighteenth century it was either, as in the work of Siberechts (*Plate 45*), a setting for a portrait of a house or a definite view of a place, or, in the work of Wootton (*Plate 46*), a background to a hunting scene, or a pastiche of the classical landscape of Claude or Gaspard Dughet.

Landscape apart, after about 1760, largely because of the annual exhibitions at the Society of Artists and later the Royal Academy, it was possible for British painters to be more adventurous in their choice of subject matter. Painting of British history was encouraged. As the national consciousness grew, buttressed by the increasing wealth and the settled constitution of Britain, painters chose subjects from medieval, Elizabethan and Stuart times. Romanticism sanctioned a taste for Gothic architecture and the Middle Ages in literature and history. In addition, after the success of Benjamin West with his *Death of General Wolfe* in 1771, it became more acceptable for painters to depict scenes from contemporary, or near contemporary, history. John Singleton Copley's *Death of Major Pierson* (*Plate 92*) is a case in point, and it was

indirectly the example of West and Copley which, in the early nineteenth century, led to Delacroix's and Géricault's paintings of contemporary history.

At the same time the works of English and Continental writers, both living and dead, were illustrated, not only in engravings in books, but also in large-scale paintings. Shakespeare became a great source for painters (*Plates 84 and 88*) and Boydell's Shakespeare Gallery was opened in 1784 with paintings by most of the leading British artists. At the beginning of the nineteenth century Sir Walter Scott's romantic novels were overwhelmingly popular and provided illustrative material for British and French artists. There was even a revival of interest in religious subjects. All this was part of the artists' attempts to paint, on a grand scale, subjects which expressed the full range of man's character, his strengths, passions and high desires. This subject matter continued in High Art throughout the nineteenth century. It showed the extent to which many painters still clung to a belief in the academic theory of the hierarchy of genres. James Barry, with his monumental series of canvases, *The progress of human culture*, painted between 1777 and 1783 for the walls of the Society of Arts building in the Adelphi, London, and done at his own suggestion and initially free of charge, is an example of this commitment to the noble Renaissance tradition (*Plate 91*). Barry was overwhelmed by the concept of the sublime, which Edmund Burke had analysed and propounded in his essay on 'The Sublime and the Beautiful' (1757), and it was the sensational and psychological aspects of sublimity which affected a number of artists in this period and which colours the early Romantic movement in England. The sublime in landscape was almost synonymous with the work of Salvator Rosa, and Thomas Jones's *Bard* (*Plate 85*) is virtually a pastiche of Rosa's wild and untamed mountainous landscapes. But the horrific sublime is also expressed by Henry Fuseli's figures, Michelangelesque in their muscular power and seeming to exist at the extremes of human endeavour (*Plate 88*). Mortimer's bandits (*Plate 89*) and monsters, borrowed from Rosa's works, have a ferocity and even obscenity which characterize his 'horrible imaginings'. And it is the sublime in a more spiritual and visionary guise which informs the work of William Blake. Blake, as primarily a watercolourist and engraver, is largely outside the scope of this book, and he occupies an isolated position as a thinker and visionary which it is difficult to fit into a brief survey of British painting, but he remains a genius whose presence it is impossible to overlook (*Plate 111*).

One European movement which affected primarily the form and to a lesser extent the content of subject painting in Britain from about 1760 until about 1840 was Neo-Classicism. Largely as a result of the Grand Tour, painters, sculptors and connoisseurs became interested in Roman classical art and in Greek sculpture and vase painting (believed to be Greek, but in fact often Etruscan). The movement, centred on Rome and Naples, was stimulated by the archaeological excavations at Herculaneum and Pompeii from the 1730s onwards. Its prophet was the German intellectual Johann Joachim Winckelmann (1717–68), whose book on Greek art was translated into English by Fuseli in 1765, and one of the painters most concerned with the origin of Neo-Classicism in painting was the Scottish artist, Gavin Hamilton (1723–98), who worked a great deal in Rome. He wrote to the collector Charles Townley in the 1770s urging that, 'the most valuable acquisition a man of refined taste can make is a piece of

fine Greek sculpture'. It was the sternness and purity of this Greek sculpture, largely only known through Roman copies or late Hellenistic works, which induced the passion for outline and shallow pictorial space which characterizes Neo-Classical painting. In England the movement influenced such artists as West (*Plate 93*), Fuseli, Angelica Kauffmann, Mortimer, Barry and to a certain extent Reynolds; but Neo-Classicism was a cold and bloodless style without the moral commitment and contemporary relevance brought to it by Jacques Louis David in France, where the style became a vehicle for expressing the moral and political fervour of the French Revolution. In England Neo-Classicism was primarily a fashionable style, made sweetly elegant in the work of Angelica Kauffmann (1741–1807), or decorative in the architecture of Adam. Where any moral force or emotional involvement occurs, as in the work of Barry in his Society of Arts paintings (*Plate 91*), then Neo-Classicism and Romanticism, often seen as poles apart and mutually exclusive, become one and the same thing working together in harness, as it were.

Joseph Wright of Derby flirted with Neo-Classicism, but he was a polymath both in his intellectual interests and in the subjects and styles which he employed. A true son of the European Enlightenment, he worked mainly in Derby, an active intellectual and industrial town, largely avoiding the constricting fashions of the capital. In his work he expressed the inventiveness and spirit of enquiry of the early phases of the Industrial Revolution with paintings such as *A philosopher giving a lecture on the orrery* (*Plate 95*). His obsession with the scientific observation of artificial light can be seen in a number of 'candlelight' pictures, or in paintings like *An iron forge* (*Plate 96*). These may have been partly influenced by the 'dark' pictures of the northern followers of Caravaggio in the seventeenth century, such as Gottfried Schalken, but their main characteristic is an essentially contemporary relevance and concern with the intellectual issues of the day.

In the nineteenth century we find an acceleration in the fragmentation of the arts. The rise of historicism is an important factor. Romantic and scholarly interest in the past sanctioned a diversity of styles as well as opening up a new range of acceptable subject matter from the medieval period. This development is most obvious in architecture, first with the Gothic Revival and later in the century with the fashions for Egyptian, Islamic, Romanesque, Queen Anne and a welter of other historical or exotic styles. But painting was affected too. The touchstone of excellence in art was no longer the Italian Renaissance, or even classical Rome and Greece. Artists were now explorers; they rejected Rome as the terminus of the Grand Tour and went to Turkey, Egypt and all over the Middle East, to the New World, to India. Exotic cultures were no longer considered merely an interesting oddity, a curious deviation from the norm, or a primitive anticipation of it. There was no 'correct' style, no right way of doing things. Everything had not only its own interest, but also its own validity. This is a movement we still see, as we nurture provincial dialects or enquire into African tribal customs.

Traditional values are, however, impossible to ignore, even if we are reacting against them, and the traditions of art were still important in the nineteenth century. If we look at, for example, the period 1810 to 1840, we find painters working with contemporary

versions or developments of a wide range of traditions, all of which were accepted as having their own worth, and this is what makes generalization impossible and the pattern of nineteenth-century art difficult to grasp. Wilkie was painting genre subjects of peasant life, such as *The penny wedding* (*Plate 141*), partially in the tradition of Teniers and seventeenth-century Netherlandish painting. Constable was painting his large exhibition pictures in the 1820s, monumentalizing, in the manner of Ruysdael, the everyday life of the countryside and the humble natural scene (*Plates 102 and 126*). Lawrence was painting portraits in the mainstream tradition of Reynolds, Gainsborough and Van Dyck (*Plates 98 and 110*). Etty was painting luscious nudes (*Plate 128*) in the tradition of Venetian art of the sixteenth century, while Turner was still painting intensely personal and original variations on Claudian models (*Plate 106*). None of these painters was being untraditional, but they were all finding in the traditions of European art different things on which to focus.

In 1862 Francis Turner Palgrave wrote: 'The Life of our Art in this century lies almost entirely in its Schools of Landscape and Incident: both practically inventions of the last sixty years.' This was written at a time when the walls of the Royal Academy were crammed with landscapes and anecdotal and narrative pictures. Portraiture was gradually on the decline. Many of the landscapes, painted by such little-known artists as F. R. Lee (1798–1879) or J. B. Pyne (1800–70), were pale imitations of the work of Constable and Turner respectively. Neither of these two great landscapists had followers of genius who managed to develop their art significantly, and so their work resembles two huge waves which were followed only by small ripples, though the ripples were multitudinous. Aside from the Pre-Raphaelites, who did make an interesting contribution to the art of landscape (*Plate 139*), it was left to the Impressionists in France to create the next great breakthrough in the depiction of the natural scene.

Constable's art appears so natural and almost obvious to us now, seen on the lids of generations of chocolate boxes, that it requires an effort of historical thinking to gauge its truly radical nature. He attempted, as no artist before him had done—and, it must be remembered, in the face of both apathy and harsh criticism—to enshrine in his paintings the shifting quality of the English weather, the flurries of rain, the hurrying and ever changing clouds (*Plate 121*), the leaves of trees bent up against the wind, shining and silvery, the peculiar quality of the precise time of day. 'No two days are alike,' he wrote, 'nor even two hours; neither were there ever two leaves of a tree alike since the creation of the world.' Set against the eighteenth-century love of generalization and idealization this was radical thinking indeed. His oil studies of clouds, especially, were intended as empirical scientific enquiry, an aspect of the natural sciences in an age increasingly concerned with scientific research. But always underlying the scientific nature of his observations was an emotional commitment to everyday things in nature and a wish to give some permanent and lasting form, in the shape of paintings, to the facts of humble nature, which he felt had a profoundly moral significance. 'The sound of water escaping from Mill dams . . . willows, old rotten Banks, slimy posts and brickwork. I love such things. . . . As long as I do paint, I shall never cease to paint such Places.'

John Ruskin (1819–1900), the art critic and great worshipper of Turner in the latter's last years, had a blind spot for Constable. 'Constable perceives', he wrote, 'in a landscape that the grass is wet, the meadows flat, and the boughs shady; that is to say, about as much, I suppose, might in general be apprehended, between them, by an intelligent faun and a skylark.' It was the very humdrum quality of Constable's subject matter, the great originality of his art, which Ruskin denigrated. Turner's art was totally different. He was not, like Constable, a countryman who could only paint those scenes for which he felt a deep affection, an affection bred largely of associations with his own family life. Turner was a Londoner and voracious traveller. He toured incessantly through Great Britain and the Continent, especially Switzerland, Germany and Italy, thirsty for new combinations of landscape with light and atmosphere, the witness to many dawns and sunsets. And he had large aspirations for the status of landscape as an art, attempting many forms of 'historical' landscape somewhat in the same way as Reynolds had sought to evolve a form of 'historical' portraiture. For Turner this meant not only incorporating into his landscapes mythological, biblical and classical subject matter, as in *Ulysses deriding Polyphemus* (*Plate 107*), or more contemporary subjects like the slave trade in his *Slaveship* at Boston, or the steam engine in *Rain, steam and speed* in the National Gallery, it meant working with frequent reference to the styles of past artists, such as Van de Velde, Claude, Poussin, Cuyp, Rembrandt or Watteau. His use of the work of these artists was not in slavish imitation, nor rivalry, though this came into it, notably in the case of Claude; it was based on his veneration for the tradition of European landscape painting, his desire to maintain and develop that tradition, and his continual interest in technique and the craft of painting as it had been handled by the individual and varying genius of such masters. It was the immense variety and breadth of Turner's observation of natural phenomena which amazed contemporaries, as it still amazes us today. Ruskin wrote: 'J. M. W. Turner is the only man who has ever given an entire transcript of the whole system of nature.' Ruskin, it is true, had his own ideas of what the perfect landscape painter should be, and made of Turner's art what he wanted, recreating him according to his own conception of the great artist, who, godlike, presents us with all the facts of nature on a cosmic scale. But Edwin Landseer, himself no mean landscapist (*Plate 124*), praised Turner in very much the same way. 'Perhaps no landscape painter', he wrote, 'has ever before so successfully caught the living lustre of Nature herself, under all her varying aspects and phenomena, of seasons, of storms, calms and times of day.'

Turner was a far more successful artist than Constable. He was a hard businessman and no sentimentalist, and much of his income came from the many engravings, often executed under his strict supervision, which were produced in series after his numerous tours, such as the *Views in the Southern Coast of England* (1811–23) or the *Rivers of France* (1833–5). It is true that he was criticized and even ridiculed by many conventional critics, and his latest essays in light and colour remained unsold, but he found patrons in the new commercial classes and he even sold to American clients.

Turner and Constable were among a number of artists who, between about 1810 and 1820, painted direct oil sketches from nature. These included William Mulready, John Linnell and William Delamotte. A little earlier, in 1803, the Norwich Society had been

founded, and the two major artists of the Norwich school, John Crome and John Sell Cotman (1782–1842), helped to establish one of the few regional schools of painting in Britain. The Norwich school owed much to Dutch seventeenth-century landscape painting, which is explained partly by the flat nature of the East Anglian countryside with its large skies, and partly by the close trade links between Holland and East Anglia, which had facilitated the building up of collections of Dutch pictures. But the paintings of the Norwich school are yet another example of the widespread appreciation of British landscape in its unspectacular aspect (*Plate 123*). Sketching clubs and societies were being formed in many parts of the country in the first quarter of the nineteenth century and most of the major provincial towns sprouted exhibiting societies where the works of local artists could be seen and bought. The new middle class patrons, unaware of, or hostile to, the concept of High Art, and the veneration of old masters, were eager to buy landscape and local views by living artists.

Palgrave, in the passage already quoted, referred to the 'Schools of Landscape and Incident'. The school of Incident really begins with David Wilkie, who came to London from his native Scotland in 1805 and in the following year had a great success at the Royal Academy with *The village politicians*. Unlike the bland sentimental rustic genre of Wheatley or George Morland, Wilkie's paintings must have appeared overwhelmingly realistic. In such a work as *The penny wedding* (*Plate 141*), it is true, the debt to Teniers is clear; at this time the paintings of the seventeenth-century Netherlandish genre school were popular in England and both the Prince Regent and later Sir Robert Peel assembled large collections. But Wilkie added elegance, humour, expression and a certain amount of morality to these scenes, though he never produced the withering satire of Hogarth. Such paintings appealed in England because they showed a Scottish peasant life that was beginning to disappear, and in this period, as we have seen, there was a growing interest in different cultures, customs and traditions. Turner tried his hand with some genre scenes and William Mulready (*Plate 113*) made a speciality of what a contemporary in about 1810 called, 'the accurate and lively representation of domestic scenes'. The taste for the genre of Incident, with infinite variation and diversification, continues throughout the nineteenth century and a late and personal development of it can be seen in the work of Sickert, with such paintings as *Ennui* (*Plate 183*), though with Sickert this genre is more one of lack of incident. At the International Exhibition in Paris in 1855, where many English paintings were shown, Baudelaire singled out as peculiarly English the 'intimate glimpses of the *home*'. The genre of Incident is indeed one of the most original contributions which nineteenth-century British painting has made to the history of art.

Scenes from contemporary life packed the walls of the Royal Academy. We find literary equivalents in the novels of Dickens and Thackeray and later Trollope. Wilkie Collins, the novelist, wrote in 1865: 'Traders and makers of all kinds of commodities . . . started with the new notion of buying a picture which they themselves could admire and appreciate, and for the genuineness of which the artist was still living to vouch. These rough and ready customers were not to be led by rules or frightened by precedent . . . they thought incessant repetitions of Saints, Martyrs, and Holy Families,

monotonous and uninteresting—and said so.' Between the Augustan academic doctrines of Reynolds and the equally limiting aesthetic theories of Roger Fry and Clive Bell, the nineteenth-century patrons wanted realism, incident and detail; and the commercially orientated and self-confident Victorian society found a welcome release at the Royal Academy from the bonds of tradition. Their taste was sanctioned, too, by royal approval: Queen Victoria bought William Powell Frith's teeming *Ramsgate Sands* (*Plates 142 and 143*), which was exhibited at the Royal Academy in 1854. Paintings of contemporary life were often moral and puritanical, as was Holman Hunt's *The awakening conscience* exhibited in the same year (*Plate 136*); and differing degrees of social conscience appear throughout the last two thirds of the century, from the gentle paintings of Richard Redgrave (1804–88) and the early works of G. F. Watts, such as his *Irish famine* of 1850, now in the Watts Gallery, which reflected the troubled times of the 1840s when the Chartist Movement and the poverty in Ireland brought England not all that far from the political revolutions of the Continent, to later works such as the *Applicants for admission to a casual ward* (*Plate 147*) of Luke Fildes, James Lobley's *The dole* (*Plate 145*), or Blandford Fletcher's *Evicted* (*Plate 146*).

Predominantly, though, the school of Incident was bland and trivial, or mildly-erotic. Jacques Tissot's *London visitors* (*Plate 152*) has a wistful yet clear cut almost Jamesian quality which offers no morality, and endless paintings charted the genteel course of that true love which never did run smooth, corseted and restrained by the Victorian sense of propriety (*Plates 140 and 177*). The accent on sentiment and feeling, which is so characteristic of Victorian painting, even overflowed its banks, as it were, into the world of animals. In some of the works of George Stubbs, for instance his paintings of lions fighting horses, and in many of the animal paintings of James Ward, animals had expressed the primeval forces of nature and had in some ways been made to suggest the violence of passions that were both human and animal. With the works of Edwin Landseer, one of Queen Victoria's favourite painters, animals are often imbued with totally human sentimental attributes to a degree that may nauseate many people today, but which is still considered a particularly British quirk. At the same time, Landseer takes his place in the tradition of British animal painting, which stretches almost unbroken from Barlow through Wootton and Stubbs right up to Munnings in this century (*Plate 188*).

Another form of Incident painting in the nineteenth century was the depiction of historical events, often done in an anecdotal way, which brings the genre very close to that of scenes from contemporary life. In an age of historicism it is not surprising that historical accuracy in the treatment of costumes, settings and architecture, should have been sought more thoroughly than in the eighteenth century. From the last part of that century, indeed, theatrical productions had benefited from the historical research into costume by the antiquary Joseph Strutt, and attempts were made to present Shakespearian productions in sixteenth-century dress. The works of Strutt and the revised editions by J. R. Planché were used by Richard Parkes Bonington to achieve accuracy in his historical costume pieces (*Plate 166*). But despite this attempt to achieve historical truth in the external forms, paintings of history in the nineteenth century tell us more about the period in which they were painted than about the periods they

depict. E. M. Ward's *Royal family of France in prison (Plate 167)* of 1851, for example, concentrates on just those domestic qualities which Baudelaire noticed in 1855. What continually appealed in the nineteenth century were the effects of great historical events on the domestic life of the protagonists, the anecdotal, rather than the epic, qualities, and especially the sentimental concern with the world of childhood. Cavaliers and Roundheads were exceptionally popular; Yeames's *And when did you last see your father? (Plate 168)* is an essentially Victorian painting, providing a domestic, anecdotal and sentimental gloss on the political events of the Civil War. Towards the end of the nineteenth century, the imperial and jingoistic pride of Victorian Britain was expressed in the depiction of contemporary or near contemporary events, which were often illustrated, with suitable exaggeration of the heroic action, in the *Illustrated London News*. This *Boy's Own Paper* attitude is summed up in a painting such as Lady Butler's *'Scotland for Ever!' (Plates 169 and 171)*, a picture which is really the late nineteenth-century successor to the paintings of contemporary history by West and Copley.

John Ruskin was troubled by what he considered to be the trivial nature of much painting. A witness before the royal commission on the Royal Academy in 1863, he lamented: 'Our upper classes supply a very small amount of patronage to artists at present, their main patronage being from the manufacturing districts and from the public interested in engravings;—an exceedingly wide sphere,—and you catch the eye of that class much more by pictures having reference to their amusements than by any noble subject better treated, and the better treated it was the less it would interest that class.' But Ruskin, with his concern for high moral purpose and seriousness in art, had found a new cause to espouse, a source of what he considered to be light and hope for British art. In May, 1850, he wrote to *The Times* in support of a number of artists who were, 'laying in our England the foundations of a school of art nobler than the world has seen for three hundred years'. High praise indeed, but Ruskin was not a man for half-measures. In 1849 an artist called Dante Gabriel Rossetti had exhibited at the Free Exhibition in the Hyde Park Gallery a picture entitled *The girlhood of the Virgin Mary* with the puzzling initials P.R.B. on it. These stood for Pre-Raphaelite Brotherhood, initially a secret association of very young artists, who had come together to attack and confound what they considered to be the despicable state of British painting as represented on the walls of the Academy by such artists as Etty, Daniel Maclise, Edwin Landseer and C. R. Leslie. They were against what they termed 'slosh', sentimental or trivial subjects treated in a manner deriving eventually from the style of Reynolds, with heavy application of viscous bitumen and a theatrical use of light and shade in what is often called a 'painterly' or rather rough and sketchy technique. They wanted 'to have genuine ideas to express'; 'to sympathize with what is direct and serious and heartfelt in previous art', especially Italian art before Raphael—hence the name Pre-Raphaelite, and 'to produce thoroughly good pictures'. All unexceptional ideas and vague in the extreme.

The main figures in the movement were all very different artists, William Holman Hunt, John Everett Millais and Dante Gabriel Rossetti. The Pre-Raphaelites formed one of the first modern movements in art and possibly too much importance has been attached to them. The movement could so easily have fallen into obscurity as did The

Clique, which consisted of a number of young rebels at the Royal Academy in the 1840s, including Augustus Egg, Richard Dadd, and W. P. Frith. But the support of Ruskin, the violent abuse of many critics including Charles Dickens, and the pseudo-secret nature of their association gave to their cause a great publicity. And the first impetus of the movement, which died out in the late 1850s largely because of the great difference in the work and temperament of the leading artists, was followed by a second wave dominated by Rossetti and Burne-Jones in the 1860s and 1870s. In addition, many fine painters who were not members of the original Brotherhood, such as Ford Madox Brown (*Plate 138*) and Arthur Hughes (*Plate 140*), were influenced by it to such an extent that Pre-Raphaelite painting became widespread outside the confines of the movement itself. .

The technical originality of the Pre-Raphaelites lay in their exceptionally detailed brightly coloured painting on a wet white ground, covering the picture section by section somewhat as fresco painting was done. This gave to their works a brightness and luminosity which is, at its best, as in Millais's *Mariana* (*Plate 137*) or Holman Hunt's *Our English coasts* (*Plate 139*), breathtaking. But in fact Mulready had previously painted on a white ground for clarity and sharpness of detail, though not directly on wet white. The Pre-Raphaelites chose three basic types of subject, which are shown especially in the paintings of Holman Hunt and Millais in the 1850s. These were religious subjects, such as Millais's *Christ in the house of his parents* of 1850; contemporary subjects often with a moral, religious or social message, for instance Hunt's *The awakening conscience* (*Plate 136*), Ford Madox Brown's *Work* (1852–63), or a somewhat allied painting like William Bell Scott's *Iron and coal* (*Plates 161 and 164*); and subjects taken from the past, often the medieval romantic past, and often illustrating the poetry of Keats or Tennyson or the Arthurian legends of Malory, an intense, obsessional, escapist world illustrated by Millais's *Mariana* (*Plate 137*) or *Lorenzo and Isabella* (1849; Liverpool, Walker Art Gallery). Again, there was nothing exceptionally original about this subject matter, for painters in the 1830s and 1840s had used similar themes and highly detailed works by such artists as Daniel Maclise (1806–70) and William Dyce, influenced by the love of detail found in the work of the German Nazarenes, were becoming common. If anything, it was the intensely serious approach of the Pre-Raphaelites which gave to the movement a cohesion and force, banishing any charges of triviality or popularity seeking which the Pre-Raphaelites themselves levelled at the painters of the 1840s.

The Pre-Raphaelite second stage movement began in about 1857/8, when, under the supervision of D. G. Rossetti, Arthur Hughes, Val Prinsep, William Morris (1834–96) and Edward Burne-Jones decorated the Oxford Union with some technically inadequate frescoes that began to disintegrate almost as soon as they were painted. This movement owed nothing to Holman Hunt, whose moral earnestness dominated the early P.R.B. and who continued until his death on the same lines, seeing himself as the guardian of pure Pre-Raphaelitism. The second phase was dominated by the visionary mysticism of Rossetti, who was a poet as well as a painter, and whose obsession with Jane Morris gave to his later work, for instance *The day dream* (*Plate 157*), a heavy, almost repulsive erotic content and also, incidentally, provided the prototype of the Pre-Raphaelite woman, with her long hair in rippling slightly frizzy waves and

her eyes distantly preoccupied with some mystic yet not entirely unearthly vision. William Morris and Co. was founded in 1861 to attempt to reintroduce craft into manufacture, with a predominantly medieval romantic bias. Morris's work, as well as forming part of this phase of Pre-Raphaelitism, looks forward to the Art Nouveau style of Walter Crane and Aubrey Beardsley. Burne-Jones is the greatest painter of this later Pre-Raphaelite movement. In terms of talent and technique far superior to Rossetti, his work has also recently come to be seen as part of the European Symbolist movement. The *Briar rose* series, based on the story of Sleeping Beauty, is a good example of the way in which he could communicate a mood of mysterious, gentle, personal symbolism, which captures the quality of an intangible dream, apparently without content or meaning, yet reverberating on the emotions like a bee-loud glade (*Plates 159 and 160*).

Another artist whose work today is seen as Symbolist is George Frederick Watts. Watts early in his career won a prize for his cartoon of *Caractacus* in the first competition to decorate the new Houses of Parliament (1843). He was the great advocate of High Art in Victorian England. Always earnest, and full of moral endeavour, in 1852 he offered to decorate Euston Station with frescoes illustrating the *Progress of Cosmos* free of charge except for the materials, a curious parallel with Barry's Society of Arts venture, but he was turned down. He stood apart from movements and never courted popularity, though a steady income from portraiture (*Plate 148*), allied with the patronage of Mr and Mrs Thoby Prinsep at Little Holland House and later residence in Melbury Road, made him one of the grand Victorian artistic figures, like Tennyson, free from want and encouraged to pursue his own high ideals. Later in his career he exhibited—like Burne-Jones—at the Grosvenor Gallery, which had been opened by Sir Coutts Lindsay in 1877, and it is from this time that the Royal Academy begins to decline as the absolute centre of the British artistic scene. From this decade on, all the significant developments in British art take place outside the Academy. Watts saw his mythological and allegorical pictures (*Plate 156*) as forming a great series of paintings illustrating the aspirations, hopes and tragedy of man in the universe. His vision was indeed cosmic. He wrote to Ruskin: 'The qualities I aim at are too abstract to be attained or perhaps to produce any effect, if attained. My instincts cause me to strive after things that are hardly within the province of art.' But he had a strong social conscience, which can be seen not only from his works of the late 1840s such as *Found drowned* and *The Irish famine*, but also from his later involvement with the exhibitions organized for the London poor by Canon Barnett at the Whitechapel Gallery.

The concern which many nineteenth-century artists felt for current social problems—poverty, unemployment, forced emigration, meaningless hard labour—is one example of how the painter, freed from the conventional aristocratic patronage of preceding centuries, found it incumbent upon himself to lead and direct thought and action within society. Connected with this was the sense of responsibility felt by artists, as well as civil servants and administrators, for the position of the arts in society. This manifested itself in a new kind of state patronage, run by committees and commissions, and concerned with such issues as the decoration of public buildings. Prince Albert was extremely active in the 1840s on the royal commission appointed to direct the

decoration of the Houses of Parliament with paintings illustrating British history. Had he been alive today, he would surely have been one of the most active figures in the Arts Council. William Dyce, who finished the first fresco in 1847, though he had not taken part in the competitions, was a painter much concerned with the administration, as well as the practice, of painting. In 1840 he had been appointed director of the newly created Government Schools of Design in the premises at Somerset House which had been vacated by the Royal Academy on its move to Trafalgar Square. He toured Europe to report on systems of art education. As a painter, he had been an associate of the German Nazarenes in Rome and was more influenced by them than any other British artist. His admiration for modern German art naturally endeared him to Prince Albert, who commissioned him to paint decorative works for Osborne House (*Plate 127*). The Pre-Raphaelites, too, were concerned about the state of painting, but they expressed their concern in private rebellion rather than public service. Later, Whistler and the protagonists of 'Art for Art's sake' reacted against the Royal Academy establishment. But all these artists, Dyce, Redgrave, the Pre-Raphaelites, Watts, Whistler, Leighton and many more, were concerned in their different ways. They felt responsible for art. They were not just superior craftsmen paid to do a job.

James McNeill Whistler was an American-born artist who settled in London in 1859. His portraits, such as that of Mrs Leyland (*Plate 172*), reflect the influence on him of Manet and Velasquez. Whistler was the first artist working in nineteenth-century England to reflect the new developments taking place in French art at the time. He was also influenced by the painting and decorative arts of Japan, which had been seen in England in the International Exhibition of 1862. His famous portrait of his mother, subtitled *Arrangement in grey and black no. I* (Paris, Louvre), was, in 1872, his last exhibit at the Royal Academy, and it showed his movement towards abstraction. From this he turned to Nocturnes (*Plate 150*), the titles of which stressed the analogy with music, and it was his *The falling rocket; nocturne in black and gold*, exhibited at the Grosvenor Gallery in 1877, which angered Ruskin, and stung him into accusing Whistler of 'flinging a pot of paint in the public's face'. This led to the famous lawsuit and the award of a farthing damages, which in turn weakened the reputations of both Ruskin and Whistler. Whistler had insisted: 'It is an arrangement of line, form and colour first.' How ironical it is that the painting which shocked Ruskin was so similar to Turner's *Rockets and blue lights* of 1840, and how clearly it showed that Ruskin saw what he wanted to see in a painting, not necessarily what was there.

An ever present thread in the immensely varied pattern of Victorian art, which I have as yet only mentioned in passing, is that of escapism. Escape into a romantic medieval past, whether historical or through the medium of imaginative literature, can of course be found from illustrations to Sir Walter Scott early in the century, through the Pre-Raphaelites and the enclosed visionary world of Rossetti right up to the paintings and illustrations of Walter Crane. Escapism, too, is found in landscapes; and this escape from the urban industrialized world of the town back into a womb-like sheltered nature is evident, perhaps paradoxically, in excessively detailed works, and not only the obsessive manic detail of Richard Dadd (*Plate 162*), but in detail which is clearly realistic in intent. In the eighteenth century, landscape painters such as Richard

Wilson generalized nature into a series of norms and schemata which were in some ways artificial, but in no sense were they an escape from reality, rather an attempt to establish some form of control or law which could contain nature within a coherent system. The Romantic movement showed up the hollowness of these laws, their inadequacy to express the overpowering forces of nature and its infinite variety. But excessive attention to detail, which is characteristic of so much Victorian art, and not only in the work of the Pre-Raphaelites, was in some ways an attempt to create a world where laws did not exist, or, in negative terms, an unwillingness to establish a pattern. One can, after all, get lost in detail. Listen, yet again, to Ruskin; 'On fine days, when the grass was dry, I used to lie down on it and draw the blades as they grew, with the ground herbage of buttercup or hawkweed mixed among them, until every square foot of meadow, or mossy bank, became an infinite picture and possession to me, and the grace and adjustment to each other of growing leaves, a subject of more curious interest to me than the composition of any painter's masterpiece.'

A more gentle form of evasion is found in the work of those painters who created a kind of latter-day classical revival, notably Frederick Leighton, Lawrence Alma-Tadema and Edward John Poynter. Leighton wrote to his German master, Steinle: 'I am by all means passionate for the true *Hellenistic* art and am touched beyond everything by its noble simplicity and unaffected directness.' Poynter's *On the temple steps* (*Plate 153*) or Alma-Tadema's *The Tepidarium* (*Plate 170*) were in fact erotic works suitably toned down for Victorian consumption: the figures were clothed in classical garb, or, if nude, at least naked in the acceptable surroundings of a Roman bath. Leighton's work was eminently respectable, a new kind of establishment art that earned him a favoured place in Victorian society. Honoured and fêted, industrious and prolific, he was a man of learning and cultivation who made art respectable and indeed beautiful, in a proper and decorative way (*Plate 155*). What of course is so apparent to us today is that he was working within a tradition that was as dead, emotionally and intellectually, as the dodo. It was supremely tasteful, but it had no reference or relevance to contemporary life, just as the style of those artists such as E. M. Ward and Charles West Cope, who earlier had helped to decorate the corridors of the Houses of Parliament with historical pictures full of Raphaelesque gesture and Renaissance compositions, had no relevance in the age of Peel and Palmerston.

During the 1870s and 1880s this evasion of all contemporary relevance bred an inevitable reaction amongst younger artists, who became discontented with the establishment art of the Royal Academy. However, far from rushing into a harsh realism, many of them, with Whistler as an important exemplar, began to attach overriding importance to formal and aesthetic values. The New English Art Club was founded in 1886 and from about 1880 onwards many young British artists went to Paris for their artistic education. Walter Richard Sickert had met Degas in 1883 and his exact contemporary Philip Wilson Steer was also influenced by the French Impressionists (*Plates 176 and 178*). Steer, and other lesser-known landscape painters such as Alfred East (1849–1913) and Fred Brown (1851–1941), were also inspired by an earlier generation of French landscape painters, notably Corot and J. F. Millet. In addition, in reaction to the art of Leighton, a form of social realism appears in the work

of Luke Fildes (*Plate 147*) and Frank Bramley (1857–1915). Whistler had visited St Ives with Sickert in 1882 and it is from this time that this small Cornish town becomes associated with new developments in English art. The so-called Newlyn school came into existence, with a still fairly academic form of realism, which is illustrated by such works as Bramley's *Hopeless Dawn* of 1888, now in the Tate Gallery. Another factor which contributed to the decline of the Royal Academy was the foundation of the Slade School in 1871. Its first professor was Poynter, who believed in academic figure drawing from the life as the basic necessity of an artist's technical equipment, but his teaching was more sympathetic to new ideas than that of the Academy Schools. In the last years of the nineteenth century the Slade became an important centre for young advanced artists like Augustus John, Harold Gilman (1876–1914) and Spencer Gore.

During the nineteenth century we have seen a continuing fragmentation of the arts and the gradual separation of the artist from his place in a unified society in which basic assumptions about the nature of life were shared. In the twentieth century this shattering of accepted values has been accelerated. If it is difficult to generalize about the development of art in the nineteenth century, it is impossible in the twentieth. From the 1870s all advanced artists began to lose contact with a public which had some control upon what was produced. They began to work for themselves and so art has become increasingly inbred, feeding upon itself, reacting against 'tradition', yet continuously concerned with developing and changing the art of its immediate predecessors and indeed contemporaries. As increasing emphasis has been placed on specialized research in the development of scientific and academic knowledge, so the artists have specialized in certain limited areas of experience and visual sensation, working on personal or group interests rather than for the demands of patrons. We find a paradox in that groups or associations of artists have been formed in abundance, yet often the unwillingness of individual artists to sink their personalities in a common aim has caused the breakup of groups and movements even before they have been coherently organized. The pressure on painters to explore new avenues has been accentuated by their isolated position within society and the amazing speed of technical progress in the last seventy years. In addition, art critics and informed patrons, at least since Roger Fry and Clive Bell, have been unwilling to formulate sure standards of evaluation or to condemn new developments, partly because of the amazing speed of change in our lives as a whole, partly because change has become accepted as good in itself, and partly, it must be said, for fear of being thought reactionary or old-fashioned. The Impressionists and Post-Impressionists were criticized and ridiculed in their lifetimes and the critics have been proved hopelessly wrong. They do not want to burn their fingers again.

In 1910, Sickert, who had been in the forefront of developments in British art for thirty years, wrote: 'I doubt if any unprejudiced student of modern painting will deny that the New English Art Club at the present day sets the standard of painting in England. He may reject it or resent it, but he will hardly deny it.' In fact Sickert was wrong. He and the older members of the N.E.A.C. such as Steer were unwilling to

support Roger Fry with his second Post-Impressionist exhibition at the Grafton Gallery in 1912. The first exhibition, 'Manet and the Post-Impressionists', had been held at the same gallery in 1910. It was an important event which introduced many to the art of Cézanne, Gauguin and Van Gogh. In 1911, Spencer Gore, Harold Gilman and Robert Bevan, who had been meeting at Sickert's studio in Fitzroy Street and feeling that the N.E.A.C. was becoming too much of an establishment body, founded the Camden Town Group. The style of their works owed much to the Impressionists and they were dedicated to the depiction of modern, everyday scenes, usually urban townscapes, but they arrived at some kind of synthesis, some kind of deliberate control of their compositions. They were not, however, in opposition to Sickert himself. In November 1913 a meeting was held at Fitzroy Street with Sickert presiding and it was resolved to found a new comprehensive society, the London Group, which could not only include the N.E.A.C. and the Camden Town Group, but also the new rebellious circle of Wyndham Lewis. In the winter of 1913/14 an exhibition was held at Brighton, the 'Camden Town Group and Others', in which the work of Lewis and his associates was hung in a 'Cubist Room'.

Wyndham Lewis, with David Bomberg, Frederick Etchells, Edward Wadsworth and others, was developing a movement which was given the name 'Vorticism' by Ezra Pound in 1914. It was considerably influenced both by the Cubism of Picasso and Braque and by the Italian Futurism of Marinetti, whose work was supported in England by Christoper Nevinson and also by Marinetti's own brand of aggressive and noisy publicity. Lewis borrowed Marinetti's raucous iconoclasm and his flat rejection of all traditional and especially Victorian art, but he criticized the Futurists' obsession with the speed of modern machines and their attempt to suggest that speed through repeated images. He wanted to glorify the 'demon of progress', but he wanted also to create an art verging on the totally abstract that was more controlled and static. In June 1914 the first issue of *Blast* appeared, attacking and 'blasting' traditional values. In some ways Lewis's ideas reflected those of Roger Fry, whose emphasis on formal values alone, rather than painting as representation, is of paramount importance in the development of British painting and art criticism in this century; but Lewis regarded Fry as something of an old-fashioned aesthete. Lewis wrote; 'All revolutionary painting today has in common the rigid reflections of steel and stone in the spirit of the artist; that desire for stability as though a machine were being built to fly or kill with; an alienation from the traditional photographer's trade and realization of the value of colour and form as such independently of what recognisable form it covers and encloses.' Bomberg's *Mud bath*, of 1912–13 (*Plate 187*), is a good example of the abstract geometric structural art of Vorticism.

The First World War inevitably caused the breakup of the Vorticist movement and ended the hectic period since 1910 when forward-looking artists had been laying the foundations of the modern movement in Britain. But under the government's enlightened scheme of sending artists as 'reporters' to the theatres of war, some of the finest British art of the century was produced, perhaps because artists were involved once again in wider human issues, however disastrous and tragic these issues were. Nevinson worked at paintings that owed a good deal to Futurism and Vorticism, with a

steely control that accentuates, rather than masks, the terror of a war waged with powerful and inhuman machinery (*Plate 192*). Paul Nash produced probably his best work, investing the battlefields with a harsh nightmare-like desolation. Lewis himself also worked as a war artist (*Plate 190*), and, as well as individual paintings (*Plate 191*), Stanley Spencer, in his post-war decoration of the Burghclere Chapel (1927–32), painted an overall mural scheme, Giotto-like in its arrangement and monumentality, which combines scenes of the soldiers' everyday life in wartime with Christian imagery and symbolism.

After the First World War the advanced painters found it difficult to pick up the pieces and start again. The 1920s were not a great period for British painting, and the flourishing activity in the field of literature was not mirrored in the visual arts. Wyndham Lewis's Group x, as an attempt to restart the motor of the *avant-garde* immediately after the war, was unsuccessful. We find, to start with, some concentration on figurative painting and a kind of Neo-Classicism which appears in France in the large figure paintings of Picasso. At the same time there is an interest in naïve painting, aiming at the innocent response of a child to the facts of the visual world. Douanier Rousseau's work was very popular in Paris in the 1920s, and in England the work of Christopher Wood, in his paintings of Cornish and Breton landscapes and fishing villages, for instance his *Boat in harbour, Brittany* (*Plate 197*), reflects this emphasis in a fresh and unacademic vision. St Ives, in Cornwall, begins to be an important centre for artists, and in 1928 Christopher Wood and Ben Nicholson discovered the work of a retired fisherman, Alfred Wallis (1855–1941), when passing the open door of his cottage one day. He had no training in art, and his paintings are essentially childlike, displaying no knowledge of perspective, but their concentration on the facts of ships and quays, their colour and their quality as textured objects in their own right, appealed to the more sophisticated artists who were in search of a fresh approach. A new group, the Seven and Five Society, had been founded in 1919, and the critic of the *Daily Mail* described it as 'a formidable rival of the London Group in the propagation of the gospel of advanced art'. Ivon Hitchens (*Plate 210*) was a member, as was Paul Nash, and Hitchens proposed the young Nicholson for election to the society in 1924.

The Royal Academy had now lost all its contact with *avant-garde* artists and its central position in the continuing life of British painting. But its walls were still full of the work of academic portraitists who managed to make their living by their art. In fact, it was only through portraiture that an artist could hope to be fully self-supporting. Augustus John, whose early works had combined a lyrical charm and sense of colour partly derived from his knowledge of Matisse, was in the 1920s concentrating on portraits, though the fire of his early works was gone (*Plate 184*).

Paradoxically, as I have suggested, although the history of painting in Britain, as on the Continent, in the twentieth century is dominated by group movements, there are a number of important artists whose work cannot be categorized and conveniently labelled. The fact that artists were painting for themselves, rather than for a public, has also tended to increase their individuality. Stanley Spencer is a case in point. His bulky figures and the smoothly detailed surface of his paintings have something in common with the work of William Roberts (born 1895), but Spencer shows an essentially

personal vision, based on his deep romantic involvement with the Thames-side village of Cookham, where he spent so much of his life, and with his creation of religious works where the villagers of Cookham act out the Christian story in a contemporary rural setting (*Plate 193*). There are also hints in his work of the influence of much earlier artists, Masaccio, Fra Angelico and Bruegel. Ivon Hitchens expresses in a near abstract way his response to the rich colours of the Sussex landscape. Duncan Grant (*Plate 196*), on the other hand, though he flirted with abstraction and was closely involved with the Bloomsbury Group and Roger Fry's aesthetic ideas, has pursued a quiet realism in the traditional genres of twentieth-century academic painting: portraits, still-life and landscape. Grant like so many artists in the first half of this century, has been concerned with the texture and quality of paint in its own right. This derives from the now accepted artistic idea that a picture is made up first and foremost of the substance of paint, before it aims to be a representation of anything else. This is no more clearly shown than in the work of Matthew Smith, who, in his paintings of still-life and nudes (*Plate 195*) influenced by the Fauves, expresses a continual delight in the free handling of thickly applied paint, its singing colours and its texture.

It is difficult to generalize in an age which has included, on the one hand, the fashionable academic but lively work of Alfred Munnings and, on the other, the abstract purity of the work of Ben Nicholson. The gulf which divides not only their art but also their attitude to the practice of painting and its place in society is enormous. Munnings was content to follow, perhaps lazily, the traditional pattern of the painter who works to commission and who produces realistic paintings to satisfy a lay public, not especially knowledgeable about art. Such an idea would appear to be both reactionary and a lamentable compromise to the *avant-garde,* who have attempted to follow contemporary developments in French painting and later, after the Second World War, American painting, and to pursue and express their own formal and emotional developments. An artist like Turner was able to combine these two aims, but such is the pace of development and change in art, and such is the conservative nature of the public as a whole, that this is no longer possible. This sad state of affairs is due very largely to the mechanics of patronage. Following the example of such inspired dealer-patrons as Durand-Ruel in France, who championed the work of the Impressionists in the 1870s and 1880s, advanced art in England has been taken up by a small number of dealers and galleries, whilst conservative art has stayed at the Royal Academy. With the formation of the Arts Council after the Second World War, modern artists have found another means of support. So there are now two worlds which rarely have any contact with one another, and new developments in art no longer, as they did in the past, feed and nourish the more traditional and conventional painters relying on widespread popular support.

In the 1930s the pace of development quickened with the emergence of such artists as Ben Nicholson in painting, and Barbara Hepworth and Henry Moore in sculpture. Hepworth and Moore joined the Seven and Five Society in 1932 and in the early years of the decade Nicholson and Hepworth made several visits to France, where they were inspired by the work of such artists as Mondrian, Albers, Kandinsky, Miró, Calder and Arp. This, and Nicholson's membership of the Association Abstraction-Création in

Paris in 1933, led him towards a purer abstraction. His interest in the work of art as an object in itself and the inspiration of the clear lines and forms of the Cornish landscape and buildings were combined in his abstract *White Reliefs* of 1934–6. Here for the first time in British painting the idea of the marriage of painting and sculpture was adumbrated, a concept which has proved fruitful, notably in the abstract works of an artist like Victor Pasmore. Nicholson's abstract paintings, though not directly inspired by the ideas of Roger Fry, do embody the latter's belief that the artist should aim 'to create form, not to imitate life but to find an equivalent to life'. Fry here was talking about the Post-Impressionists, but what he says does point towards complete abstraction. As he wrote: 'The logical extreme . . . would undoubtedly be the attempt to give up all resemblance to natural form, and to create a purely abstract language of form—a visual music.'

The 1930s, however, also witnessed a rejection of Roger Fry's and Clive Bell's concept of an art devoid of subject matter and dependent only on 'significant form', a phrase coined by Bell. Although Paul Nash painted some abstract compositions at the end of the 1920s, a visit to Avebury in 1933 helped to stimulate his interest in the emotive qualities of natural forms (*Plate 202*). This, together with the interest of such artists as John Armstrong in dreams and Freudian symbols (*Plate 199*), led to a British form of Surrealism which has affinities with the work of de Chirico, Ernst and Magritte. The painters, including Edward Wadsworth (*Plate 200*), all produced individual and personal interpretations of Surrealism, but their work was based on the belief that images and objects have a suggestive and resonant effect on man's intuitive feelings and thoughts. Both Surrealist and abstract painters were members of a group called Unit One which was formed in 1933. The second exhibition of this group, held at the Mayor Gallery in 1934, toured the provinces and aroused considerable controversy. The group included such different artists as Edward Burra (*Plate 194*), Edward Wadsworth, Ben Nicholson, John Armstrong and Henry Moore and it was supported by the art critic Herbert Read. An 'International Surrealist Exhibition' was held in London in 1936.

In the late 1930s and early 1940s a quiet academic realism is found in the work of the Euston Road school, reviving to a certain extent the aims of the Camden Town Group. William Coldstream, Victor Pasmore, Claude Rogers and Lawrence Gowing were amongst its members. Pasmore produced landscapes of the London Thames (*Plate 207*), which show a delicate sense of tone and colour derived partly from Whistler and Turner, but with a feeling for abstract pattern in the forms of trees which heralds his deliberate turning to complete abstraction in 1948.

The Second World War inevitably drove artists into isolation from the Continent. This was accentuated by the fact that some *emigré* Continental artists, such as Mondrian, did not settle in England, but crossed the Atlantic to America. But again, as in the First World War, the government sponsored British artists to record their reactions to war and Paul Nash combined realism and Surrealism to create unforgettable images (*Plate 202*). Graham Sutherland and John Piper produced paintings of bomb damage which are harshly evocative (*Plates 203 and 204*). Sutherland brought to British art a romantic quality partly reminiscent of the landscapes of Samuel Palmer. In some ways

his art demonstrates a retreat into the native tradition, but at the same time he found in the forms of the Welsh landscape a quality of surrealism that was up-to-date, a concentration on the weirdness and emotive qualities of natural forms such as rocks and thorns. His work influenced a younger generation of artists, like Keith Vaughan, John Minton, John Craxton and Prunella Clough. Sutherland has also produced some of the most vital portraits painted by a British artist in this century (*Plate 218*).

Since the war British painting has continued to pursue its path between the Scylla and Charybdis of abstract art and different forms of realism. It has on the whole been over self-conscious about its position in relation to the increasing internationalism of modern art movements, though it has at least four painters, Graham Sutherland, Ben Nicholson and more recently David Hockney and Francis Bacon, who have secured international reputations. In the late 1940s St Ives again became a centre where the intensely local combined with wider concerns, and painters such as Peter Lanyon (1918–64) expressed this with an abstract art that was none the less full of references to the Cornish landscape. In the 1950s, the critic Lawrence Alloway arranged a number of exhibitions of abstract art, and British painters like William Scott (*Plate 209*), Roger Hilton and Patrick Heron established their reputations. The effect of the work of American abstract painters, Jackson Pollock, Mark Rothko and Barnett Newman, began to be felt. In about 1960 there emerges a group of abstract painters, John Hoyland and Robyn Denny amongst them, who work on a large scale in a style of controlled restraint, much concerned with flat areas of colour and their interaction with and effect on other colours, as well as with the actual joining edge between two colours. We find 'hard edge' and 'soft edge' painting replacing the expressionism of Jackson Pollock, though a denser, mistier version of the Pollock style is found in the work of Ian Stephenson (*Plate 219*). There also emerges a new concern with optical effect and paintings organized by logical geometrical systems, partly inspired by the work of Vasarely, and to be seen in the paintings of Bridget Riley (*Plate 221*).

In the late 1950s a group of painters and critics, both in Britain and America, worried by the increasing separation of art from the world of everyday life, sought to produce pictures that contained references to what is known as 'pop' culture—images of film stars, advertising slogans, soup cans, cars—anything that people saw every day in the streets or on television. Richard Hamilton, one of the first Pop artists, expressed their ideas when he wrote in 1961: 'If the artist is not to lose much of his ancient purpose he may have to plunder the popular arts to recover the imagery which is his rightful inheritance.' Peter Blake is one of the British artists in this movement (*Plate 214*) and popular culture has provided much of the subject matter of the work of David Hockney, which he treats with both wit and sophistication—continually plundering many styles to create a half-satirical commentary on contemporary culture (*Plate 220*). He has also developed a 'hard edge' portrait style which is blandly realistic yet fastidiously modern (*Plate 217*).

Painting has continued to produce its unclassifiable realists and possibly the greatest talent to emerge since 1945 is that of Francis Bacon. His powerful and disturbing images do not by any means spring from the canvas without reference to the art of the past. His work has contained reference to Rembrandt and Velasquez (*Plate 213*) as well

as Van Gogh, but his grotesquely shattered human figures reflect more acutely than any words the fragmentation and human suffering which this century of progress has brought with it (*Plate 215*). His work is profoundly pessimistic. He has said: 'I think that man now realizes that he is an accident, that he is a completely futile being, that he has to play out the game without reason.' He has also trenchantly expressed the problem which all artists, especially those concerned with realism, face in an age which has lost a coherent sense of commonly held values and beliefs. 'When you're outside a tradition, as every artist is today, one can only want to record one's feelings about certain situations as closely to one's own nervous system as one possibly can.'

Some reflections on British painting

BAINBRIGG BUCKERIDGE: *An Essay towards an English School of Painting*, 1706, appearing at the end of an English translation of Roger de Piles's *Abrégé de la vie des Peintres* (Paris, 1699). In the dedication to Robert Child, Esq.

You know, Sir, by the many beautiful pieces you have seen of the principal masters of both nations, that if they [the French] have had their Vouets, their Poussins, and Le Bruns, we have had our Fullers, our Dobsons, and our Coopers; and have not only infinitely out-done them in Portraits, but have produced more masters in that kind than all the rest of Europe.

ABBÉ LE BLANC: *Letters on the English and French Nations*, first published in English, 1747. Referring to the late 1730s.

But in vain are the seeds of arts imported hither [England], the soil seems not to be proper for them. They have not the same sun to make them grow: and if they shoot a few roots, they are soon killed by productions of bad taste, the plant that thrives and multiplies the most easily in this climate.

The portrait-painters are at this day more numerous and worse in London than ever they have been. Since mr. VANLOO came hither, they strive in vain to run him down; for nobody is painted but by him. I have been to see the most noted of them; at some distance one might easily mistake a dozen of their portraits for twelve copies of the same original. Some have the head turned to the left, others to the right: and this is the most sensible difference to be observed between them.

VOLTAIRE: *Letters concerning the English Nation*. Voltaire was in England from 1726 to 1729; the letters were written between 1729 and 1731 and were first published in English in 1733.

Neither the English nor any other people have foundations established in favour of the polite arts like those in France. There are Universities in most countries, but it is in France only that we meet with so beneficial an encouragement for astronomy and all parts of the mathematics, for physic, for researches into antiquity, for painting, sculpture, and architecture. Louis XIV has immortalised his name by these several foundations, and this immortality did not cost him two hundred thousand livres a year.

HORACE WALPOLE: *Anecdotes of Painting in England*. There is evidence that this work was compiled by Horace Walpole between 1760 and 1770 largely from the manuscript notes of George Vertue, which he had purchased. Vertue's notebooks have been published in this century in their complete form by the Walpole Society. The original Vertue manuscript is in the British Museum. Walpole added his own thoughts and ideas to the basically factual notes of Vertue.

In a country so profusely beautified with the amenities of nature, it is extraordinary that we have produced so few good painters of landscape. As our poets warm their imaginations with sunny hills, or sigh after grottoes and cooling breezes, our painters draw rocks and precipices and castellated mountains, because Virgil gasped for breath at Naples, and Salvator wandered amidst Alps and Apennines. Our ever-verdant lawns, rich vales, fields of haycocks, and hop-grounds, are neglected as homely and familiar objects. The latter, which I never saw painted, are very picturesque.

JOSHUA REYNOLDS: *Fourteenth Discourse*, 10 December 1788.

If ever this nation should produce genius sufficient to acquire to us the honourable distinction of an English School, the name of Gainsborough will be transmitted to posterity, in the history of the Art, among the very first of that rising name.

Seventh discourse, 10 December 1776.

The great variety of excellent portraits with which Vandyck has enriched this nation, we are not content to admire for their real excellence, but extend our approbation even to the dress which happened to be the fashion of that age. We all very well remember how common it was a few years ago for portraits to be drawn in this fantastick dress; and this custom is not yet entirely laid aside. By this means it must be acknowledged very ordinary pictures acquired something of the air and effect of the works of Vandyck, and appeared therefore at first sight to be better pictures then they really were.

WILLIAM BLAKE: Annotations, written about 1808, to Joshua Reynold's *Discourses*.

Who will Dare say that Polite Art is Encouraged or Either Wished or Tolerated in a Nation where The Society for the Encouragement of Art Suffer'd Barry to Give them his Labour for Nothing, A Society Composed of the Flower of the English Nobility and Gentry?—Suffering an Artist to Starve while he Supported Really what They, under Pretence of Encouraging, were Endeavouring to Depress.—Barry told me that while he Did that Work, he Lived on Bread and Apples.

O Society for Encouragement of Art! O King and Nobility of England! Where have you hid Fuseli's Milton? Is Satan troubled at his Exposure?

ERNEST CHESNEAU: *The English School of Painting*, 1885.

But if from that date [the second quarter of the eighteenth century] we can point to such true English masters as Reynolds, Gainsborough, Constable, Lawrence, Hogarth, and Wilkie, this is only a passing glimmer, a glorious fire of straw, which was speedily extinguished in the absurd and monstrous Italianism which soon enveloped it and suffocated it to death. No good end is served by recalling the sad names of Benjamin West, Fuseli, James Northcote, John Opie, Benjamin Haydon, James Barry, and of all the moths who burnt their poor wings in the flame of Latin art, blinded themselves there, and then returned, to din into our ears through all the long period of their blindness the Heroics of their hideous nightmare.

BENJAMIN ROBERT HAYDON (1786–1846): Diary.

Portraiture is always independent of art and has little or nothing to do with it: Wherever the British settle, wherever they colonise, they carry, and will ever carry, trial by jury, horse-racing and portrait painting.

FRANCIS WEY (a French visitor to Britain in 1856): *A Frenchman sees the English in the fifties*, translated by Valerie Pirie, 1935. After a long passage belittling English art.

To be fair one must add that the modern movement in English literature has had a considerable effect on her painters. The Paris Exhibition of 1855 has shown us in pictures by Goodall, Maclise, Millais, Landseer, etc., the experiments of a new school, founded not on the material cult in art, but on mind and originality. The manner plays a secondary part, the expression of the idea is everything. . . . We must give our neighbours their due and admit that they possess, not a school of painting, but a group of scholarly humourists trusting to their brushes to convey impressions too difficult to express in writing.

CHARLES BAUDELAIRE: Having seen the English section at the Exposition Universelle in Paris in 1855, Baudelaire laments the absence of English paintings in the *Salon* of 1859.

And so farewell, you tragic passions—gesticulations *à la* Kean or Macready; you charming, intimate glimpses of the *home*; you splendours of the Orient, reflected in the poetic mirror of the English mind; you Scottish verdures, magical visions of freshness, receding depths in water-colours as vast as stage-decorations, although so small—we shall not gaze upon you, this time at least. Were you so badly received then the first time, you eager representatives of the imagination and of the most precious powers of the soul? and do you consider us unworthy of understanding you?

MID NINETEENTH-CENTURY PARODY of a Royal Academician's lament:

> *I paints and paints,*
> *Hears no complaints,*
> *And sells before I'm dry;*
> *Till savage Ruskin*
> *Sticks his tusk in*
> *And nobody will buy.*

ROGER FRY: *Reflections on British Painting*, 1934. Written on the occasion of a large exhibition of British art held at Burlington House in the same year.

The love of landscape . . . I believe to be universal, but none the less the Englishman's attachment to country life and his love of nature is peculiarly strong, and also, I think, he is peculiarly conscious of this feeling, and therefore delights in giving it expression or having it expressed for him.

I do not mean to say that no British artists attain to plastic pictorial form, but rather that it does not seem to come to them easily or naturally. Their art is primarily linear, descriptive and non-plastic.

I think that his [Hogarth's] influence on British art has been bad upon the whole. It has tended to sanction a disparagement of painting as a pure art—has tended to make artists think that they must justify themselves by conveying valuable, or important, or moral ideas. Watts in the later nineteenth century afforded a pathetic illustration of this tendency—nor has it ceased to operate to-day. It has obscured the truth that art has its own specific function, that it conveys experiences which are *sui generis*, not to be defined or valued by anything outside—experiences which have immense, but quite inexplicable, value to those who are sensitive to them—experiences closely analogous to those conveyed by music.

NIKOLAUS PEVSNER: *The Englishness of English Art*, Reith Lectures, 1955, published in book form, 1956.

If Holbein's and Van Dyck's English portraits look unmistakably English, that may not prove a change in the style of the two painters, but rather the actually English features and deportment of their sitters. But Rossetti is entirely an English painter, although he was 75 per cent Italian, and Whistler is just as English, although he was 100 per cent American. One may call the sensuality of Rossetti un-English, but need only compare his women to those of the more sensuous contemporary French, of Courbet or Renoir, to recognize how English his attitude to female beauty and its display really is. And as for Whistler, his over-emphasis on disintegration by atmosphere, so much more extreme than in Monet or any other French Impressionist, and also his long attenuated figures and his preference for the whole-length portrait are all familiar English traits.

But here also no rule can be made. Sickert, it seems to me, remained incorrigibly Bavarian to the end, and yet had much to contribute. In acclimatizing Impressionism in England his robustness was an antidote to Whistler's disembodiment and aestheticism. And England has indeed profited just as much from the un-Englishness of the immigrants as they have profited from the Englishing they underwent. No-one in English history is a more telling and encouraging case of this than the Prince Consort.

THE PLATES

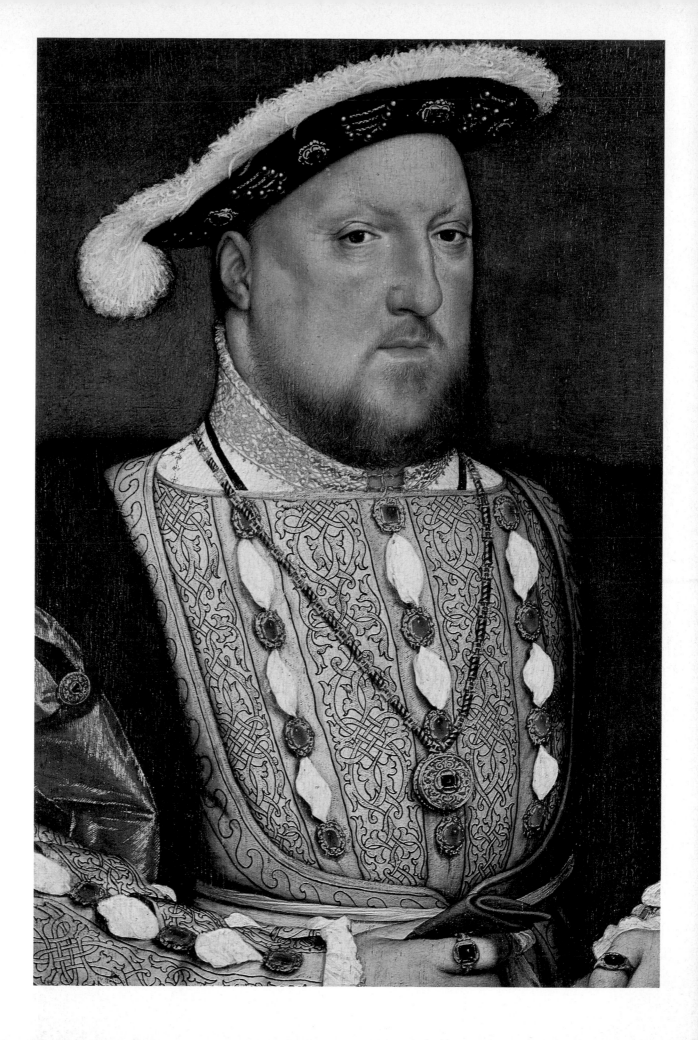

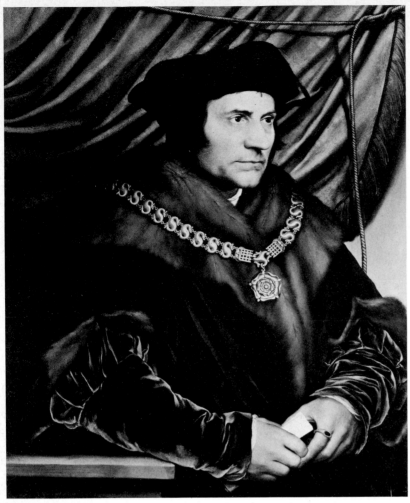

2 & 4 HANS HOLBEIN (1497–1543): *Sir Thomas More*. 1527.
Panel, $29\frac{1}{4} \times 25\frac{1}{2}$ in. New York, Frick Collection

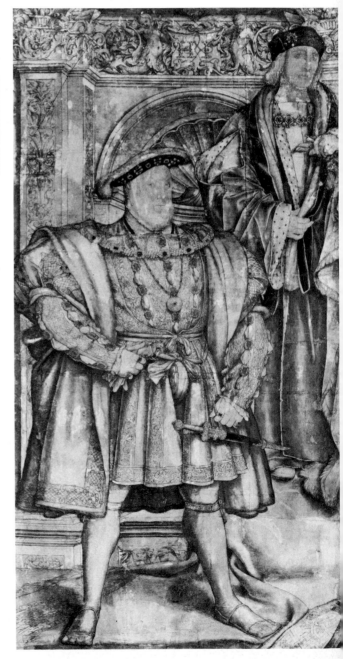

3 HANS HOLBEIN (1497–1543): *Henry VIII* (cartoon). 1536–7.
Paper laid on canvas, 101 × 54 in. London, National
Portrait Gallery

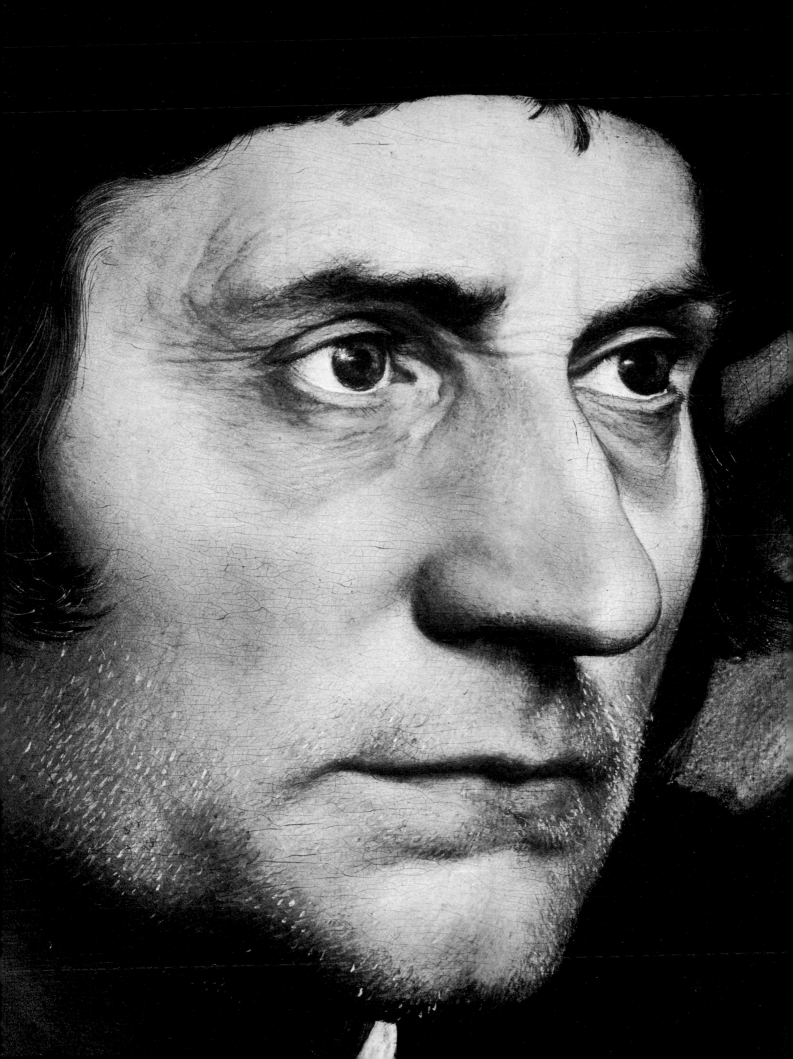

5 BRITISH SCHOOL: *Elizabeth I when princess.* About 1546. Panel, $42\frac{7}{8} \times 32\frac{1}{8}$ in. Windsor, Royal Collection

HANS EWORTH (working 1540–73): *Mary Neville, Baroness Dacre*. Inscribed HE, about 1555. Panel, 29 × 22½ in. Ottawa, National Gallery of Canada

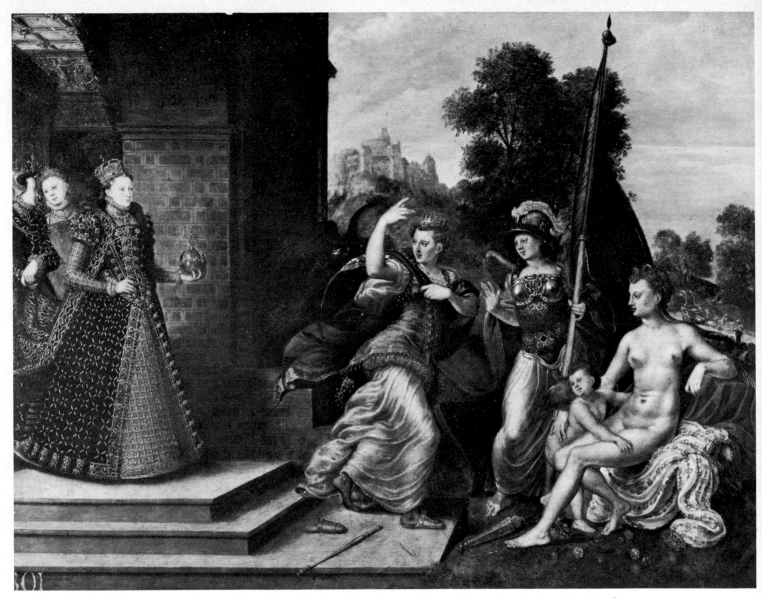

7 MONOGRAMMIST HE (working 1569): *Elizabeth I and the three goddesses*. Signed and dated 1569. Canvas, $27\frac{7}{8} \times 33\frac{1}{4}$ in. Royal Collection

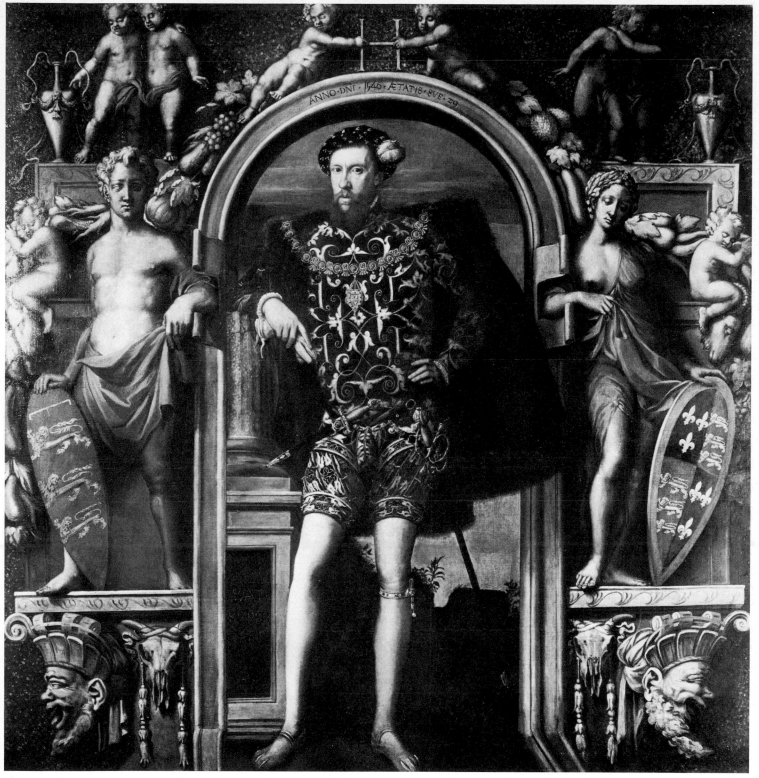

8 WILLIAM SCROTS (working 1537–54): *Henry Howard, Earl of Surrey*. About 1550. Canvas, $87\frac{1}{2} \times 86\frac{1}{2}$ in.
Arundel, Duke of Norfolk

9 NICHOLAS HILLIARD (1547–1619): *An unknown youth leaning against a tree amongst roses*. About 1588. Watercolour on card, $5\frac{3}{8} \times 2\frac{3}{4}$ in. London, Victoria and Albert Museum

10 NICHOLAS HILLIARD (1547–1619): *A man clasping a hand from a cloud*. 1588. Watercolour on card, $2\frac{3}{8} \times 2$ in. London, Victoria and Albert Museum

11 ISAAC OLIVER (about 1565–1617): *Frances Howard, Countess of Essex and Somerset*. About 1595. Watercolour on vellum, 5 in. diameter. London, Victoria and Albert Museum

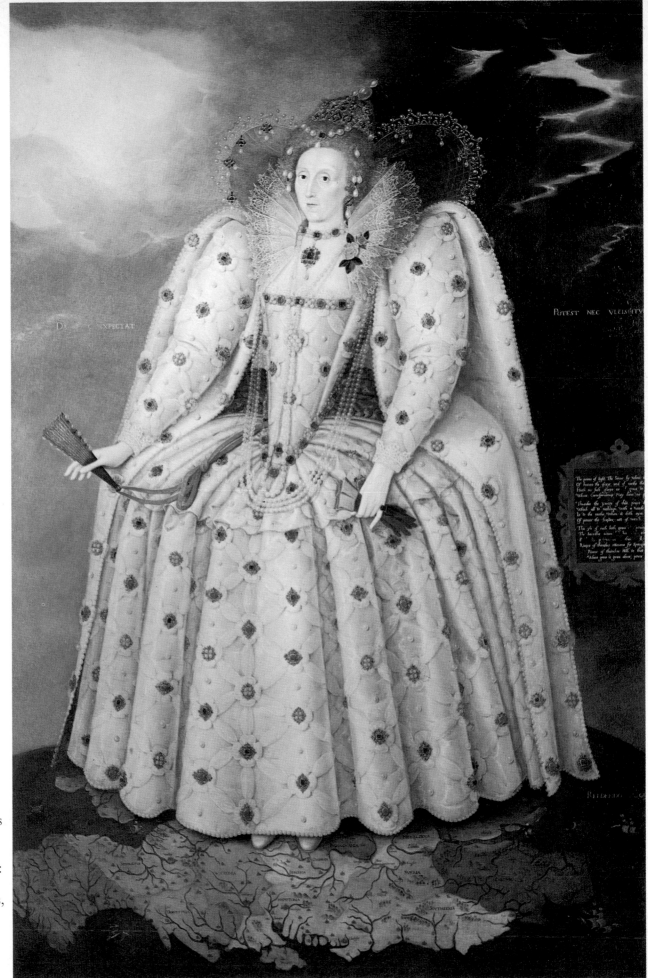

12 MARCUS
GHEERAERTS
THE
YOUNGER
(1561–1635):
Elizabeth I.
1592. Canvas,
95 × 60 in.
London,
National
Portrait
Gallery

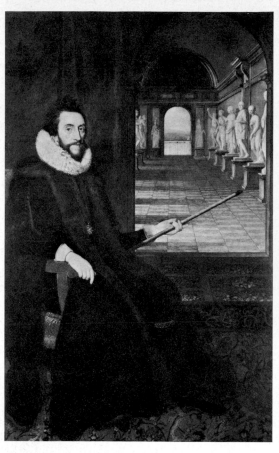

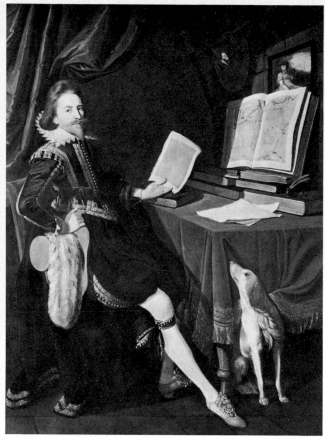

13 DANIEL MYTENS
(about 1590–1647):
Thomas Howard,
Earl of Arundel.
About 1618.
Canvas, $81\frac{1}{2} \times 50$ in.
Arundel, Duke
of Norfolk

14 NATHANIEL
BACON (1583?–
1627): *Portrait of the*
artist. About 1623–4.
Canvas, $81\frac{1}{4} \times 60\frac{1}{2}$ in.
Collection of the
Earl of Verulam

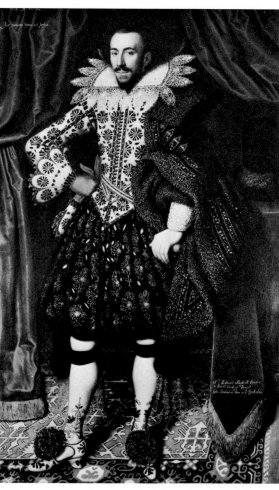

15 EDWARD BOWER
(died 1666/7):
Portrait of a man.
Signed and dated
1638. Canvas,
92×60 in.
Collection of
Lt Col. G. W.
Luttrell

16 WILLIAM
LARKIN (work-
ing 1610–19):
Richard Sackville,
3rd Earl of
Dorset. 1613.
Canvas, 80×47 in.
London, Ranger's
House, Greater
London Council

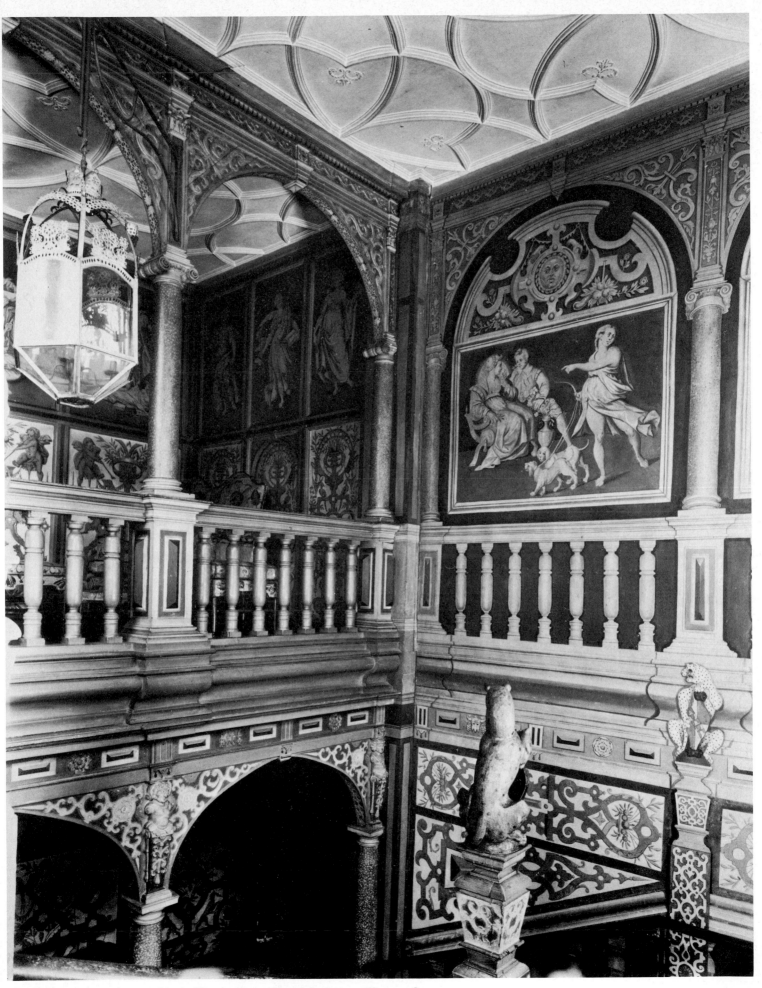

17 UNKNOWN ARTIST: *Knole House, Kent: Grand Staircase.* About 1605

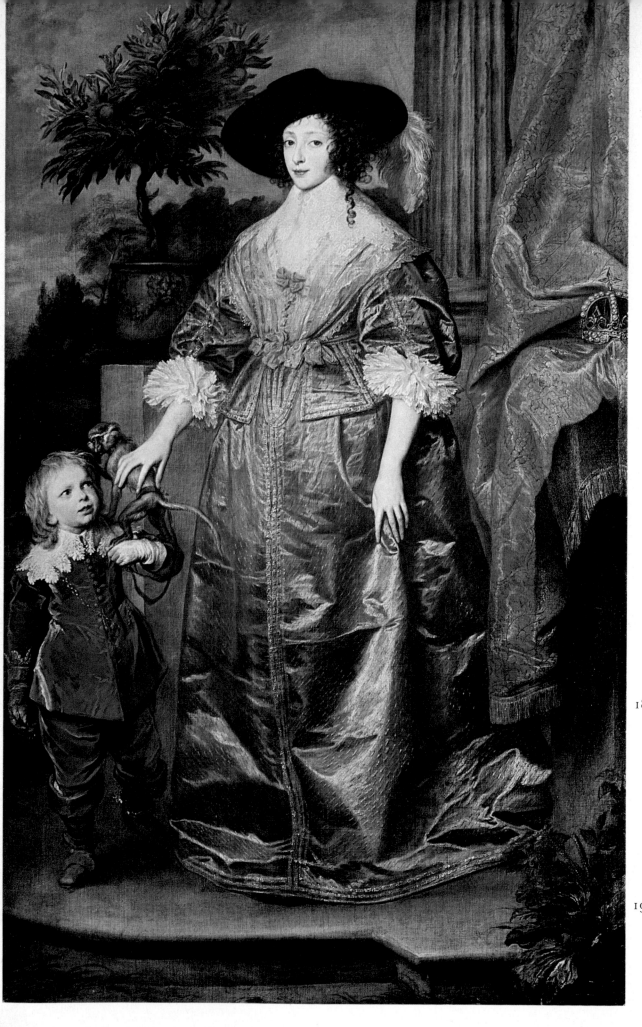

18 ANTHONY
VAN DYCK
(1599–1641):
*Henrietta Maria
with her dwarf.*
About 1633.
Canvas,
86¼ × 53 in.
Washington,
National
Gallery of
Art

19 PETER PAUL
RUBENS:
*Landscape with
Saint George
and the dragon*
(detail of
Plate 20)

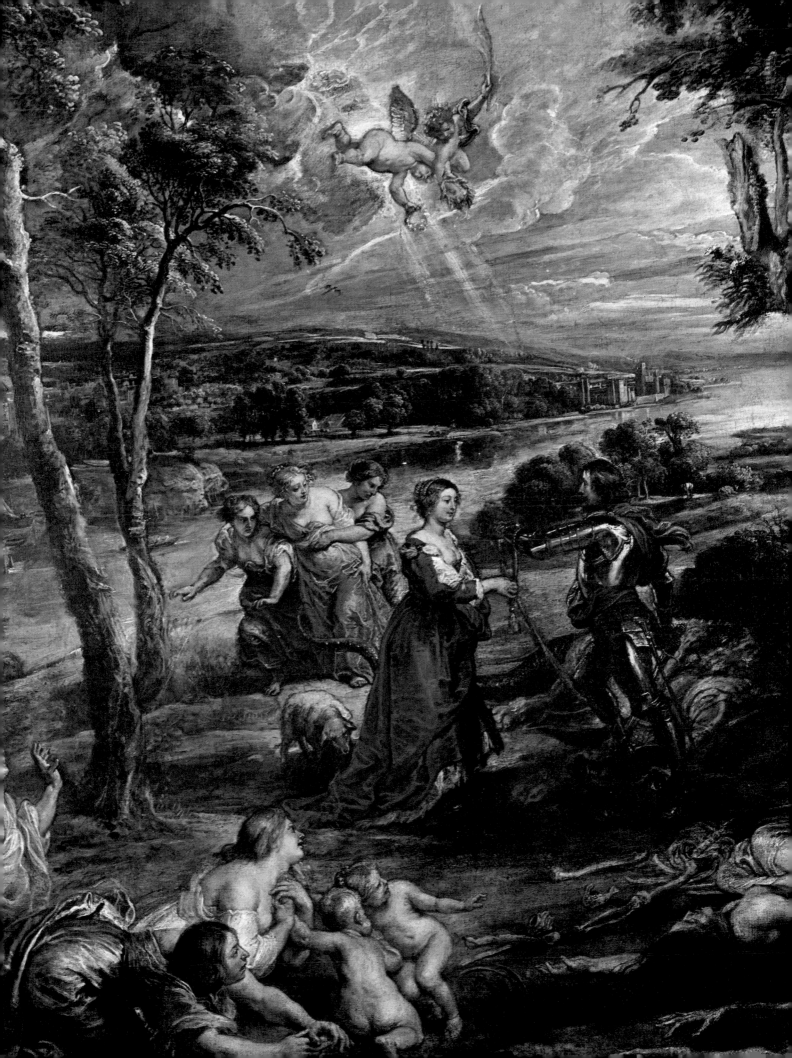

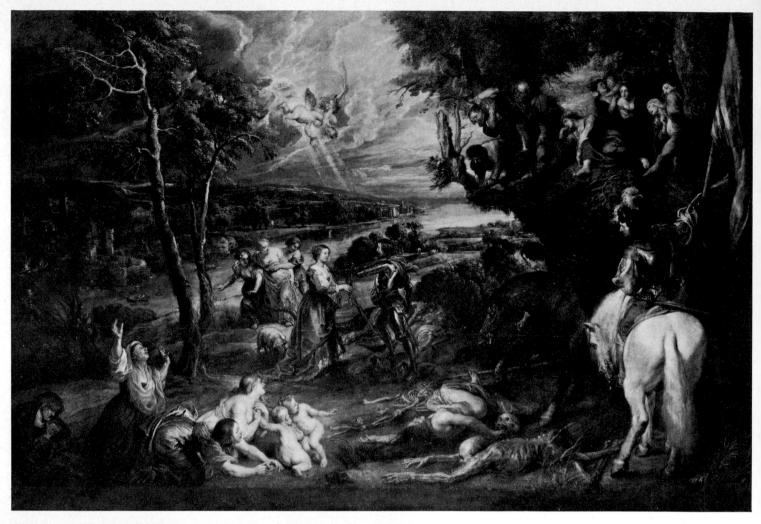

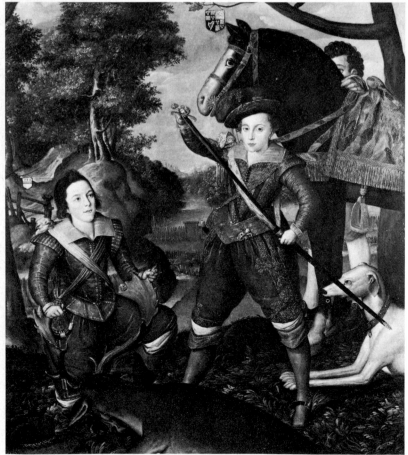

20 PETER PAUL RUBENS (1577–1640): *Landscape with Saint George and the dragon.* About 1630. Canvas, 59½ × 78½ in. Royal Collection

21 ROBERT PEAKE (working 1580–1619): *Henry, Prince of Wales, and Robert Devereux, 3rd Earl of Essex.* About 1606–7. Canvas, 75 × 65 in. Hampton Court, Royal Collection

22 ANTHONY VAN DYCK (1599–1641): *Charles I hunting.* About 1635. Canvas, 107 × 83½ in. Paris, Louvre

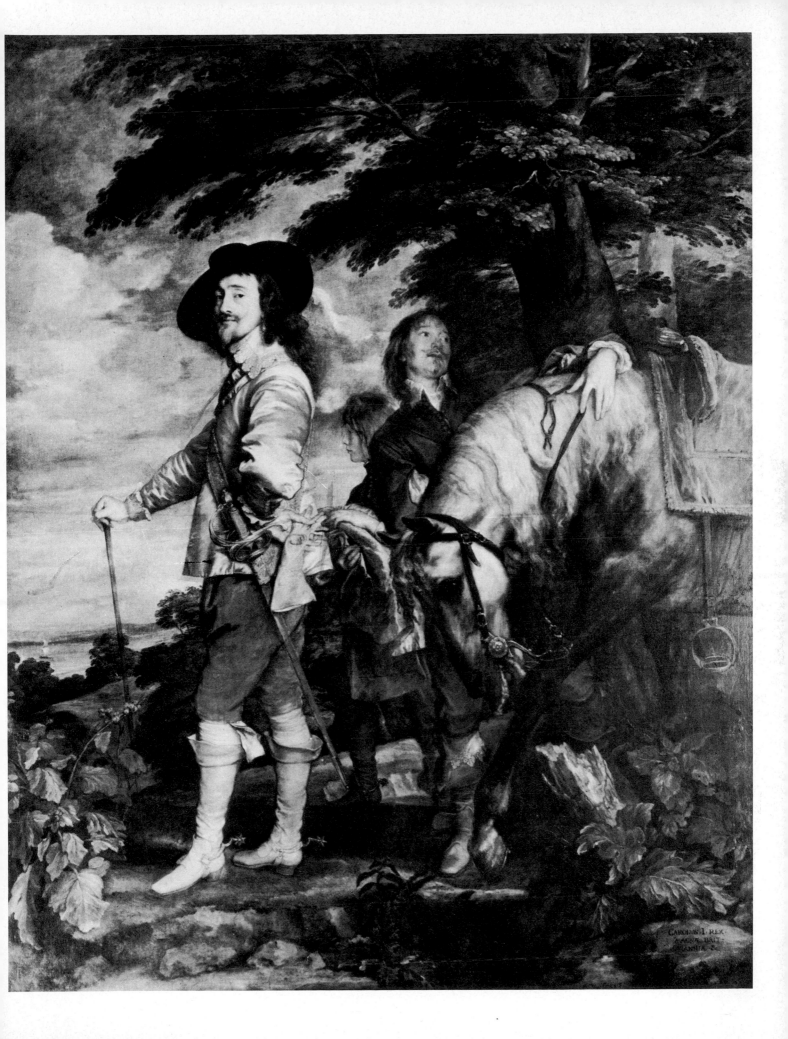

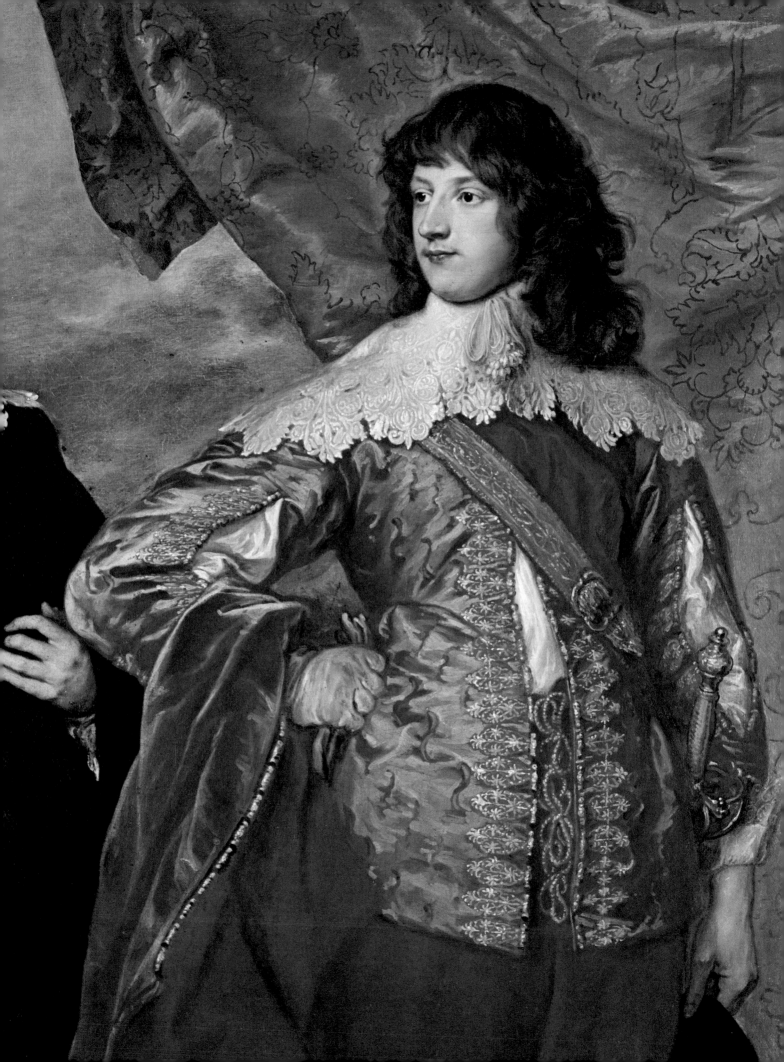

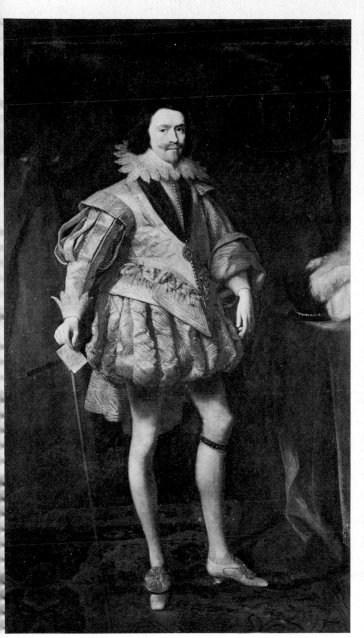 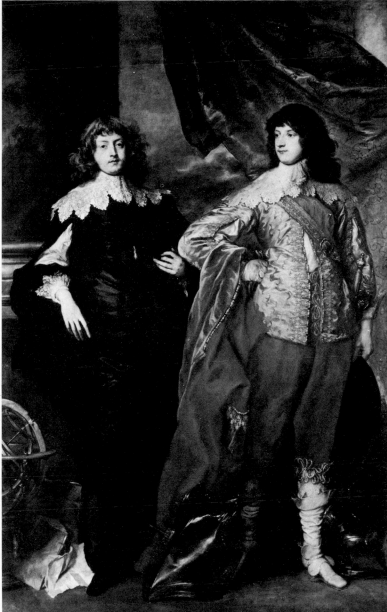

24 DANIEL MYTENS (about 1590–1647): *George Villiers, 1st Duke of Buckingham.* Signed and dated 1626. Canvas, $94\frac{1}{2} \times 52$ in. Collection of the Duke of Grafton

23 & 25 ANTHONY VAN DYCK (1599–1641): *George, Lord Digby, later 2nd Earl of Bristol and William, Lord Russell, later 5th Earl and 1st Duke of Bedford.* About 1633. Canvas, $99 \times 62\frac{3}{4}$ in. Althorp, Earl Spencer

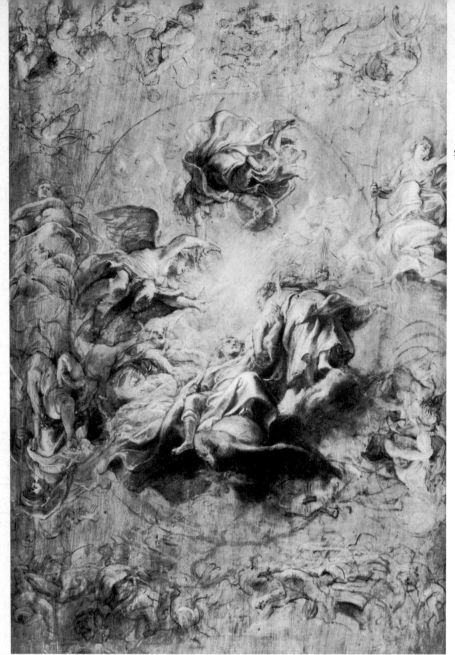

26 PETER PAUL RUBENS (1577–1640): *Sketch for the central panel of the Whitehall ceiling.* About 1630. Panel, $37\frac{3}{8} \times 24\frac{7}{8}$ in. Collection of Mrs Humphrey Brand

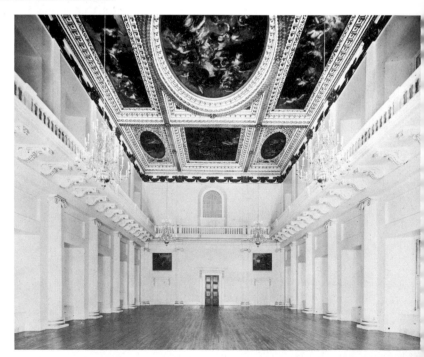

27 PETER PAUL RUBENS (1577–1640): *General view of the Banqueting Hall ceiling.* 1630–5

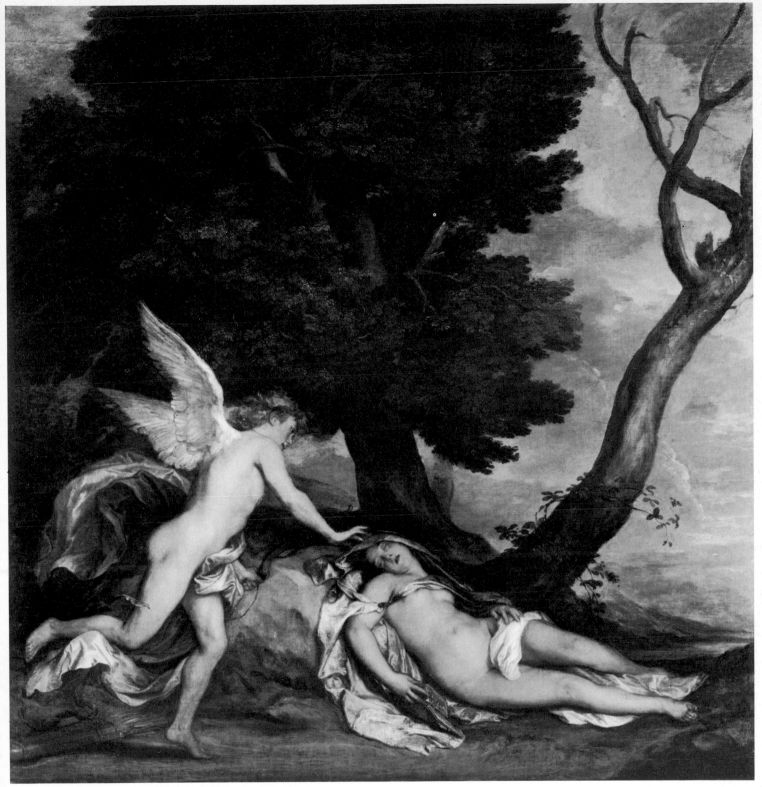

28 ANTHONY VAN DYCK (1599–1641): *Cupid and Psyche*. 1639–40? Canvas, 78½ × 75½ in. Royal Collection

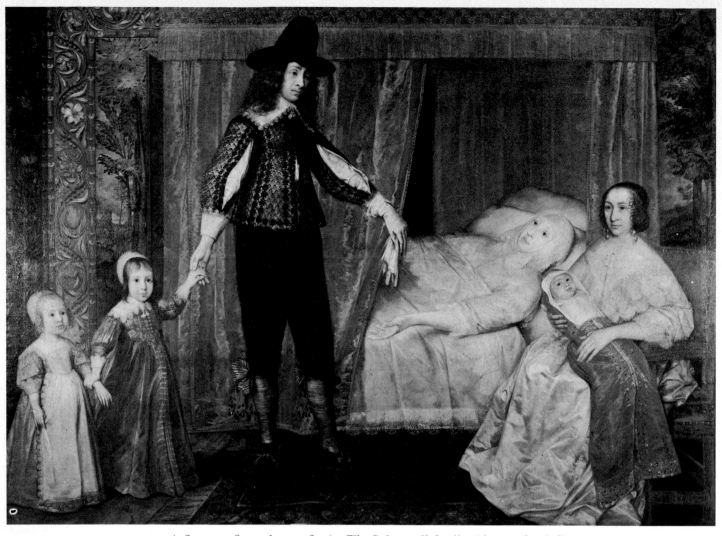

29 DAVID DES GRANGES (1611 or 1613–about 1675): *The Saltonstall family*. About 1645? Canvas, 78 × 107 in. London, Tate Gallery

30 CLAUDE DE JONGH (working 1626–63): *Old London Bridge* (detail). Signed and dated 1630. Panel, 20 × 66 in. Kenwood, Iveagh Bequest

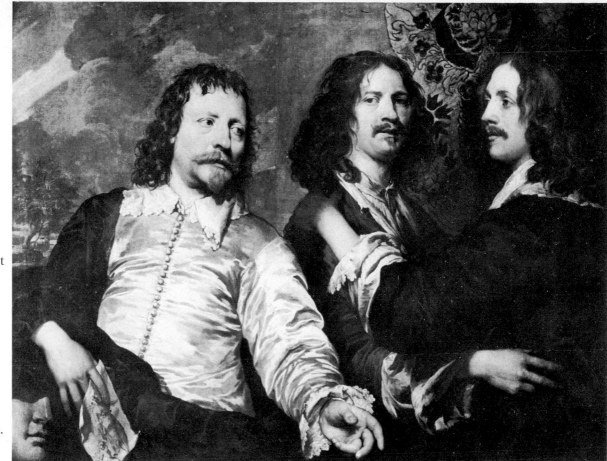

31 WILLIAM DOBSON
(1611–46): *Portrait
of the artist with Sir
Charles Cotterell and
an elderly man*. About
1643–5. Canvas,
$38\frac{1}{2} \times 49\frac{1}{2}$ in.
Alnwick, Duke of
Northumberland

32 CORNELIUS
JOHNSON (1593–
1661): *The family
of Arthur, Lord
Capel*. About 1639.
Canvas, 63×102 in.
London, National
Portrait Gallery

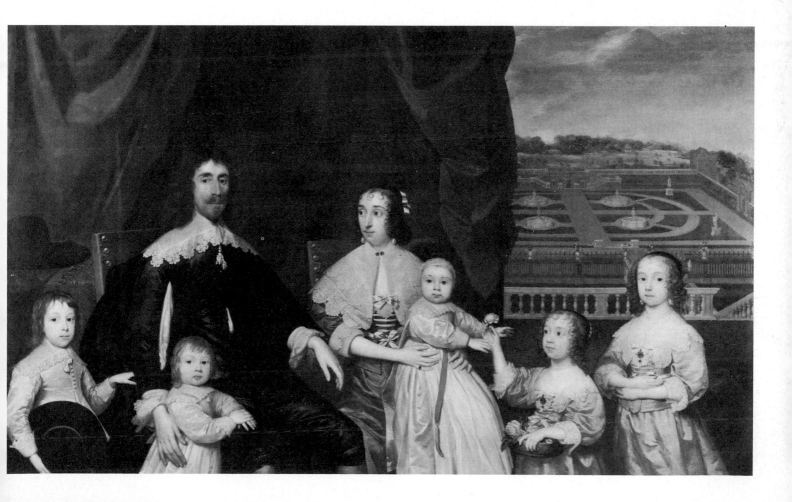

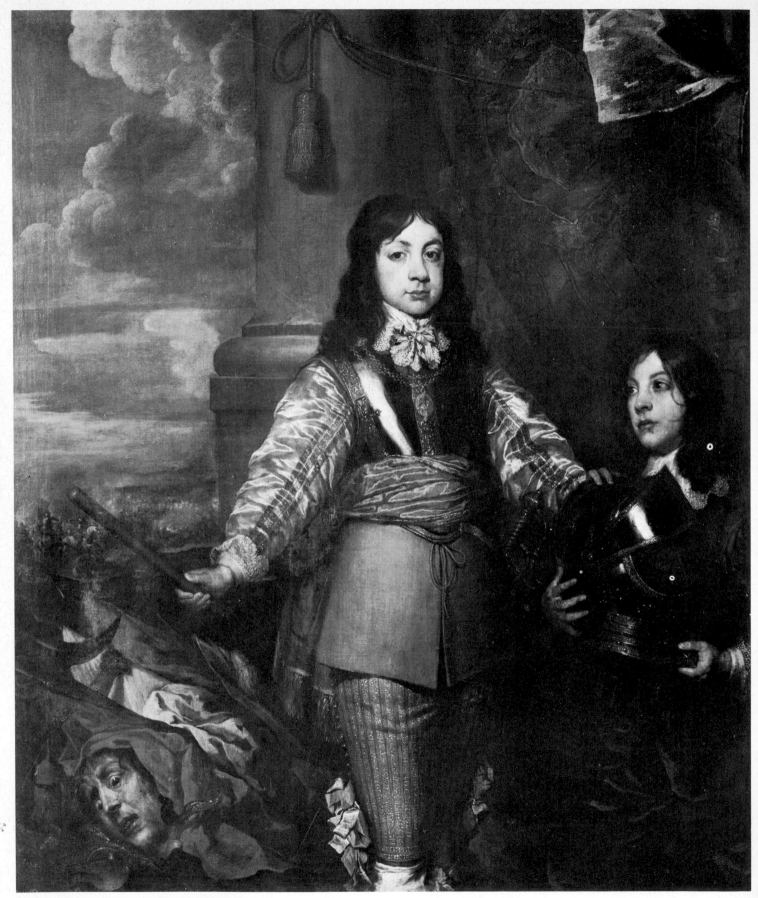

33 WILLIAM DOBSON (1611–46): *Charles II when Prince of Wales*. 1643? Canvas, 59½ × 50½ in. Edinburgh, Scottish National Portrait Gallery

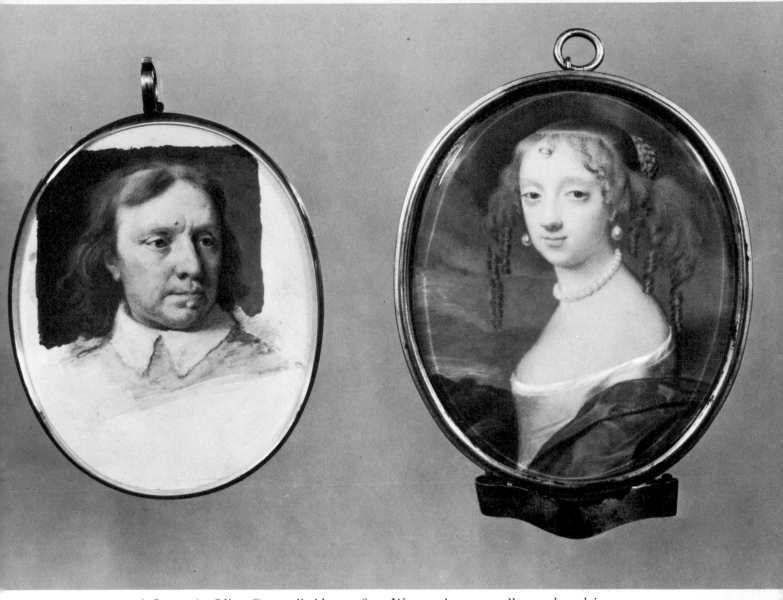

34 SAMUEL COOPER (1609–72): *Oliver Cromwell*. About 1650. Watercolour on vellum, $3\frac{1}{8} \times 2\frac{1}{2}$ in.
Drumlanrigg, Duke of Buccleuch

35 SAMUEL COOPER (1609–72): *Jane Myddelton*. About 1660. Watercolour on vellum, $3\frac{7}{8} \times 2\frac{1}{4}$ in.
Collection of the Earl of Beauchamp

36 FRANCIS BARLOW (died 1704): *Southern-mouthed hounds*. About 1667. Canvas, $35\frac{1}{4} \times 139\frac{1}{2}$ in. Surrey,
Clandon Park, National Trust

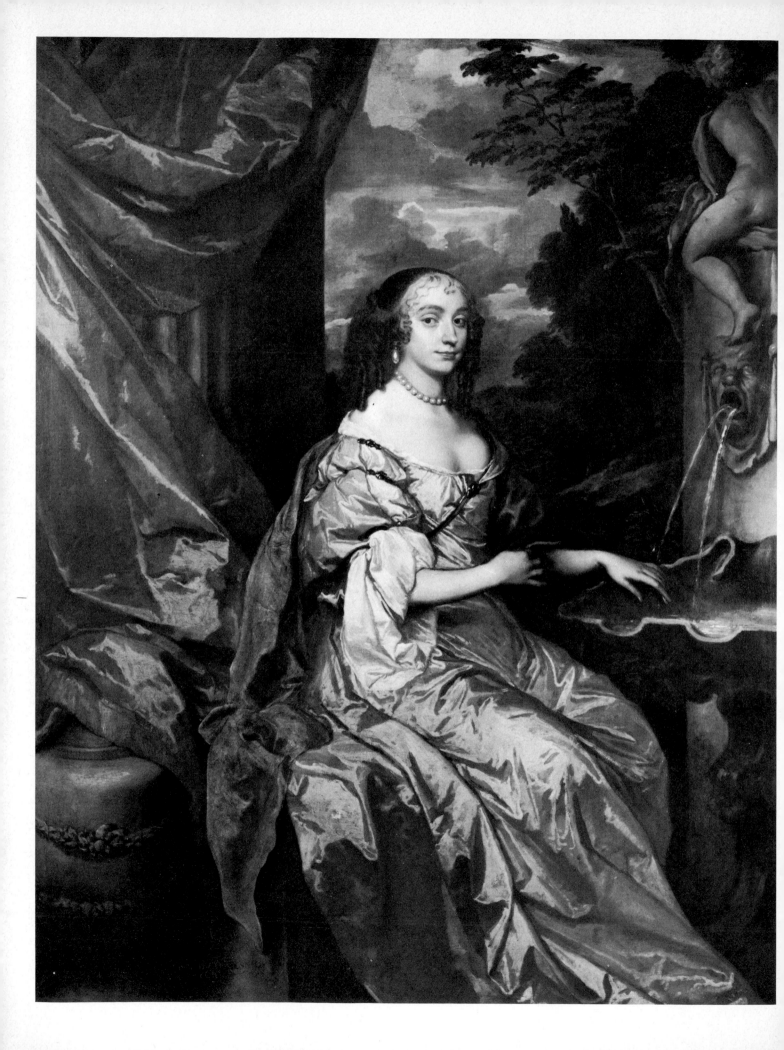

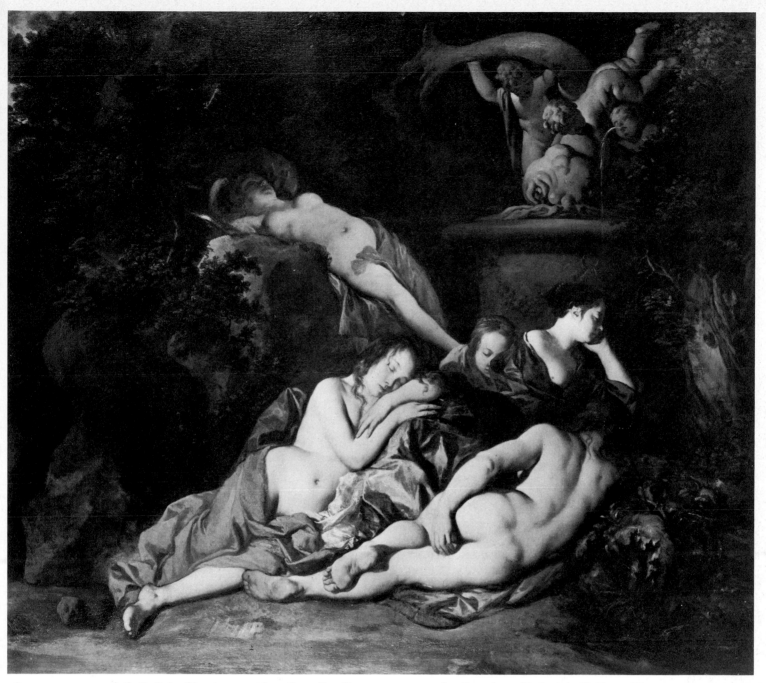

38 PETER LELY (1618–80): *Sleeping nymphs*. 1650–60. Canvas, 59 × 55 in. London, Dulwich College Picture
Gallery

37 PETER LELY (1618–80): *Anne Hyde, Duchess of York*. About 1670. Canvas, 71 × 55 in. Edinburgh,
Scottish National Portrait Gallery

40 GERARD SOEST (died 1681): *Sir Richard Rainsford*. Signed and dated 1678. Canvas, $49\frac{1}{2} \times 40\frac{1}{4}$ in. London, Lincoln's Inn

39 & 41 GODFREY KNELLER (1646–1723): *John Dryden*. About 1698. Canvas, $37\frac{1}{4} \times 25\frac{1}{2}$ in. Cambridge, Trinity College

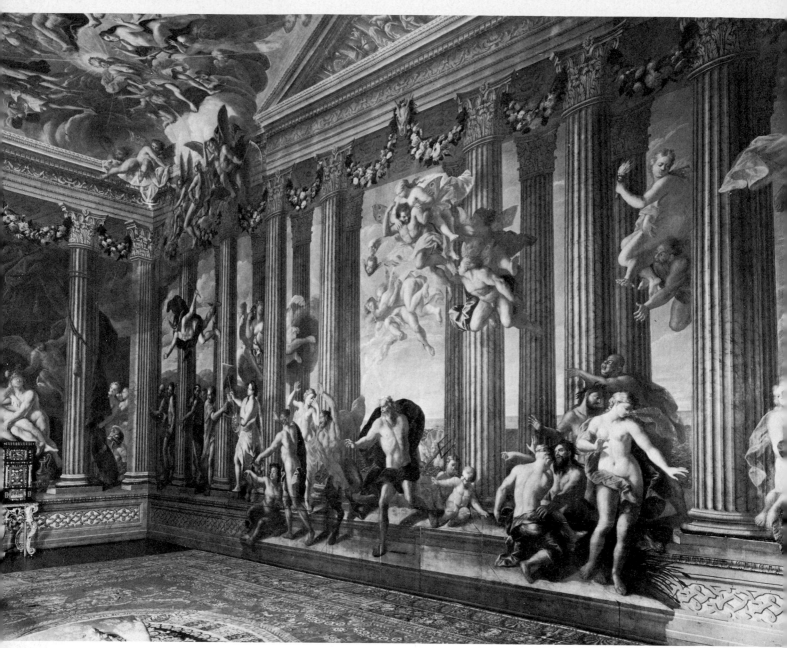

42 ANTONIO VERRIO (about 1639–1707): *The Heaven Room*. Near Stamford, Lincs., Burghley House

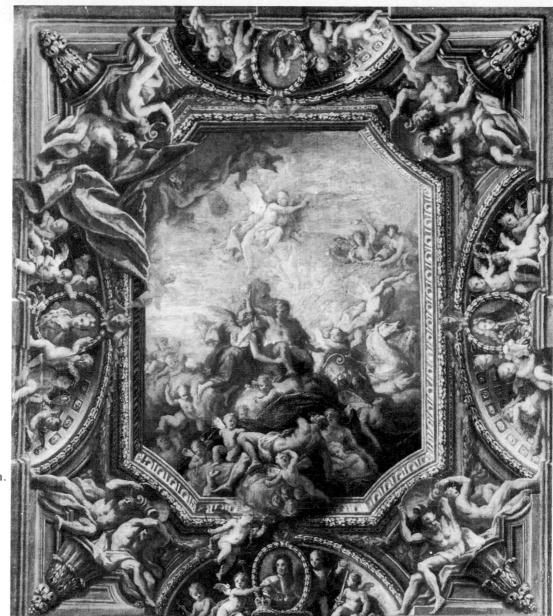

43 JAMES THORNHILL
(1675/6–1734): *Sketch for
the ceiling of the queen's
bedchamber, Hampton Court.*
1714–15. Canvas, 29 × 25½ in.
London, Sir John
Soane's Museum

44 SEBASTIANO RICCI (1659–
1734): *The Triumph of
Galatea.* About 1715.
Canvas, 137 × 178½ in.
London, Burlington
House

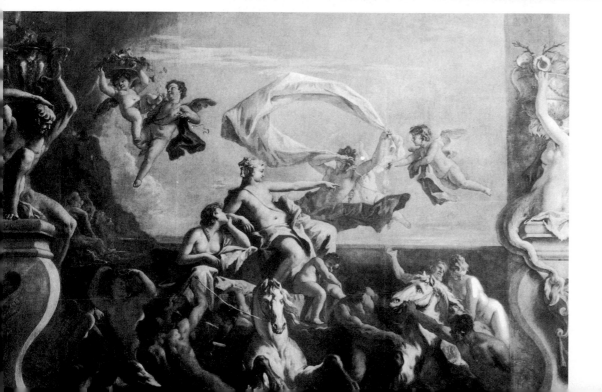

45 JAN SIBERECHTS
(1627–1703):
*Landscape with a
view of Henley-
on-Thames.*
Signed and
dated 1692.
Canvas, 17 × 20 in.
Collection
of Lord
Middleton

46 JOHN WOOTTON
(about 1682–
1764): *Lady
Henrietta Harley
hunting with
harriers.* Canvas,
32½ × 54 in.
Collection of
Lady Thompson

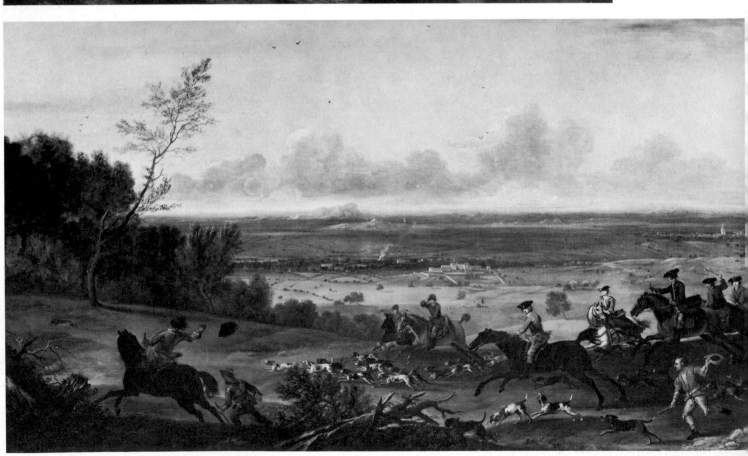

47 PETER
TILLEMANS
(1684–1734):
*Mr Jemmet
Browne at a
meet.* Signed.
Canvas,
$38\frac{1}{4} \times 48\frac{1}{2}$ in.
Collection of
Mr and Mrs
Paul Mellon

48 GEORGE
STUBBS
(1724–1806):
*The Duke of
Richmond's
racehorses
exercising at
Goodwood.*
1760–1.
Canvas,
$50\frac{1}{4} \times 80\frac{3}{4}$ in.
Goodwood
House, Earl
of March

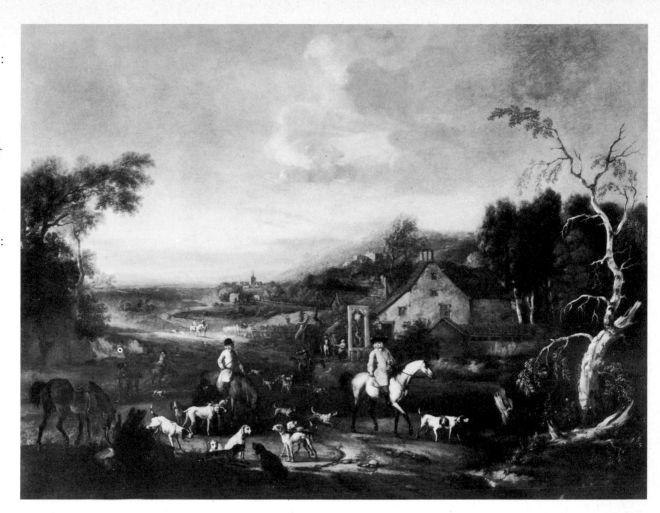

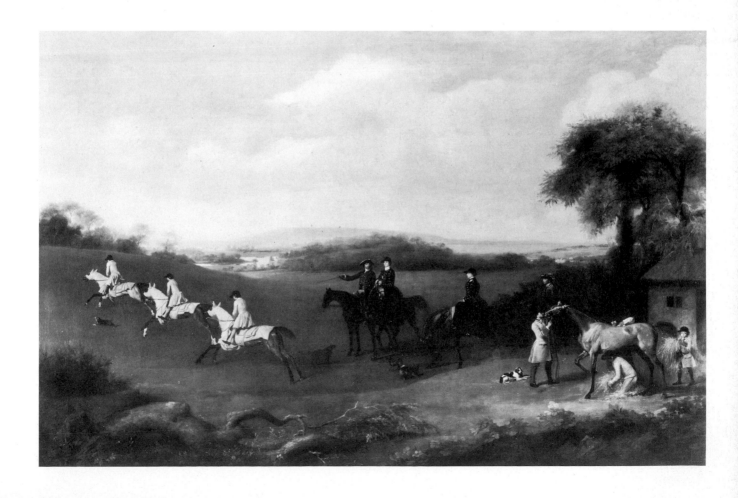

49 GEORGE LAMBERT (1700–65): *Hilly landscape with a cornfield.* 1733. Canvas, $35\frac{3}{4} \times 72\frac{1}{2}$ in. London, Tate Gallery

50 & 51 ARTHUR DEVIS (1711–87): *Sir George and Lady Strickland at Boynton Hall.* 1751. Canvas, 35 × 44 in. Kingston upon Hull, Ferens Art Gallery

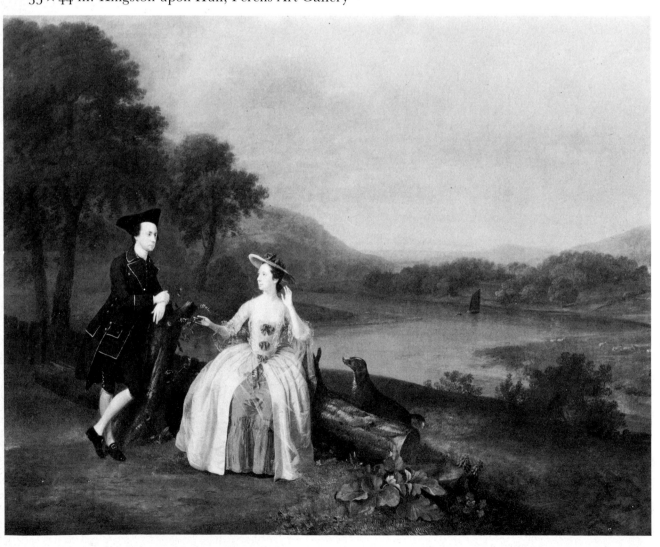

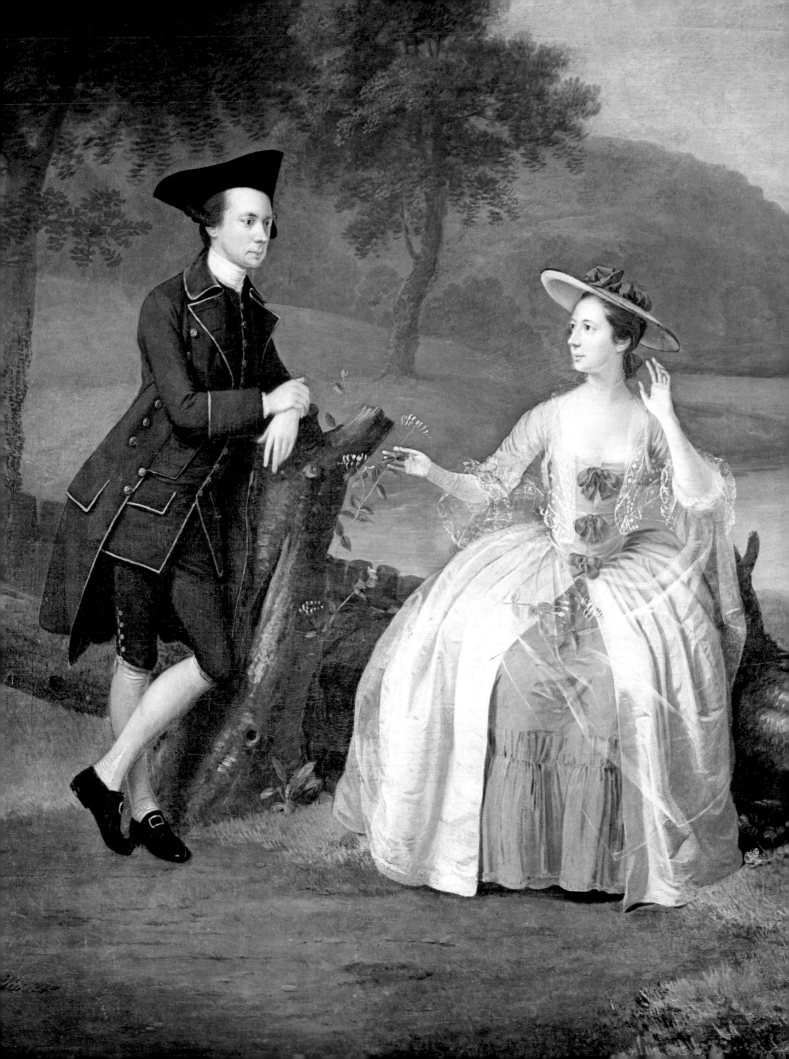

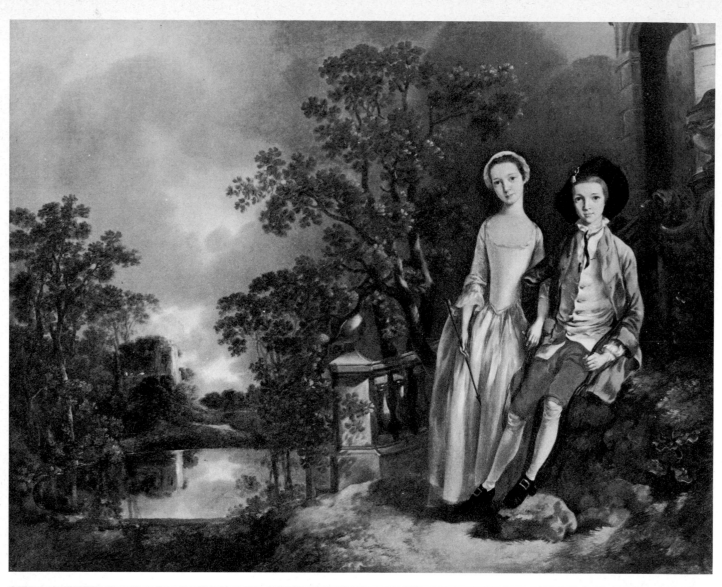

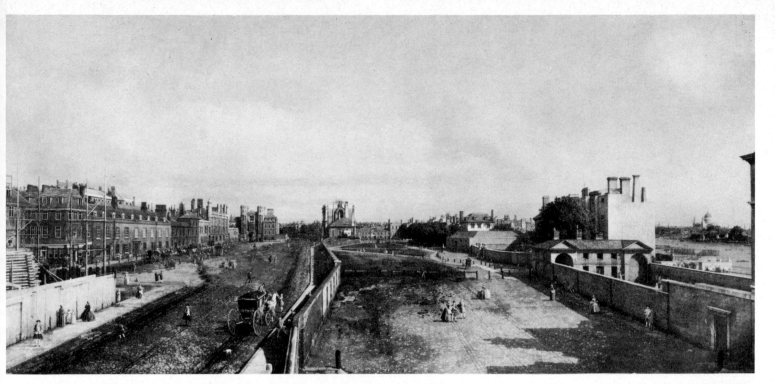

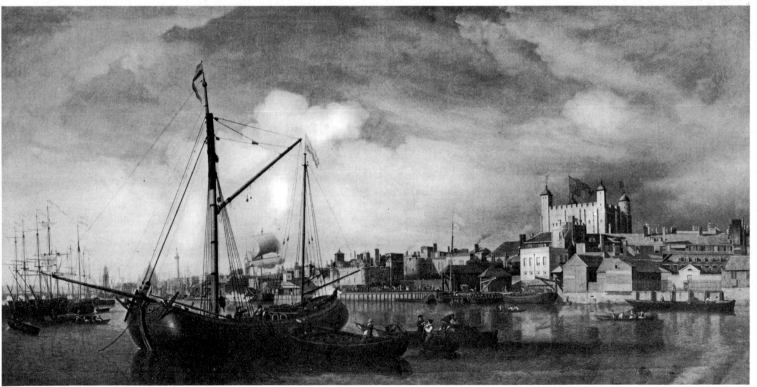

52 THOMAS GAINSBOROUGH (1727–88): *Heneage Lloyd and his sister*. About 1750–2. Canvas, 25 × 31½ in. Cambridge, Fitzwilliam Museum

53 FRANCIS HAYMAN (1708–76): *The see-saw*. About 1740–3. Canvas, 54 × 95 in. London, Tate Gallery

54 ANTONIO CANALETTO (1697–1768): *View of Whitehall looking north*. About 1751. Canvas, 46¾ × 93½ in. Bowhill, Duke of Buccleuch

55 SAMUEL SCOTT (about 1702–72): *The Tower of London*. Signed and dated 1753. Canvas, 39 × 73½ in. Norfolk, Felbrigg, National Trust

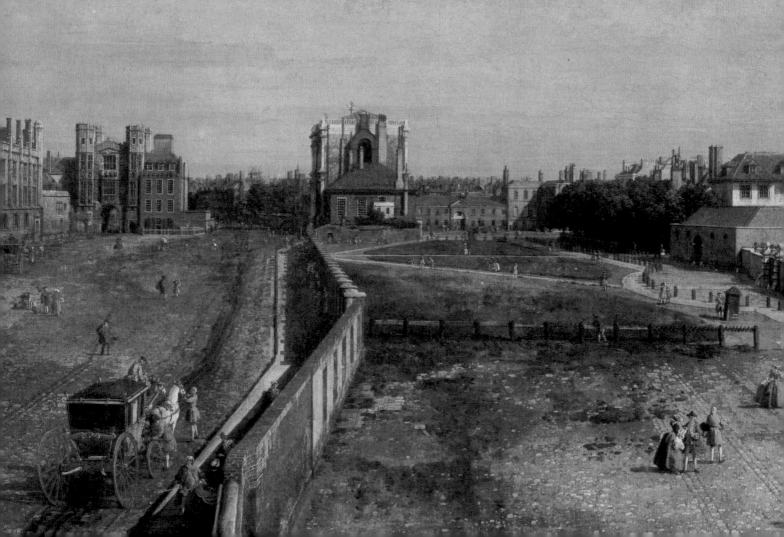

56 ANTONIO CANALETTO (1697–1768): *Old Walton Bridge*. 1754. Canvas, 18¼ × 29½ in. London, Dulwich College Picture Gallery

57 ANTONIO CANALETTO: *View of Whitehall looking north* (detail of Plate 54)

58 RICHARD WILSON (1714–82): *Kew Gardens: The ruined arch*. About 1760–2. Canvas, 18½ × 28⅝ in. Collection of Mr Brinsley Ford

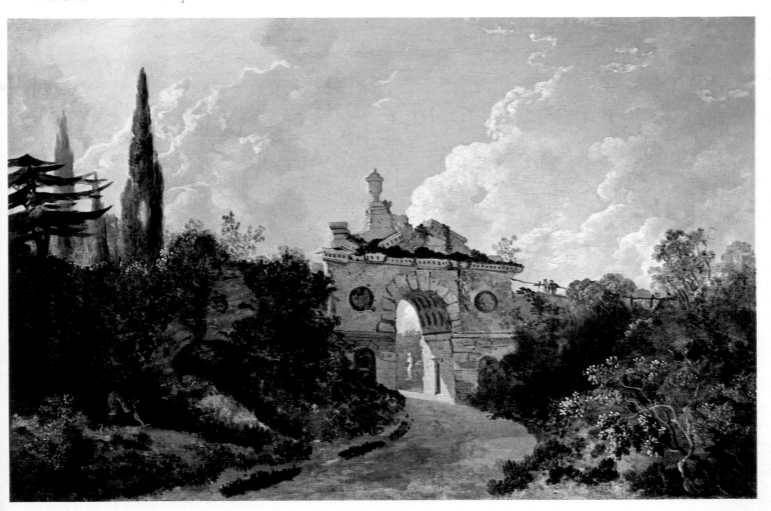

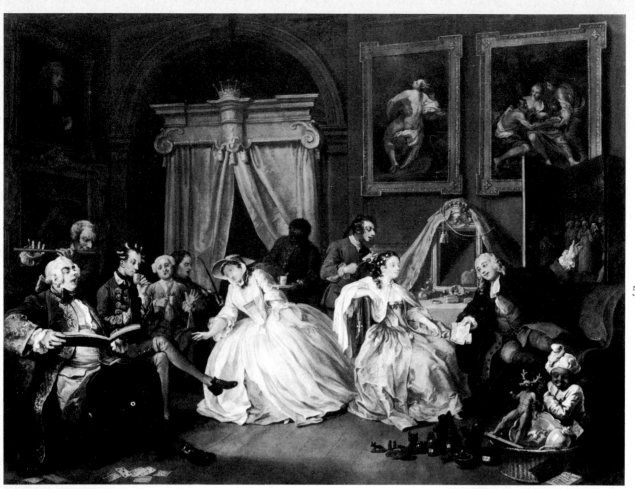

59 WILLIAM
HOGARTH
(1697–1764):
*Marriage à la
mode IV: The
countess's
morning levée.*
1743–5.
Canvas,
27 × 35 in.
London,
National
Gallery

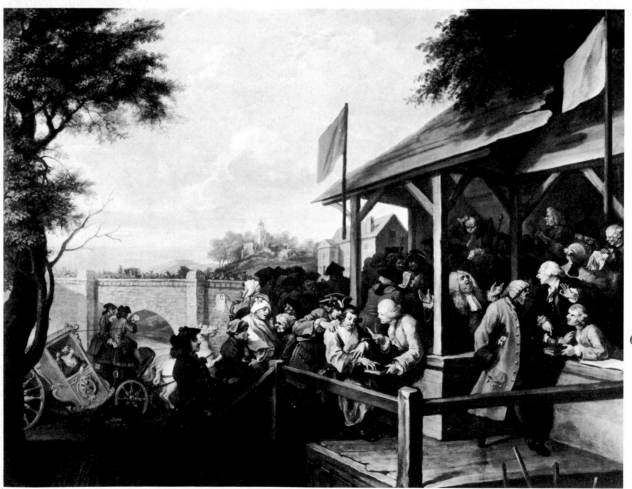

60 WILLIAM
HOGARTH
(1697–1764):
*An election:
Polling.* About
1754. Canvas,
40 × 50 in.
London, Sir
John Soane's
Museum

61 & 62 WILLIAM
HOGARTH
(1697–1764):
*Lord Hervey and
his friends.*
About 1737.
Canvas, 40 × 50 in.
Suffolk,
Ickworth,
National Trust

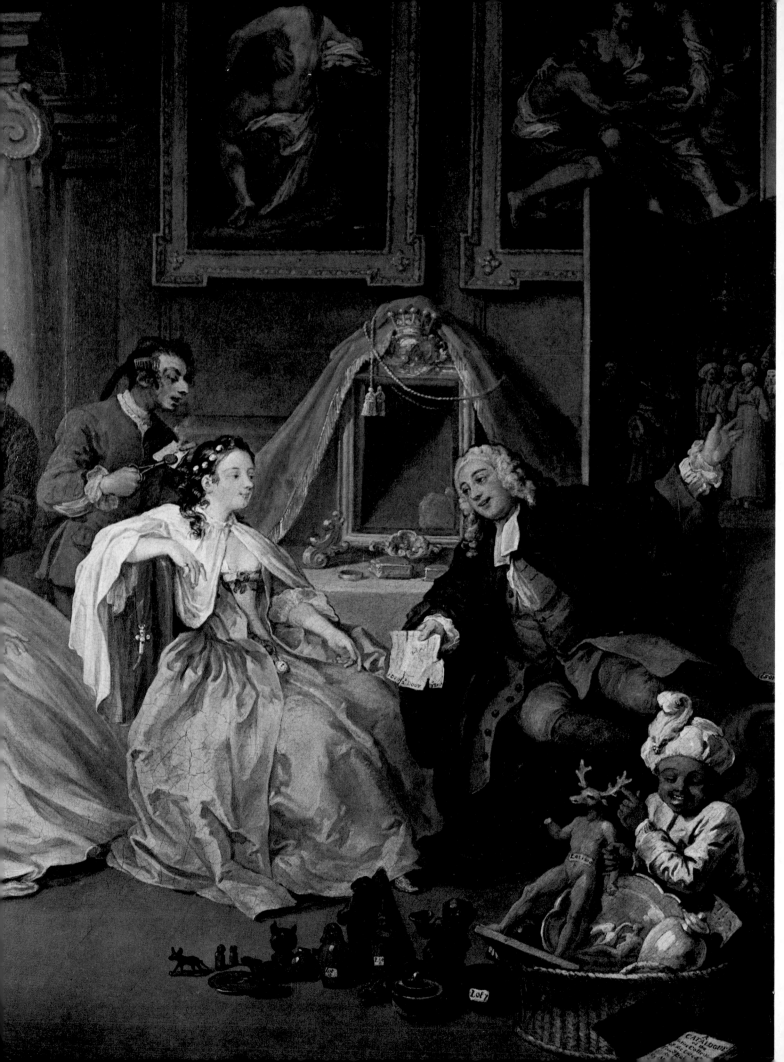

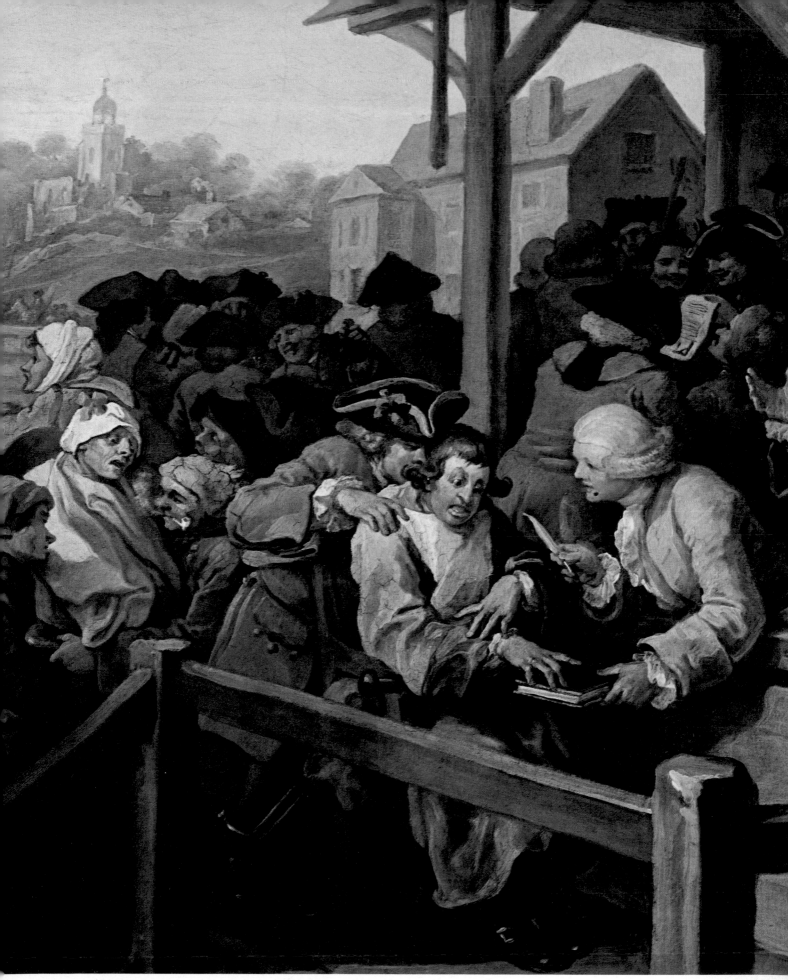

64 WILLIAM HOGARTH: *An election* (detail of Plate 60)

63 WILLIAM HOGARTH: *Marriage à la mode* (detail of Plate 59)

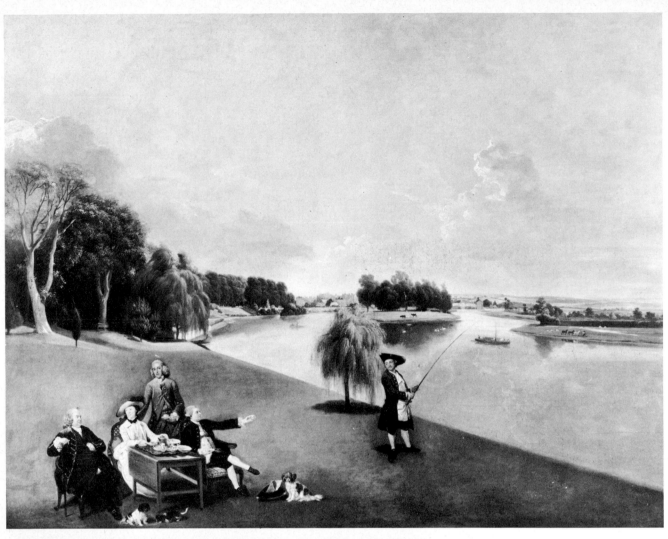

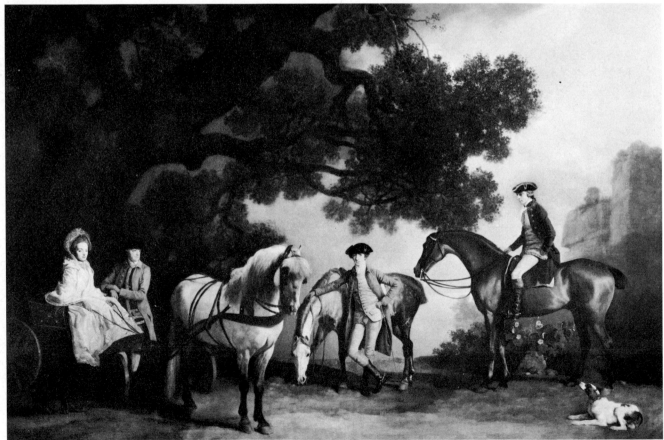

65 JOHANN ZOFFANY (1734/5–1810): *A view in Hampton Garden with Mr and Mrs Garrick taking tea*. About 1760–5. Canvas, 40 × 50 in. Collection of Lord Lambton

66 GEORGE STUBBS (1724–1806): *Lord and Lady Melbourne, Sir Ralph Milbanke and John Milbanke*. 1769–70. Canvas, 38¼ × 58¾ in. London, National Gallery

67 GEORGE STUBBS: *Racehorses exercising at Goodwood* (detail of Plate 48)

68 GEORGE STUBBS (1724–1806): *Mares and foals*. 1762. Canvas, 39 × 75 in. Collection of Earl Fitzwilliam

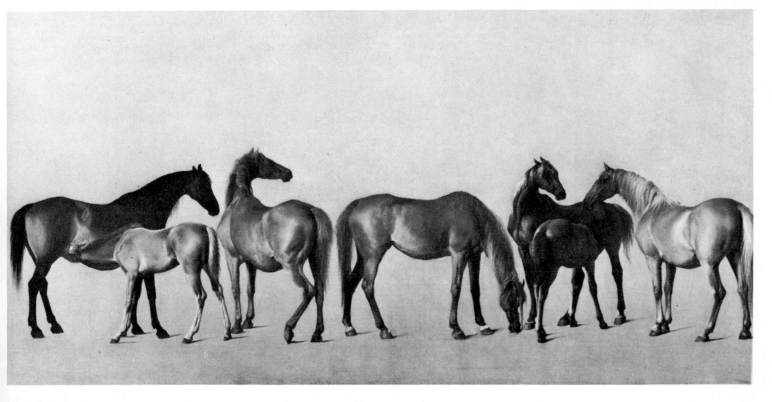

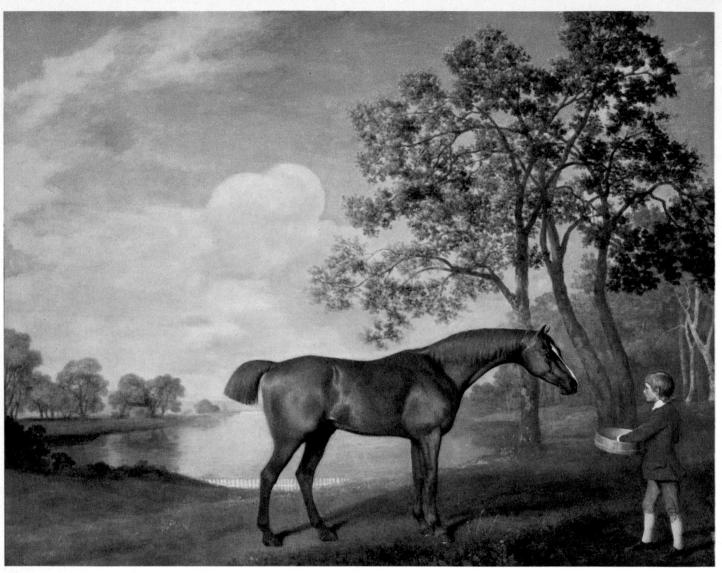

69 GEORGE STUBBS (1724–1806): *Pumpkin with stable lad*. Signed and dated 1774. Panel, $31\frac{1}{2} \times 39\frac{1}{4}$ in. Collection of Mr and Mrs Paul Mellon

70 JOHANN ZOFFANY: *A view in Hampton Garden with Mr and Mrs Garrick taking tea* (detail of Plate 65)

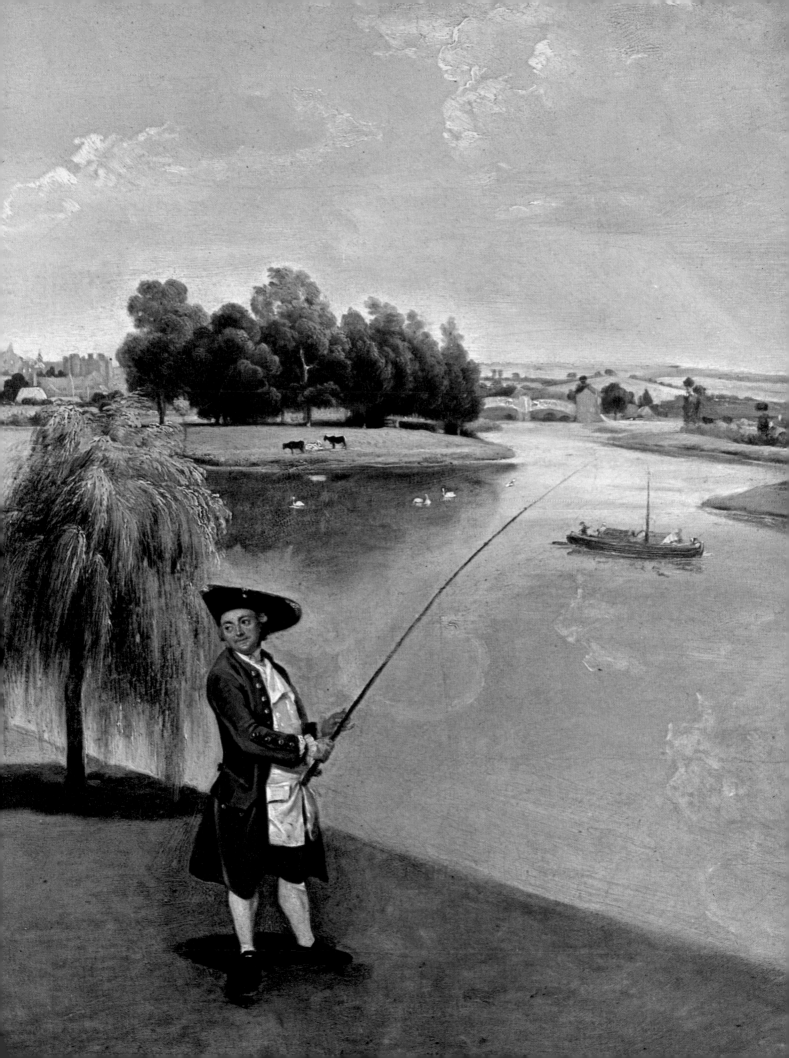

71 ANDREA SOLDI (about 1703–71): *Catherine Havers*. About 1745–50. Canvas, 50 × 40 in. Leeds, Temple Newsam House

72 WILLIAM HOGARTH (1697–1764): *Thomas Herring, Archbishop of Canterbury*. Signed and dated 1744, Canvas, 50 × 40 in. London, Tate Gallery

73 & 74 JOSHUA REYNOLDS (1723–92): *Laurence Sterne*. Signed and dated 1760. Canvas, 49 × 39½ in. London, National Portrait Gallery

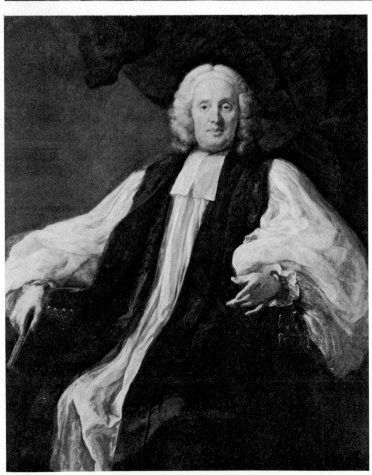

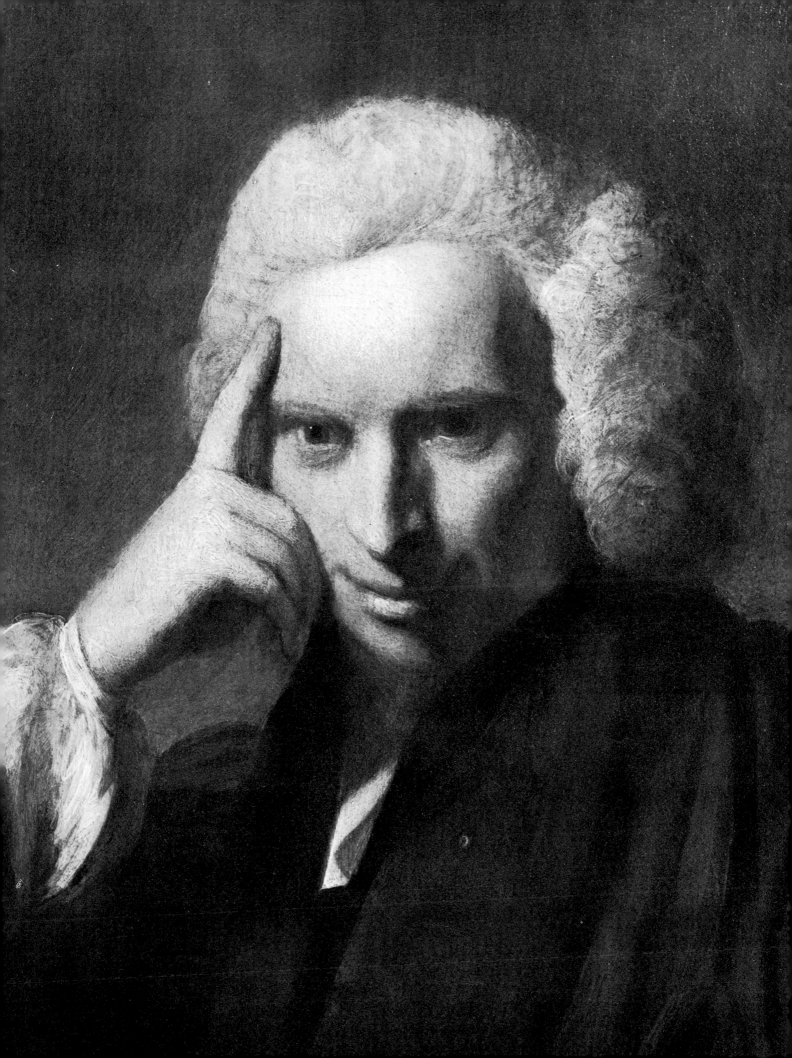

75 & 76 THOMAS GAINSBOROUGH (1727–88): *John, 4th Duke of Argyll.* Exhibited 1767. Canvas, 96 × 62 in. Edinburgh, Scottish National Portrait Gallery

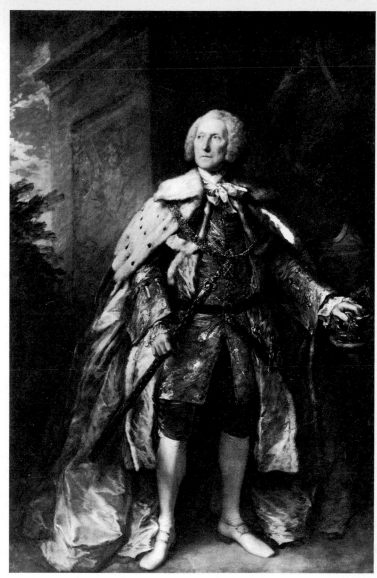

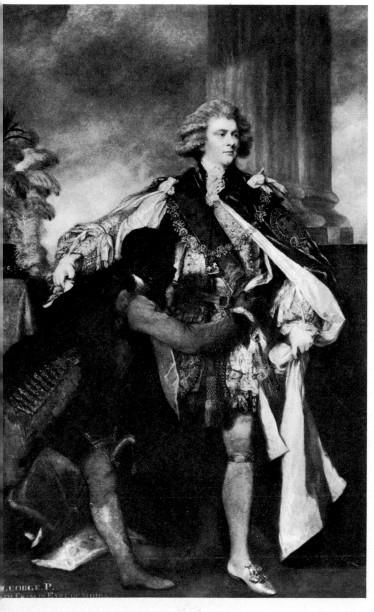

77 JOSHUA REYNOLDS (1723–92): *George, Prince of Wales.* 1787. Canvas, 84 × 60 in. Arundel, Duke of Norfolk

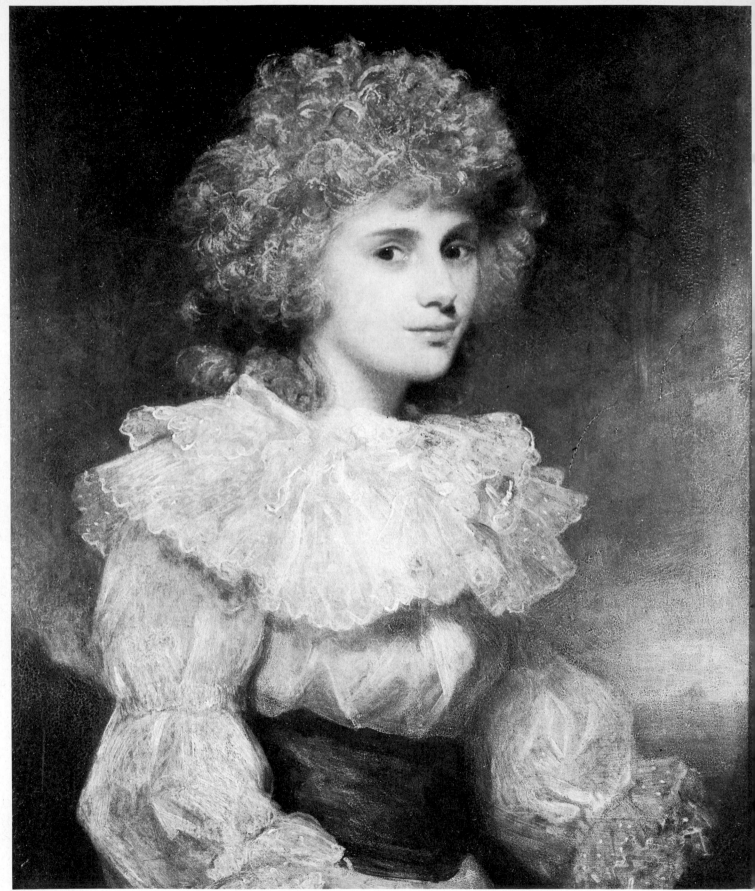

78 JOSHUA REYNOLDS (1723–92): *Lady Betty Foster*. 1787. Canvas, $29\frac{1}{2} \times 24\frac{1}{2}$ in. Chatsworth, Trustees of the Chatsworth Settlement

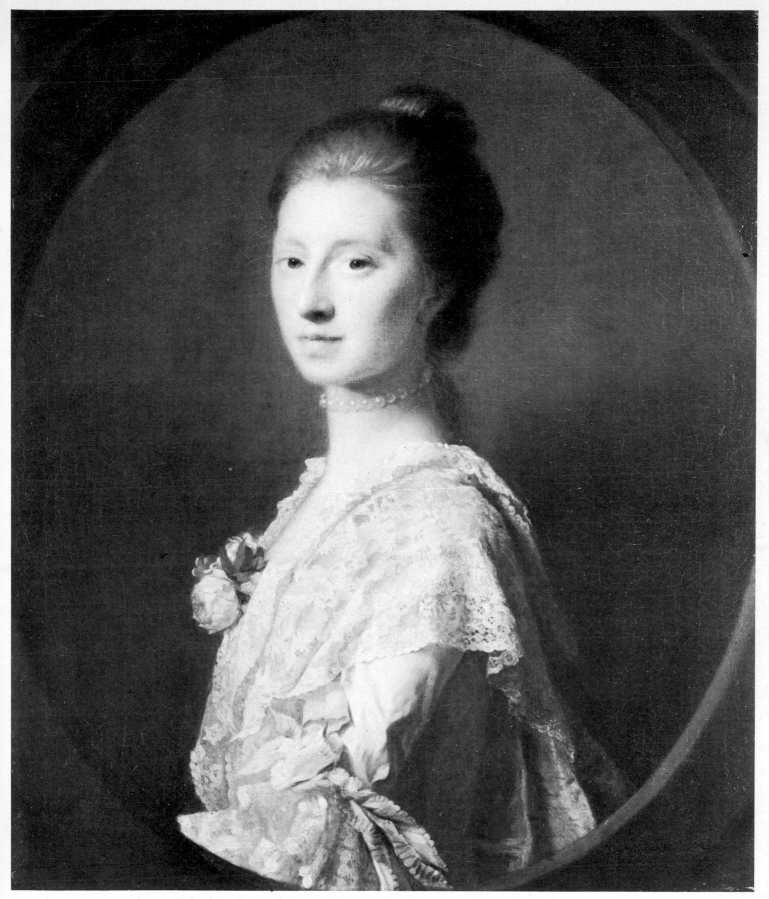

79 ALLAN RAMSAY (1713–84): *Mrs Bruce of Arnot*. About 1765. Canvas, 29⅛ × 24 in. Edinburgh, National
Gallery of Scotland

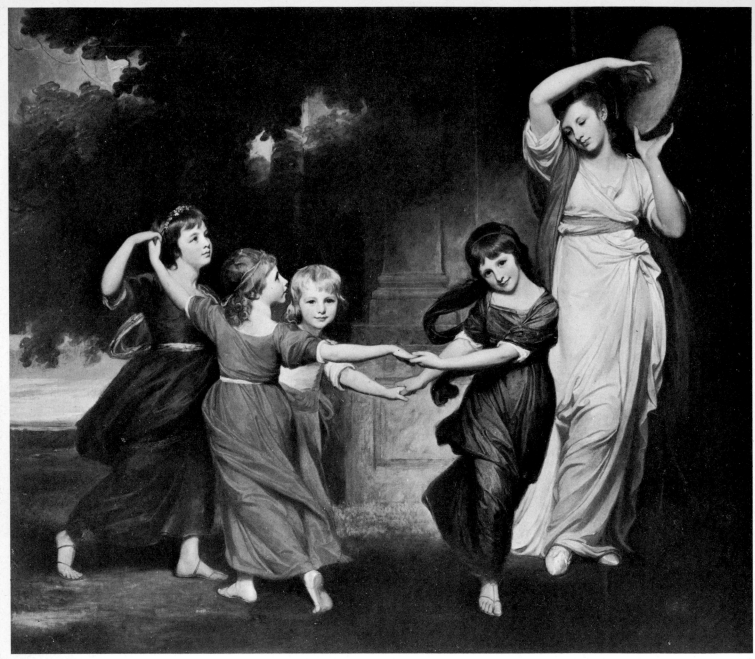

80 GEORGE ROMNEY (1734–1802): *The Gower family.* 1776–7. Canvas, 80 × 90 in. Kendal, Abbots Hall Museum

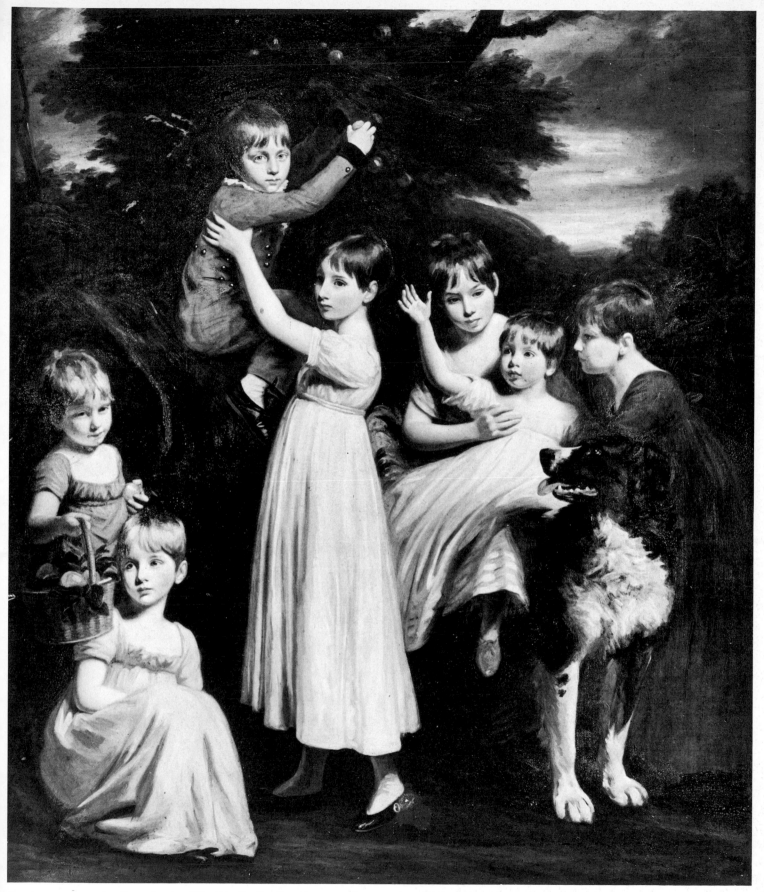

81 JOHN OPIE (1761–1807): *The Brodie family*. Canvas, 84 × 70 in. Collection of the Brodie of Brodie

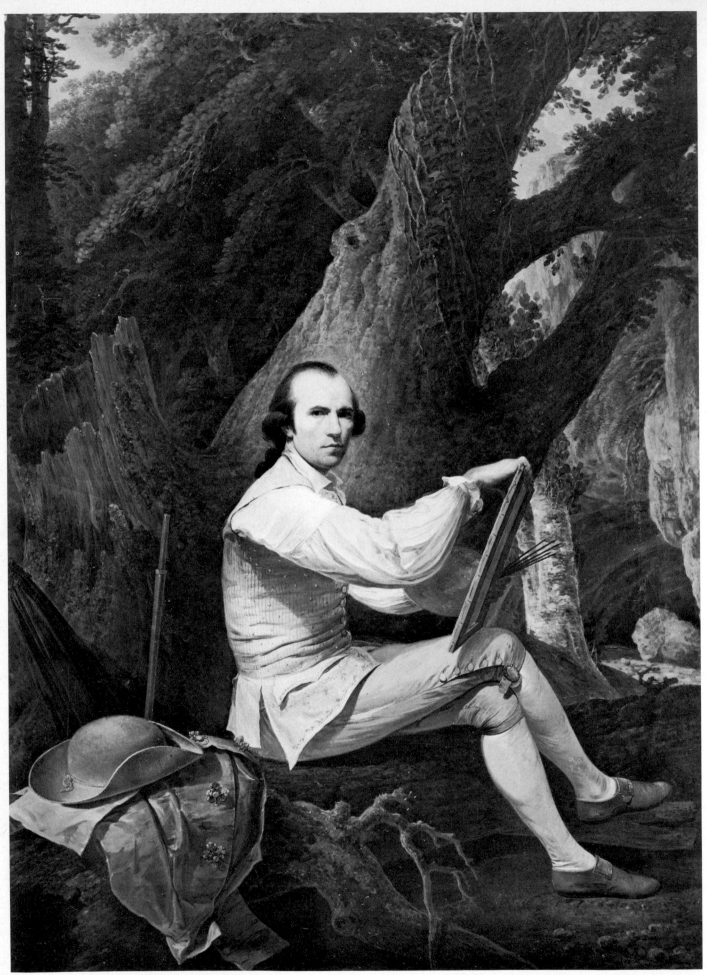

82 JACOB MORE (1740–93): *Self-portrait*. Signed and dated 1783. Canvas, 78 × 58 in. Florence, Uffizi

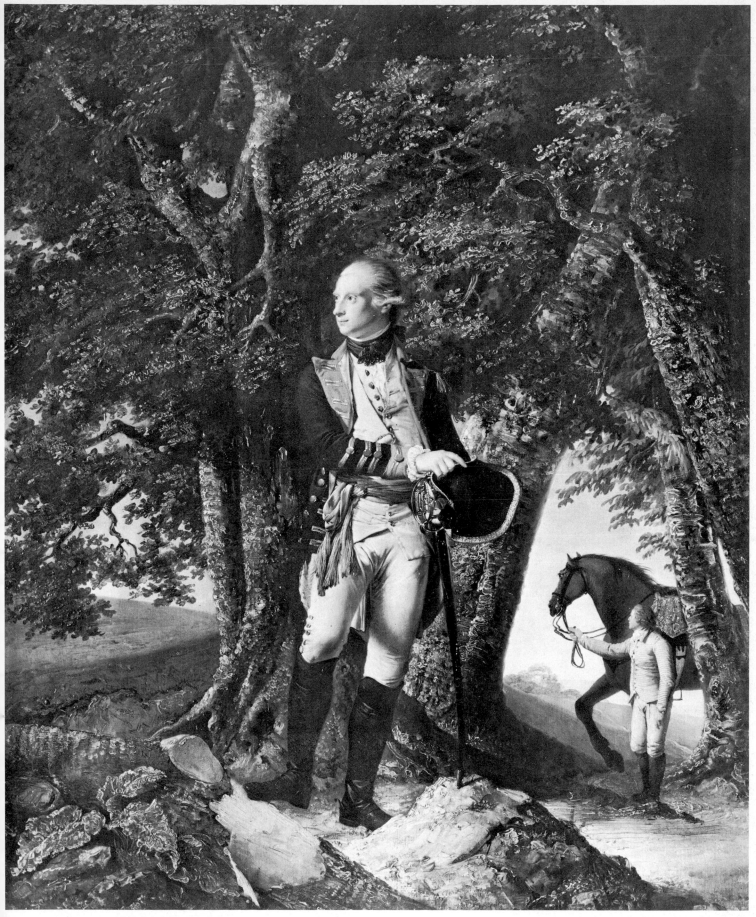

83 JOSEPH WRIGHT OF DERBY (1734–97): *Robert Shore Milnes*. About 1771–2. Canvas, 50 × 40 in. Collection of Mrs Lawrence Copley Thaw

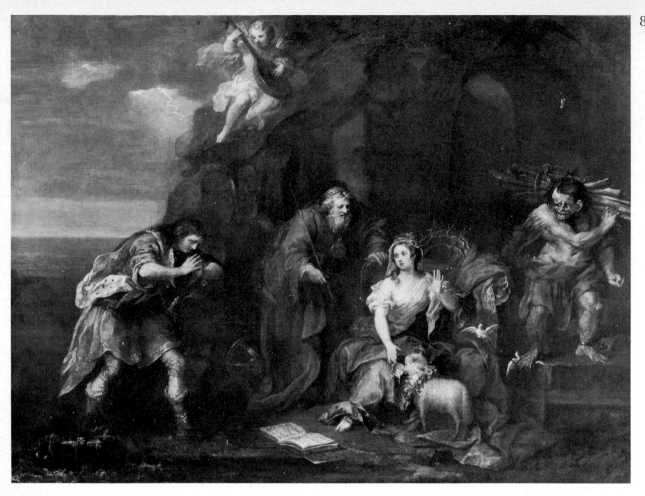

84 & 86 WILLIAM
HOGARTH
(1697–1764):
*A scene from
The Tempest.*
About 1730–5.
Canvas, 31½ ×
40 in. Nostell
Priory, Major
the Rt Hon.
Lord St
Oswald

85 THOMAS JONES
(1742–1803):
The bard.
Inscribed with
name and
dated 1774.
Canvas,
45½ × 66 in.
Cardiff,
National
Museum of
Wales

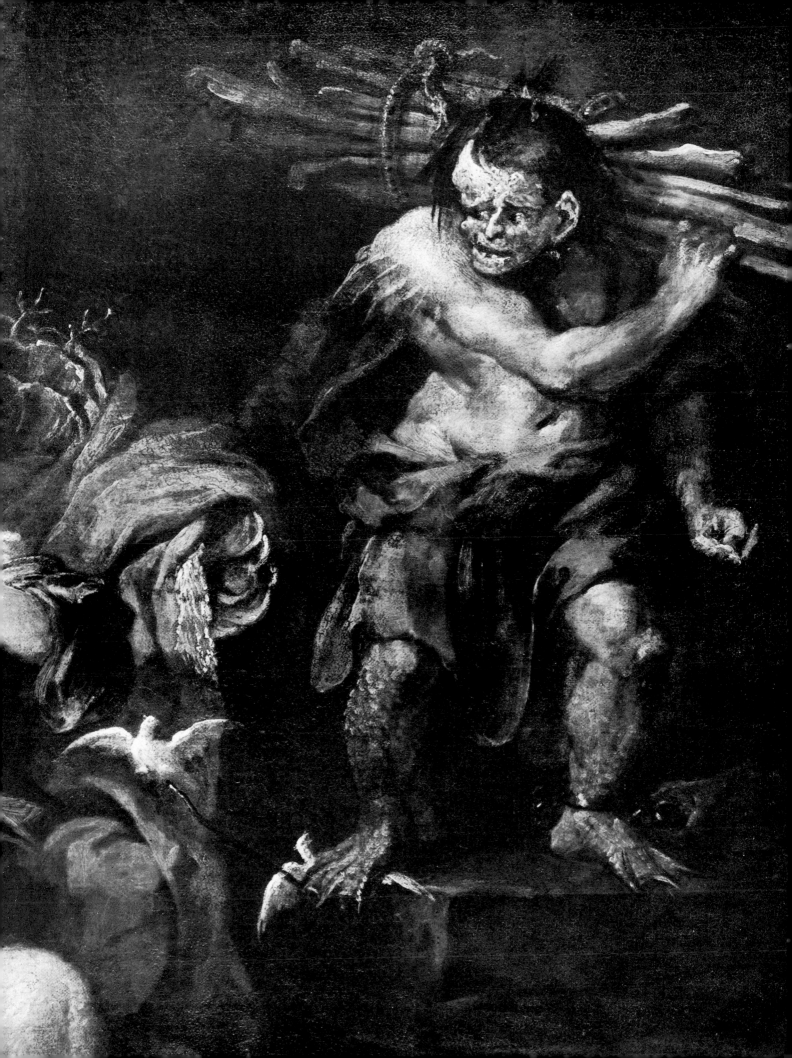

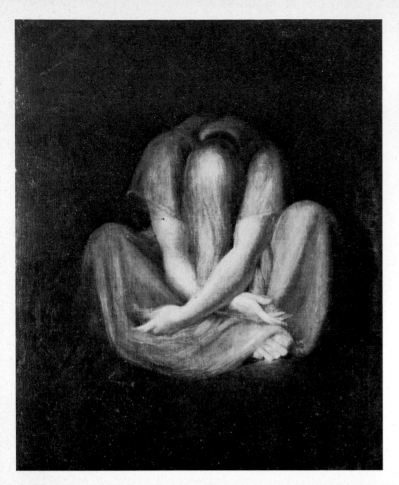

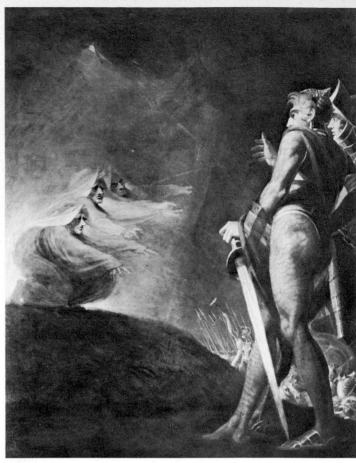

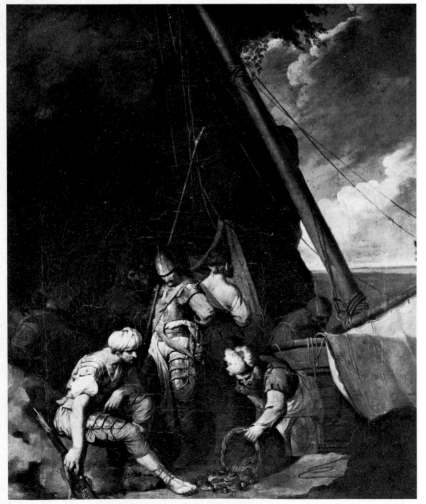

87 HENRY FUSELI (1741–1825): *Silence*.
About 1800. Canvas, 24¾ × 20 in.
Collection of Mrs P. Ganz, Basle

88 & 90 HENRY FUSELI (1741–1825): *Macbeth,
Banquo and the witches on the heath*. 1793–4.
Canvas, 66 × 53 in. Petworth, National
Trust (Egremont Collection)

89 JOHN HAMILTON MORTIMER (1740–79):
Banditti fishing. About 1775–7. Canvas,
30 × 24 in. Collection of Mr D. P. H.
Lennox

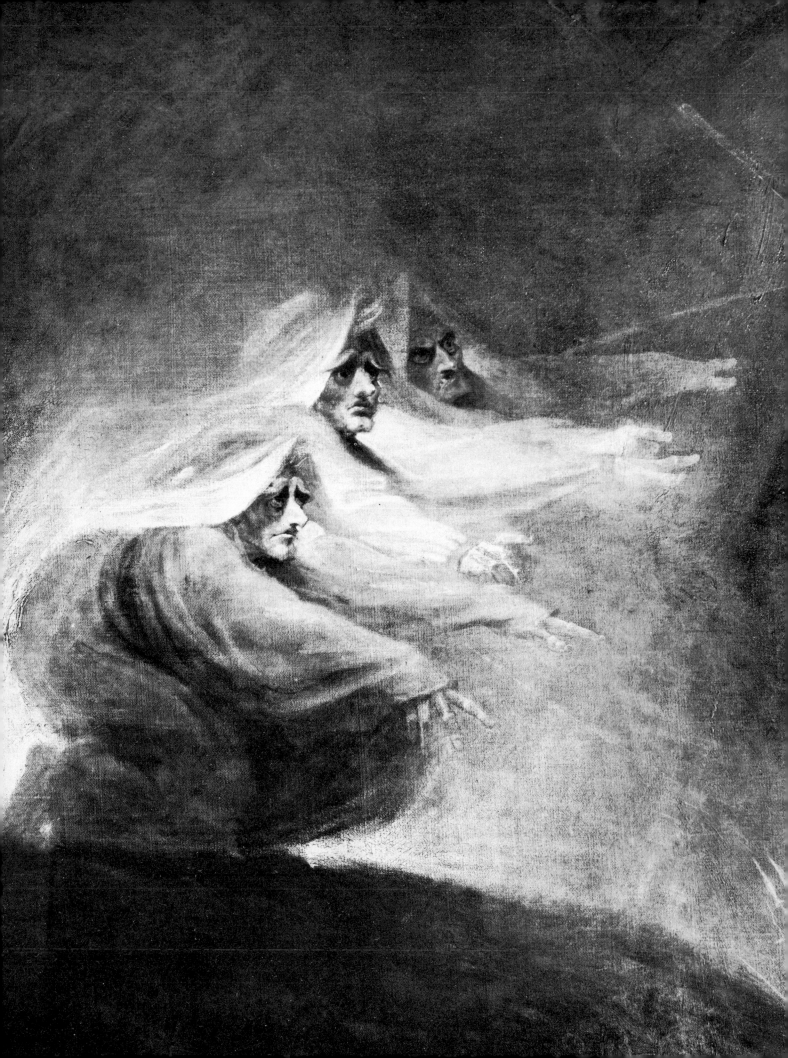

91 JAMES BARRY (1741–
1806): *The progress of
human culture: Orpheus.*
1777–83. Canvas,
142 × 182 in. London,
Royal Society of Arts

92 JOHN SINGLETON
COPLEY (1738–1815):
*The death of Major
Pierson.* 1782–4. Canvas,
97 × 144 in. London,
Tate Gallery

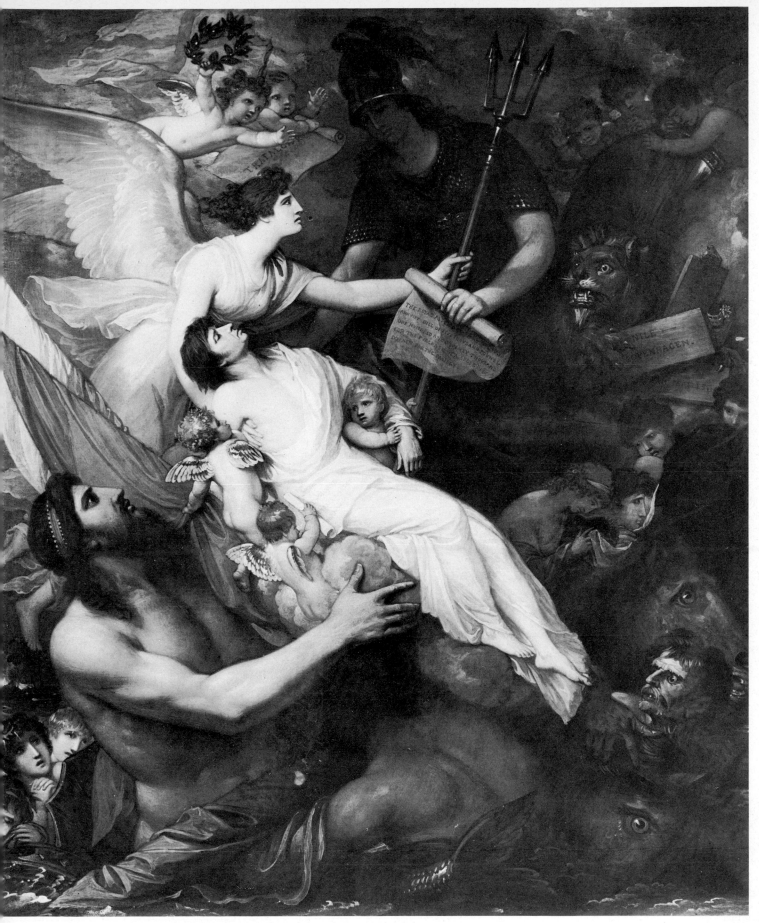

93 BENJAMIN WEST (1738–1820): *Apotheosis of Nelson*. Signed and dated 1807. Canvas, 35½ × 29½ in. Greenwich, National Maritime Museum

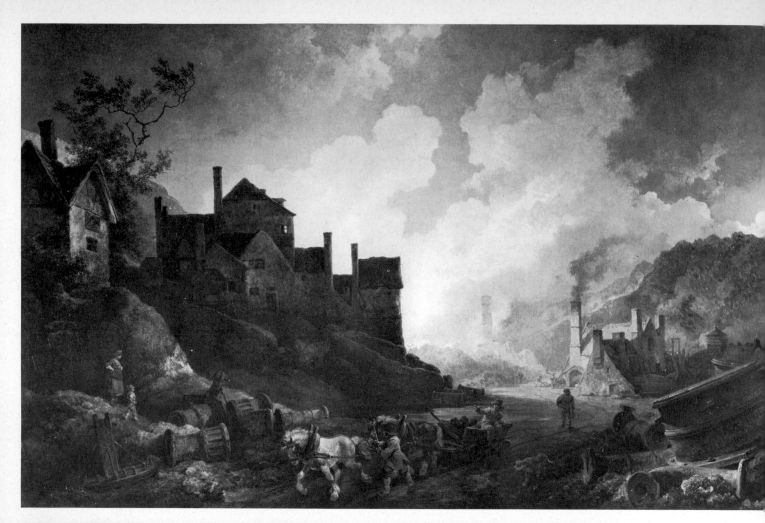

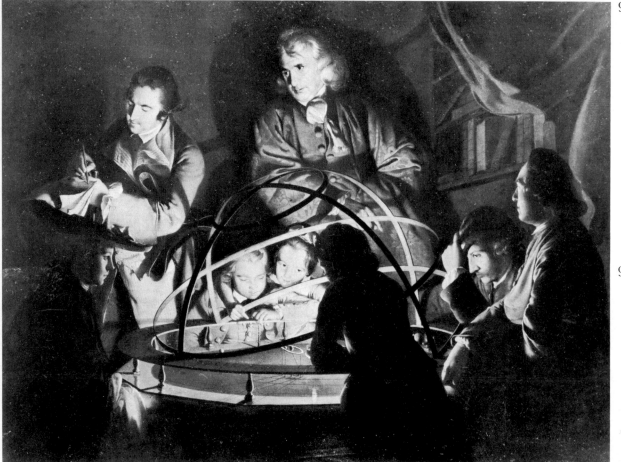

94 PHILIPPE JACQUES DE LOUTHERBOURG (1740–1812): *Coalbrookdale by night*. Signed and dated 1801. Canvas, $26\frac{3}{4} \times 42$ in. London, Science Museum

95 JOSEPH WRIGHT OF DERBY (1734–97): *A philosopher giving a lecture on the orrery*. Exhibited 1766. Canvas, 58×80 in. Derby, Museum and Art Gallery

96 JOSEPH WRIGHT OF DERBY (1734–97): *An iron forge*. Signed and dated 1772. Canvas, $56\frac{3}{4} \times 60\frac{3}{4}$ in.
 Collection of the Countess of Mountbatten of Burma

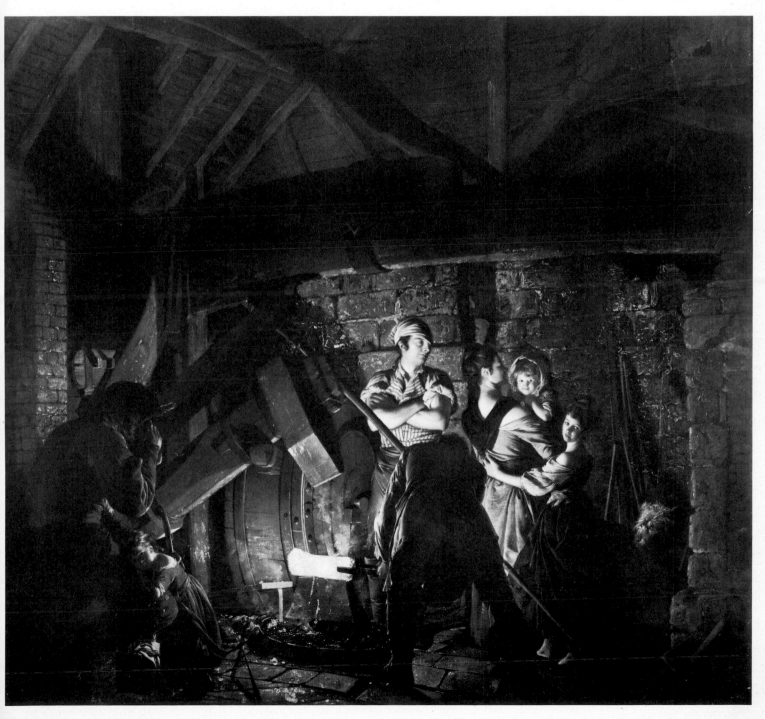

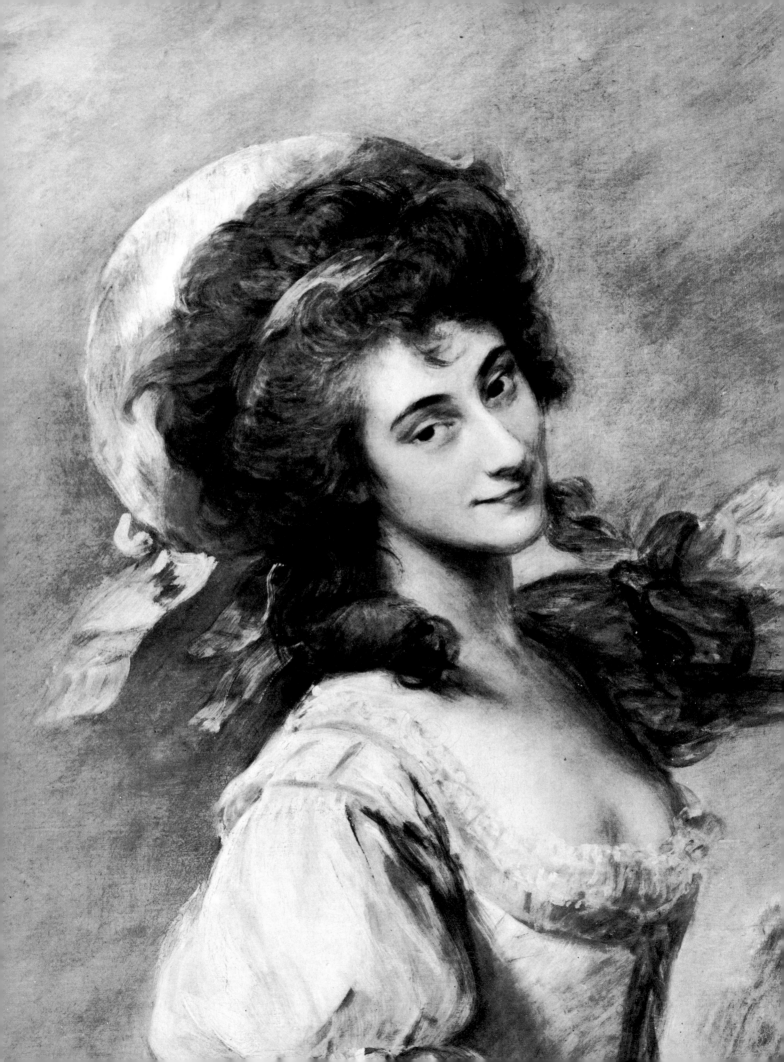

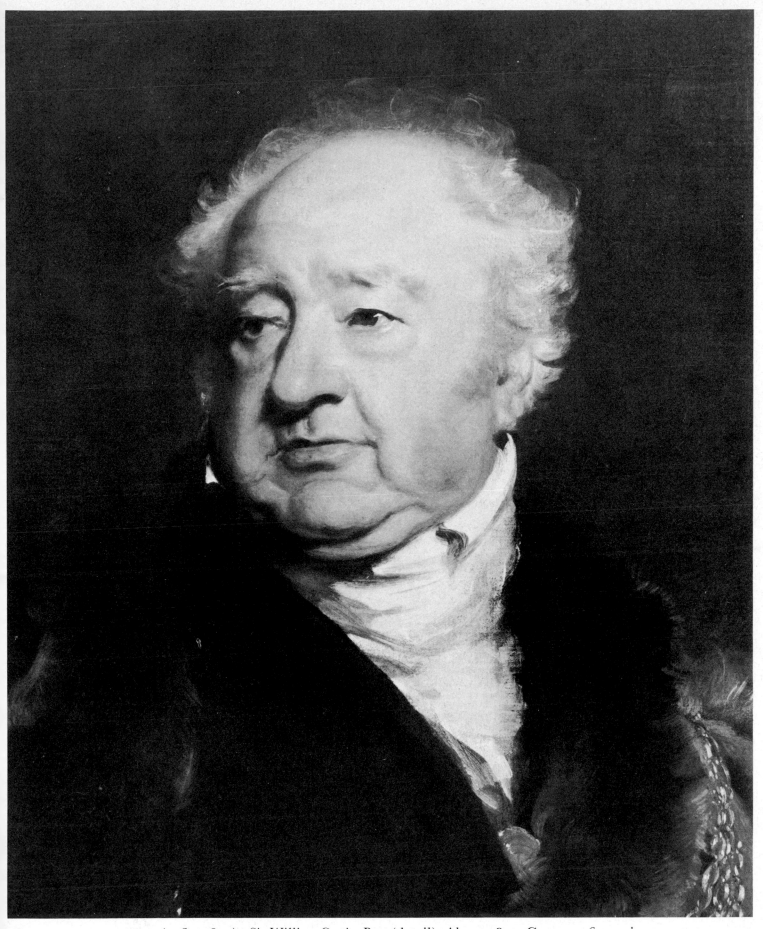

98 THOMAS LAWRENCE (1769–1830): *Sir William Curtis, Bart* (detail). About 1824. Canvas, 36 × 21 in.
Royal Collection

97 THOMAS GAINSBOROUGH: *Madame Baccelli* (detail of Plate 100)

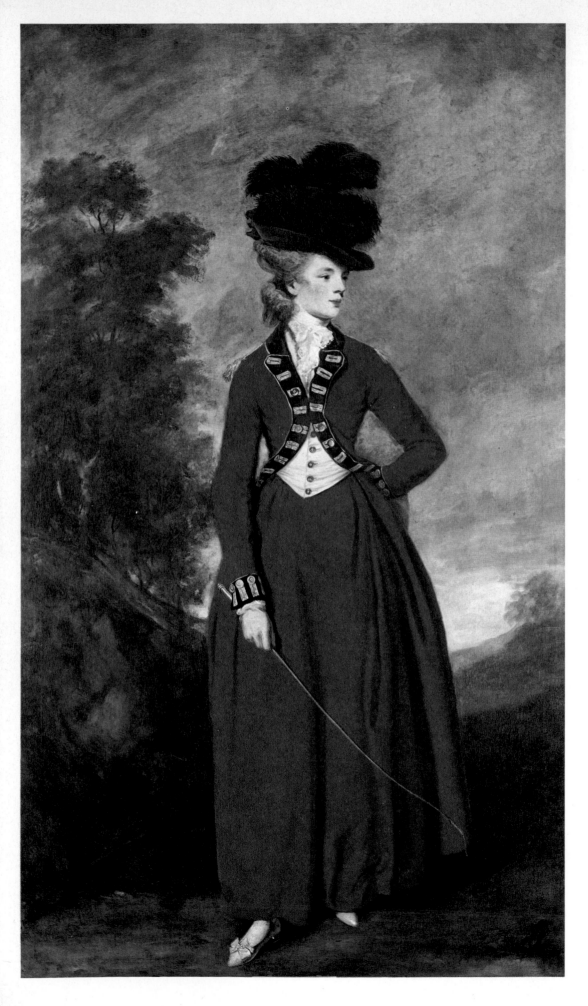

99 JOSHUA REYNOLDS
(1723–92): *Lady Worsley*.
Exhibited 1780. Canvas,
93 × 56¾ in. Yorkshire,
Harewood House, Earl
of Harewood

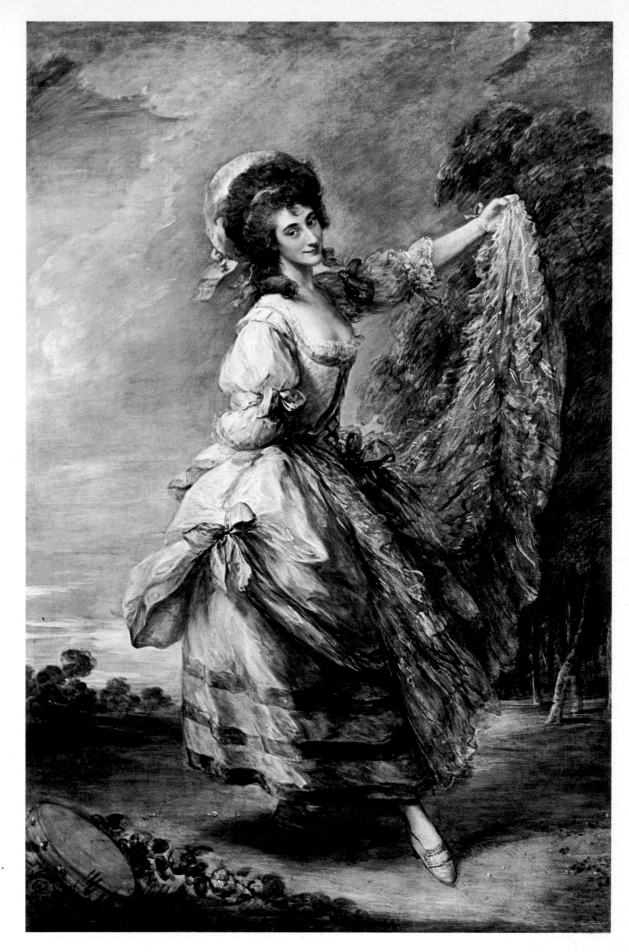

100 THOMAS
GAINSBOROUGH
(1727–88):
Madame Baccelli.
1782. Canvas,
$88\frac{1}{2} \times 57$ in.
London, Tate
Gallery

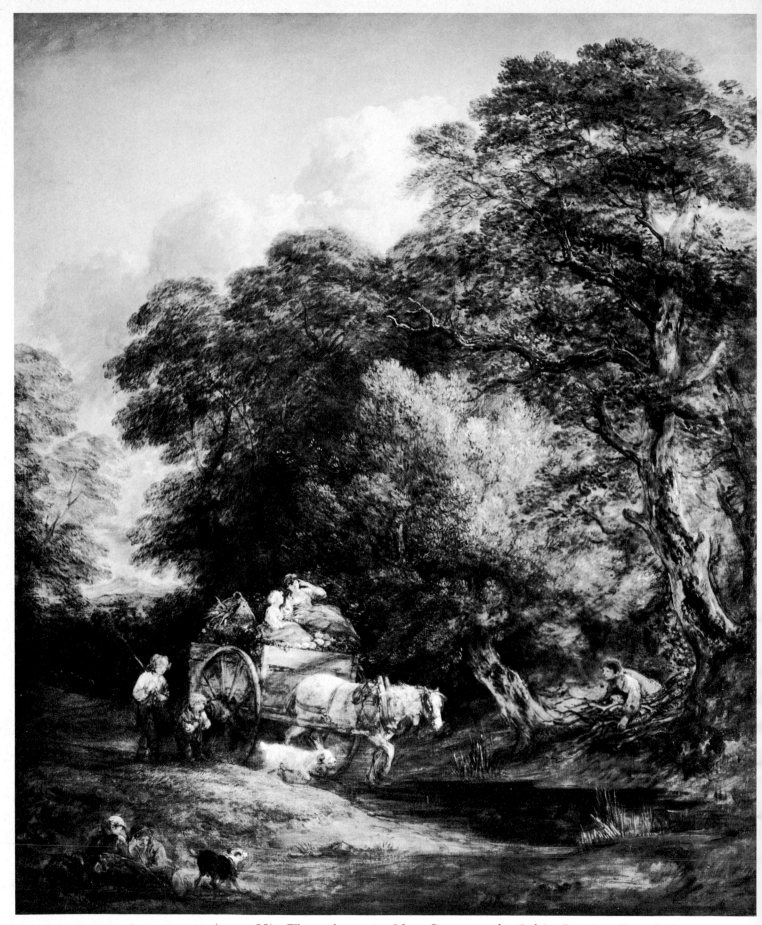

101 THOMAS GAINSBOROUGH (1727–88): *The market cart.* 1786–7. Canvas, $72\frac{1}{2} \times 60\frac{1}{4}$ in. London, Tate Gallery

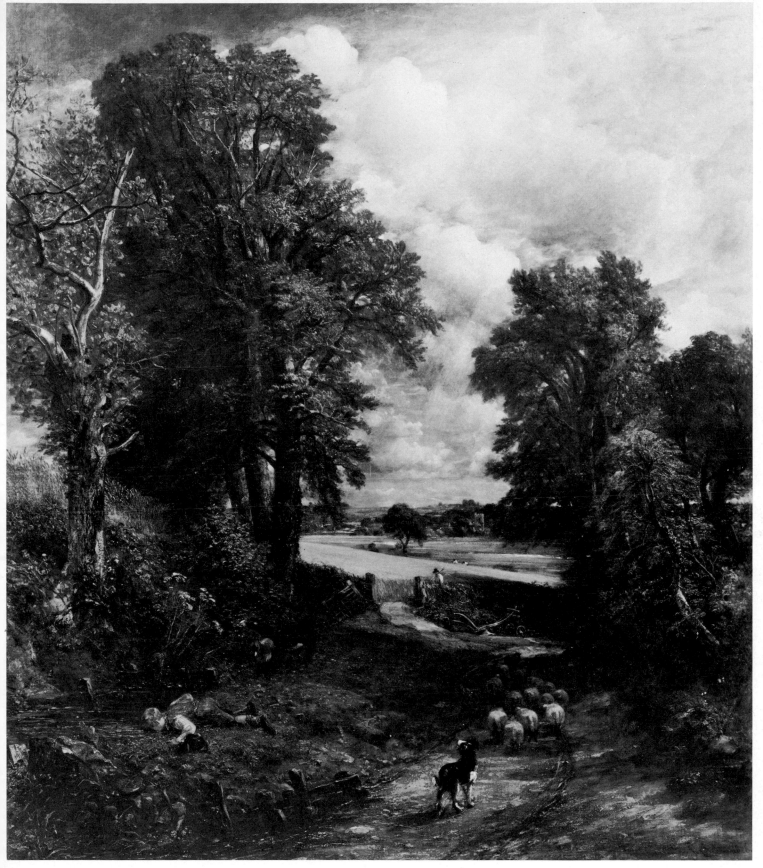

102 JOHN CONSTABLE (1776–1837): *The cornfield*. Signed and dated 1826. Canvas, $56\frac{1}{4} \times 48$ in. London, National Gallery

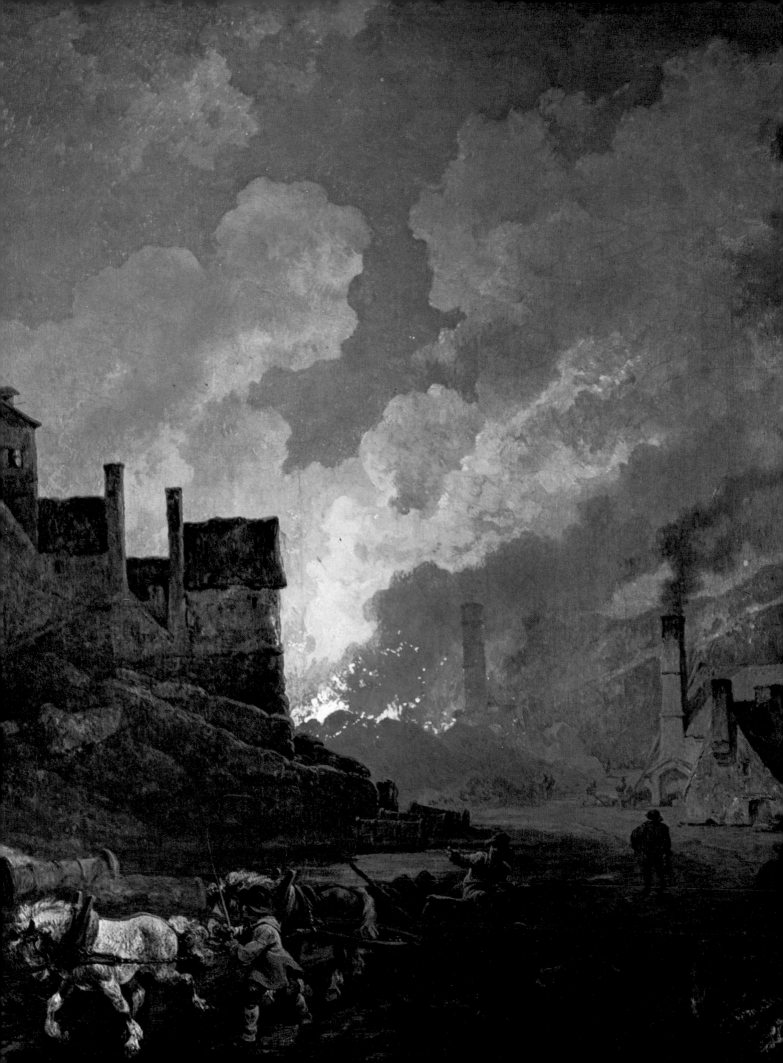

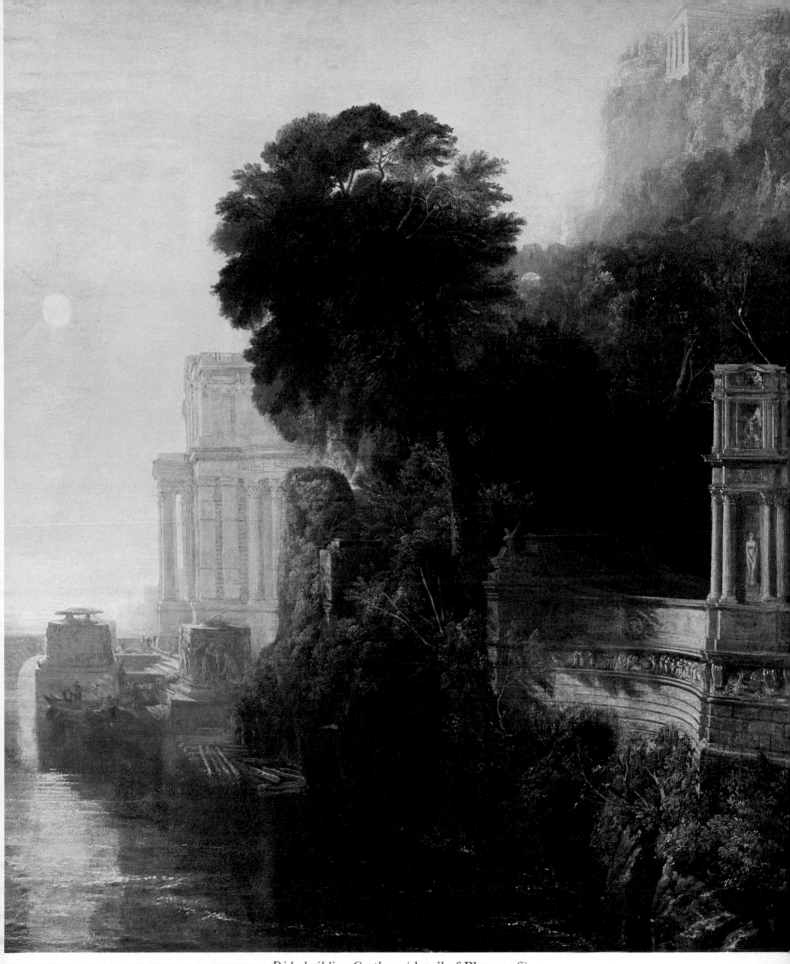

104 JOSEPH MALLORD WILLIAM TURNER: *Dido building Carthage* (detail of Plate 106)

103 PHILIPPE JACQUES DE LOUTHERBOURG: *Coalbrookdale by night* (detail of Plate 94)

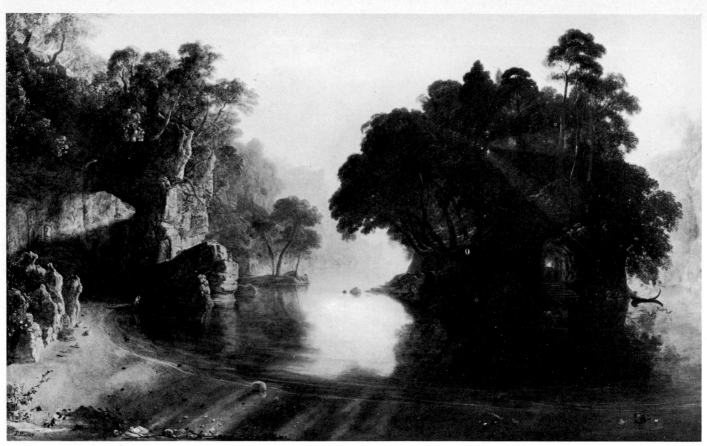

105 FRANCIS DANBY (about 1793–1861): *An enchanted island.* 1824–5. Canvas, 36 × 58 in. Private Collection

106 JOSEPH MALLORD WILLIAM TURNER (1775–1851): *Dido building Carthage, or the rise of the Carthaginian empire.* Signed and dated 1815. Canvas, 61¼ × 91¼ in. London, National Gallery

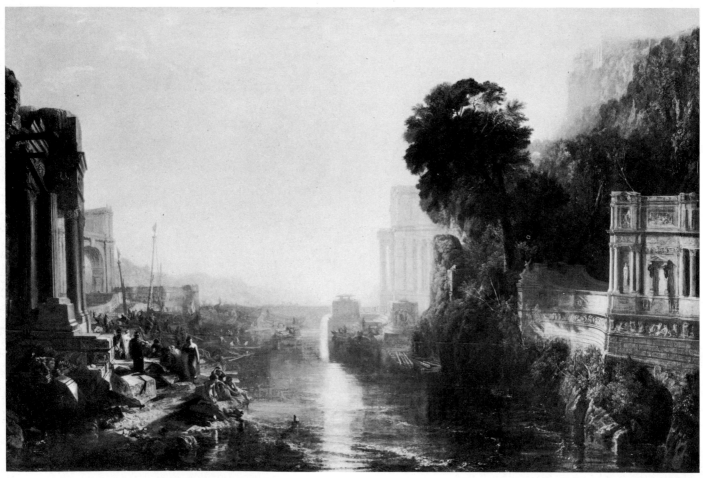

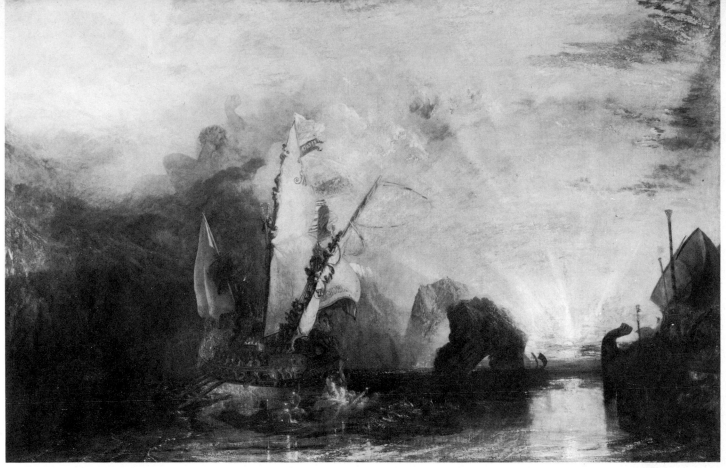

107 JOSEPH MALLORD WILLIAM TURNER (1775–1851): *Ulysses deriding Polyphemus*. 1829. Canvas, 52¼ × 80 in. London, National Gallery

108 JOHN MARTIN (1789–1854): *Belshazzar's feast*. Signed and dated 1820. Canvas, 63 × 98 in. Collection of Mrs Ruth F. Wright

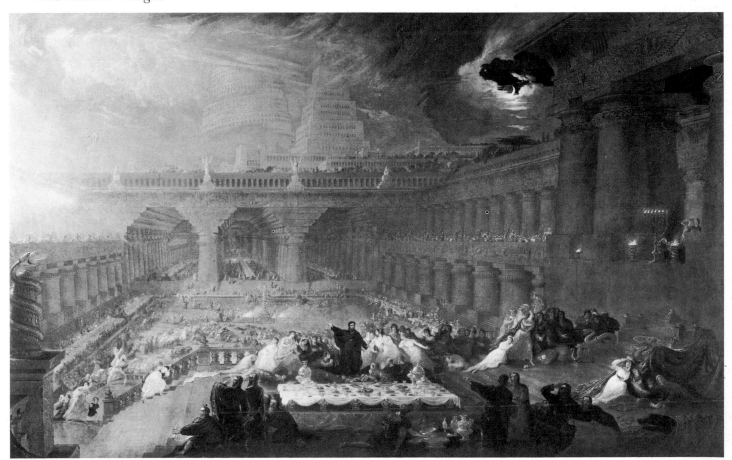

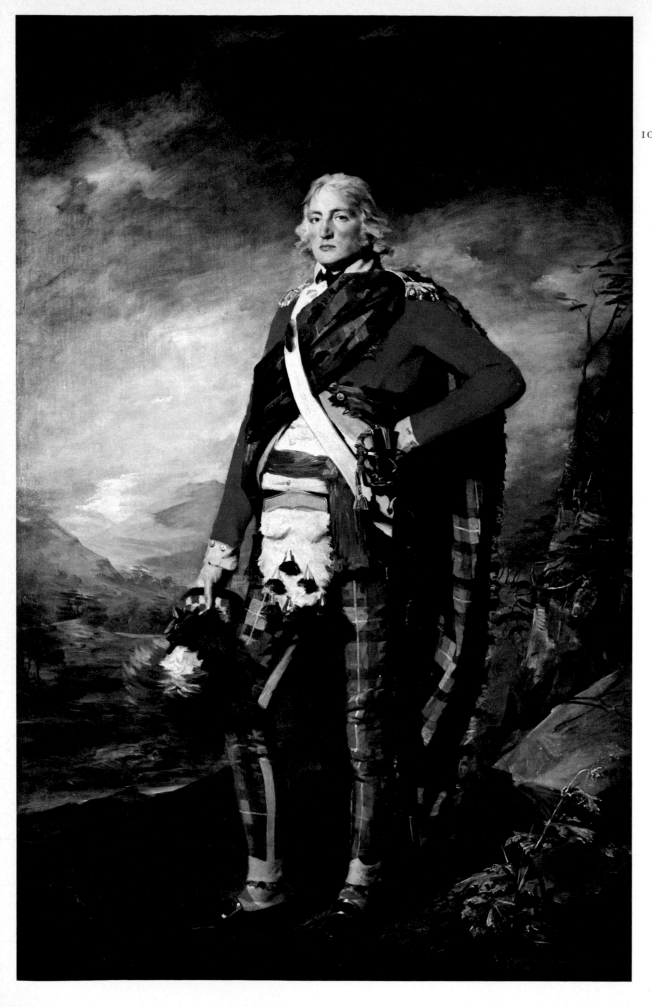

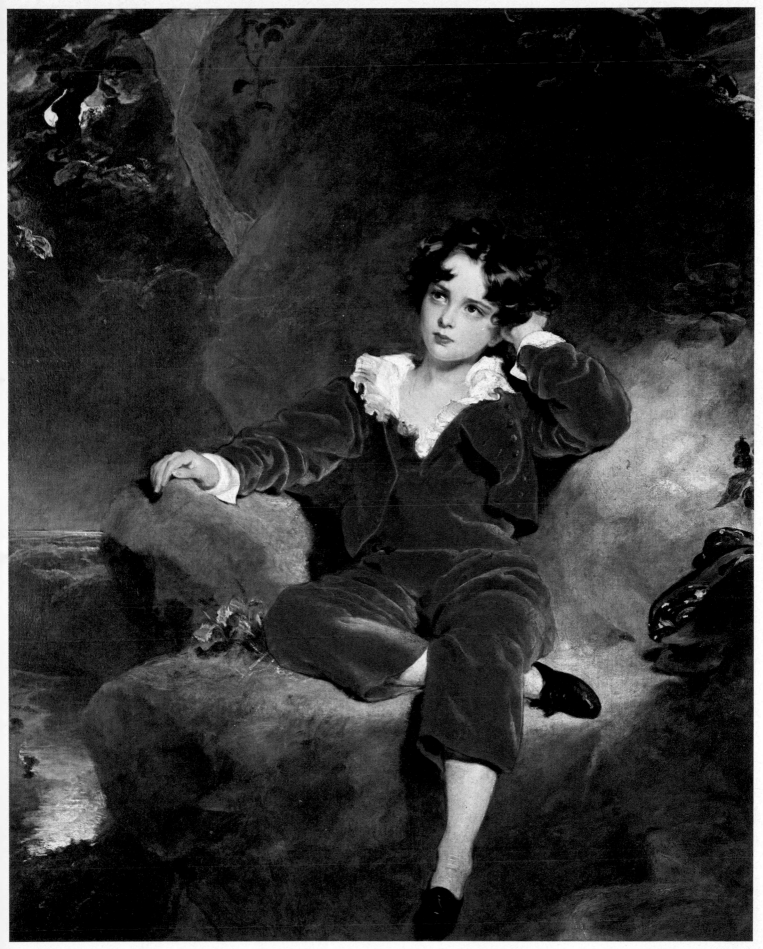

110 THOMAS LAWRENCE (1769–1830): *The son of J. G. Lambton, Esq.* Exhibited 1825. Canvas, $54\frac{1}{2} \times 43\frac{1}{2}$ in. Collection of Lord Lambton

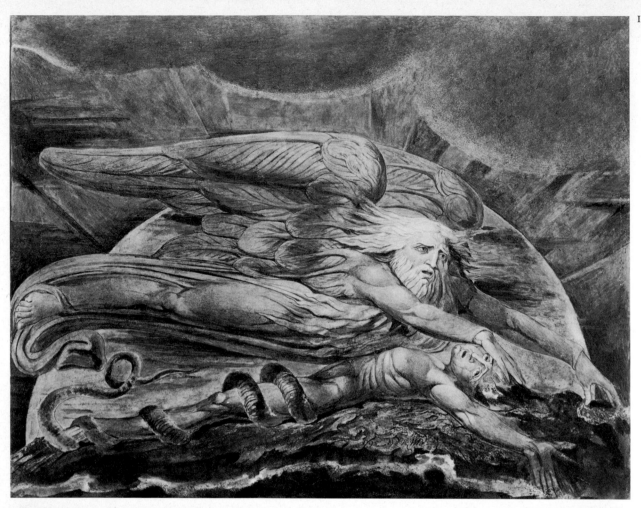

111 WILLIAM
BLAKE (1757–
1827): *Elohim
creating Adam.*
Signed and
dated 1795.
Colour print
finished in
pen and
watercolour,
17 × 21 in.
London,
Tate Gallery

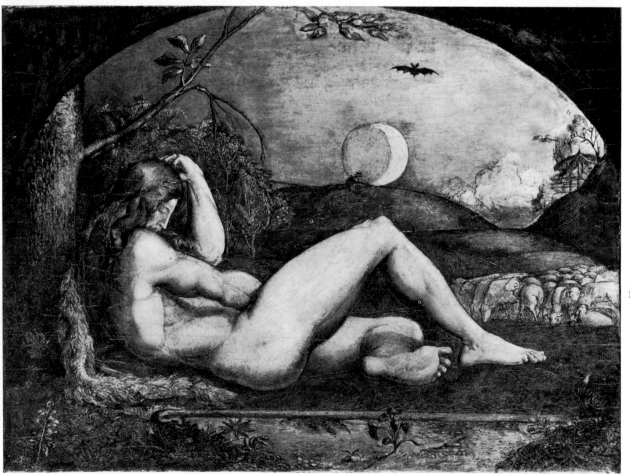

112 GEORGE
RICHMOND
(1809–96):
*Abel the
shepherd.*
Signed and
dated 1825.
Tempera on
panel,
9 × 12 in.
London,
Tate Gallery

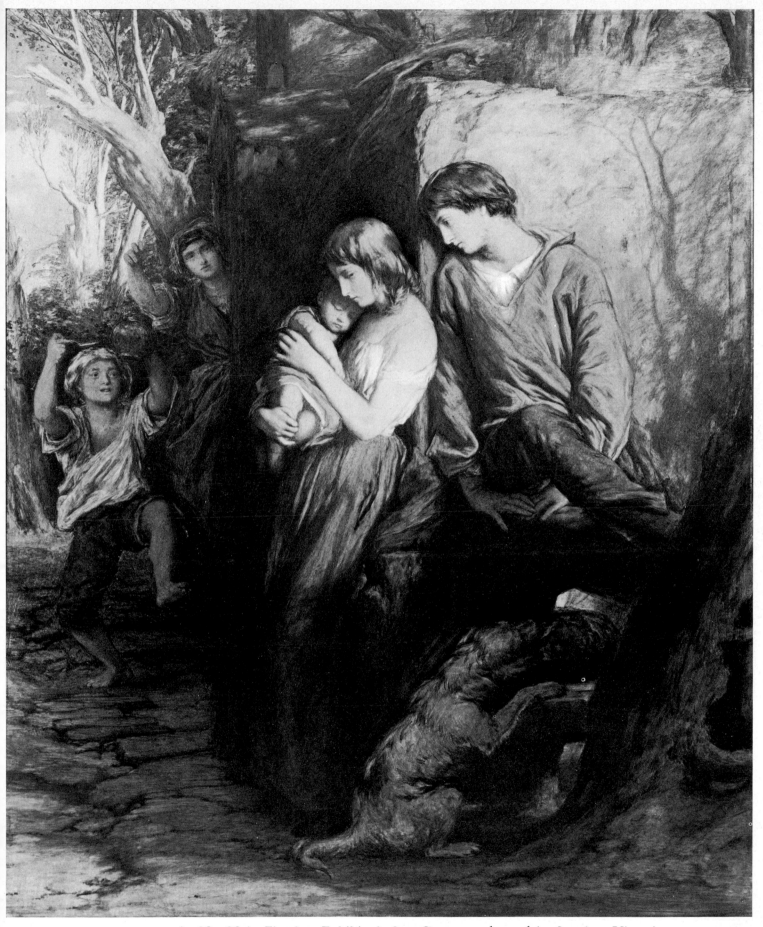

113 WILLIAM MULREADY (1786–1863): *First love*. Exhibited 1840. Canvas, 30½ × 24½ in. London, Victoria and Albert Museum

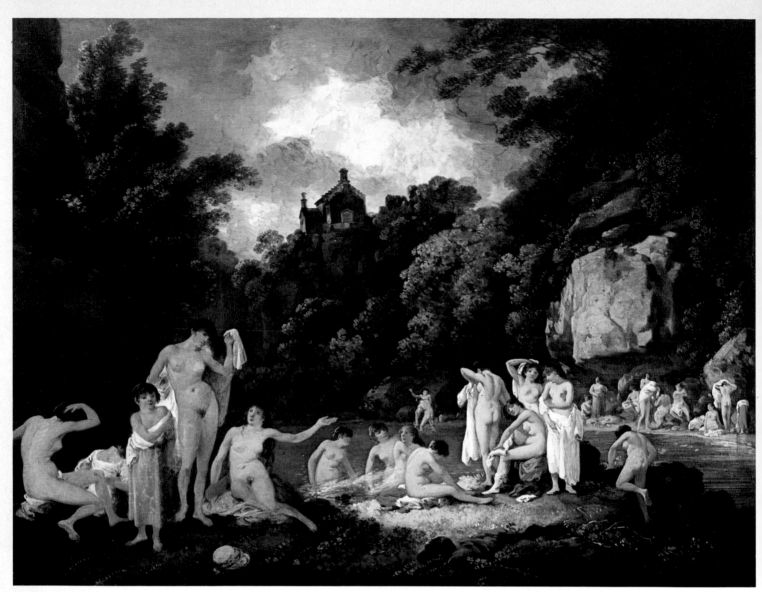

114 JULIUS CAESAR IBBETSON (1759–1817): *The mermaids' haunt*. Signed and dated 1804. Panel,
14¾ × 19 in. London, Victoria and Albert Museum

115 SAMUEL PALMER (1805–81): *Hilly scene*. About 1826–8. Tempera, 8¼ × 5½ in. London, Tate Gallery

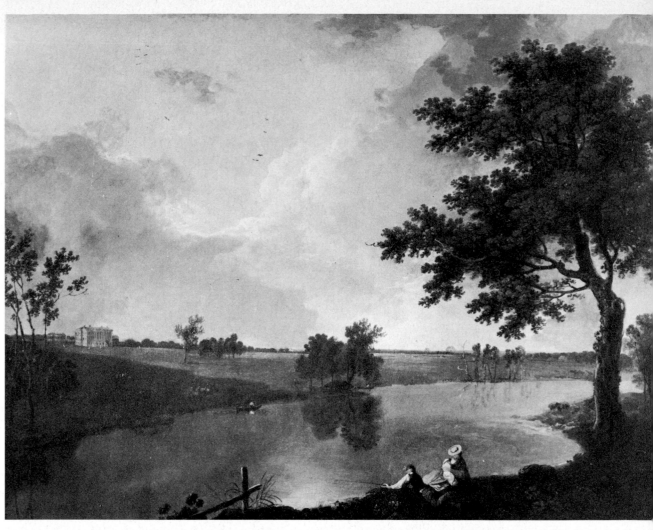

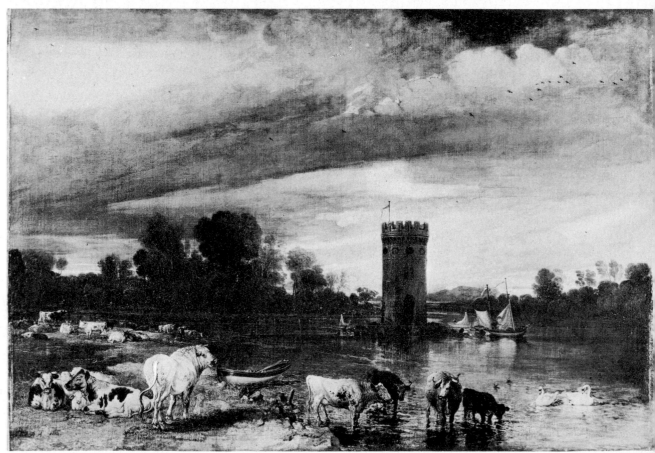

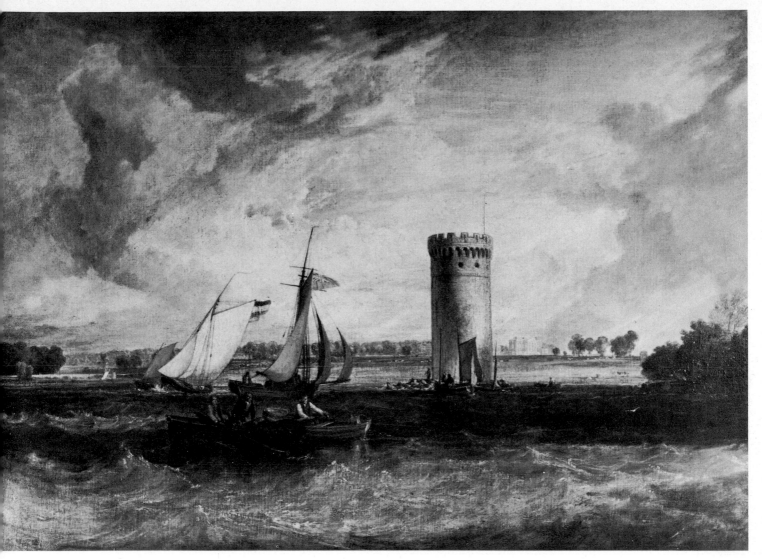

118 JOSEPH MALLORD WILLIAM TURNER (1775–1851): *Tabley Lake*. 1808–9. Canvas, 36 × 47½ in.
Collection of the executors of the estate of Lt Col. J. L. B. Leicester-Warren

116 RICHARD WILSON (1714–82): *Tabley House*. About 1774. Canvas, 39½ × 49½ in. Collection of Lord
Ashton of Hyde

117 JAMES WARD (1769–1859): *Tabley Lake*. Inscribed with cipher and dated 1814. Canvas, 37 × 53½ in.
London, Tate Gallery

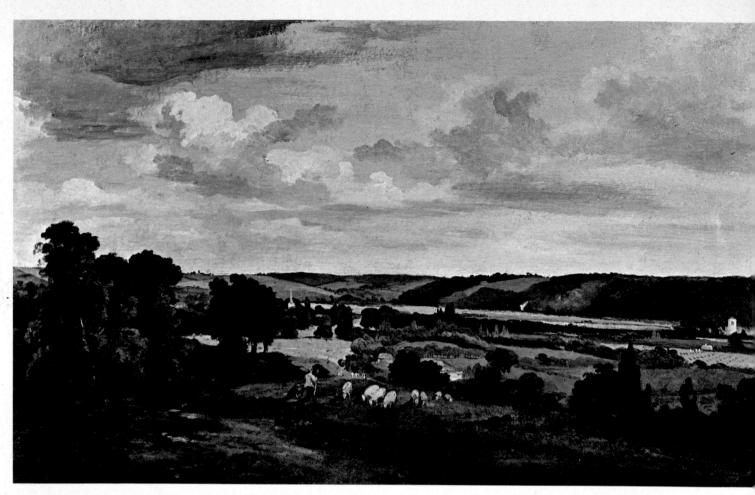

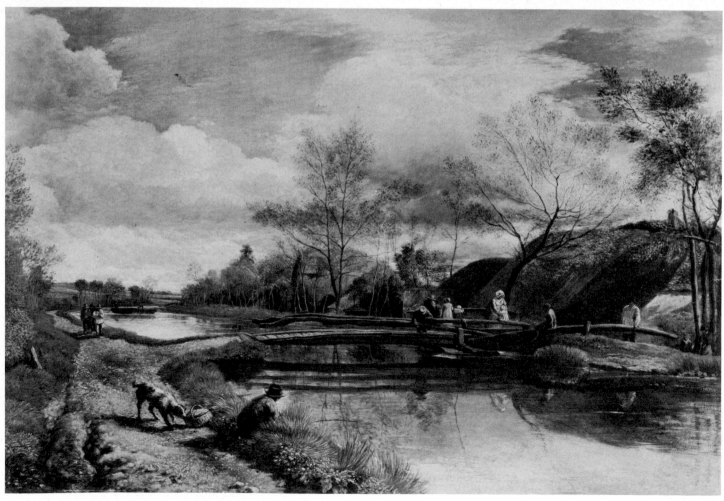

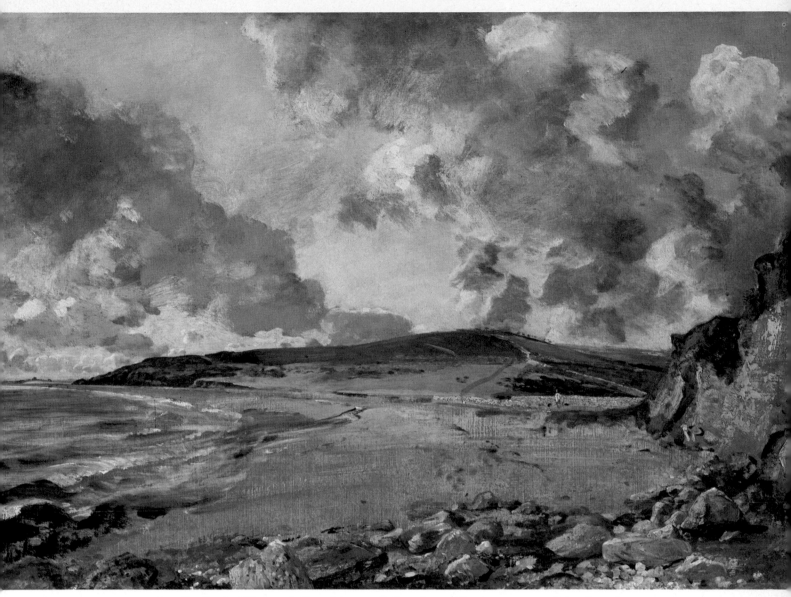

121 JOHN CONSTABLE (1776–1837): *Weymouth Bay*. About 1816 or later. Canvas, 21 × 29½ in. London, National Gallery

119 WILLIAM DELAMOTTE (1775–1863): *The Thames Valley between Marlow and Bisham*. Signed and dated on the verso 1806. Oil on board, 13¼ × 20 in. Collection of Mr Peter D. Jolly

120 JOHN LINNELL (1792–1882): *The river Kennet, near Newbury*. Signed and dated 1815. Oil on canvas laid down on panel, 17½ × 25½ in. Cambridge, Fitzwilliam Museum

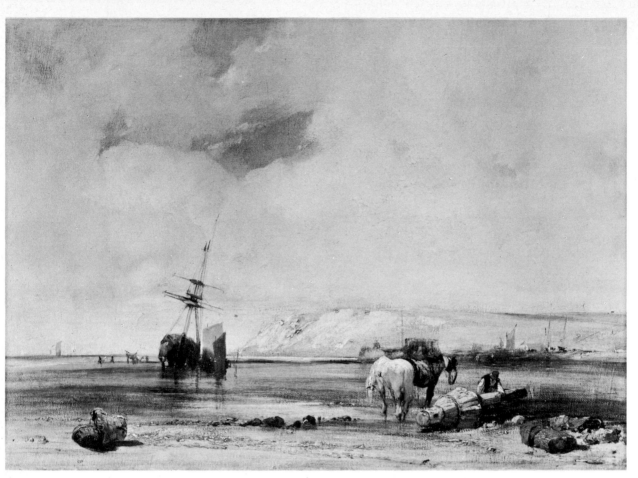

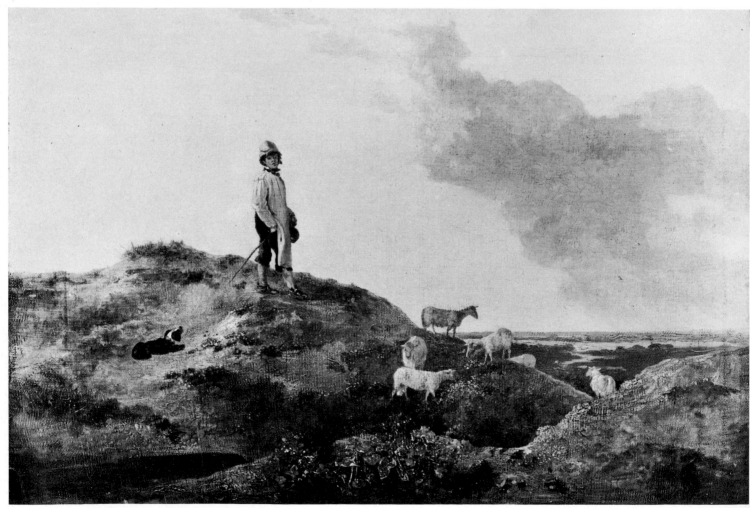

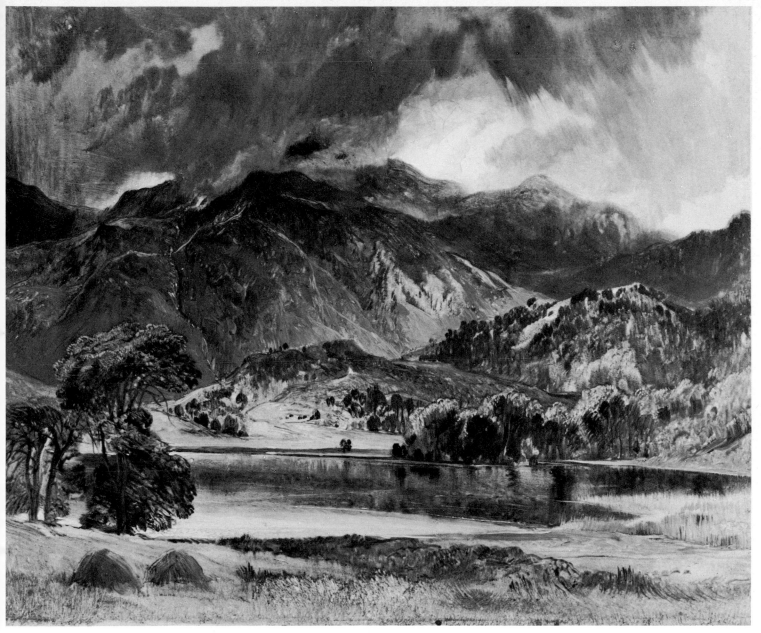

124 EDWIN HENRY LANDSEER (1802–73): *Landscape in the Lake District*. Before 1830. Oil on board, $9\frac{1}{4} \times 11$ in. Collection of Mrs Gilbert Russell

122 RICHARD PARKES BONINGTON (1802–28): *Coast of Picardy*. Canvas, 14×20 in. London, Wallace Collection

123 JOHN CROME (1768–1821): *On Mousehold Heath*. About 1812. Canvas, $21\frac{1}{4} \times 32$ in. London, Victoria and Albert Museum

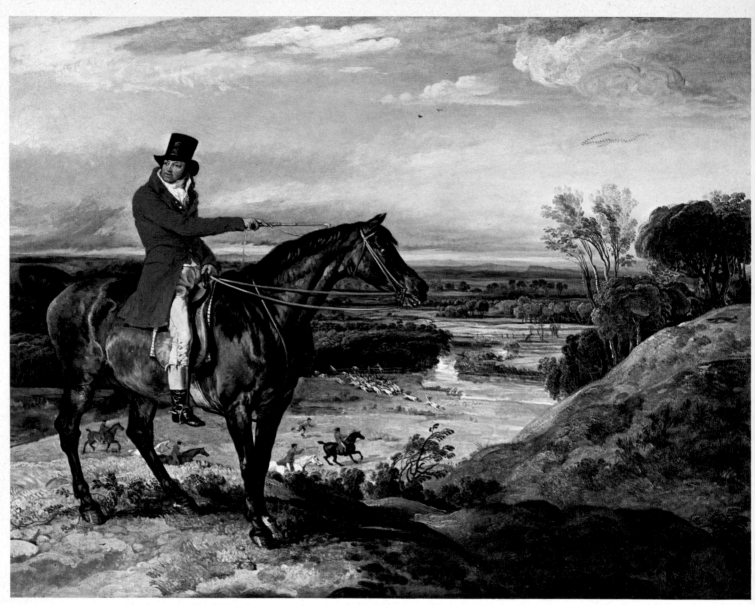

125 JAMES WARD (1769–1859): *John Levett out hunting in the park at Wychnor*. Signed and dated 1817. Canvas, 40 × 50 in. Private Collection

126 JOHN CONSTABLE (1776–1837): *The Vale of Dedham*. 1828. Canvas, $55\frac{1}{2}$ × 48 in. Edinburgh, National Gallery of Scotland

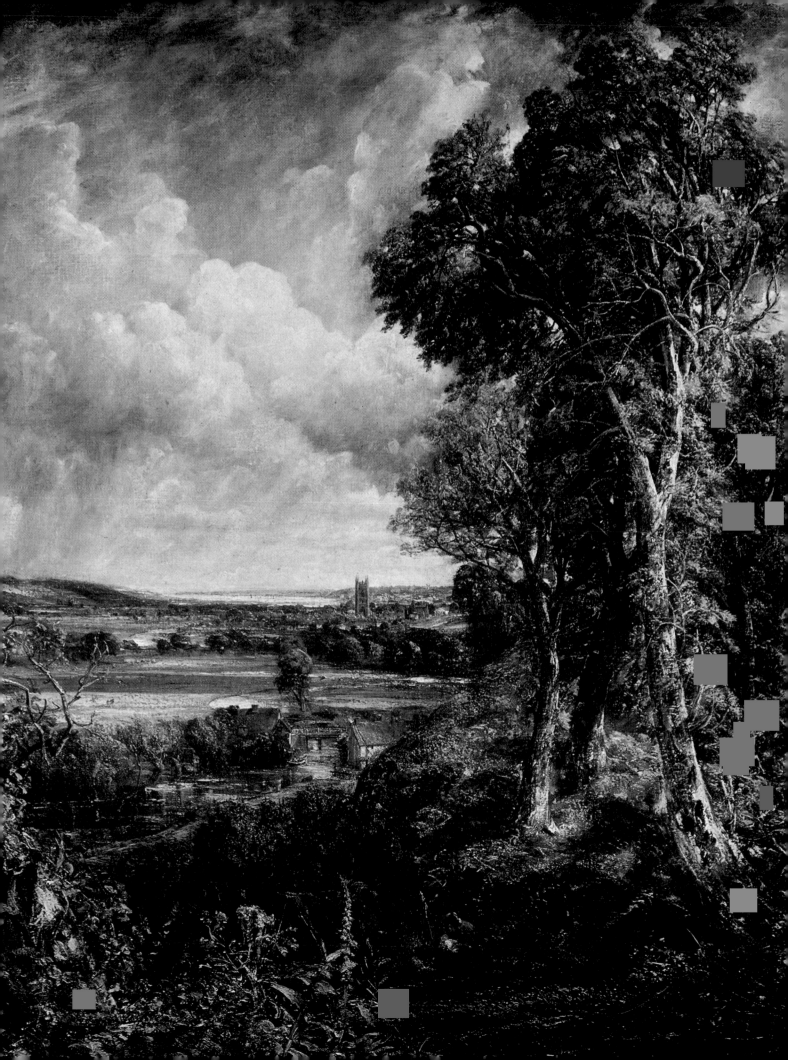

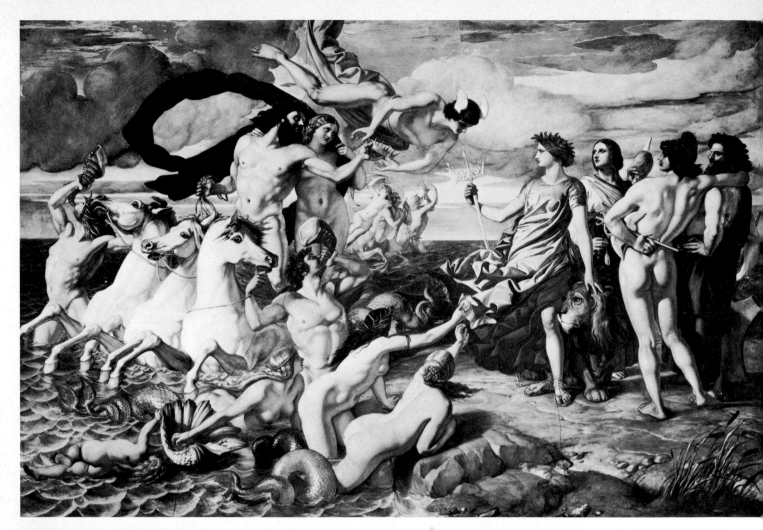

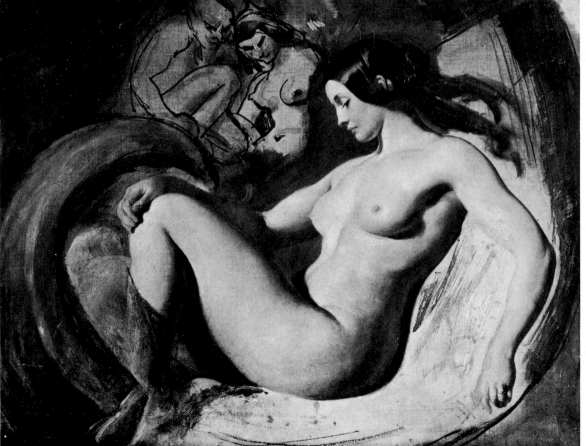

127 WILLIAM DYCE
(1806–64):
*Neptune resigning
to Britannia the
Empire of the Sea.*
1847. Fresco,
approx. 120 × 204 in
Isle of Wight,
Osborne House

128 WILLIAM ETTY
(1787–1849):
Female nude (Leda).
About 1825–30.
Canvas, 16 × 20 in.
Collection of the
Earl of Sandwich

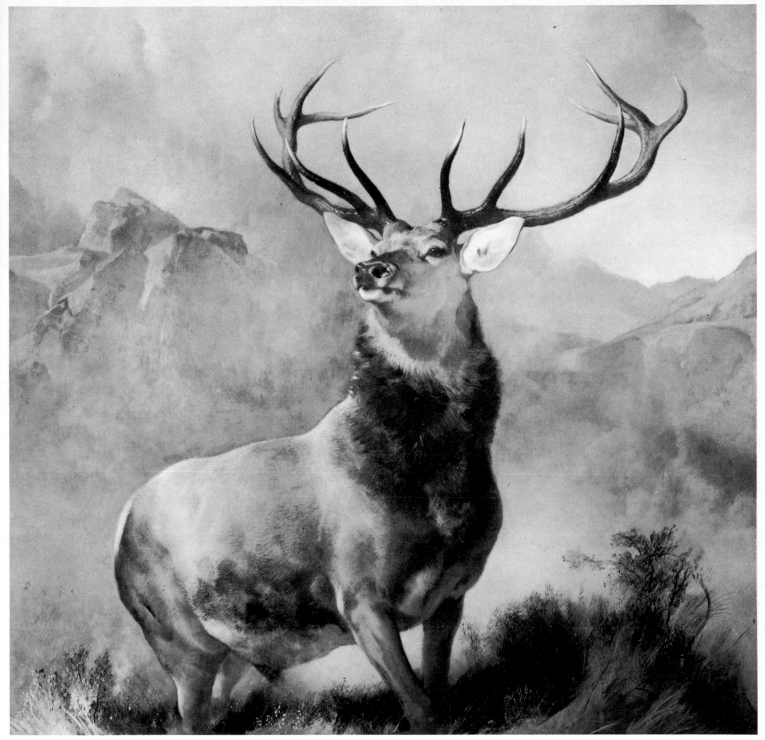

129 EDWIN HENRY LANDSEER (1802–73): *The Monarch of the Glen.* 1851. Canvas, 64½ × 66½ in. Collection of Messrs John Dewar and Sons Ltd

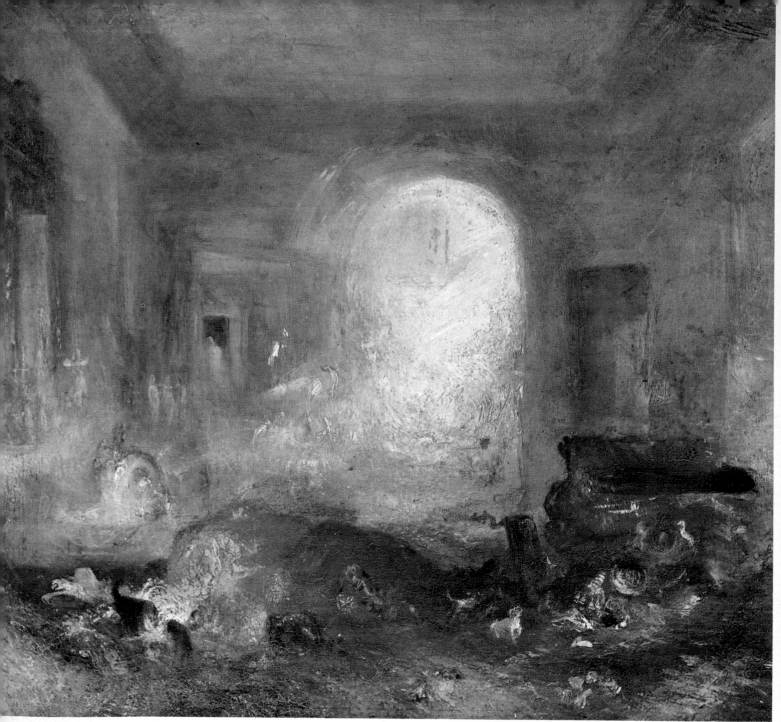

130 JOSEPH MALLORD WILLIAM TURNER (1775–1851): *Interior at Petworth* (detail). About 1837. Canvas, 35¾ × 48 in. London, Tate Gallery

131 SAMUEL COLMAN: *St James's Fair* (detail of Plate 135)

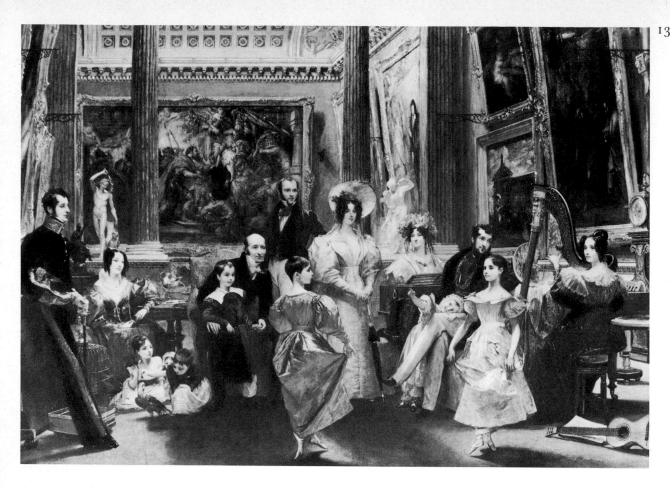

132 CHARLES
ROBERT
LESLIE
(1794–
1859): *The
Grosvenor
family.*
Exhibited 18
Canvas,
46 × 64 in.
Collection
of the
executors
of the
Duke of
Westmin-
ster's estate

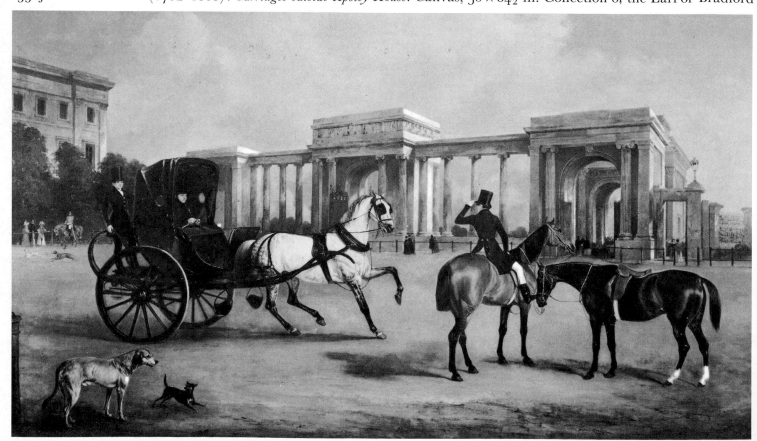

133 JOHN FERNELEY (1782–1860): *Carriages outside Apsley House.* Canvas, 50 × 84½ in. Collection of the Earl of Bradford

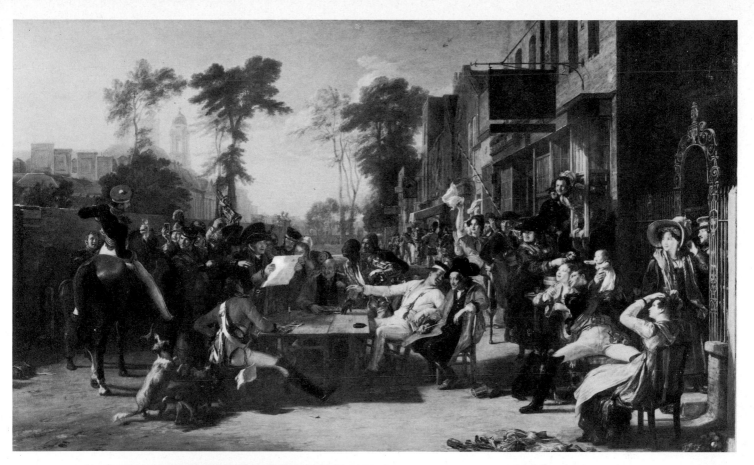

134 DAVID WILKIE (1785–1841): *Chelsea Pensioners receiving the London Gazette Extraordinary of Thursday June 22, 1815, announcing the Battle of Waterloo.* 1822. Canvas, 36 × 60 in. London, Apsley House (Wellington Museum)

135 SAMUEL COLMAN (working 1816–40): *St James's Fair, Bristol.* Signed and dated 1824. Canvas, $34\frac{1}{2} \times 52\frac{3}{4}$ in. Bristol, City Art Gallery

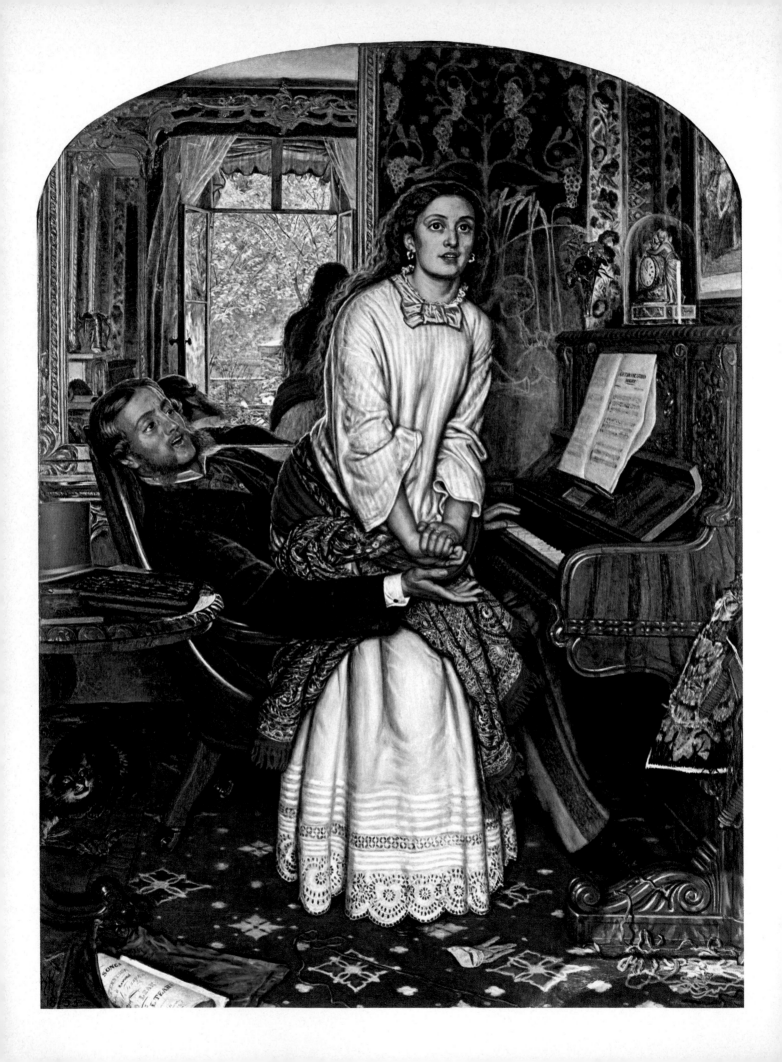

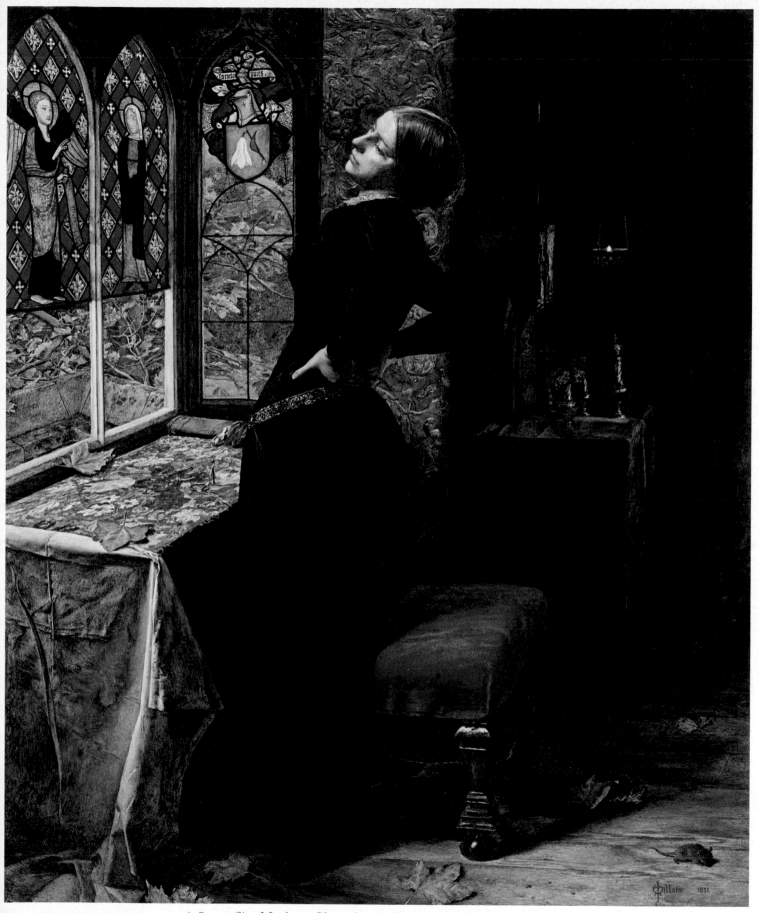

137 JOHN EVERETT MILLAIS (1829–96): *Mariana*. Signed and dated 1851. Panel, 23½ × 19½ in. Collection of Lord Sherfield

136 WILLIAM HOLMAN HUNT (1827–1910): *The awakening conscience*. Signed and dated 1853. Canvas, 29¾ × 21¾ in. Collection of the trustees of Sir Colin and Lady Anderson

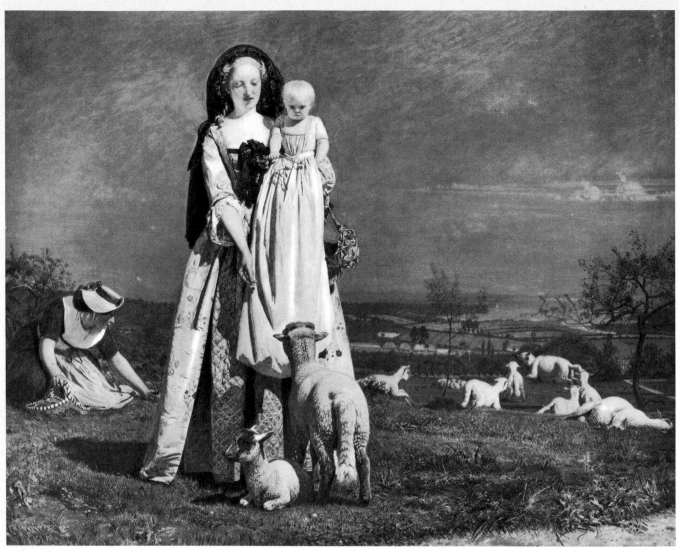

138 FORD MADOX BROWN (1821–93): *Pretty baa-lambs*. Signed and dated 1851–9. Panel, 24 × 30 in. Birmingham, City Museum and Art Gallery

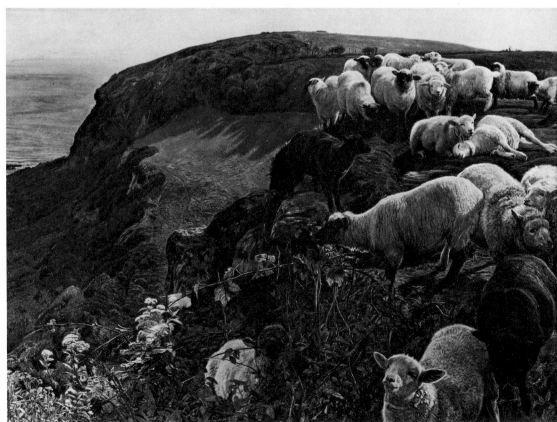

139 WILLIAM HOLMAN HUNT (1827–1910): *Our English coasts, 1852* ('Strayed Sheep'). Signed and dated 1852. Canvas, 17 × 23 in. London, Tate Gallery

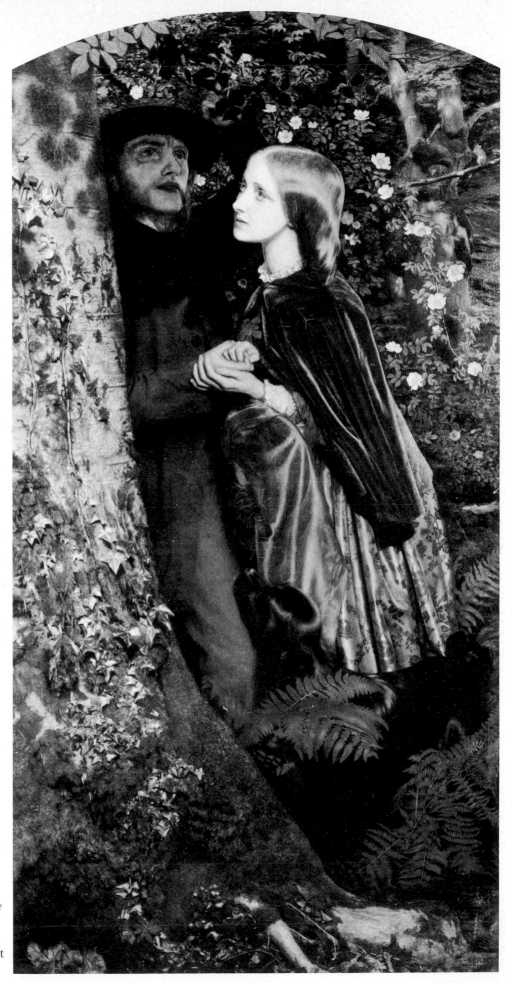

140 ARTHUR HUGHES (1832–1915): *The long engagement*. Signed and dated 1859. Canvas, $41\frac{1}{2} \times 20\frac{1}{2}$ in. Birmingham, City Museum and Art Gallery

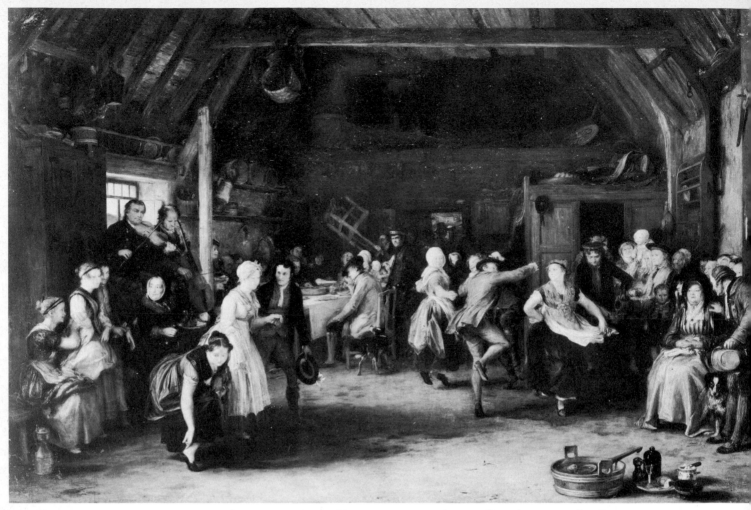

141 DAVID WILKIE (1785–1841): *The penny wedding*. Signed and dated 1818. Panel, 25 × 37 in. Royal Collection

142 & 143 WILLIAM POWELL FRITH (1819–1909): *Life at the seaside (Ramsgate Sands)*. 1851–4. Canvas, 30 × 60 in. Royal Collection

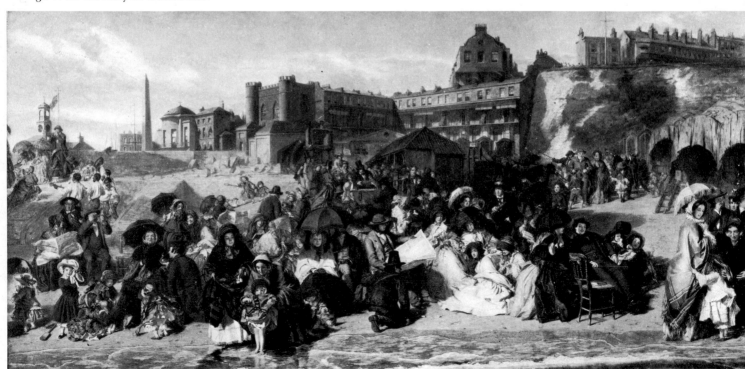

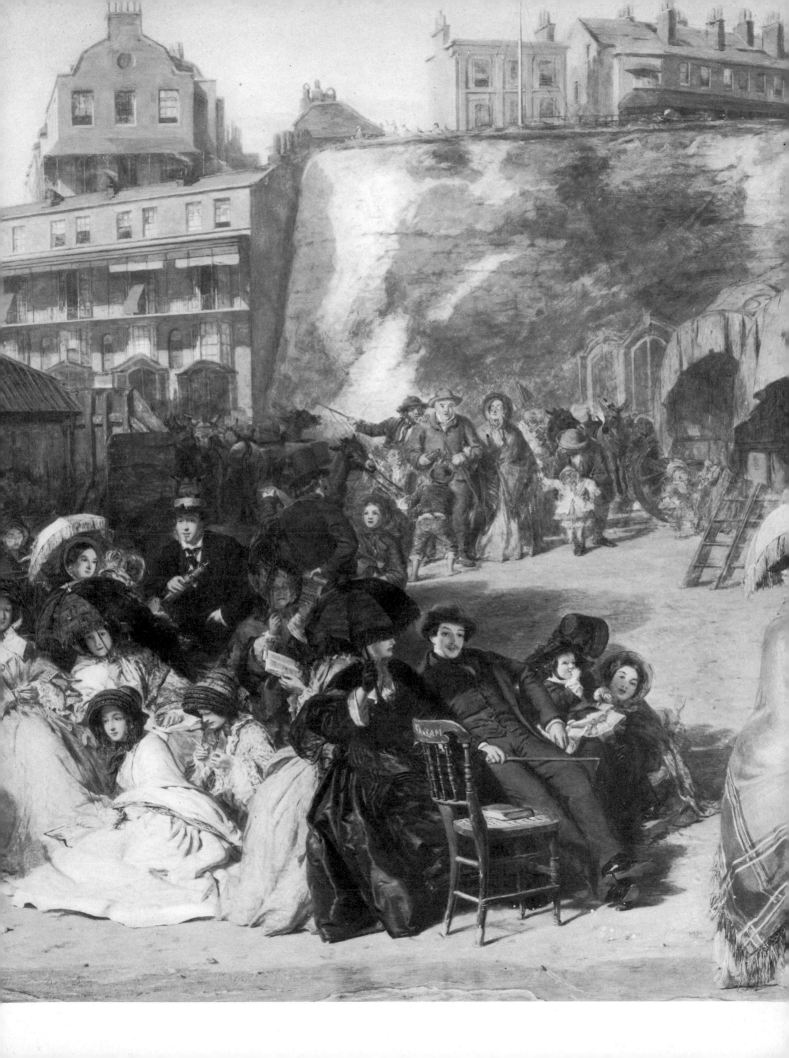

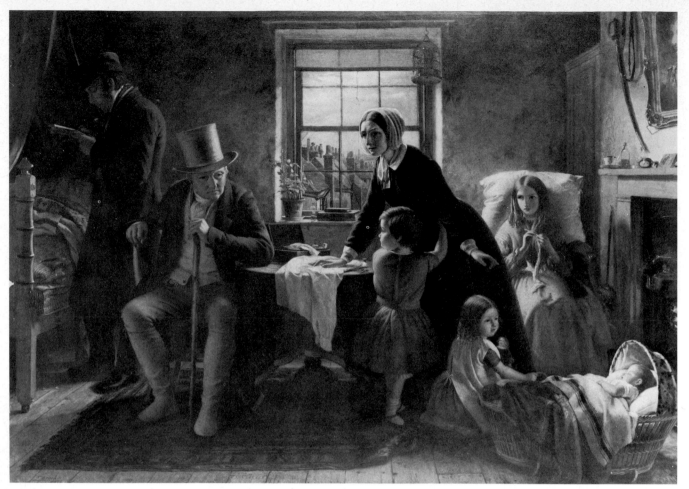

144 THOMAS BROOKS (1818–91): *Relenting*. Signed and dated 1855. Canvas, 34 × 46 in. Private Collection

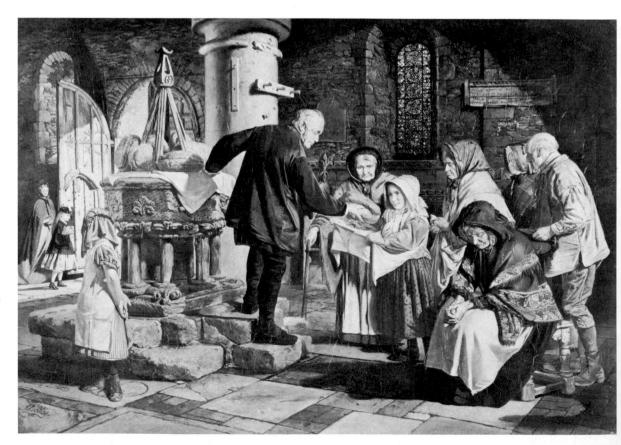

145 JAMES LOBLEY (1829–88): *The dole*. Exhibited 1867? Canvas, 19¾ × 28 in. Bradford, Cartwright Hall Art Gallery and Museum

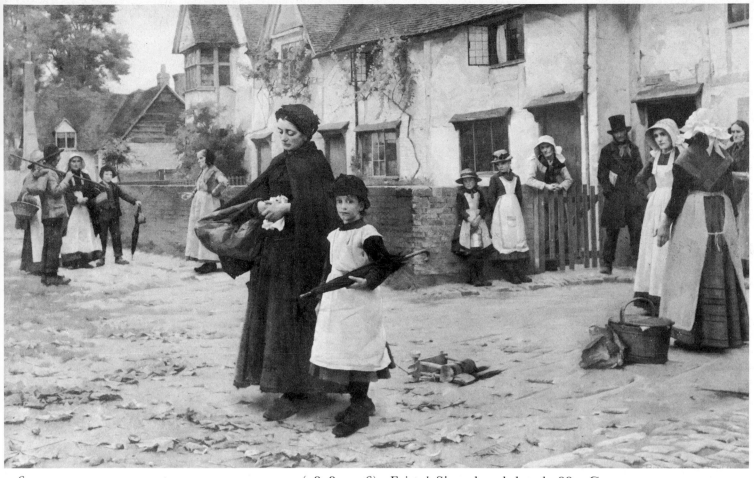

146 WILLIAM TEULON BLANDFORD FLETCHER (1858–1936): *Evicted*. Signed and dated 1887. Canvas,
50 × 72 in. Brisbane, Queensland Art Gallery

147 SAMUEL LUKE FILDES (1844–1927): *Applicants for admission to a casual ward*. Signed and dated 1874.
Canvas, 56 × 97½ in. London, Royal Holloway College

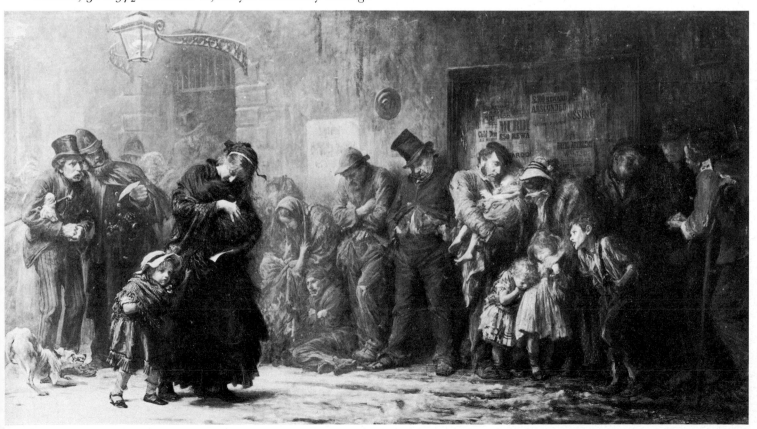

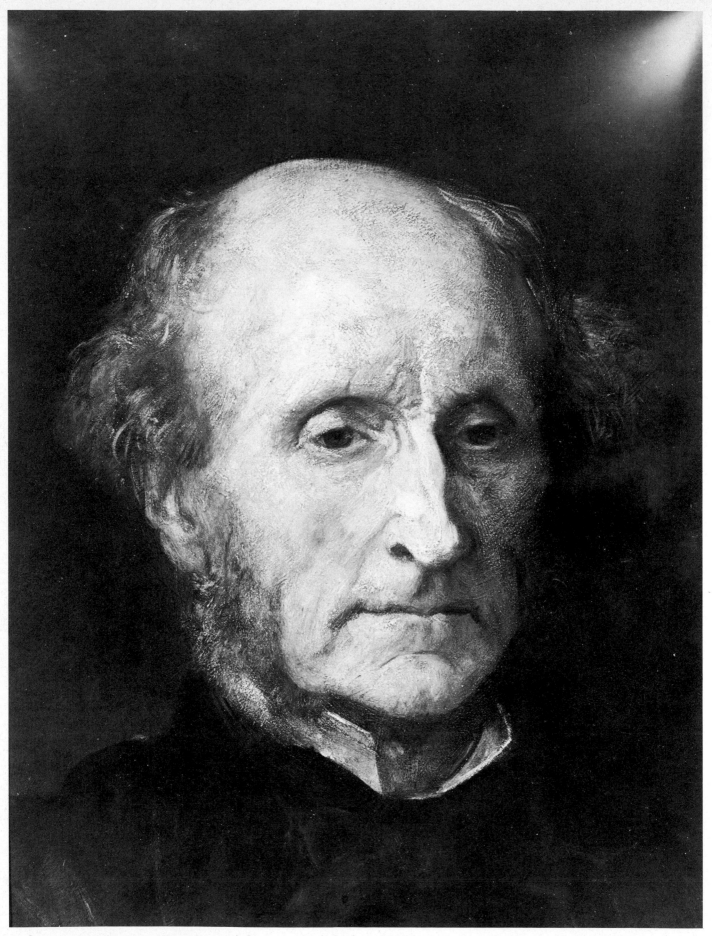

148 GEORGE FREDERICK WATTS (1817–1904): *John Stuart Mill*. 1873. Canvas, 26 × 21 in. London,
Westminster City Council

149 ALFRED STEVENS (1817–75): *Mrs Elizabeth Young Mitchell and her baby* (detail). 1851. Canvas,
25 × 30 in. London, Tate Gallery

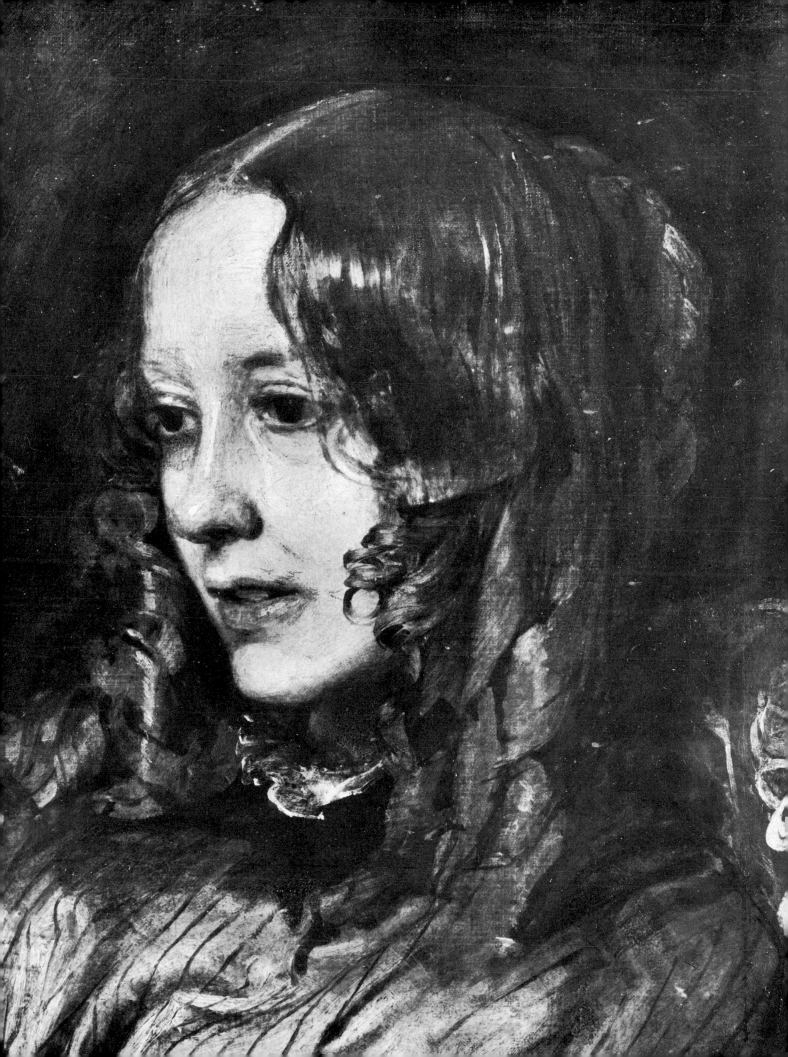

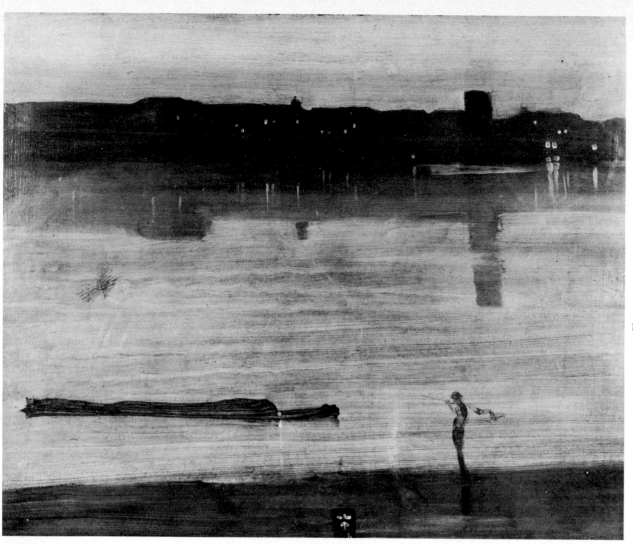

152 JACQUES
JOSEPH
TISSOT
(1836–190
*London
visitors.*
1874.
Canvas,
63 × 45 in.
Toledo,
Ohio,
Museum o
Art

150 JAMES
ABBOTT
MCNEILL
WHISTLER
(1834–
1903):
*Nocturne in
blue-green.*
Signed and
dated 1871.
Panel,
$19\frac{5}{8} \times 23\frac{7}{8}$ in.
London,
Tate Gallery

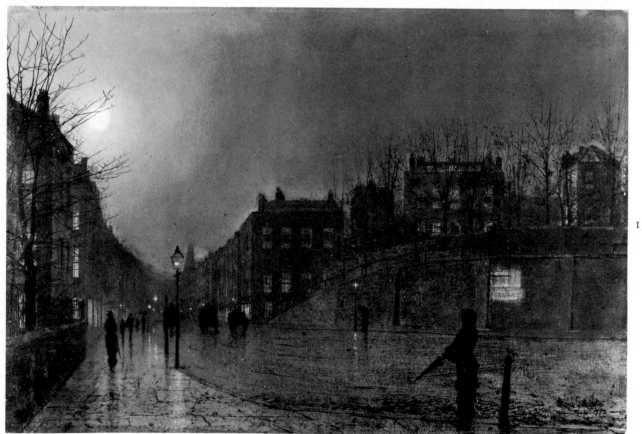

151 JOHN
ATKINSON
GRIMSHAW
(1836–93):
*View of
Heath Street,
Hampstead,
by night.*
Signed and
dated 1882.
Oil on panel,
$14\frac{1}{2} \times 20\frac{3}{4}$ in.
London,
Tate Gallery

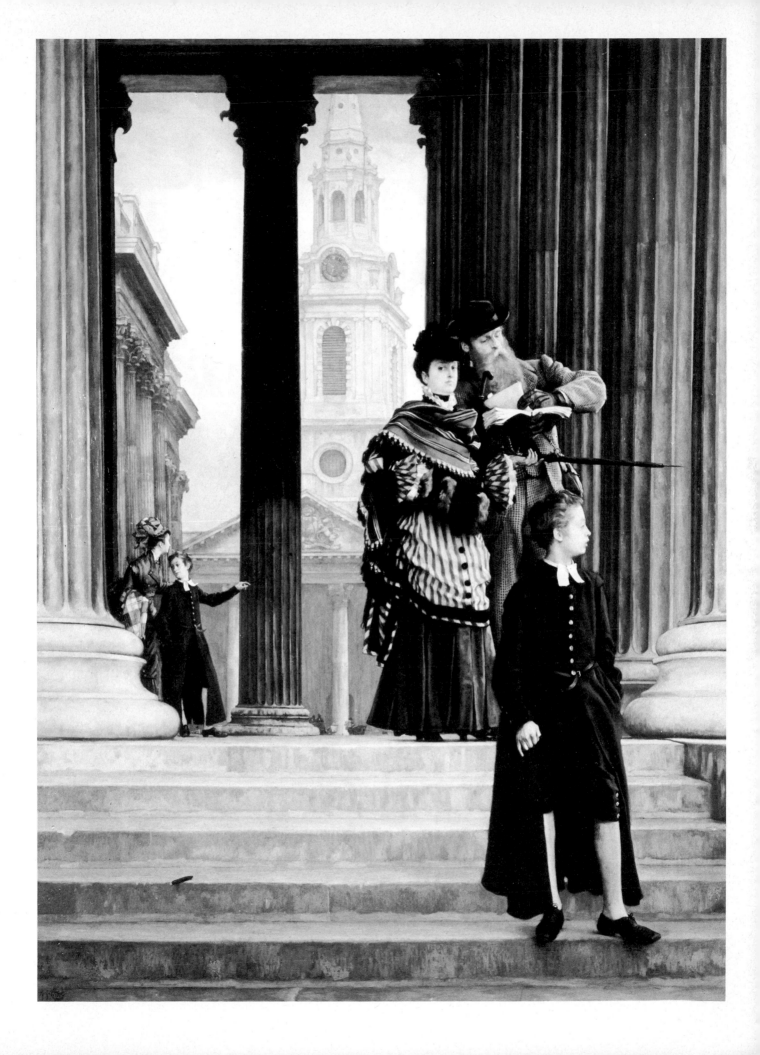

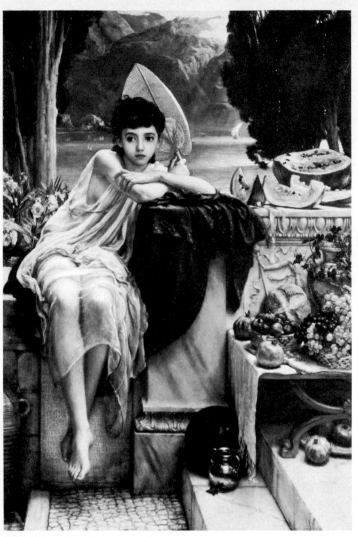

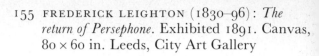

155 FREDERICK LEIGHTON (1830–96): *The return of Persephone*. Exhibited 1891. Canvas, 80 × 60 in. Leeds, City Art Gallery

153 EDWARD JOHN POYNTER (1836–1919): *On the temple steps*. Signed and dated 1889. Canvas, 30½ × 20½ in. Burnley, Towneley Hall Art Gallery and Museum

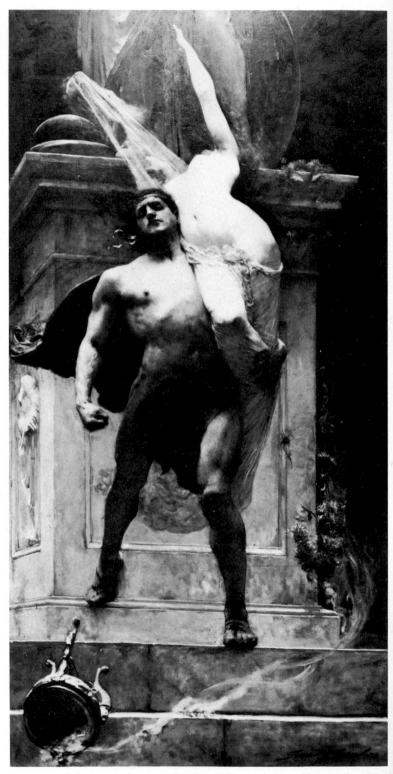

154 SOLOMON JOSEPH SOLOMON (1860–1927): *Ajax and Cassandra*. Signed and dated 1886. Canvas, approx. 132 × 60 in. Victoria, Ballarat Fine Art Gallery

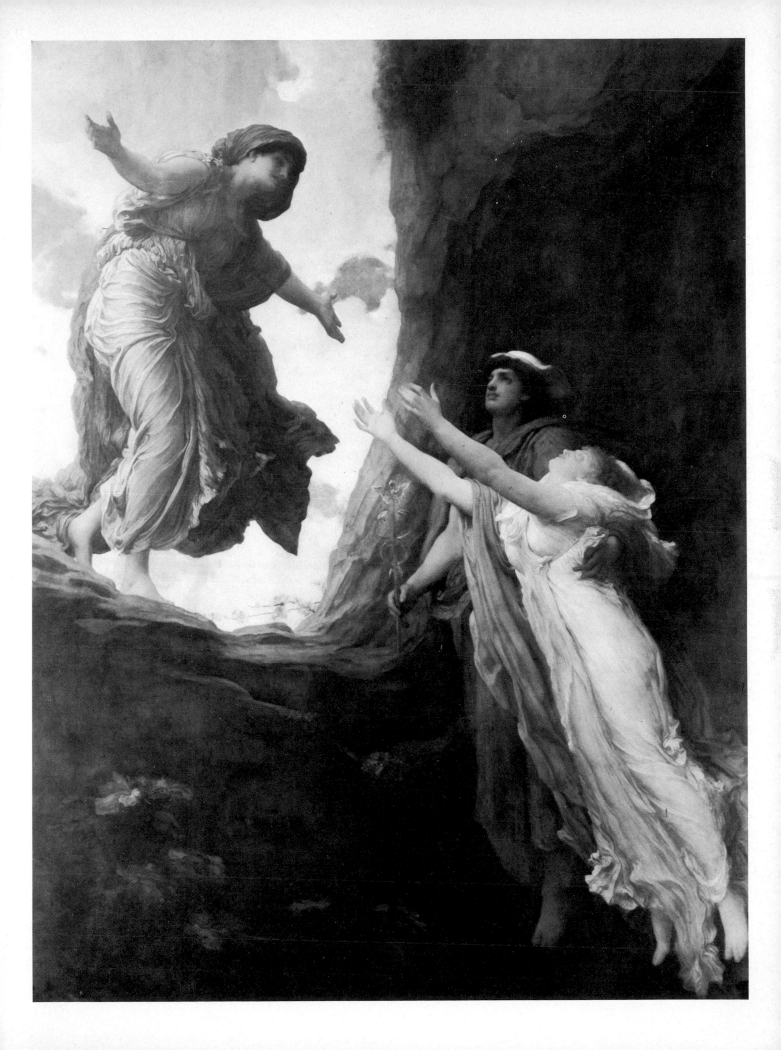

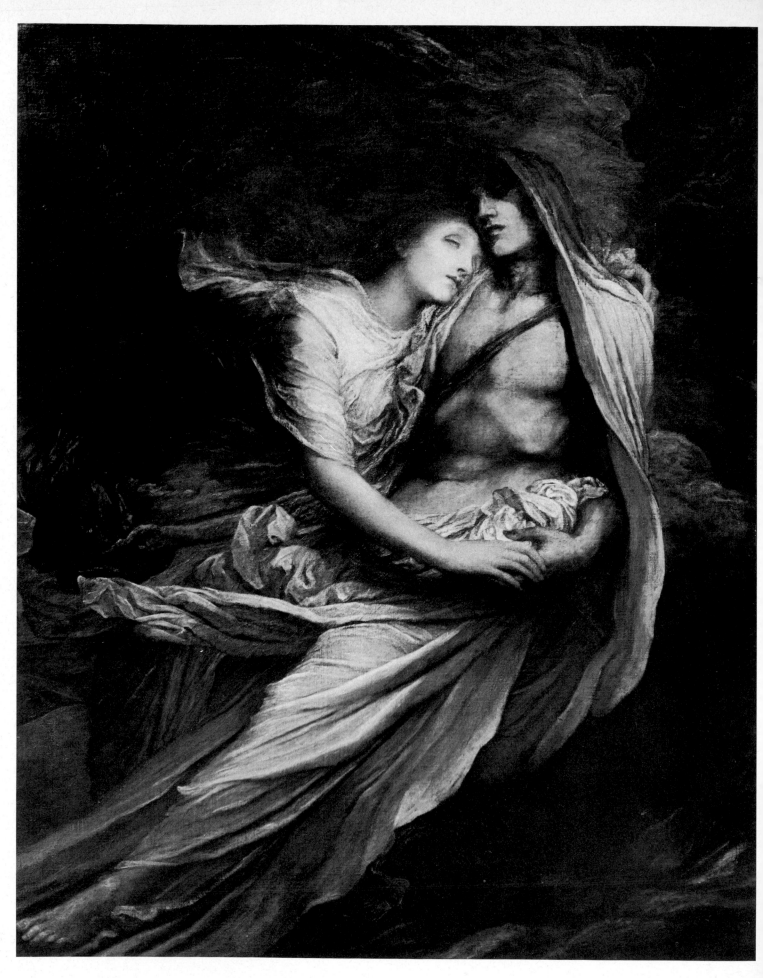

156 GEORGE FREDERICK WATTS (1817–1904): *Paolo and Francesca*. 1860s? Canvas, 60 × 51 in. Compton, Watts Gallery

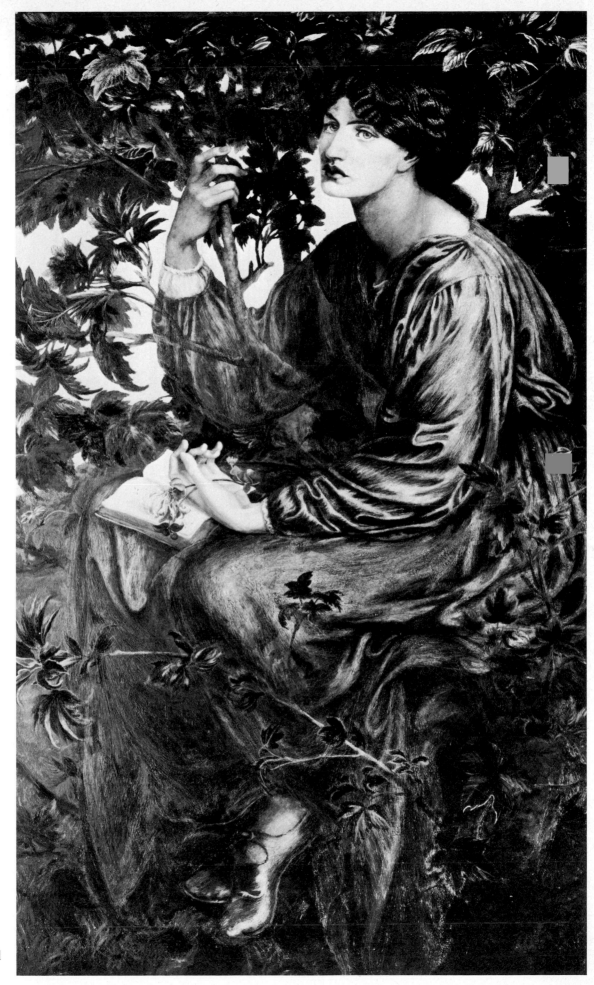

157 DANTE GABRIEL
ROSSETTI (1828–82):
The day dream. Signed
and dated 1880.
Canvas, 62½ × 36½ in.
London, Victoria and
Albert Museum

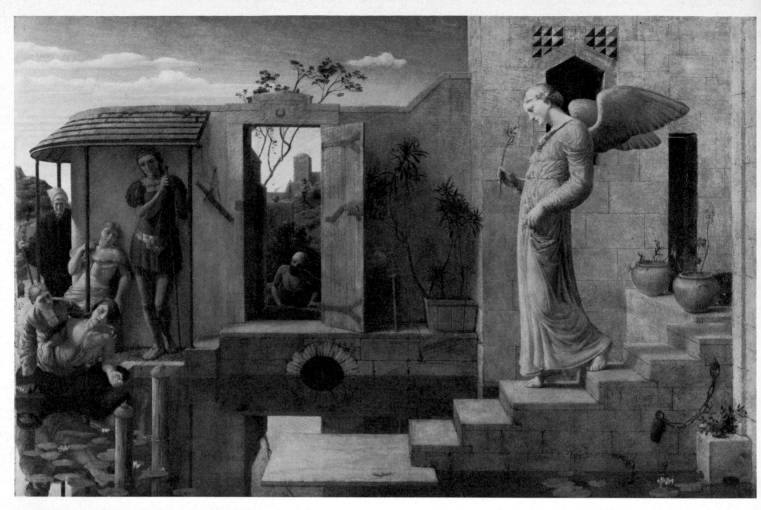

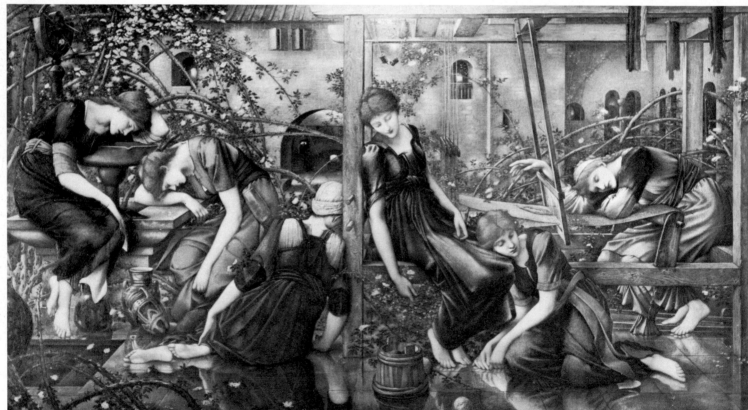

158 ROBERT BATEMAN (1841/2–after 1889): *The Pool of Bethesda*. Signed and dated 1877. Canvas,
20 × 29¼ in. Private Collection

159 & 160 EDWARD BURNE-JONES (1833–98): *The legend of the briar rose: The garden court*. Series signed and
dated 1870–90. Canvas, 49½ × 91 in. Berkshire, Buscot Park, Trustees of Lord Faringdon

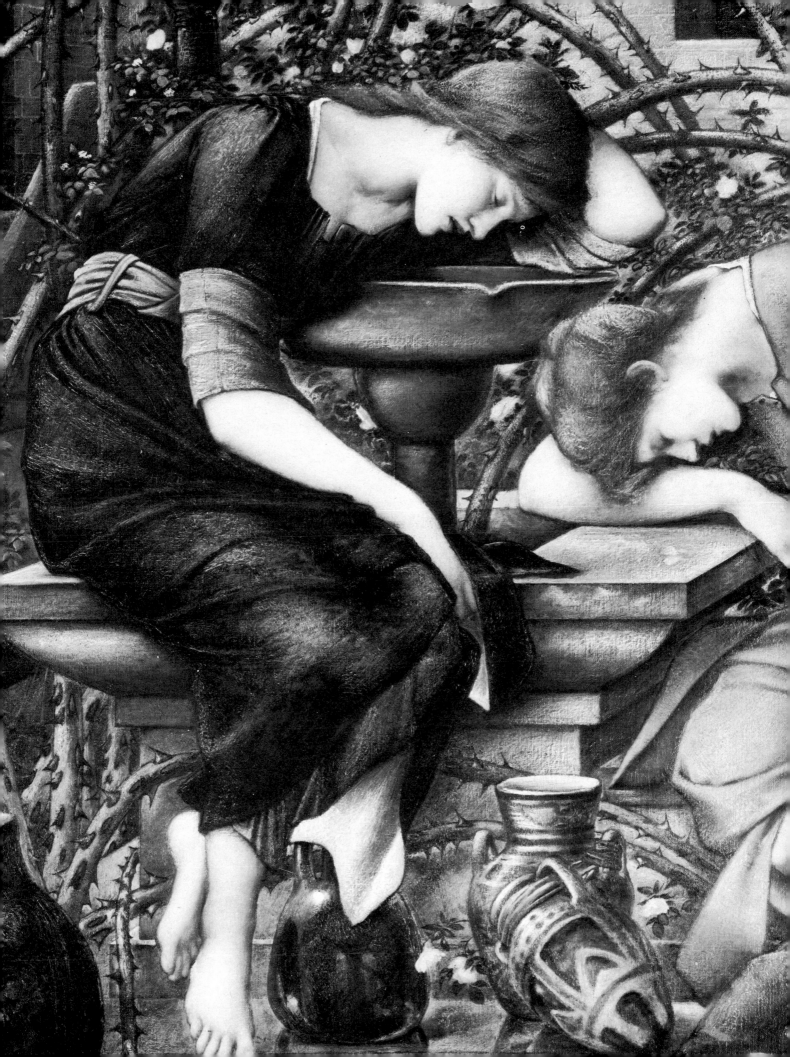

161 WILLIAM BELL SCOTT (1811–90): *Iron and coal*. 1857–61. Canvas, 74 × 74 in. Northumberland,
Wallington Hall, National Trust

162 RICHARD DADD (1817–86): *Contradiction; Oberon and Titania*. Signed and dated 1854–8. Canvas,
24 × 29¾ in. Private Collection

163 JOSEPH NOEL PATON (1821–1901): *The quarrel of Oberon and Titania*. 1849. Canvas, 39 × 60 in.
Edinburgh, National Gallery of Scotland

165 JOSEPH NOEL PATON: *The quarrel of Oberon and Titania* (detail of Plate 163)

164 WILLIAM BELL SCOTT: *Iron and coal* (detail of Plate 161)

166 RICHARD PARKES
BONINGTON
(1802–28): *Henri
III and the English
ambassadors*.
Canvas, 21 × 26 in.
London,
Wallace
Collection

167 EDWARD
MATTHEW WARD
(1816–79): *The
royal family of
France in the prison
of the Temple*.
Signed and dated
1851. Canvas,
40 × 50 in.
Preston, Harris
Museum and Art
Gallery

168 WILLIAM FREDERICK YEAMES (1835–1918): '*And when did you last see your father?*' Signed and dated 1878. Canvas, 48 × 98 in. Liverpool, Walker Art Gallery

169 LADY ELIZABETH BUTLER (1846–1933): '*Scotland for Ever!*' Signed and dated 1881. Canvas, 40 × 76 in. Leeds, City Art Gallery

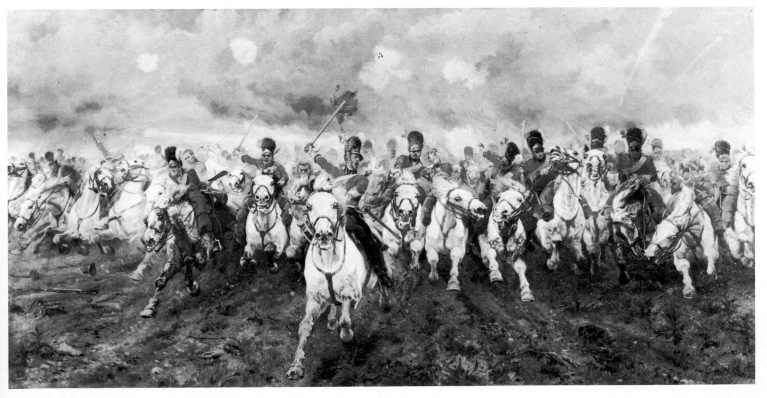

170 LAWRENCE ALMA-TADEMA (1836–1912): *The Tepidarium.* 1881. Panel, $9\frac{1}{2} \times 13$ in. Port Sunlight, Lady Lever Art Gallery

171 LADY ELIZABETH BUTLER: '*Scotland for Ever!*' (detail of Plate 169)

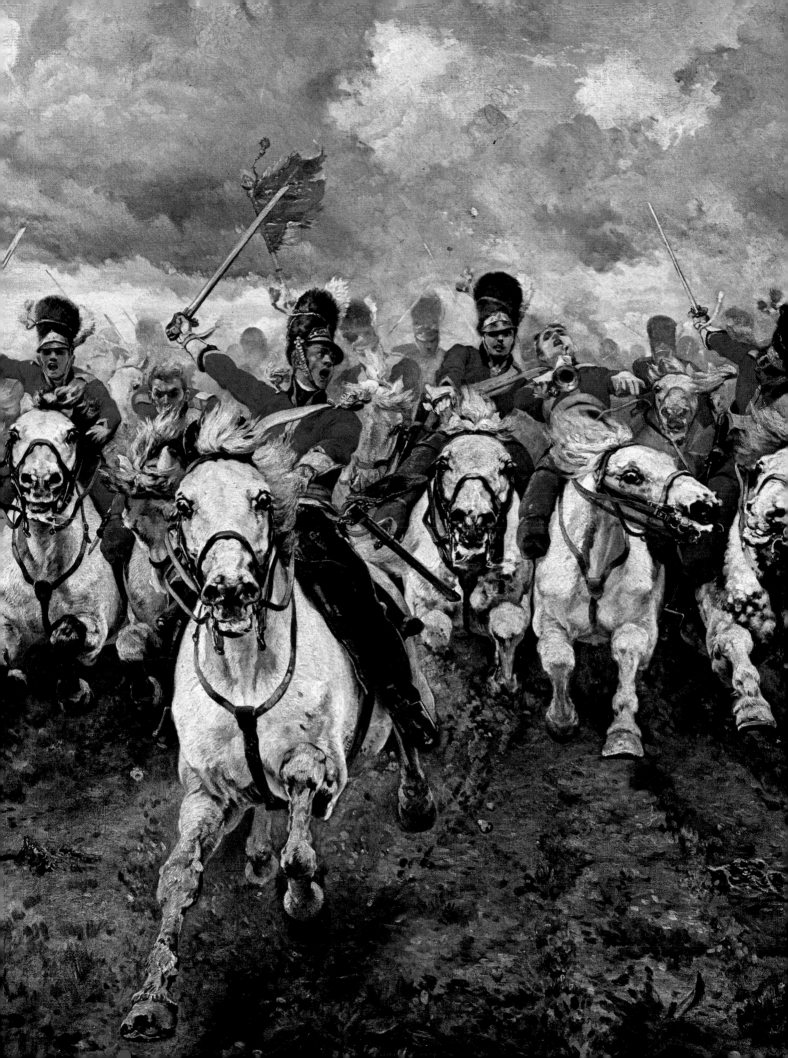

172 JAMES ABBOTT MCNEILL
WHISTLER (1834–1903):
*Symphony in flesh colour and pink:
Mrs F. R. Leyland. 1872–3.*
Canvas, $77\frac{1}{8} \times 40\frac{1}{4}$ in. New
York, Frick Collection

173 EDWARD BURNE-JONES
(1833–98): *Portrait of
Georgiana Burne-Jones, with
Philip and Margaret.* About
1879. Canvas, $29\frac{3}{4} \times 20\frac{3}{4}$ in.
Private Collection

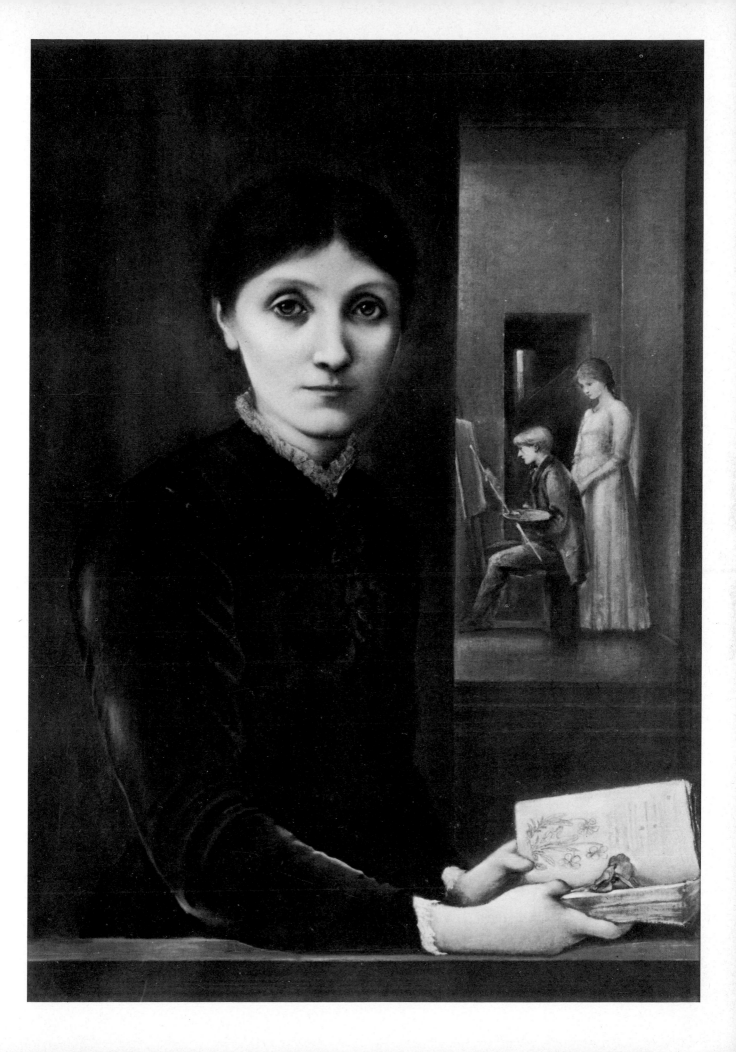

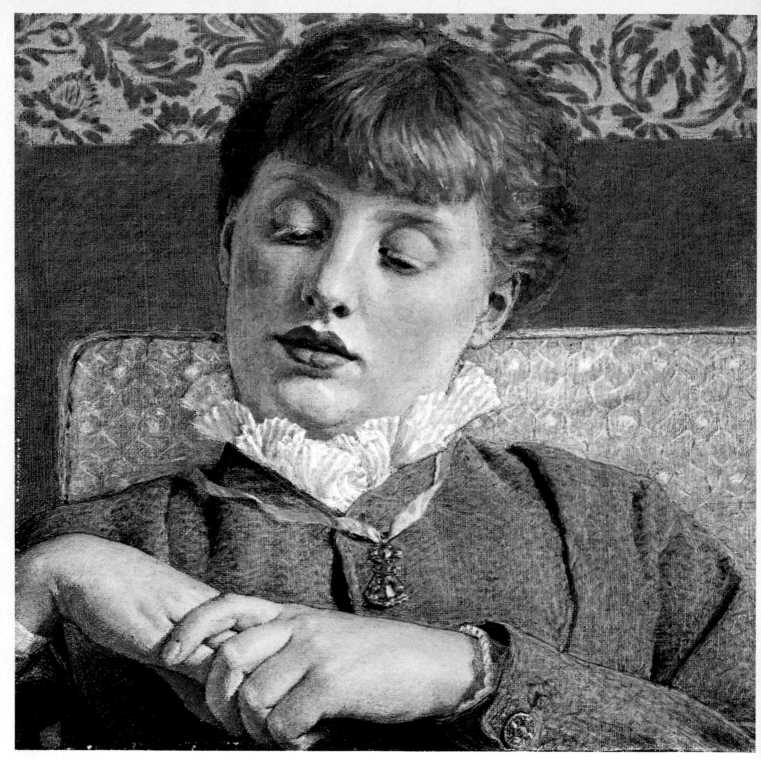

174 ALBERT JOSEPH MOORE (1841–93): *Portrait of a girl*. Canvas, 10 × 10 in. Private Collection

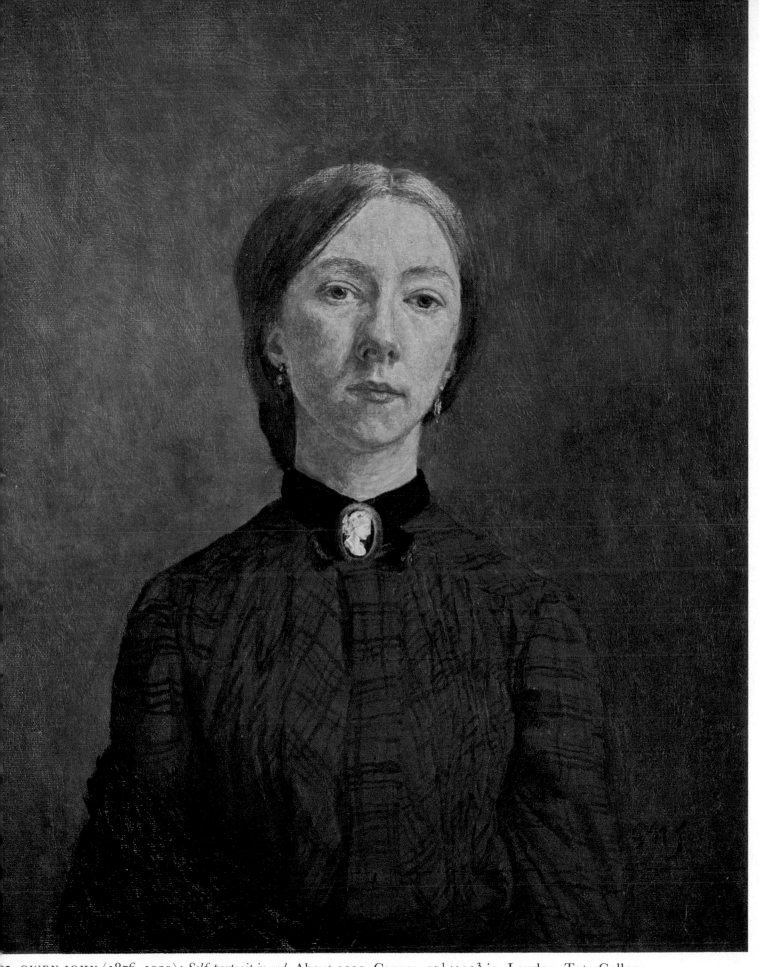

75 GWEN JOHN (1876–1939): *Self-portrait in red*. About 1900. Canvas, $17\frac{1}{2} \times 13\frac{3}{4}$ in. London, Tate Gallery

176 PHILIP WILSON
STEER (1860–
1942): *The
bridge*. 1887.
Canvas,
$19\frac{1}{2} \times 25\frac{3}{4}$ in.
London, Tate Gall

177 MARCUS STONE (1840–1921): *Two's company, three's none*. Signed and dated 1892. Canvas, 16 × 36 in. Blackburn, Museum and Art Gallery

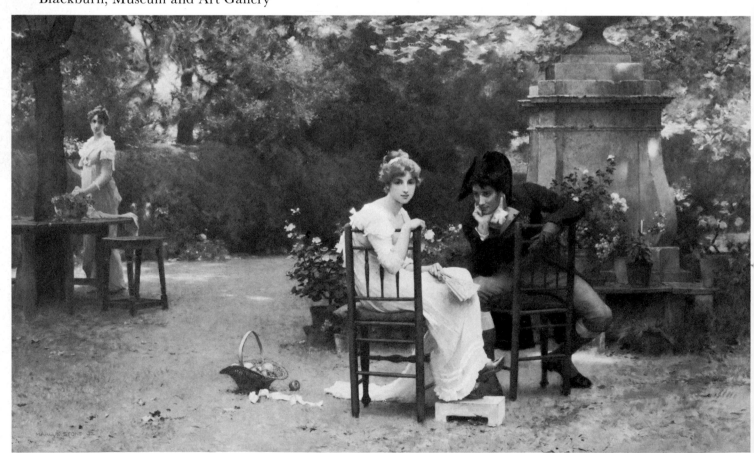

178 WALTER RICHARD SICKERT (1860–1942): *La rue Pecquet (St Jacques)*. Signed and dated 1900. Canvas,
21½ × 18 in. Birmingham, City Art Gallery

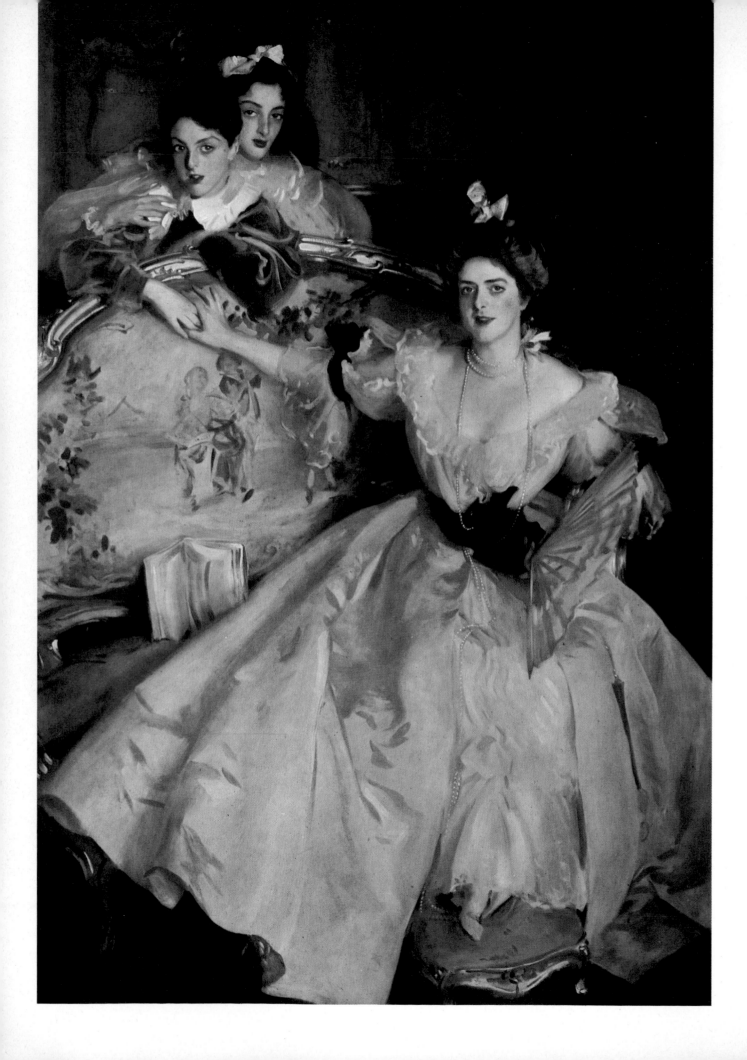

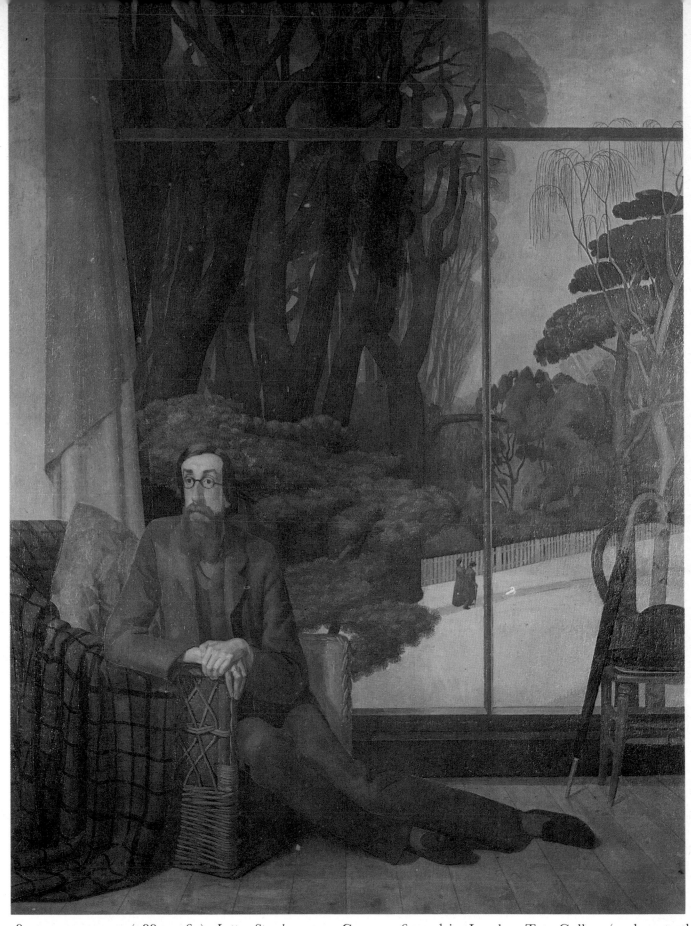

180 HENRY LAMB (1883–1960): *Lytton Strachey*. 1914. Canvas, 96 × 70¼ in. London, Tate Gallery (on loan to the National Portrait Gallery)

179 JOHN SINGER SARGENT (1856–1925): *Mrs Carl Meyer and her children*. Signed and dated 1896. Canvas, 79½ × 53½ in. Collection of Sir Anthony Meyer, Bart.

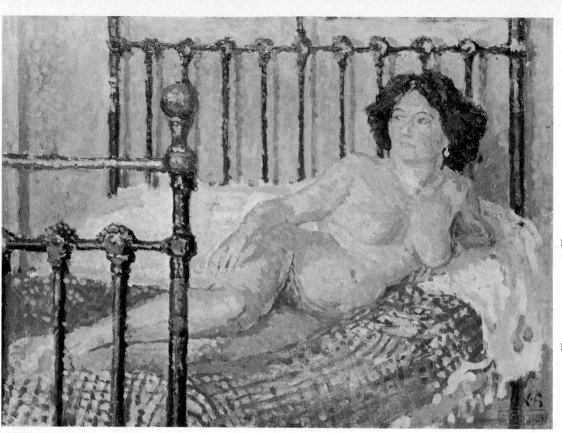

183 WALTER RICHARD
SICKERT (1860–1942):
Ennui. About 1913–14.
Canvas, 60 × 44¼ in.
London, Tate Gallery

181 SPENCER FREDERICK
GORE (1878–1914):
*Nude female figure on a
bed*. 1910. Canvas,
12 × 16 in. Bristol, City
Art Gallery

182 ROBERT BEVAN (1865–
1925): *Swiss Cottage*.
1912–13. Canvas,
24 × 32 in. Collection
of the heirs of Mr
Robert A. Bevan

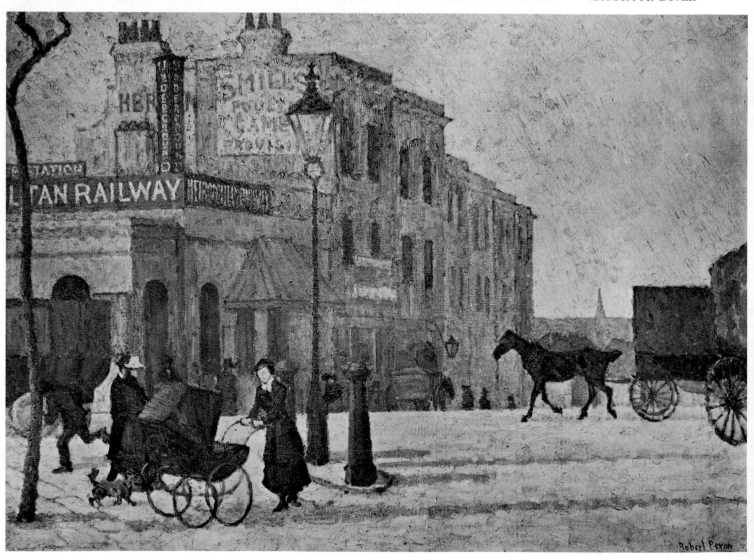

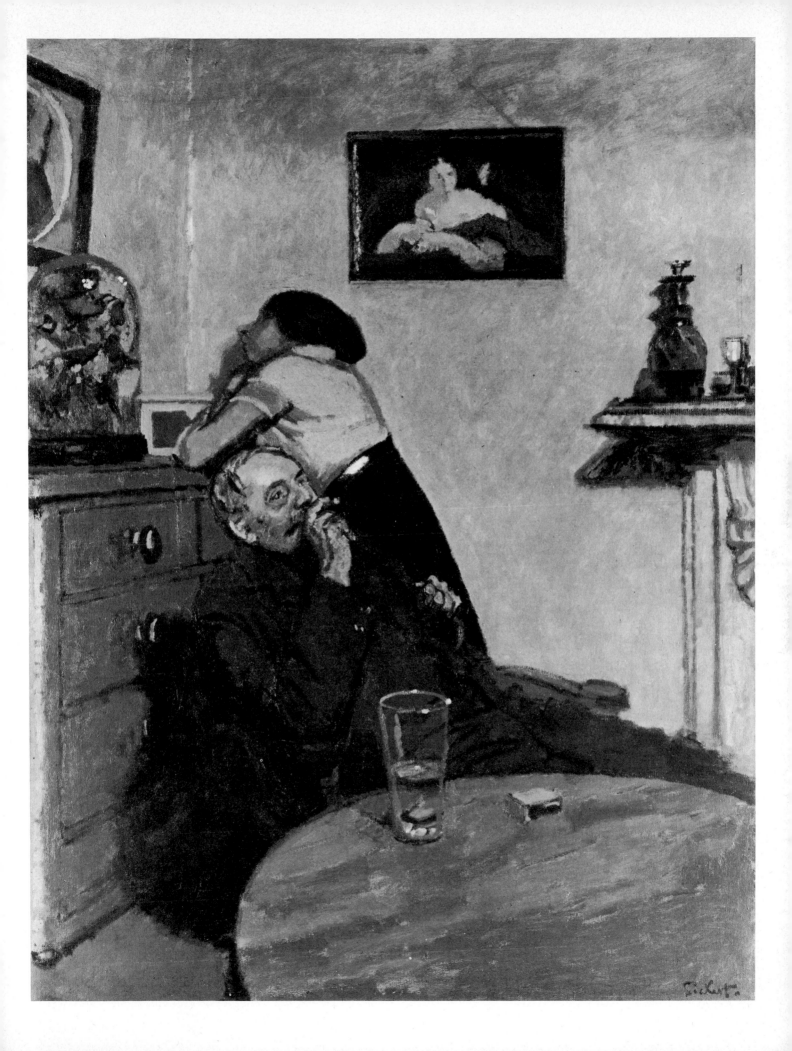

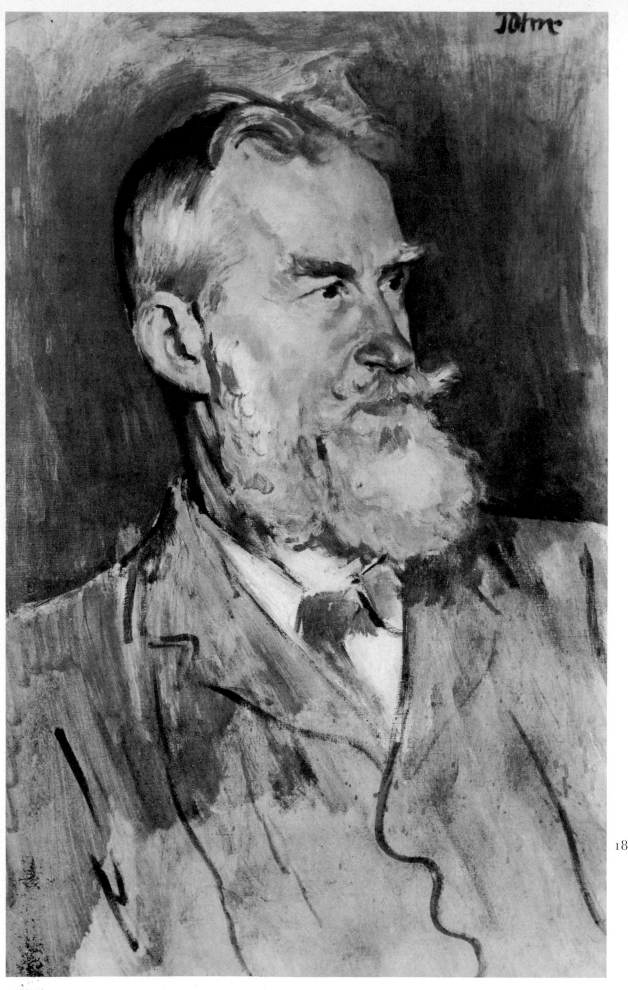

184 AUGUSTUS JOHN
(1878–1961):
*George Bernard
Shaw*. Exhibited
1922. Canvas,
$29\frac{3}{4} \times 17\frac{1}{2}$ in.
Cambridge,
Fitzwilliam
Museum

185 HENRI GAUDIER-BRZESKA (1891–1915): *Portrait of Horace Brodzky*. About 1913. Pastel, 29 × 22 in. Private Collection

186 STANLEY SPENCER (1891–1959): *Self-portrait*. 1913. Canvas, $24\frac{3}{4}$ × 20 in. London, Tate Gallery

187 DAVID BOMBERG (1890–1957): *The mud bath*. 1912–13. Canvas, 60 × 88¼ in. London, Tate Gallery

188 ALFRED MUNNINGS (1878–1959): *The arrival of the gypsies at Epsom Downs for Derby Week*. 1920. Canvas, 40¾ × 51½ in. Birmingham, City Art Gallery

189 MARK GERTLER (1891–1939): *Merry-go-round*. 1916. Canvas, 76 × 56 in. London, Ben Uri Gallery

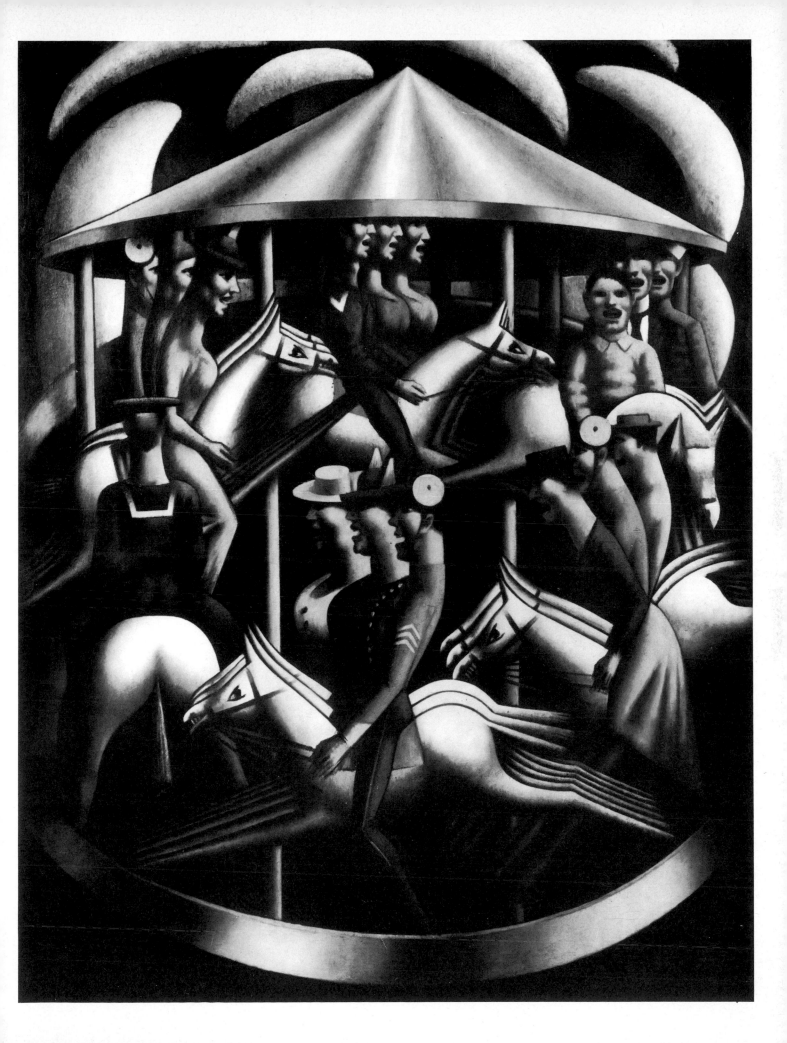

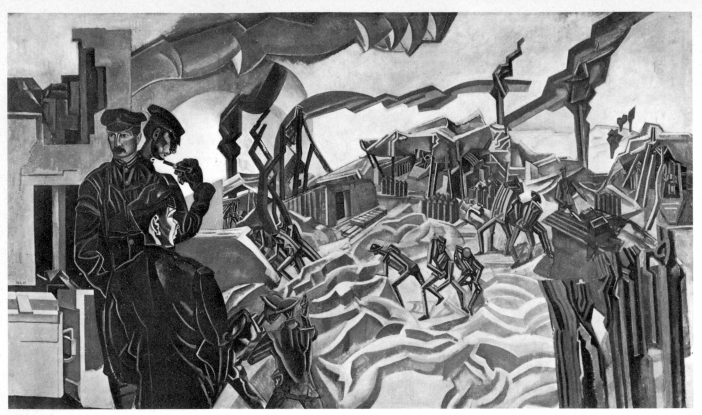

190 WYNDHAM LEWIS (1882–1957): *A battery shelled*. Signed and dated 1919. Canvas, 72 × 125 in. London, Imperial War Museum

191 STANLEY SPENCER (1891–1959): *Wounded arriving at a dressing station, Smol, Macedonia, 1916*. 1919. Canvas, 72 × 86 in. London, Imperial War Museum

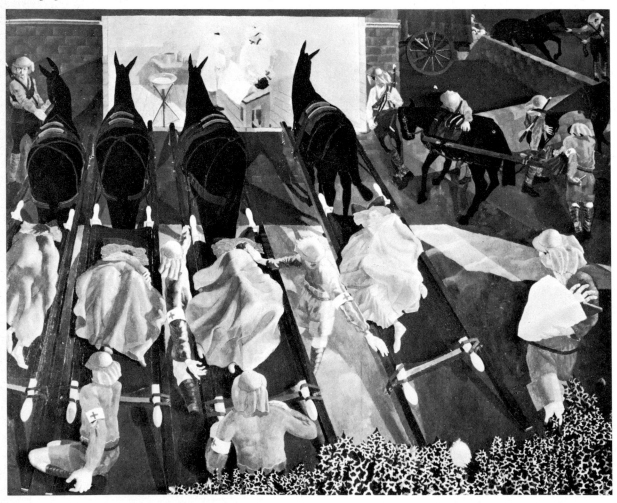

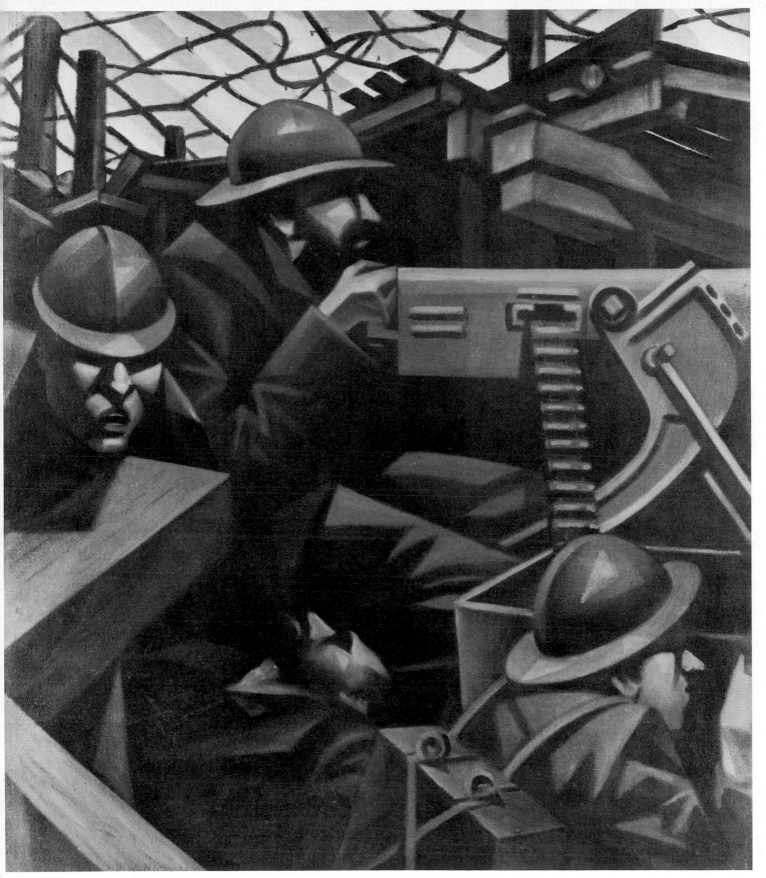

192 CHRISTOPHER RICHARD WYNNE NEVINSON (1889–1946): *La Mitrailleuse*. 1915. Canvas, 24 × 20 in.
London, Tate Gallery

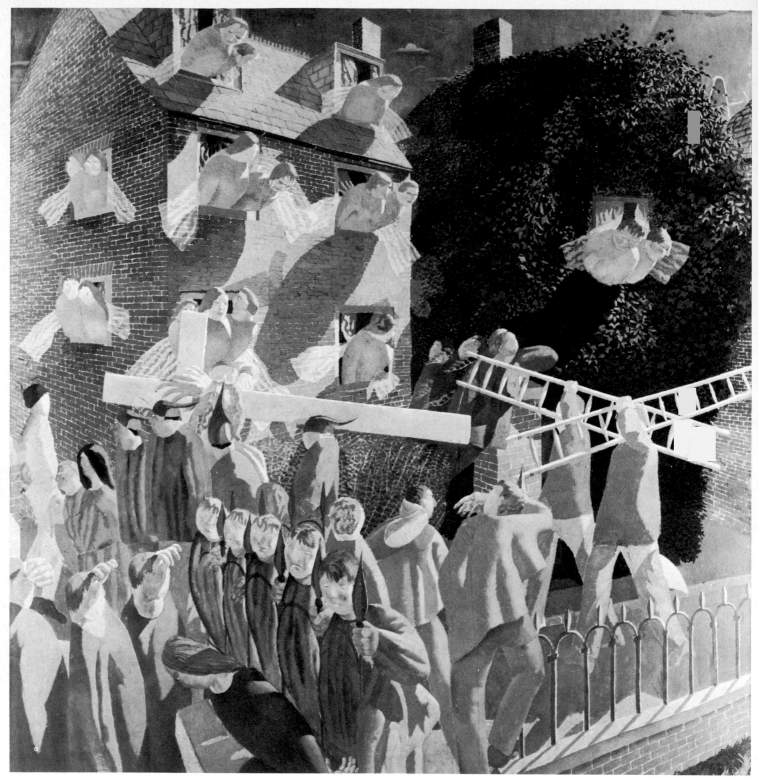

193 STANLEY SPENCER (1891–1959): *Christ carrying the Cross*. 1920. Canvas, 60 × 56 in. London, Tate Gallery

EDWARD BURRA (born 1905): *John Deth*. 1932. Watercolour, 22 × 30 in. Private Collection

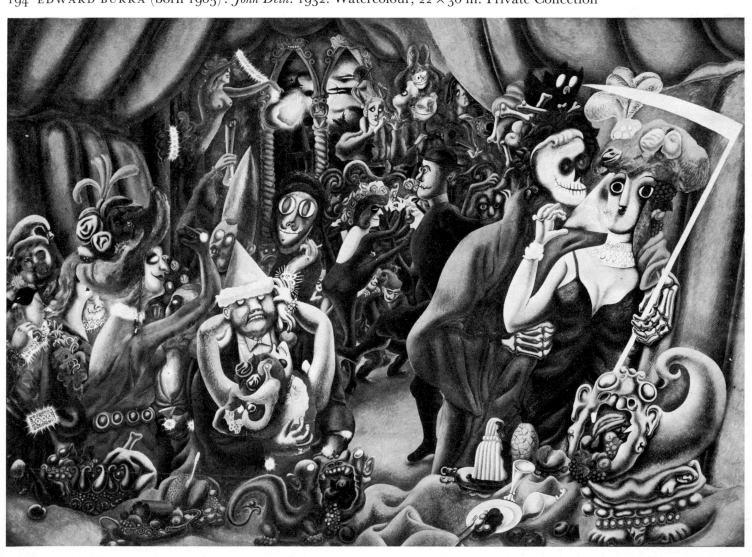

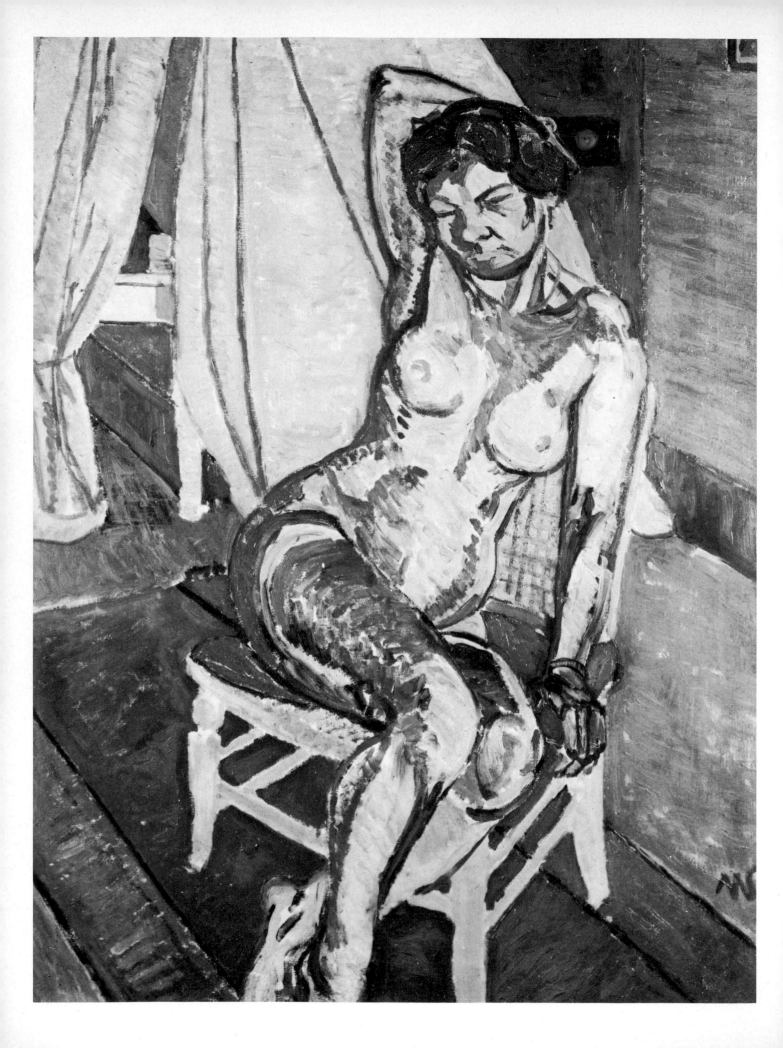

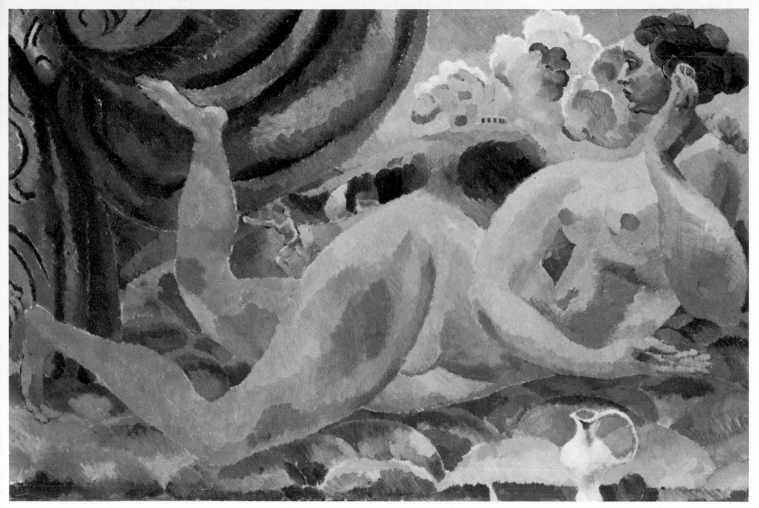

196 DUNCAN GRANT (born 1885): *Venus and Adonis*. About 1919. Canvas, $24\frac{1}{2} \times 36\frac{1}{2}$ in. London, Tate Gallery

195 MATTHEW SMITH (1879–1959): *Fitzroy Street nude no. 2*. Signed and dated 1916. Canvas, 40×30 in. London, British Council

197 CHRISTOPHER WOOD (1901–30): *Boat in harbour, Brittany.* 1929. Oil on board, $31\frac{1}{4} \times 42\frac{3}{4}$ in. London, Tate Gallery

198 LAURENCE STEPHEN LOWRY (1887–1976): *An organ grinder.* Signed and dated 1934. Canvas, $21 \times 15\frac{1}{2}$ in. Manchester, City Art Gallery

199 JOHN ARMSTRONG (1893–1973): *Dreaming head*. Signed and dated 1938. Tempera on panel, $18\frac{1}{4} \times 30\frac{3}{4}$ in. London, Tate Gallery

201 CERI RICHARDS (1903–71): *The female contains all qualities*. Signed and dated 1937. Oil and mixed media on canvas, 42 × 35 in. London, Tate Gallery

200 EDWARD WADSWORTH (1889–1949): *The beached margin*. Signed and dated 1937. Tempera on fabric, 28 × 40 in. London, Tate Gallery

202 PAUL NASH (1889–1946): *Totes Meer*. 1940–1. Canvas, 40 × 60 in. London, Tate Gallery

203 GRAHAM SUTHERLAND (born 1903): *Devastation, 1941: an East End street*. Signed and dated 1941. Ink, chalk and wash, 25½ × 44¾ in. London, Tate Gallery

204 JOHN PIPER (born 1903): *St Mary-le-Port, Bristol*. 1940. Canvas, 30 × 25 in. London, Tate Gallery

206 LUCIAN FREUD (born 1922): *Girl with a rose*. 1947–8. Canvas, $41\frac{1}{2} \times 29\frac{5}{8}$ in. London, British Council

205 CONROY MADDOX (born 1920): *Passage de l'Opera*. 1940. Canvas, $53\frac{3}{4} \times 37$ in. London, Hamet Gallery

207 VICTOR PASMORE (born 1908):
Evening, Hammersmith. Early 1940s.
Canvas, $34\frac{1}{4} \times 47\frac{1}{4}$ in. Ottowa,
National Gallery of Canada

208 JOHN MINTON (1917–57):
Street and railway bridge. Signed
and dated 1946. Canvas,
18×24 in. London, Tate
Gallery

209 WILLIAM SCOTT (born 1913): *Frying pan, eggs and napkin.* 1950. Canvas, 29 × 36 in. Collection of Lady Rendlesham

210 IVON HITCHENS (born 1893): *Poppies in a jug.* Signed and dated 1943. Canvas, 41 × 27½ in. Private Collection

211 BEN NICHOLSON (born 1894) *Feb 28–53 (vertical seconds).* Signed and dated 1953. Canvas, 29¾ × 16½ in. London, Tate Gallery

212 ALAN DAVIE (born 1920): *Entrance for a red temple, no. 1*. Signed and dated 1960. Canvas, 84 × 68 in. London, Tate Gallery

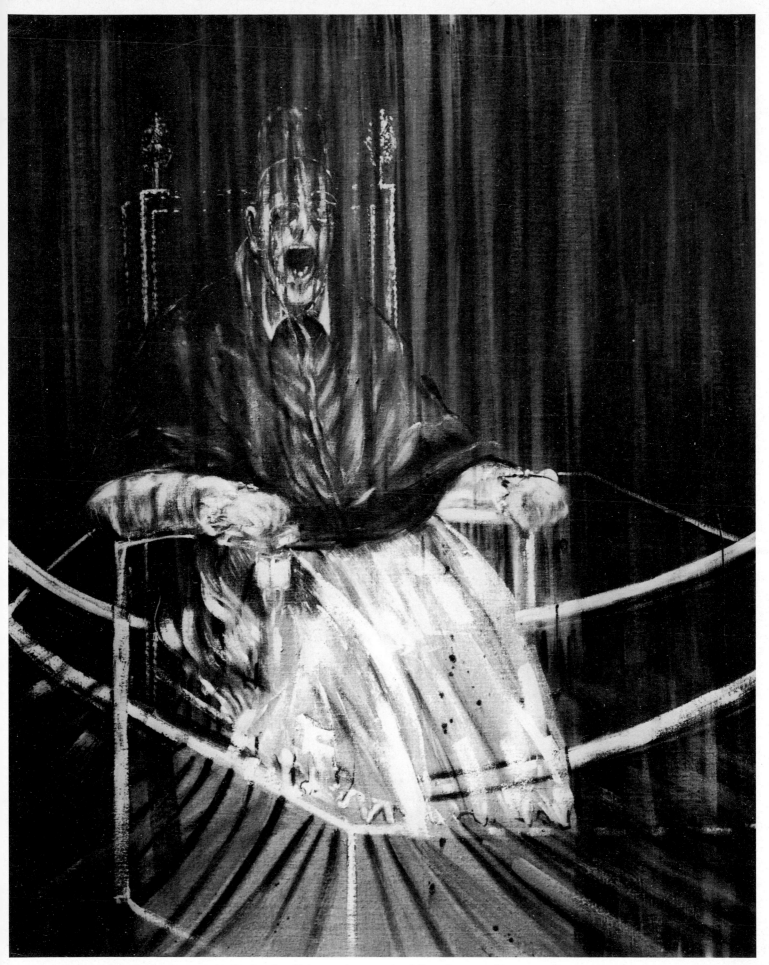

213 FRANCIS BACON (born 1909): *Study after Velasquez's portrait of Pope Innocent X.* 1953. Canvas,
$60\frac{1}{8} \times 46\frac{1}{2}$ in. Collection of Mr and Mrs William A. M. Burden, New York

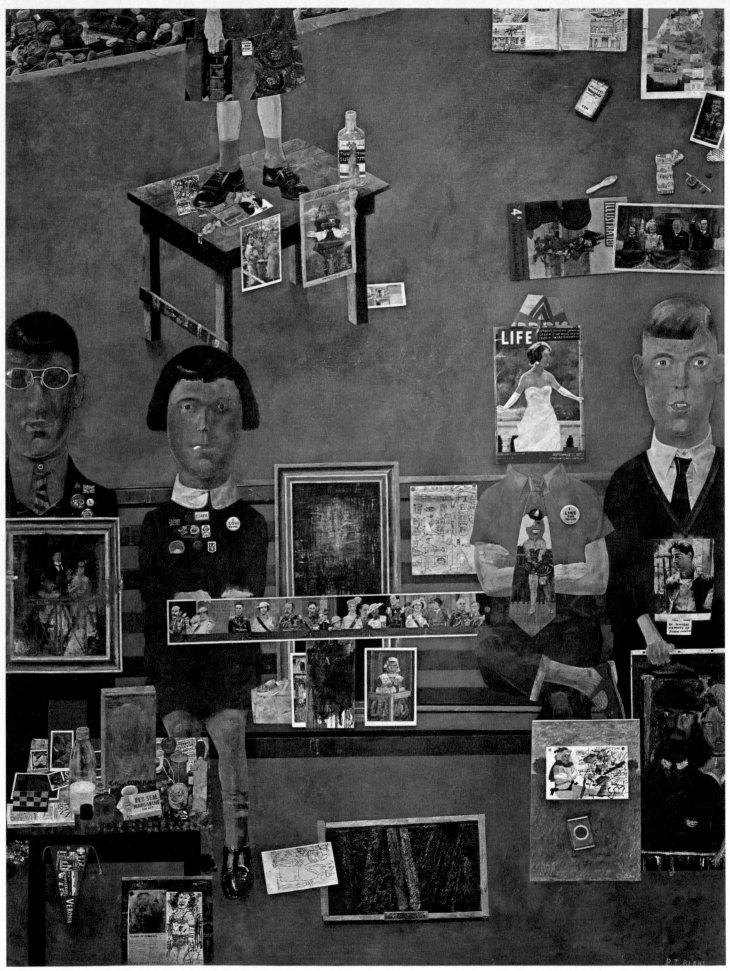

214 PETER BLAKE (born 1932): *On the balcony.* 1955–7. Canvas, $47\frac{3}{4} \times 35\frac{3}{4}$ in. London, Tate Gallery

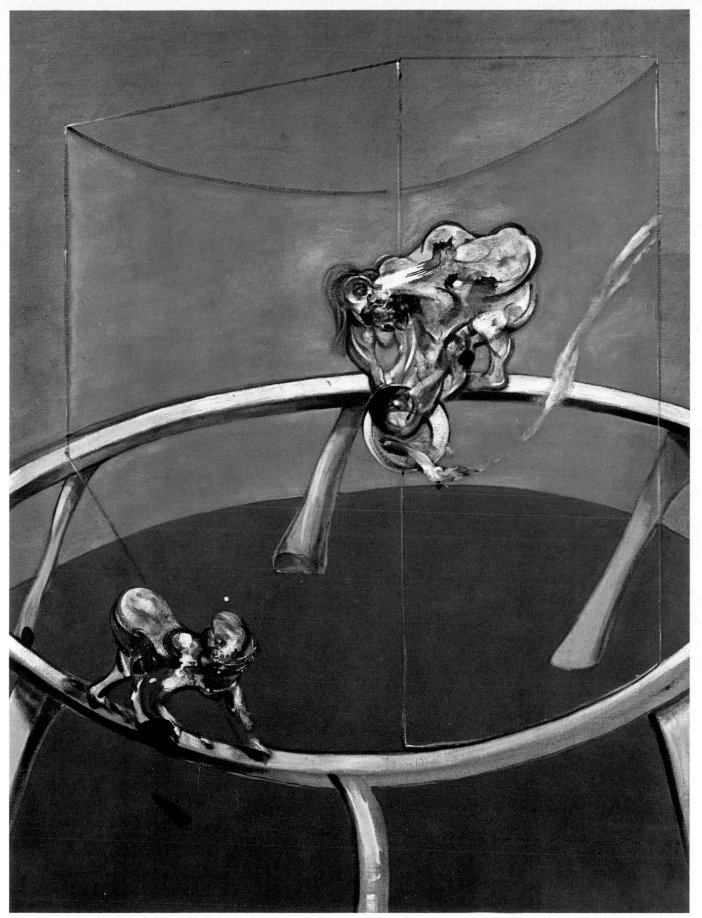

215 FRANCIS BACON (born 1909): *After Muybridge—woman emptying a bowl of water and paralytic child on all fours.* 1965. Canvas, $77\frac{1}{2} \times 57\frac{3}{4}$ in. Private Collection

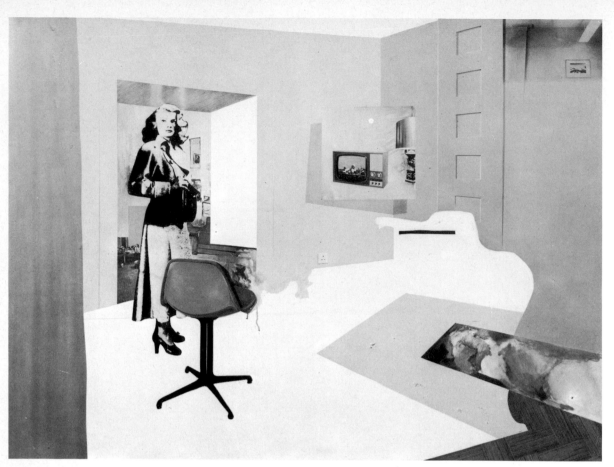

216 RICHARD
HAMILTON
(born 1922):
Interior II. 1964.
Oil, collage,
cellulose, metal
relief on panel,
48 × 64 in.
London, Tate
Gallery

217 DAVID HOCKNEY
(born 1937):
*Portrait of Sir
David Webster.*
1971. Acrylic
on canvas,
57 × 72 in.
London, Royal
Opera House

218 GRAHAM SUTHERLAND (born 1903): *Portrait of Lord Goodman*. 1974. Canvas, $37\frac{3}{4} \times 37\frac{3}{4}$ in. London, Tate Gallery

219 IAN STEPHENSON (born 1934): *Parachrome*. 1964. Canvas, 84 × 84 in. London, Tate Gallery

220 DAVID HOCKNEY (born 1937): *A bigger splash*. 1966–7. Acrylic on canvas, 96 × 96 in. Collection of the Marquis of Dufferin and Ava

221 BRIDGET RILEY (born 1931): *Fall*. 1963. Acrylic on board, $55\frac{1}{2} \times 55\frac{1}{4}$ in. London, Tate Gallery

Lawrence Alma-Tadema (1836–1912)

Born in Holland, Alma-Tadema studied at the Antwerp Academy and later with Baron Leys. Although initially he painted medieval history subjects, after visiting Italy in 1863 he devoted the rest of his career to imaginary scenes from the life of classical Rome, Greece and ancient Egypt, which combine a dedicated attention to archaeological accuracy with an interpretation of the classical world as a hedonistic dream. Alma-Tadema gave all his finished paintings opus numbers in Roman numerals and, after settling in London in 1870, he even designed his house in St John's Wood as a Pompeian villa.

170. The Tepidarium

Painted in 1881 and exhibited at the Grosvenor Gallery in 1883, the opus number, CCXXIX, can be seen below the animal skin. That a work of such a frankly erotic nature could be painted by an eminently popular artist at the height of the Victorian period shows the distancing effect provided by the thinly suggested 'classical' subject matter.

John Armstrong (1893–1973)

A Sussex parsonage childhood, spells at Oxford and art school, and service in the First World War left Armstrong a penniless aspiring artist in 1920s London. Theatre designs for Elsa Lanchester and interior decoration for the Courtaulds preceded his first one-man show in 1928 and his designs for the ballet *Façade* in 1931. He joined Unit One in 1933 and designed eight films for Alexander Korda and some vintage Shell advertisements. A war artist, 1940–4, his socialism and opposition to nuclear arms emerged in his post-war painting. Latterly he employed still-life, abstract and symbolist themes. An exhibitor at the Academy from 1951, elected an associate in 1966, he died in 1973.

199. Dreaming head

Armstrong's lifelong interest in religious and mythological imagery, rooted in an early appreciation of the more literary English artists like Millais, led him naturally to European Surrealism, once he had overcome the mannerisms of his theatrical designs. The 1936 International Surrealist exhibition in London reinforced his earlier knowledge of de Chirico; both the latter and Salvador Dali have informed this painting. It is essentially ambivalent: the head is at once a fragment of sculpture and yet lifelike; it leans casually against bleak brown rocks, a blonde northern sphinx massive in its landscape of muted colour, as the trails of pastel convolvulus wind out towards the onlooker.

Francis Bacon (born 1909)

Bacon was born in Dublin but came to London in 1925. In the following year he went to Paris where he worked sporadically as a designer and interior decorator. In the 1930s he started to paint seriously but was largely self-taught and he destroyed many of the paintings he did before the war. After the war he began to be recognized as a major talent and in the late 1950s and 1960s his works were exhibited throughout Europe and America. His paintings are almost all figurative, the figures being shattered and distorted as if by some grotesque motor accident or as a result of violence. Apart from his admiration for Rembrandt and Velasquez, he has been inspired by the photographs of the human body in action of Eadweard Muybridge, a nineteenth-century Philadelphia photographer. He sees the creation of his paintings as a combination of accident and deliberate intention.

213. Study after Velasquez's portrait of Pope Innocent X

Bacon painted the first of his 'Pope' paintings in 1949 and this picture, executed in 1953, belongs to a large series which stems from his admiration for Velasquez's famous portrait in the Doria Gallery, Rome. Bacon said, 'I bought a book on diseases of the mouth when I was quite young—it had always fascinated me, and I'd also been hypnotized by Velasquez's portrait of Innocent X and at the time I thought that with the colour of the portrait and the mouth, the saliva and glitter of the mouth, I would be able to make a marvellous image—but I never succeeded in doing it. When the Pope was screaming, it wasn't screaming, I wanted to make the scream into something which would have the intensity and beauty of a Monet sunset.'

215. After Muybridge—Woman emptying a bowl of water and paralytic child on all fours

Painted in 1965, the first part of the title refers to the photographer, Eadweard Muybridge. The figures in this painting are amongst the most emotionally disturbing which Bacon has produced, reminiscent in some ways of Goya's etchings of the *Disasters of war*. Whatever may have led him to create these distorted figures, they have a sickening impact. The curious framing lines, a recurrent element in Bacon's paintings, the flat areas of discordant colour, the strange stand on which the figures are placed, all serve to heighten the gruesomely physical nature of the bodies of the woman and child.

Nathaniel Bacon (1583?–1627)

14. Portrait of the artist

Sir Nathaniel Bacon was a gifted amateur painter who painted for his own family. In this ambitious portrait he shows himself in his study, where his palette is included amongst a variety of accessories that illustrate the scholarly interests of the educated gentleman. This idea of the learned artist was confirmed by the writings of Henry Peacham and Sir Henry Wotton. The silvery grey tonalities and interest in still-life suggest the influence of Netherlandish painting.

Francis Barlow (died 1704)

Barlow was probably born in the 1620s and is first known by some etched book illustrations of 1652. He was the first English artist to make a speciality of the sporting scene, and his paintings, drawings and etchings show a variety of sporting activities. He also painted animals and studies of farm and country life. Compared with the elegance and theatricality of

the Flemish tradition of animal painting, Barlow's works are distinguished by a straightforward observation of nature and have an attractive simplicity of design.

36. Southern-mouthed hounds
This is one of a series of large canvases of sport and of farm life which was commissioned by Sir Denzil Onslow to decorate the hall of his house at Pyrford (one is dated 1667). Barlow's feel for the structure and character of the animals was to be further developed by Stubbs.

James Barry (1741–1806)
Barry, born in Cork, was inspired by Edmund Burke's essay on 'The Sublime and the Beautiful' (1757). He came to London in 1764 and studied in Italy from 1766 to 1771. Barry was intoxicated by the ideals of High Art, which he found expressed in the works of Raphael, Michelangelo and Poussin and advocated in Reynolds's *Discourses*. An argumentative and cantankerous nature led to his expulsion from his professorship at the Royal Academy in 1799. His veneration for Renaissance art was coloured by his romantic attachment to the huge and the sublime and he remains a lonely but at the same time characteristic figure, always aspiring to the noble and the ideal.

91. The progress of human culture: Orpheus
Between 1777 and 1783 Barry painted a series of vast canvases illustrating the Progress of Culture, also providing an explanatory published text, for the Society of Arts Grand Room in the Adelphi, London. His offer to do the work was accepted by a nervous society on the condition that he agreed to paint it free of charge. Here Orpheus is represented as the founder of Grecian culture, rescuing the noble but helpless savages from a primitive state of nature.

Robert Bateman (1841/2–after 1889)
Bateman entered the Royal Academy Schools in 1865 and in his later career exhibited infrequently at the Academy and the Grosvenor Gallery. Few of his paintings are known to survive, but he would appear to have been amongst the later Pre-Raphaelite followers of Burne-Jones, though his work shows a very individual knowledge of Italian painting.

158. The Pool of Bethesda
An illustration to the Gospel of St John, chapter v, which tells of the healing powers of the waters of Bethesda when stirred by the touch of an angel and recounts Christ's curing of the lame man; 'Take up thy bed and walk.' The composition has a quality of geometric organization reminiscent of Quattrocento painting.

Robert Bevan (1865–1925)
After a childhood in England, Bevan studied art in Paris and stayed at Pont Aven, Brittany, in the 1890s, where he met Gauguin. He travelled widely and married the Polish artist, Stanislawa de Karlowska, in Poland in 1897, though he had first met her in Paris. He was a founder member with Gore and Gilman of the Camden Town Group in 1911 and was also a member of the London Group and the New English Art Club. Gauguin's influence can be discerned in his early brightly coloured paintings and also throughout his life in the angular and rather flat forms he depicted, though his palette became more restrained in the works by which he is now best known, the paintings of horse sales and urban townscapes.

182. Swiss Cottage
Painted in 1912–13, this is a typical Camden Town Group subject, showing an everyday London street scene. Bevan's love of flat pattern, far more pronounced than in the more fragmented paint surfaces of the work of Gore and Gilman, is here apparent. It almost certainly derives from his knowledge of Gauguin's work, though Bevan is an original and distinctive painter with a highly personal style.

Peter Blake (born 1932)
Blake was born in Kent, studied at the Gravesend School of Art, and, after national service in the R.A.F., at the Royal College of Art from 1953 to 1956. Blake, who has been understandably classified as a Pop artist, has an affectionate and nostalgic attitude to his subject matter, which produces an effect quite different from the impersonal depiction of images found in the work of the American Pop artist, Andy Warhol.

214. On the balcony
This picture was painted between 1955 and 1957, initially as his diploma work at the Royal College of Art, but it was not finished until his return from travels on the Continent. The subject matter, photographs from magazines, the royal family 'on the balcony' at Buckingham Palace, children with badges proclaiming their likes and allegiances, is all everyday, popular imagery. Pop artists felt this should be introduced into painting, which they considered was losing all contact with mass culture. The painting is a statement of Blake's allegiance to popular images, but it also includes witty references to the styles of other artists, including his own contemporaries at the Royal College of Art—the whole being a personal artistic manifesto.

William Blake (1757–1827)
Blake was trained as an engraver and made his living out of engraving the designs of other artists, often his friends such as Thomas Stothard, John Flaxman and Henry Fuseli. He was a poet and a visionary and his great contribution to art was his series of illustrated books, in which, with a highly individual and original technique, he combined text and illustration in the same engraving process. Apart from a few admirers, like Thomas Butts and later John Linnell and Samuel Palmer, he was regarded by contemporaries as both mad and technically ill-equipped. His visionary world stands in great contrast to the preoccupation with realism and the depiction of the facts of the visual world which concerned the great majority of his contemporaries. D. G. Rossetti was a great admirer of Blake.

111. Elohim creating Adam
There were originally at least thirteen subjects treated by Blake in a series of large colour prints, dated 1795, of which this print is

one. Subjects are drawn seemingly at random from the Bible, Milton and Shakespeare, but they were probably chosen because Blake found in them illustrations to his own visionary philosophy. Elohim is one of the Hebrew names for God, and here Blake stresses the creation as an act of enslavement, the imprisonment of man in the material world—one of the recurring themes in Blake's art and writings.

David Bomberg (1890–1957)

Brought up in London's East End, Bomberg trained as a lithographer before deciding at eighteen to become an artist. He studied with Sickert and at the Slade with Nevinson, Roberts, Spencer and Wadsworth, and he started to exhibit in 1913 when he also visited Paris, meeting Picasso, Derain and Modigliani. A founder-member of the London Group, with which he exhibited for the rest of his life, he had his first one-man show at the Chenil, Chelsea, in 1914, and showed with the Vorticists in 1915, before serving in the war. He lived in Palestine from 1923 to 1927, visiting Petra for six months, and in 1929 visited Spain where he lived from 1934 to 1935. Otherwise, his home was in Britain, mostly in London, until his death.

187. The mud bath

This painting, the starting point of which may have been Schevzik's Steam Baths in Brick Lane, Whitechapel, was exhibited as the main picture of Bomberg's one-man show in 1914. His independent, Cubist-inspired ideas are here expressed with an uncompromising vigour that impressed even Wyndham Lewis, and this painting is one of the most complete expressions of Vorticism. Bomberg wrote in the catalogue; 'I look upon *Nature*, while I live in a steel city. . . . I am *searching for an Intenser* expression. . . . My object is the *construction of Pure Form*.' His later work entirely rejected these values, and he turned to landscapes, painted with bold, expressive sweeps of the brush, often in rich earth and terracotta tones.

Richard Parkes Bonington (1802–28)

Bonington's family emigrated to France in 1817 and after early training with François-Louis Francia, an artist experienced in the technique of English watercolours, he studied at the Louvre and in the studio of Gros. Bonington, who admired Constable, travelled extensively during his brief life and produced numerous landscapes in oil and watercolour in a specifically English style. But he also, through a close friendship with Delacroix, played an important role in the development of French Romantic art, particularly in small scenes of historical incident.

122. Coast of Picardy

Bonington's landscapes have a disarmingly fresh and *plein air* quality which prompts the obvious comparison with Constable. They are, however, much more sophisticated in technique than Constable's work, with fluent brushstrokes of amazing virtuosity. His coast scenes, with their emphasis on large skies and a low horizon, look forward to the works of later French landscapists such as Eugène Boudin.

166. Henri III and the English ambassadors

Exhibited at the Royal Academy in 1828, the subject of Henri III surrounded by his adored pets allowed Bonington to introduce the exotic details and richly coloured costumes he enjoyed in Venetian painting of the sixteenth century. Bonington often drew his subject matter from French history, thereby depicting incidents unfamiliar and novel to the British public.

Edward Bower (died 1666/7)

15. Portrait of a man

Very little is known about Edward Bower; he probably worked in London where he drew the king at his trial in 1648-9. This portrait is a provincial imitation, executed with a certain panache and gaiety, of the fashionable Baroque pattern with twisted column, curtain and terrace that had been used by Mytens.

British School

5. Elizabeth I when princess

One of the most sophisticated and elegant royal portraits painted in the middle years of the century, the painter has not yet been satisfactorily identified. The linear style and emphasis on patterned surface suggests the influence of Holbein's later English period.

Thomas Brooks (1818–91)

A Yorkshireman, Brooks came to London and the Academy Schools in 1838, studied under H. P. Briggs, the history painter, then painted in Paris and at home in Hull, before settling in London in 1845. Principally a genre painter, he regularly exhibited at the Royal Academy (from 1843) and the British Institution (from 1846) paintings with titles like *Happiness and grief*, 1851, and '*C'est lui!*', 1872. After the exhibition of *The lifeboat going to the rescue* (R.A. 1861, Bristol City Art Gallery), Brooks added marine subjects to his repertoire and, though he never won Academy honours, produced a steady output of popular work.

144. Relenting

Even a contemporary critic, James Dafforne in 1872, was forced to call one of Brooks's paintings 'dreary', and there is no doubt that the generally tragic, or at least melancholic, note in his genre pictures was his principal claim to fame. Here a landlord seems to be taking pity on a widow and her four children. The portrait of the dead husband over the mantelpiece suggests that she may be a Crimean war widow. The painting was exhibited at the Royal Academy in 1855.

Ford Madox Brown (1821–93)

Slightly older than the Pre-Raphaelite Brethren, Brown was the most important painter to be associated with their movement, though he was never a member of it. He visited Rome in 1845 and, like Dyce, came under the influence of the Nazarenes.

D. G. Rossetti became his pupil in 1848. His *The last of England* (1852–5; Birmingham, City Art Gallery) and *Work* (1852–65; Manchester, City Art Gallery) are concerned with modern life and social problems. Towards the end of his life he painted a series of frescoes of English history for Manchester Town Hall (1881–7). Brown also painted literary and biblical subjects.

138. Pretty baa-lambs
Exhibited at the Royal Academy in 1852, this is one of Brown's most Pre-Raphaelite works, notably in the way it was painted. Brown wrote in his diary; 'The *Baa-Lambs* picture was painted almost entirely in sunlight which twice gave me a fever while painting.' The work of the Pre-Raphaelites was always ransacked by contemporary critics for hidden meaning, and Brown was disturbed by the fact that the painting was described as 'Catholic Art' and 'blasphemous'. 'Few people I trust', Brown wrote, 'will seek for any meaning beyond the obvious one, that is—a lady, a baby, two lambs, a servant girl, and some grass.'

Edward Burne-Jones (1833–98)

Burne-Jones planned to enter the Church, but he met William Morris while at Oxford and a shared enthusiasm for medieval romance and chivalry, epitomized by Malory, combined with an excited response to Pre-Raphaelite painting, led to his decision to dedicate himself to art. His style was originally influenced by Rossetti, who accepted him as a pupil, but after 1862 Burne-Jones's paintings become larger and more monumental, suggesting his interest in Botticelli, Mantegna and Michelangelo. His subject matter was drawn from myth and legend, from which he created a dream world of statically graceful figures. Burne-Jones frequently designed tapestries and stained glass for William Morris and Co., but he did not, unlike Morris, consider his art as a means of social reform; rather, he wrote; 'I have learned to know beauty when I see it and that's the best thing.' His paintings influenced the Aesthetic movement and Art Nouveau design.

159 and 160. The legend of the briar rose: The garden court
One of a series of paintings illustrating the *Sleeping Beauty*. In this panel Burne-Jones enmeshes his characteristic frieze of female figures within and behind a framework of the arcs and lines of the briar roses. The rigid and forceful elements of the composition, such as the briars and the sharp drapery lines, contrast with the soft inertia of the enchanted figures.

173. Portrait of Georgiana Burne-Jones, with Philip and Margaret
Burne-Jones showed little interest in portrait painting, but here, in this portrait of his wife and children, he was able to show 'those wonderful eyes of dearest grey'. Graham Robertson said that behind Georgiana's eyes could be sensed 'an Energy, dominant, flame-like'. It was probably painted in the late 1870s and early 1880s. Lady Burne-Jones said that it was worked on 'for years at intervals, but was never finished to satisfy himself'.

Edward Burra (born 1905)

A lifetime of physical ill-health, which began in childhood, allowed Burra to escape normal schooling until he went first to the Chelsea Polytechnic, then the Royal College of Art in 1923. His solitary self-education led him into esoteric French and English literature—from Blaise Cendrars to Horace Walpole's *Castle of Otranto* and the Elizabethans. In his twenties he started the frequent travelling which has fuelled his work, exploring the full gamut of Parisian and French port life, Mexico and America. He has always lived, withdrawn, at Rye in Sussex, exhibiting only irregularly, but now shows biennially at the Lefevre Gallery, London.

194. John Deth
The intrusion of Death turns the claustrophobic decadence of the party into a macabre masquerade. Earlier work, though frank and never sentimental, had reflected the seamy world of Pigalle and Marseilles, but the privileged classes were as savagely dealt with as by George Grosz. Spain—Goya, El Greco, and here perhaps Hieronymus Bosch—gave him means to express the increasing pessimism of the 1930s, contained in his representations of what could be termed the super-normal.

Lady Elizabeth Butler (1846–1933)

After studying at the South Kensington Art Schools and in Italy, Lady Butler became famous when her painting, *Calling the roll after an engagement, Crimea* (1884), was bought by Queen Victoria. Her works, which were frequently engraved, display heroic and patriotic military incidents, and combine a lively draughtsmanship of horses with a precise attention to uniform and regimental tradition much appreciated by the army. Her paintings, praised by Ruskin for 'gradations of colour and shade of which I have not seen the like since Turner's death', share the British imperial assurance of the poetry of Kipling and Henry Newbolt.

169 and 171. 'Scotland for Ever!'
Painted in 1881 this represents the charge of the Scots Greys at the Battle of Waterloo when this heavy cavalry regiment suffered severe casualties. Lady Butler wrote of her preparations; 'I twice saw a charge of the Greys before painting '*Scotland for Ever!*' and I stood in front to see them coming on. One cannot, of course, stop too long to see them too close.'

Antonio Canaletto (1697–1768)

Canaletto was the supreme exponent of *vedute* painting, pictures of topographical accuracy usually depicting urban views or townscapes. It was through Joseph Smith, British consul in Venice, that Canaletto first became well known for his Venetian views to British patrons in the 1730s. He came to London in 1746 and until 1750 was fully occupied painting views of London, though he also went as far afield as Alnwick Castle in Northumberland. His art has always been popular and he influenced the work of Samuel Scott in the eighteenth century. Canaletto returned to Venice, probably in 1756.

54 and 57. View of Whitehall looking north
Probably painted in 1751, the painting shows, in the centre foreground, the wall separating Whitehall from the Privy Garden with the Banqueting House, seen end on, in the centre middle distance. St Paul's is in the distance on the right. A curiously disorganized and unpicturesque view, it none the less, and partly because of this, has some of the directness and individuality of Canaletto's masterpiece, *The stonebreaker's yard*, now in the National Gallery, London.

56. Old Walton Bridge
Painted in 1754. Among the trees on the left is the house of Samuel Dicker, who had the bridge built in 1750. This is a much more conventional view than the *View of Whitehall*. With its elaborately composed quality, the theatrical clouds, and the painterly clutter of 'staffage' figures and foreground incident, it can be compared and contrasted with the much more naturalistic landscape by Lambert (*Plate 49*).

Samuel Colman (working 1816–40)
A little-known provincial artist, Colman worked in Bristol as a portraitist and drawing master between 1816 and 1838 when he may have been influenced by the early work of Francis Danby. Colman exhibited only twice at the Royal Academy, in 1839 and 1840.

131 and 135. St James's Fair, Bristol
Scenes depicting the varied incidents of town and country fairs were popular with British artists from the time of Hogarth. St James's Fair, established in the thirteenth century and finally abolished in 1838, is here given an air of thieving trickery and ill-repute, which was also reflected in contemporary pamphlets of moral condemnation. Colman's painting clearly suggests the influence of Hogarth's prints, notably the detail of the procuress on the right (*Plate 131*) which is derived from the first plate of the *Harlot's progress*.

John Constable (1776–1837)
The son of a prosperous mill-owner, Constable started his career drawing picturesque cottages for J. T. Smith. Not gifted with easy facility, he worked hard at the Royal Academy Schools, where he went in 1799. From about 1802 he conceived of a new kind of natural painting, which he expressed through numerous direct oil studies of the Stour Valley from about 1809 to 1816, and indeed he continued the practice throughout his career. From 1819 he painted the large 'six-foot' canvases which he exhibited at the Royal Academy throughout the 1820s, attempting to give lasting form to his love of the English natural scene and the watery quality of the English weather. After 1829 his work became more expressive and more concerned with a cosmic and scientific portrayal of natural forces.

102. The cornfield
This picture entered the National Gallery in 1837 soon after Constable's death. Constable referred to the painting as 'The Drinking Boy' and it almost certainly shows the lane leading from East Bergholt to Dedham. But the church in the background appears to be an invention and is one of a number of changes which Constable made to particular views he painted. Indeed, although the particularity of this view contrasts with the generalized nature of Gainsborough's *Market cart* (*Plate 101*), Constable did endeavour, in his large exhibition pictures—this was exhibited at the Royal Academy in 1826—to make a monumental composition which could take its place in the European tradition of landscape painting.

121. Weymouth Bay
Seemingly poised midway between a sketch and a finished picture, this could have been painted by Constable on his honeymoon in 1816. But there is a rough sketch in the Victoria and Albert Museum which was probably done on the spot and it is conceivable that this is an unfinished later version. Certainly the preoccupation with the strongly painted clouds suggests a date in the early 1820s, when Constable was making closely observed cloud studies on Hampstead Heath.

126. The Vale of Dedham
This was painted in 1828 but derives from a rather hesitant oil sketch of the same composition done in 1802, which is in the Victoria and Albert Museum. The sketch was, in its turn, based on the composition of Claude's *Hagar and the Angel*, which Constable admired when it was in the collection of Sir George Beaumont. Especially later in his career, Constable turned to earlier studies and sketches for inspiration and the connection with the Claude is an interesting example of how, through his veneration for the work of this seventeenth-century artist, Constable attempted to set his own work within the traditions of art.

Samuel Cooper (1609–72)
Samuel Cooper was a nephew of John Hoskins, the miniature painter, and apprenticed to him. Between 1634 and 1642 he left his uncle's studio and probably during this period travelled widely in Europe. He was patronized by Cromwell and after the Restoration, before 1663, was appointed King's Limner. He was the most celebrated British artist of his day. His style was deeply influenced by Van Dyck and his miniatures have a new breadth of handling and sophisticated sense of design and form. His approach to character is realistic and direct.

34. Oliver Cromwell
This was probably painted in the early 1650s. It may have been left unfinished so that Cooper could retain it in his possession in order to make further versions. A number of finished replicas are known. It remains the most spontaneous and penetrating portrait of Cromwell in existence.

35. Jane Myddelton
The relaxed pose and delicate approach to character are characteristic of Cooper's style. His subtle and subdued use of colour may be appreciated in the sombre background and harmony of silver, grey and white.

John Singleton Copley (1738–1815)

Copley was brought up in Boston and came to London, a mature artist, in 1774, before travelling to Rome. On his return to London in 1775 he started a series of paintings of contemporary history which were inspired by the example of Benjamin West's *Death of General Wolfe* (1771), but which have an even greater vividness and almost journalistic aplomb. His modern history paintings were far more successful and popular than the classical themes treated by Barry (*Plate 91*). He helped to elevate the genre of modern history subjects by treating them not only with drama and realism, but also with reference to the poses and compositions of Renaissance and Baroque painters such as Raphael and Rubens.

92. The death of Major Pierson

Painted in 1782–4, the picture represents the moment in 1781 when Major Pierson was mortally wounded while rallying the English forces against the invading French on the Island of Jersey. An overwhelmingly popular picture, it was exhibited on its own and drew enormous crowds. In depicting contemporary heroic action on the grandest scale, Copley's art looks forward to the works of Delacroix and Géricault.

John Crome (1768–1821)

The pupil of a carriage and sign painter, Crome met Thomas Harvey of Catton in 1790. The latter was a wealthy collector of English and Dutch landscapes who made his paintings available to artists. Crome was one of the founders of the Norwich Society in 1803, and also taught art. He is said to have taken his pupils to the banks of the Yare and exclaimed; 'This is our Academy!' Crome was influenced by Dutch painters of the seventeenth century, especially Hobbema, but he was also inspired by the landscapes of Wilson and Gainsborough.

123. On Mousehold Heath

Crome's debt to Wilson, in the clear and luminous painting of the sky, and Gainsborough (the composition may be based on a drawing by him) is clear in this painting. His fastidious concern for the texture and feel of paint is also here apparent.

Richard Dadd (1817–86)

Dadd was a promising student at the Royal Academy Schools, which he entered in 1837, and already a successful artist with literary and historical subjects, as well as 'fairy' paintings, before he became insane and killed his father in 1843. In the following year he was admitted to Bethlem Hospital, whence he was moved to Broadmoor, in Berkshire, in 1864, where he died. Dadd benefited from the reforming and sympathetic Dr Charles Hood, who became superintendent of Bethlem in 1852. Although his detailed, obsessive 'fairy' paintings have inevitably been associated with his insanity, it is quite likely that, had he led a normal life, his art would not have been substantially different.

162. Contradiction; Oberon and Titania

A photograph of Dadd at work on this picture shows that he worked out the design in detail first and then painted tiny areas at a time. Shakespeare's *A Midsummer Night's Dream* provided suitable material for 'fairy' subjects and had in fact been illustrated by Reynolds and Fuseli as well as Joseph Noel Paton. Dadd may indeed have heard of the success of Paton's *Oberon and Titania* (*Plate 163*) before he started on this picture. He painted it for Dr Hood.

Francis Danby (about 1793–1861)

Danby first worked at Bristol and in the early 1820s painted a number of highly detailed yet emotionally charged landscapes of the Avon Gorge and the environs of Bristol. Between 1830 and 1838 he lived abroad, partly because of a scandal in his private life. He painted some 'sublime' historical landscapes, such as *The delivery of Israel* (1825) and *The deluge* (1837–40), in competition with John Martin and similar to Turner's paintings in this genre. It was, however, his capacity to invest landscape with a richly poetic and poignant meaning which is the most important aspect of his art.

105. An enchanted island

This is a fine example of one of Danby's 'poetical landscapes', and it was enthusiastically received when it was exhibited in 1825. Landscape painting in this period can be divided into those pictures that were concerned with an almost scientific naturalism, such as the work of Constable, and those that were concerned with the expression of imaginative ideas and poetic feelings, such as the work of Danby and Samuel Palmer in particular. Both poetic and factual landscape played an important role in the Romantic movement, and of course the two kinds were not mutually exclusive.

Alan Davie (born 1920)

Davie was born at Grangemouth in Scotland and attended the Edinburgh College of Art in 1937. During the war he wrote poetry and was a jazz musician for a time in the late 1940s. Travel in Italy, Switzerland, France and Spain in 1948–9 brought a full commitment to painting. This bore fruit in the mid 1950s with a powerful series of canvases which drew on his experience of Celtic and primitive art and Byzantine mosaics, as well as on his knowledge of Jackson Pollock's early style and the work of Klee and Picasso. His first major retrospective exhibition was in 1958.

212. Entrance for a red temple, no. 1

Davie's work is not abstract, for it contains a wealth of personal symbolism deriving from his knowledge of Buddhism and Oriental mysticism as well as his own Celtic roots. This painting is gayer and more decorative than his work of the mid 1950s and it demonstrates his emotive reaction to the physical presence of architecture. Although he uses some of the techniques of Abstract Expressionism, Davie is not concerned with communicating the drama of the act of painting, but with expressing in his work the distillation of his intuitive reaction to the magic and mystery of life itself.

William Delamotte (1775–1863)

Born of a French refugee family, Delamotte studied at the Royal Academy and later became a drawing master at a military academy. His early work shows the influence of Girtin. His landscapes, in oil, watercolour and lithography, depicted views both in England and on the Continent.

119. The Thames Valley between Marlow and Bisham

This is a direct oil study of the Thames Valley, comparable in its truth to nature and fidelity of tone to the oil studies by Turner of the Thames and the Wey which have been variously dated between 1807 and 1815, and also comparable to the oil sketches by Constable. Its somewhat block-like brushstrokes can be compared to Constable's painting of Weymouth Bay (*Plate 121*).

Arthur Devis (1711–87)

Devis was a native of Preston and in the 1740s, by which time he had settled in London, he was painting conversation pieces and small portraits. He was considered a minor painter in his day, but the freshness and naïve charm of his work is appreciated today perhaps more than it was in his own lifetime. His style remained constant throughout his career.

50 and 51. Sir George and Lady Strickland at Boynton Hall

Painted in 1751, this picture is more prosaic than the Gainsborough of *Heneage Lloyd and his sister* (*Plate 52*), but it has, none the less, an informal charm and delicacy of colouring which show that Devis was one of the finest exponents of the conversation piece genre.

William Dobson (1611–46)

Dobson was the most talented English-born painter of the seventeenth century. Very little is known about his style before 1642; between 1642 and 1646 he worked at the wartime court at Oxford and his portraits provide a fascinating commentary on the royalists at this troubled period. His style reveals a very strong Venetian influence in both colour and brushwork. Compared with the elegance of Van Dyck, his portraits are blunter and more vigorous and he often introduced learned and allegorical accessories.

31. Portrait of the artist with Sir Charles Cotterell and an elderly man

Dobson is the middle figure, embracing his friend Cotterell, who is looking towards the third unidentified man. The meaning of the picture has not been satisfactorily explained and its enigmatic quality is typical of Dobson's group portraits, which, in their psychological complexity, go even beyond the eighteenth-century conversation pieces which they in some other respects prefigure. The solid and assertive bulk of the three figures is a consistent feature of Dobson's work, as is the finely painted drapery, showing the direct influence of Titian.

33. Charles II when Prince of Wales

Probably painted in 1643 and traditionally said to com-

memorate the Battle of Edgehill. The impression of immediacy and Baroque movement is created by the unconventional cutting off of the figure at the knees; the atmosphere of drama is accentuated by the battle raging in the distance and the piling up of accessories, amongst them a Medusa's head.

William Dyce (1806–64)

Dyce was encouraged by Thomas Lawrence to take up painting as a career. He made a number of visits to Rome, where he was strongly affected by the work of the German Nazarenes, Overbeck and Cornelius. In his love of a clear and detailed surface in painting he comes close to the Pre-Raphaelites, with whose ideals he sympathized. He painted frescoes for the House of Lords and was a favourite painter of Prince Albert, as well as being involved with the Government Schools of Design, of which he was director from 1840 to 1843.

127. Neptune resigning to Britannia the Empire of the Sea

Commissioned in 1846, when Dyce was working on his Westminster frescoes, the subject was chosen by Queen Victoria and Prince Albert as appropriate for their 'marine residence'. The design, which has sources both in Raphael's *Galatea* and in Dyce's admiration for Poussin, was first exhibited as a sketch at the Royal Academy in 1847, when the prince 'thought it rather nude, the Queen, however, said not at all'. Dyce suffered from Prince Albert's supervision during the painting of the fresco, writing to C. W. Cope; 'When you are about to paint a sky seventeen feet long by some four or five broad I don't advise you to have a prince looking in upon you every ten minutes or so.'

Anthony van Dyck (1599–1641)

Van Dyck, a Flemish painter, was born in Antwerp and between 1618 and 1621 he worked as principal assistant to Rubens, on whom his brilliant early style was based. In 1620 he entered the service of James I, but in 1621 he left London with leave of absence to study in Italy; he defaulted from the king's service and remained in Italy from 1621 to 1627, spending longest at Genoa. He lived from 1627 to 1632 in Antwerp. In 1632 he returned to England and was received into royal service with great favour; apart from two visits to Flanders in 1634 and 1640 he remained in England till his death. His stay redirected the course of English painting; he brought to his interpretation of the ethos of the court of Charles I a new elegance and refinement, both of composition and brushwork and a new sympathy with the poetic sensibilities of those around him.

18. Henrietta Maria with her dwarf

The queen is shown with her dwarf, Jeffrey Hudson, and her pet monkey, Pug. The composition and the accessories that Van Dyck introduced here—the column, the grand curtain of falling drapery, and the orange tree—were to be endlessly repeated by later portrait painters (*Plate 77*). The influence of his brilliant painterly surface and delicacy of pose and gesture may be seen at its best in the full-lengths of Gainsborough (*Plate 100*).

22. Charles I hunting

Probably painted in 1635, this is a brilliant interpretation of the traditional Stuart hunting picture; compared with Peake's painting (*Plate 21*), Van Dyck stresses, with a new dramatic realism, not the picture of the hunt but Charles's nobility of appearance; he is shown as the perfect cavalier, in a relaxed and elegant pose, which none the less suggests unquestioned authority. The horse is based on Titian and the composition on a detail from a Rubens oil sketch of *Roma Triumphans* in the Constantine Cycle (The Hague, Mauritshuis).

23 and 25. George, Lord Digby, and William, Lord Russell

Probably painted about 1633. Lord Digby is shown with attributes which stress his scholarly leanings; Lord Russell, who later fought on the Parliamentary side at Edgehill but joined the king in 1643, has the armour of a soldier at his feet. The colours and poses underline this contrast, the bright red of Russell's dress against Digby's sober black. The shallow space and flowing rhythms are characteristic of Van Dyck's group portraits.

28. Cupid and Psyche

Probably painted about 1639–40. The painting shows Cupid discovering Psyche asleep after she had opened the box of beauty brought to her by Proserpine. It was possibly intended as part of a projected decorative scheme for the Queen's Cabinet at Greenwich. Van Dyck's love for the poetry of Titian is here apparent; the delicacy and tenderness of both colour and touch lead on to the rococo, and remind one of the pastoral mood of Gainsborough.

William Etty (1787–1849)

Etty trained from 1807 at the Royal Academy Schools and in the studio of Lawrence, remaining a lifelong student at the R.A. life classes and a frequent copyist of the Venetians and Rubens. Uniquely in British nineteenth-century art, his career was dedicated to the depiction of the female nude, both in casual sensual sketches and—more successfully with the Victorian audience—in allegorical and history painting supporting the ideals of the academic tradition. His work was admired especially for its colour, and Etty himself spoke of the art of Venice as 'the hope and ideal of my professional life'.

128. Female nude (Leda)

This spontaneous oil sketch, probably painted between 1825 and 1830, is clearly taken from the life but based on the pose of Michelangelo's *Leda*. Etty would have been particularly familiar with this design because of the recent gift to the Royal Academy, in 1821, of Rosso's large cartoon after the Michelangelo.

Hans Eworth (working 1540–73)

Hans Eworth was born in Antwerp; he is recorded as a member of the Antwerp Guild in 1540 and later worked in England from 1549–73. Mary I appointed him official portraitist; he lost royal patronage in the early years of Elizabeth's reign but regained it in 1572. Eworth's style is most deeply indebted to Holbein with hints of the influence of Fontainebleau, Christoph Amberger and Antonio Mor; his early portraits are distinguished by their vigorous realism and sense of character; in his later years he moved towards a more highly patterned and decorative style.

6. Mary Neville, Baroness Dacre

The small Holbeinesque portrait in the background is of the sitter's first husband, Lord Dacre, who was hanged for murder in 1541. Eworth here emulated the solid monumental figures and lavish accessories of Holbein's earlier English period; the pose is based directly on that of Erasmus or Warham. However, compared with the spatial clarity of Holbein's *Sir Thomas More* (*Plate 2*), Eworth's style already shows a tendency to stress the surface.

John Ferneley (1782–1860)

Apprenticed to his father, a wheelwright, Ferneley's earliest works were probably on wagon and coach panels, until, sponsored by the Duke of Rutland, he went to London in 1801 to study under the sporting painter, Ben Marshall. In 1814 he settled in the hunting district of Melton Mowbray, working largely for private patrons. Ferneley is particularly noted for his 'scurries', long narrow shaped canvases recording hunting incidents.

133. Carriages outside Apsley House

Ferneley was one of the most prolific and successful of British sporting artists, capturing in his paintings the elegance and romance of the upper classes' preoccupation with horses and country life. He visited London each year where he painted portraits of horses and of horses and carriages in the fashionable districts of London, such as the east end of Hyde Park.

Samuel Luke Fildes (1844–1927)

Before exhibiting at the Royal Academy, Fildes worked for *The Graphic* and other magazines, whereby his name became known to Charles Dickens, who commissioned him to illustrate *Edwin Drood*. *The Graphic*, a periodical much concerned with social observation, was an important influence on Fildes, who became famous between 1870 and 1890 for a series of large social realist paintings of a highly emotive nature. He visited Italy in 1875 and also painted Venetian fancy pictures, though his greatest financial success was achieved in portraiture, including a number of royal commissions.

147. Applicants for admission to a casual ward

Fildes first produced this composition and subject matter as a drawing entitled 'Houseless and Hungry' and, published in *The Graphic* of 1869, it was this particular design which led to Dickens's interest in the young artist. When the large canvas was exhibited five years later it was accompanied by a quotation from Dickens's description of the scene outside the Whitechapel Workhouse in 1855; 'Dumb, wet, silent horrors! Sphinxes set up against that dead wall, and none likely to be at pains of solving them until the *general overthrow*.'

William Teulon Blandford Fletcher (1858–1936)

Trained at South Kensington and the Belgian Royal Academy, Fletcher visited Brittany where he met Stanhope Forbes, who became a lifelong friend, and Bastien-Lepage, whose type of sentimental social realism profoundly influenced his own. Returning to England, Fletcher painted with Forbes and the Newlyn school in Cornwall, exhibited at the Academy from 1884 and found a niche in late Victorian art with successful Academy paintings like '*When the evening is low*' (1888) and *Under petticoat government* (1892). For the last thirty years of his life he lived quietly in Surrey, painting portraits and landscapes, as well as subject pictures.

146. Evicted

The almost photographic quality of the representation strikes the well-tried Victorian chord of anecdotal pathos, and provoked Gladstone's admiration at its Academy showing in 1887. Fletcher's friendship with Stanhope Forbes (1857–1947) and his admiration for the influential watercolour style of Fred Walker (1840–75), combined with the influence of Lepage, moulded his work as it developed from its early Pre-Raphaelite tendencies through the Newlyn period to the mature, full-coloured genre work, for which he was best known, well-painted and always with a tear at the corner of its eye.

Lucian Freud (born 1922)

Grandson of Sigmund Freud, his first ten years were spent in the extraordinary ambience of Berlin, until the family came to England in 1932. By the age of seventeen Freud was mixing with London writers, artists and collectors, and was drawing a great deal. Invalided out after five months wartime service in the merchant navy, and with minimal formal art training, the end of the war allowed him to explore and absorb Paris and Greece. Otherwise his commitment has always been to London, and specifically to the seedy, run-down areas in and around Paddington, where he still lives.

206. Girl with a rose

Freud's base as an artist is in drawing, and even when he started to use paint it was dry and spare, with an obsessive emphasis on the flat linearity of the image, little three-dimensional space behind the subject and, as here, often a sense of anxiety conveyed in the taut line. Although this is an early, restrained example, the roses too are typical of a number of paintings in which plants take on an overpowering presence, looming over and dwarfing the human subject.

William Powell Frith (1819–1909)

In a curious reversal of the normal situation, Frith was forced against his will by ambitious parents to take up painting; a fact which possibly explains his commercial attitude to art. In the 1840s he was a member of the rebellious 'Clique', which reacted against the conservatism of the Royal Academy, and first painted historical and literary genre scenes. Inspired by the Pre-Raphaelites, he took up modern life subjects in the 1850s, producing such well-known works as *Derby Day* (1858; Tate Gallery) and *The railway station* (1862; Royal Holloway College). He also painted moral subjects such as the *Road to ruin* series (1878), an up-dated version of Hogarth's *Rake's progress*.

142 and 143. Life at the seaside (Ramsgate Sands)

The first studies for this painting, Frith's first major modern life subject, were made in 1851 after a holiday spent at Ramsgate. It was exhibited at the Royal Academy in 1854 and was bought by Queen Victoria. Frith's acute and on the whole unsentimental observation gives us a fascinating insight into Victorian social life, though it is difficult to believe that so many people crowded on to the beach at Ramsgate at one time.

Henry Fuseli (1741–1825)

Fuseli was brought up in Zurich but came to England in 1764. He at first concentrated on writing but Reynolds encouraged him to become a painter and he was in Rome from 1770 until 1778. Subsequently he settled in London and became professor of painting at the Royal Academy in 1799 and keeper in 1804. His intellectual vigour and volatile temperament produced an art that in its energy and almost surrealist quality made an important early contribution to Romanticism.

87. Silence

Painted about 1799–1801, this personification of sorrow is similar to a figure which appears in Fuseli's painting of *Melancholia*, an illustration to Milton's *Il Penseroso*, part of his vast Milton Gallery project, which he worked on throughout the 1790s in emulation of Boydell's Shakespeare Gallery. Fuseli was obsessed with sexual power and dominance in women, but here he uses a female figure to express a mood of complete desolation. He employed the human figure as his sole vehicle of Romantic expression, and in this can be compared with Blake (*Plate 111*). There are poses similar to this figure in the work of Blake.

88 and 90. Macbeth, Banquo and the witches on the heath

Fuseli had translated *Macbeth* into German whilst still in his teens in Switzerland and it was this play above all others which provided him with a continuous source of inspiration. This painting was one of four he did in 1793–4 for Woodmason's *Shakespeare Gallery*. The figures of Macbeth and Banquo show Fuseli's debt to Michelangelo and possibly Salvator Rosa, but their frenzied eyes and the arresting image of the witches illustrate the taste for horror and flesh-tingling sensation which was current in England at the time, and which has its literary counterpart in the Gothic novels of Anne Radcliffe and Matthew Gregory 'Monk' Lewis.

Thomas Gainsborough (1727–88)

Gainsborough was born at Sudbury in Suffolk, the son of a wooltrader. He studied in London (1740–8) under Hubert François Gravelot at the St Martin's Lane Academy and came into contact with Francis Hayman. He returned to East Anglia in 1748 and worked at Ipswich, producing landscapes and

portraits. In 1759 he moved to Bath and became the most successful portraitist there until he came to London in 1774, where he remained until his death. In the 1780s he began to diversify his subjects, producing 'fancy' pictures, seascapes and more 'sublime' landscapes, and paintings on glass (Victoria and Albert Museum) as well as portraits.

52. Heneage Lloyd and his sister

This is more lyrical and pastoral in mood than the conversation piece by Devis (*Plate 50*). The landscape background, with its silvery tones, is reminiscent of the work of the seventeenth-century Dutch landscape painter, Wynants—Gainsborough knew the work of Dutch painters well because in his youth he worked on repairing paintings for the art trade—and the figures have more than a hint of the portraits of Hayman. But Gainsborough, even in this relatively early painting of about 1750–2, is able to rise above his sources to produce a completely original composition of great delicacy.

75 and 76. John, 4th Duke of Argyll

Exhibited at the Society of Artists in 1767, this painting shows the duke in peer's robes holding the staff of Hereditary Grand Master of the Household. It is of necessity a portrait in the Grand Manner, complete with classical vase and aristocratic trappings, but it shows, even in Gainsborough's middle period, his wonderfully free and personal treatment of the drapery with the 'hatchings and scratchings' which were to become even more pronounced later in his career.

97 and 100. Madame Baccelli

Exhibited at the Royal Academy in 1782, the painting is of Giovanna Baccelli, the famous dancer, who was the mistress of the 3rd Duke of Dorset. It shows Gainsborough's ability, late in life, to evolve original and striking compositions. It also demonstrates the complete harmony between sitter and background which Gainsborough achieved throughout his life. Here this is largely due to the glittering brushstrokes, which weld into a visual unity the dress and the trees behind. Reynolds admired in particular this quality of harmony in the whole composition, which he said Gainsborough achieved by working on all areas of the picture together.

101. The market cart

After 1783 Gainsborough did not exhibit at the Royal Academy following a quarrel over the hanging of his portraits. This painting was exhibited in 1786 at his own residence, Schomberg House, in London. One of his late 'pastorals', influenced by the landscapes of Rubens, it shows Gainsborough's tendency in the 1780s to monumentalize his compositions. Compared with Constable's *Cornfield* (*Plate 102*), it has a generalized, almost timeless quality, suggesting a golden age of rustic tranquillity.

Henri Gaudier-Brzeska (1891–1915)

Born near Orleans, son of a carpenter, Gaudier studied in England and Germany (1906–9) drawing and sketching constantly. Returning to Paris, he met Sophie Brzeska in 1910, Polish and twenty years his senior, who supported his decision to become a sculptor. They moved to London and Gaudier studied

art in museums, and, though impoverished, started to meet artists and writers, including Epstein and Katherine Mansfield. In 1913 he met Roger Fry, Frank Harris and Ezra Pound, who introduced him to Vorticism; Gaudier contributed to both issues of *Blast*, 1914–15. Serving in the French army, he was killed in action in June 1915; Sophie Brzeska organized a memorial exhibition in 1918. A large collection of his work is now at Kettle's Yard, Cambridge.

185. Portrait of Horace Brodzky

Gaudier invited Brodzky to a meeting in January 1913, and they became close friends. Gaudier drew and sculpted portraits of him; this pastel is inscribed in Polish, 'to my friend Brodzky'. Fauve in the pitch of its colour, Gaudier's sculptural pre-occupations are clear in the strong planes, constructed more than drawn; but the acid yellows and greens on the face, complemented by the predominantly orange-reds of the jacket, reveal his interest in colour, evident too in his choice of sculpture materials like red Mansfield stone, veined marbles and alabaster. The dynamic composition advocated by Wyndham Lewis is here highly decorative, the background near to abstraction.

Mark Gertler (1891–1939)

Brought up in the tightly enclosed East End Jewish community, Gertler was apprenticed in a stained glass works until his introduction to William Rothenstein led to the Slade. He won prizes and joined the circle of Nevinson, Wadsworth and Roberts, exhibiting for the first time in 1911 at the Friday Club. A pacifist, he did not serve in the war, and mixed with writers, some of the Bloomsbury Group and the most progressive factions in English art. He showed with the London Group from 1915, who with Roger Fry championed his work. The first attack of turberculosis was in 1920, almost preventing his first one-man show at Goupil's in 1921, and with continuing ill-health and financial worries through the twenties and thirties, Gertler took his life in June 1939.

189. Merry-go-round

Painted in 1916, *Merry-go-round* was a bitter comment on the war and the society which produced it. The intense colour and schematized forms frozen into mechanistic regularity have a deceptively naïve, decorative gaiety until the expressions are read and the implications of the inexorable round are understood. Gertler's painting was always figurative—much of his earlier work was on specifically Jewish themes—and he became concerned increasingly with surface pattern, balancing weighty figures with densely covered backgrounds, all meticulously painted.

Marcus Gheeraerts the Younger (1561–1635)

Marcus Gheeraerts lived in England from 1568; his father was a painter and Isaac Oliver was his brother-in-law. He probably visited Antwerp in the 1580s. From about 1592 until about 1617 he dominated English portrait painting, backed by the powerful patronage first of Queen Elizabeth and later of Anne of Denmark; he became less fashionable after the arrival of Van

Somer and Mytens. Gheeraert's portraits are more realistic than the highly decorative works of Hilliard's school, which had flourished in the seventies and eighties; his full-length figures, often in novel open-air settings, stand more firmly in space.

12. Elizabeth I

Painted for Sir Henry Lee, this portrait is traditionally said to commemorate an entertainment that he held in the queen's honour at his home in Ditchley in 1592; the queen's feet are placed near Ditchley on the globe of the world. The sonnet, probably by Lee, explains the symbolism of the sun and thunder, images of Elizabeth's power and emblematic of her leading England from strife into peace. Gheeraert's realistic style—apparent in his sympathetic description of the queen's ageing face—is here successfully fused with the decorative qualities of the native school which transform the painting into an hieratic image of spectacular splendour.

Spencer Frederick Gore (1878–1914)

A student at the Slade with Gilman (1896–9), Gore was introduced to Sickert in Neuville by Albert Rothenstein in 1904 and worked in Paris and on the Normandy coast at Dieppe and Neuville from 1904 to 1906. Returning to London, Gore was a founder-member of the Fitzroy Street and of the Camden Town Group, of which he was made first president in 1911. Fry's first Post-Impressionist exhibition in 1910 revealed Cézanne to him; he himself was in the second Post-Impressionist exhibition. He shared an exhibition at the Carfax Galleries in 1913 with Gilman, was elected a member of the London Group, and arranged a Camden Town Group show at Brighton, 1913–14, just before his death in March 1914 at home in Richmond.

181. Nude female figure on a bed

Painted in 1910 at 31 Mornington Crescent, Gore's *odalisque* reclines in an unmistakably Fitzrovian manner. The severe bars of the bedstead are a foil to the generous proportions of the nude, which looks back gratefully to French and classic precedents, though the paint surface is not quite successful in rendering the play of light on the figure. Gore, like Sickert, was a music hall fan, and painted and drew many variations on the theme, as well as landscapes and the Camden Town staples of interiors and nudes.

David des Granges (1611 or 1613–about 1675)

David des Granges, who began his career as an engraver, is best known as a miniature painter. He was employed by Charles I and Charles II when in Scotland.

29. The Saltonstall family

This painting shows Sir Richard Saltonstall (died 1650) at the bedside of his wife immediately after the birth of their child. It has an attractive naïve charm and delicacy unusual at this period and reminiscent of Cornelius Johnson.

Duncan Grant (born 1885)

Grant lived in India until he was eight. He studied at Westminster School of Art; in Italy, where he was captivated by the Italian primitives; in Paris under Jacques Emile Blanche, and at the Slade School in London. He worked in Roger Fry's Omega Workshop, producing decorative designs on furniture, and he was much influenced by Fry's ideas on art. He was closely associated with the Bloomsbury Group and in particular with the work of the painter Vanessa Bell. He has lived at Firle, in Sussex, for many years.

196. Venus and Adonis

Painted in about 1919, this picture was owned by Lytton Strachey, with whose family Grant stayed when young. Although Duncan Grant has always been concerned with using paint to suggest form and volume, his greatest gifts are as a colourist and in his talent for decorative pattern. These can be seen in this painting, partly derived from his knowledge of Matisse, but inspired also by his admiration for such earlier Italian artists as Piero della Francesca.

John Atkinson Grimshaw (1836–93)

Born in Leeds, Grimshaw developed an interest in townscapes, often painting scenes of docks or streets by moonlight or gaslight, and his subject matter and style remained consistent throughout his career. The settings of his paintings depict various areas in which he lived in Leeds, Scarborough and London, where he took a house in Chelsea. Grimshaw rarely exhibited, having established many private patrons.

151. View of Heath Street by night

Grimshaw's 'nocturne' effects were admired by Whistler, but this painting of Hampstead is far less experimental or original than Whistler's work, proving popular with the public rather more for its sense of specific location. The artist was interested in photography and sometimes used a camera obscura to project images on to his canvas.

Richard Hamilton (born 1922)

Hamilton at fourteen started alternating art school—Westminster Technical, St Martin's, Royal Academy and Slade—with jobs in advertising, display and as an engineering draughtsman. He exhibited from 1950, and organized exhibitions on themes like 'Growth and Form' (1951) and 'This is Tomorrow' (1956). In 1952 he began teaching at the Central School (later at Newcastle and the Royal College), and with Reyner Banham, Lawrence Alloway, Eduardo Paolozzi and others formed the Independent Group at the Institute of Contemporary Arts, which gave birth to English Pop art. He published his edition of Marcel Duchamp's *Green box* in 1960, and reproduced Duchamp's *Large glass* in 1965–6 (Tate Gallery); he visited America first in 1963 and won joint first prize in the John Moores competition in 1969. He lives in London.

216. Interior II

The intention of Pop art was to break down barriers between conventional art and popular taste: to do this it exploited the media, advertising and commercially packaged consumer goods. The result has been that Coke and Campbell's soup,

toasters and hamburgers have been transformed into modern icons, potent symbols of mass dreams, while most Pop images of them remain an in-joke to the, admittedly numerous, minority of the initiated. This *Interior*, starring Patricia Knight, is redolent of 1964—its cinema, magazines, status goods—but is also an exploration of space and a statement on the nature of modern values.

Francis Hayman (1708–76)

First employed as a scene painter at Drury Lane, Hayman produced a number of book illustrations, notably for Hanmer's edition of Shakespeare (1744), in collaboration with Hubert François Gravelot, as well as being the major contributor to the Vauxhall Gardens painted decorations. He was the president of the Society of Artists from 1766 to 1768 and became librarian of the Royal Academy in 1771. He had a finger in most of the artistic pies of his time.

53. The see-saw
This is one of the decorative pictures which Hayman painted for Vauxhall, the pleasure gardens opened by Jonathan Tyers in 1732. These included rustic and urban genre scenes, illustrations to Shakespeare and popular history pictures. Hayman provides a realistic and coarser version of the *fête galante* scenes of Watteau. Considering that the pictures painted for Vauxhall decorated supper-boxes and other relatively temporary structures, it is lucky that a good number have survived as an example of the more popular decorations of the 1730s and 1740s.

Nicholas Hilliard (1547–1619)

Hilliard was trained as a goldsmith but by the early 1570s was established as a miniaturist with royal and aristocratic patronage; he worked for the English court throughout his life apart from a visit to France in 1576–8. He is the most important native artist of the sixteenth century and one who gave perfect expression to the atmosphere of courtly chivalry that surrounded the Elizabethan court. His style remains closely connected with that of medieval manuscript illumination, as is apparent in his dislike of shadow and his jewel-like colours.

9. An unknown youth leaning against a tree amongst roses
This miniature bears an inscription, which may be translated, 'My praised loyalty brings my penalty,' and is from Lucan's *De Bello Civili* VIII. The lovesick courtier leans against the tree, surrounded by roses, a common Elizabethan symbol of the joys and pains of love; miniatures were often used as part of the ritual of courtly love and this one in particular seems to capture the spirit of Elizabethan lyric poetry. It may be dated to about 1588, and initiates a series of full-length miniatures painted between 1590 and 1598.

10. A man clasping a hand from a cloud
A work of Hilliard's maturity, this is one of a series of portraits of elegant Elizabethan courtiers. The meaning of the clasped hands and inscription is not now clear, but such elusive emblems are common in miniatures and increase their refreshingly personal quality.

Ivon Hitchens (born 1893)

A painter's son, Hitchens studied at the Royal Academy under Orpen and Sargent. Elected a member of the Seven and Five Society, he met Ben Nicholson in 1924; his first one-man show was at the Mayor Gallery, 1925, and he was elected a member of the London Group, 1931. In 1940 he moved to Sussex where he still lives. There have been a number of large mural and decorative commissions since the twenties, including a backdrop for Covent Garden, 1956, and a mural for Sussex University, 1963. His first retrospective was in Leeds in 1945, followed by a Tate retrospective in 1963; a monograph by Alan Bowness was published in 1973.

210. Poppies in a jug
Painted in a brief interlude of naturalism in his progression towards near (but never total) abstraction, the *Poppies* celebrate colour, as did Matthew Smith, worthy of Matisse. Hitchens's usual format is a horizontal double square, ideal for landscape; by the forties he had developed the typical broad sweeps of colour, brushed boldly on to the canvas, in colours always related to natural earth, leaf and sky tones, and in rhythms aware of aural and visual music. Occasionally figures intrude, but generally his devotion to his Sussex landscape produces studies filled with vigorous motion, concerned with the qualities of individual colour areas as they flow together or oppose each other.

David Hockney (born 1937)

From Bradford, Hockney was at the Royal College (1959–62), rapidly achieving his first one-man show at the Kasmin Gallery in 1963. Critical recognition and popular success brought him a *Sunday Times* commission for a series of Egyptian drawings, art school teaching and his first visit to Los Angeles the same year. He travelled widely, taught at American universities (1964–7) and worked on a long series of Californian paintings. Major exhibitions in London (Whitechapel Gallery, 1970) and in Paris (Musée des Arts Decoratifs, 1974) have confirmed an international reputation; he at present lives in Paris.

217. Portrait of Sir David Webster
Hockney's formal portraits are severe, clinical examinations of the subject and his environment, and have a hieratic stillness that is an evocative amalgam of dynastic Egyptian and Californian modern. This portrait, of the administrator of the Royal Opera painted just before his death in 1971, like that of *Ossie Clark and Celia Birtwell* in the Tate Gallery, is an exercise in formal relationships; colour areas, forms and figure are controlled with precise placing and tight line characteristic of Hockney, a brilliant draughtsman and etcher.

220. A bigger splash
The largest of three splash paintings (1966–7), it is enigmatic and empty of figures, the rigidly painted, archetypal Californian

setting barren in the harsh, bright light. Painted from a photograph, it freezes a sunny instant with precision. One of the best-known of Hockney's paintings, it reflects his involvement with Pop art and his preoccupations as a painter: the representation of three dimensions on two, the action of light on colour, the use of an arid acrylic paint surface, here drily used for a large expanse of wetness.

William Hogarth (1697–1764)

After apprenticeship to a silver-plate engraver, Hogarth set up as an engraver on his own about 1720. By 1730 he had begun to paint conversation pieces. His *Harlot's progress*, the first of his engraved series of 'Modern Moral Subjects', was published in 1732. A more conventionally moralistic tone is introduced in 1747 with his *Industry and idleness* series, and in 1753 he published an art treatise, the *Analysis of Beauty*. His last great series, *An election*, of 1754, was a satirical send-up of corruption and chaos in the whole community.

84 and 86. A scene from The Tempest

Shakespeare's plays were an almost infinite source of inspiration for painters, especially in the second half of the eighteenth century, as well as for book illustrators. This is a comparatively early example, painted about 1730–5, and shows Hogarth's tendency to be in advance of his times with regard to subject matter. It is also, in the figure of Caliban on the right, an early example of the taste for the weird and horrific which later reappears in the work of Fuseli (*Plates 88 and 90*), Barry and Mortimer.

61 and 62. Lord Hervey and his friends

John Hervey is standing with the key of the Vice Chamberlain to the Queen at his waist. A typically Hogarthian satirical note is introduced with the Reverend Peter Louis Wilman toppling off his chair in his eagerness to view through a telescope the village where he had been promised a living. The painting has all the delicacy associated with Hogarth's conversation pieces, as can be seen from the unusual detail of the basket of flowers. It was one of his latest essays in this genre and was painted about 1737.

72. Thomas Herring, Archbishop of Canterbury

Herring, who was Archbishop of York when this picture was painted, wrote that 'none of [his] friends could bear [the] picture', but it is one of Hogarth's most sensitive portraits and Herring's remark perhaps illustrates the fact that Hogarth was unwilling to flatter his sitters. The treatment of the lawn sleeves has a French painterly refinement often found in English painting of this period and the colours are softer and more pastel than is usual in Hogarth's work. It is, however, a good example of the down-to-earth grand style which looks forward to the portraiture of Reynolds.

59 and 63. Marriage à la mode IV: The countess's morning levée

The countess, whose husband has succeeded to the earldom, is pursuing her intrigue with the lawyer, Silvertongue, on the right of the picture, and he is suggesting a visit to the Masquerade.

The various over-sophisticated fashions in High Life are suggested by, amongst other things, the Italian castrato singer, left, and the hideous ornaments in the right foreground. In this series, elegantly engraved by French craftsmen and published in 1745, Hogarth's main purpose was to attack the marriage of convenience and the greed and tastelessness of fashionable life, whereas his earlier series, the *Harlot's progress* and the *Rake's progress*, were aimed at a lower level of society. *Marriage à la mode* was not as successful as his earlier series, probably because the message was too near the bone for prospective purchasers.

60 and 64. An election: Polling

This series, painted about 1754, is a grand summing up of Hogarth's satirical observation. The painting is handled broadly and fluently, but without sacrificing an abundance of telling detail. All the sections of society are comically yet harshly dealt with, from the candidates down to the mindless, sick or blind voters. The treatment of such figures suggests that Hogarth's position at the end of his career was one of unrelieved cynicism for humanity as a whole, made all the more poignant by his concern with morality and all the more acute by his ability to convey human character through gesture and expression.

Hans Holbein (1497–1543)

In 1514 Holbein went to Basle and worked initially as an engraver. He first visited England from 1526 to 1528 and stayed with Sir Thomas More in his house at Chelsea. He returned to settle in England in 1532 from a Basle racked by the religious strife of the Reformation. His first patrons in London on his second visit were the merchants of the Hansa Steelyard, but after 1536 he became the official court painter until he died in London of the plague. It was the realism of his style which was his great contribution to British painting. At the end of the seventeenth century John Evelyn wrote; 'Holbein really painted to the life beyond any man this day living.'

1. Henry VIII

This is the only certain painting of the king by Holbein, done in 1537. It possibly at one time formed one side of a diptych with the portrait of Jane Seymour now in the Mauritshuis in The Hague. There is a linear quality about this portrait, with its precise portrayal of the jewelled and patterned doublet and the rather two-dimensional rendering of Henry's cruel face, that looks forward to later portraits of Queen Elizabeth (*Plate 5*).

2 and 4. Sir Thomas More

Sir Thomas More, who was Holbein's first patron in England and at whose house the artist stayed between 1526 and 1528, was chancellor (1529–32) to Henry VIII and was executed for treason in 1535. Here he is shown wearing a chain that was an emblem of service to the king. The monumentality, the sense of character and clarity of space, together with the sure relationship of detail to the composition as a whole, are characteristic of Holbein's early English period and mark this painting as one of his masterpieces.

3. Henry VIII (cartoon)

The painting for which this cartoon was drawn was commis-

sioned by Henry VIII in 1536–7 for the Privy Chamber in the New Palace of Whitehall. This painting was destroyed in the fire of 1698, and the cartoon itself is only a fragment of the composition, but a copy by Leemput in the royal collection shows that in the finished painting Henry VIII was shown full-face, the model for many single portraits of the king, of which good examples exist in the Walker Art Gallery, Liverpool, and Belvoir Castle. In the cartoon Henry is shown three-quarter face, as in the Thyssen Collection portrait (*Plate 1*). The complete painting showed the king with his third wife, Jane Seymour, and his parents, Henry VII and Elizabeth of York.

Arthur Hughes (1832–1915)

Trained under Alfred Stevens and at the Royal Academy, Hughes was influenced by the ideas of the Pre-Raphaelites after reading their magazine, *The Germ*, and meeting members of the group. Though never a member of the Brotherhood, Hughes worked with Rossetti and Burne-Jones on the Oxford Union frescoes in 1858, and his earlier work shares their glowing colour and the exquisite detailed rendering of textures and fabrics. In later years Hughes produced many book illustrations and the subject matter of his painting became less narrative and more lyrical in mood.

140. The long engagement

This painting was originally exhibited untitled with a quotation from Chaucer; 'For how myght ever sweetnesse have be known to hym that never tastyd bitternesse.' Hughes introduces into this emotional 'problem picture' of modern life a gentle symbolism in the flowering dog rose, the evergreen clinging ivy and the faithful dog.

William Holman Hunt (1827–1910)

Hunt had a dour sense of purpose, but no easy facility. He met Millais in 1844 and a friendship between them developed which led to the founding of the Pre-Raphaelite Brotherhood with Rossetti. Hunt had been inspired by Ruskin's *Modern Painters*, with its emphasis on truth to nature and the excellence of the early Italian masters. His picture, *Rienzi*, was exhibited at the Royal Academy in 1849, and with Millais's *Lorenzo and Isabella* and Rossetti's *Girlhood of the Virgin Mary* it launched the Pre-Raphaelite movement. In 1854 Hunt visited the Holy Land, where he painted the disturbing, but unsuccessful, *Scapegoat*. He remained faithful to the original principles of the movement throughout his career, and was the only member of the Brotherhood to do so.

136. The awakening conscience

This was the first of the Pre-Raphaelite Brotherhood's modern moral subjects to be exhibited; Hunt was moved to the theme after reading of Peggotty's search for his fallen Emily in *David Copperfield*. Each meticulously painted detail in the room, such as the cat tormenting the bird, the score of Tennyson's 'Tears, Idle Tears' on the floor, the design of the wallpaper and the glittering newness of the furniture is intended to enforce the earnest morality of the work, and was so recognized by Ruskin who described the interior as, 'common, modern, vulgar . . . but tragical if rightly read'. One critic, however, complained that the picture was 'drawn from a very dark and repulsive side of domestic life'.

139. Our English Coasts, 1852 ('Strayed Sheep')

Although popularly known by the title 'Strayed Sheep', Hunt himself never called it by this name. It may contain Christian symbolism in the roaming and endangered sheep, but it is first and foremost one of the finest pure landscapes painted in the highly detailed Pre-Raphaelite style. The treatment of the sunlight and the jewel-bright colours make it one of Hunt's masterpieces.

Julius Caesar Ibbetson (1759–1817)

Ibbetson was born in Leeds and first employed at Hull in the painting of ships' figureheads. He moved to London, where he worked for a picture restorer, and in 1787 was appointed draughtsman to the first British Mission to Pekin. For the rest of his life he was an itinerant artist in Britain beset by recurrent financial troubles. He eventually moved to the Lake District in about 1800 and he died in Masham in Yorkshire. He painted genre scenes and 'picturesque' landscapes, both in oil and watercolour, in a style which owes something to George Morland and de Loutherbourg.

114. The mermaids' haunt

Ibbetson's bland pastoral landscape genre is here enlivened, unusually in his work, by the presence of a female bathing party. Such quasi-mythological paintings were common in French and Netherlandish painting of the seventeenth and eighteenth centuries, but very rare in England. Another unexpected example is Gainsborough's freely painted *Diana and Actaeon* in the royal collection.

Augustus John (1878–1961)

Born at Tenby, in Wales, the brother of Gwen John, he studied at the Slade School from 1894 to 1898 at a time when the Slade had taken over from the Royal Academy Schools as the training ground for young *avant-garde* artists. John was a member of the New English Art Club. His early scenes of figures in landscapes, partly inspired by the Fauves, are brilliantly coloured and lyrical in mood. His work, throughout his life, is characterized by that fluent and dashing brushwork which seems to complement the self-consciously Bohemian life he led. Although his later work, mainly portraiture, lacks his early brilliance, some of his portraits, such as that of *Madame Suggia* (1920–3; Tate Gallery), are compellingly dramatic images.

184. George Bernard Shaw

John was elected an associate of the Royal Academy in 1921 and this painting was exhibited there in the following year. Although elected R.A. in 1928, he resigned ten years later, only to be re-elected in 1940. This portrait of Shaw shows John's outstanding draughtsmanship and his ability to draw with the brush directly on to the canvas.

Gwen John (1876–1939)

Gwen John's fastidious and timidly courageous nature was in complete contrast to the extrovert bohemianism of her brother, Augustus John. Trained at the Slade School, she moved to Paris and studied at Whistler's school. She was a devoted admirer and friend of the sculptor Rodin, and became a committed member of the Roman Catholic Church in 1913. She rarely sold, or wished to sell, her paintings, and their tense, private and reticent quality reflects her own determination 'to make something rare and delicate with our lives'.

175. Self-portrait in red

Painted about 1900, this is a typical example of the artist's gifts as a portrait painter. It shows how, in sensitive hands, a restrained academicism can still be charged with feeling and psychological intensity.

Cornelius Johnson (1593–1661)

Cornelius Johnson was born in London although his family had fled from Antwerp; his early style is closely associated with that of the Netherlandish artists already established in London. He retired to Holland in 1643 and died in Utrecht in 1661. His portraits are distinguished by a tender and sensitive approach to his sitter and by a subtle use of silvery grey tonalities.

32. The family of Arthur, Lord Capel

In the attempt at grandeur and elegance and the use of elaborate accessories this group shows the influence of Van Dyck on Johnson in the 1630s; none the less the portrait still reveals the charm of his own more hesitant and domestic interpretation of character. Lord Capel, a loyal royalist, was executed in 1649.

Thomas Jones (1742–1803)

Thomas Jones painted classical landscapes somewhat in the manner of Richard Wilson, under whom he studied. Today he is best known for his *Memoirs*, which provide a delightful insight into the life of British painters and tourists in Italy, where he stayed from 1776 until 1783. He also painted a number of direct oil studies from nature, both in Wales and also in Italy and especially in Naples, which in their fresh and 'uncomposed' quality look forward to the oil studies of Constable, though the latter is unlikely to have seen them. After his return from Italy Jones gave up painting as a professional career and looked after his estate at Pencerrig in Wales.

85. The bard

The subject is taken from Thomas Gray's poem of the same title, published in 1757. It tells of how the Celtic bards of Wales were ruthlessly massacred by Edward I's invading army until only one remained in defiance until he too plunged to his death. The painting, as well as the poem, is an essay in the Sublime, the bard echoing in his unkempt and craggy appearance the wild landscape in which he stands. Formally the picture derives from the landscapes of Salvator Rosa, whose work was overwhelmingly popular in the eighteenth century in Britain and whose name was almost synonymous with sublime landscape.

Claude de Jongh (working 1626–63)

Little is known about Claude de Jongh who is recorded in Utrecht in 1626 and 1633, in Canterbury in 1627, and in Haarlem.

30. Old London Bridge

There were few native landscape painters in the seventeenth century but a small demand for topographical landscape attracted some Netherlandish artists: this is one of the most impressive views of London by a foreign artist dating from this period.

Godfrey Kneller (1646–1723)

In about 1662 Kneller went to Leyden University to study mathematics but gave it up in favour of painting, when he studied under Ferdinand Bol. In 1672 he went to Italy, first to Rome and later to Venice. In 1675 he was back in Germany. Between 1676 and 1679 he arrived in England. He became Principal Painter to William and Mary in 1688, and was knighted in 1692. Kneller had a vast output and much of his work is mediocre; his style was influenced by Lely but is stiffer and less voluptuous. However at his best he had a greater penetration into character and a direct and vivid simplicity of presentation.

39 and 41. John Dryden

The finest of Kneller's late portraits are included in the Kit-Cat series (1702–21; National Portrait Gallery) and this painting is one of the earliest examples of the Kit-Cat size, dating from about 1698, although it did not actually form part of the series. The new format allowed a greater variety of pose than the bust portrait, while the sitter can be shown lifesize with greater informality than the three-quarter length permits.

Henry Lamb (1883–1960)

Born in Australia, Lamb was trained as a doctor in Manchester and served in the First World War in Macedonia, Palestine and France. In the Second World War he was an official war artist. He exhibited with the New English Art Club, and was a member of the Camden Town Group, the London Group and was associated with the Bloomsbury Group. His art was influenced by the work of Augustus John and it has something in common with that of Duncan Grant.

180. Lytton Strachey

Painted in 1914, this portrait of Lytton Strachey, the author of *Eminent Victorians*, a withering attack on Victorian values, is by far his best-known work. It has the simplified and slightly distorted forms which derive ultimately from the art of Cézanne.

George Lambert (1700–65)

Lambert's life, or what is known of it, gives us an insight into how a landscape painter in the eighteenth century could earn his living. He was a scene painter for the London theatre from the 1720s until almost the end of his life and he also travelled

round painting views of country houses, such as Chiswick Villa for Lord Burlington. Obviously a sociable person, he was connected with many of the artists' informal clubs and was closely involved with the early years of the Society of Artists, founded in 1760. He also collaborated with other painters, for instance Samuel Scott and William Hogarth, providing landscape backgrounds.

49. Hilly landscape with a cornfield
Painted in 1733, this landscape, which is one of a pair, shows an early attempt to portray the English countryside with an honest truthfulness. The framing trees to left and right are only vestigial reminders of the 'picture making' of classical landscape. It is not known for certain what hills are represented, but it may be a view of Dunstable Downs in the Chilterns. There is no apparent subject—no country house, or ruined castle, or literary association. But it is not typical of Lambert's work as a whole and remains an unusual harbinger of humble naturalism.

Edwin Henry Landseer (1802–73)
Landseer was a precocious artist who began exhibiting at the Royal Academy at the age of twelve, establishing his reputation in 1818 when he sold *Fighting dogs getting wind* to Sir George Beaumont. His early work shows the influence of Snyders and Rubens, though his depiction of animals was also based on anatomical dissection. Aside from his large and heroic Highland canvases, begun after visiting Scotland in 1824, in his smaller works Landseer humanized domestic animals, endowing them with sentimental pathos and sugary charm. He painted his first portrait of Queen Victoria in 1839 and became a frequent visitor at Osborne House and Balmoral. Landseer received public honours and popular acclaim throughout his career, though increasing melancholia led to his refusing the presidency of the Royal Academy in 1865.

124. Landscape in the Lake District
The popularity of the Lake District was well established in the eighteenth century, but Landseer's work, while within the Picturesque tradition, has a specific sense of topographical location. The landscape shows a freedom of brushstroke more common in the early part of his career and probably dates from before 1830.

129. The Monarch of the Glen
One of the most well-known images in Victorian art, this picture was painted for the Refreshment Room of the House of Lords and exhibited at the Royal Academy in 1851, but Parliament refused to vote the necessary purchase money. It is in Landseer's most popular and characteristic style. A heroic stag, an animal equivalent of the noble savage, confronts the spectator against a background of wild mountains and misty clouds.

William Larkin (working 1610–19)
Very little is known about William Larkin; references to him suggest that he worked for an aristocratic circle between about 1610 and 1619. His style carried to an extreme the archaising qualities of high Elizabethan painting.

16. Richard Sackville, 3rd Earl of Dorset
The spectacular decorative qualities of the portrait, created by the glowing enamelled colours and the flat patterning of carpet, costume and curtains, are characteristic of the paintings which have been attributed to Larkin; the effect of a long gallery lined with such works, as at Charlton Park, Wiltshire, was one of overwhelming splendour. Many works have been attributed to Larkin by the appearance of identical studio props, such as carpet or curtain.

Thomas Lawrence (1769–1830)
Lawrence was the son of an innkeeper, but from relatively humble beginnings he established himself in the 1790s as the leading London portrait painter, the natural successor to Reynolds. His chief rivals were John Hoppner (about 1758–1810) and William Beechey (1753–1839). In 1818 he was commissioned by George IV to paint the generals and politicians who had helped to defeat Napoleon and he embarked on a tour of Europe, where he was received as the leading portrait painter of his day. The series of portraits that resulted are now in the Waterloo Chamber at Windsor. He succeeded Benjamin West as the president of the Royal Academy in 1820.

98. Sir William Curtis, Bart
Curtis was member of parliament for the City of London for many years and Lord Mayor in 1795. This portrait was exhibited at the Royal Academy in 1824. It is a typical example of Lawrence's style, with its sophisticated, dashing brushstrokes, its sharp, crisp juxtaposition of light and dark and its psychological perception of character.

110. The son of J. G. Lambton, Esq
Exhibited at the Royal Academy in 1825 and popularly known as *The red boy*. Lawrence's ability, not only to catch a likeness, but to give an image of almost magical charm to his sitters, especially, of course, women, is here employed with a child. The success of this portrait attested to the growing preoccupation with the world of childhood which was to become a feature of Victorian life. A contemporary remarked; 'The sight of it [the painting] calms the mind, and soothes the disposition to all that is soft and good.'

Frederick Leighton (1830–96)
Born in Yorkshire, Leighton's family travelled extensively during his youth and he gained his general education and artistic training in Rome, Florence and Frankfurt, where he studied with Steinle, a follower of the Nazarenes. While he was still abroad, his first Royal Academy exhibit, *Cimabue's celebrated Madonna carried in procession through the streets of Florence* (1855), was bought by Queen Victoria, giving initial royal patronage to a long and successful career which culminated in 1896, when, as president of the Royal Academy, he was elevated to the peerage. When Leighton settled in London in 1860 he turned from biblical and medieval subjects to mythological and Hellenic themes, developing from his foreign experience a cosmopolitan

academicism which exerted a strong influence on other British artists and led to his initiating the Royal Academy winter exhibitions of Old Master painting.

155. The return of Persephone
This painting was exhibited at the Royal Academy in 1891. Although Leighton was a Victorian establishment figure *par excellence* who always painted definite subjects, in later works, such as this, he is not far from the formal aestheticism of Albert Moore. His intensive early training and study on the Continent always gave to his paintings a highly professional and competent quality. His interest in the detailed depiction of soft drapery as it covers the human form shows his knowledge of classical sculpture; in later life he executed some sculpture himself.

Peter Lely (1618–80)
Peter Lely, a Dutch artist, was trained at Haarlem under Pieter de Grebber; he is first certainly recorded in England in 1647. His earliest works in this country were landscapes, history and mythological paintings; he turned to portraiture in the late 1640s and after the Restoration became Principal Painter to Charles II. Lely had an apparently inexhaustible power to invent new poses for the ladies of his court, and the portrait patterns introduced by him continued to be fashionable until the early nineteenth century. Although his style is heavily indebted to Van Dyck, his accessories and poses are more Baroque, and the atmosphere more cloyingly pastoral and voluptuous.

37. Anne Hyde, Duchess of York
This is one of Lely's most luscious portraits, painted about 1670, with broadly sensual areas of paint in the blue and gold draperies and curtains. Lely's emphasis on the horizontal gives his paintings the look of a loosely painted Van Dyck seen as if in cinemascope. The weight and bulk of the figure and the painting of the sculpted fountain on the right, however, show Lely's debt to the Dutch tradition and to artists such as Jacob Adriaensz Backer.

38. Sleeping Nymphs
Lely continued to paint mythological scenes in the 1650s and this painting dates from then. His style shows the influence of Italianate Dutch subject painting, perhaps particularly of Jan Both and Cornelis van Poelenbergh.

Charles Robert Leslie (1794–1859)
Educated in America, Leslie came to London, studied at the Royal Academy Schools and exhibited at the Academy between 1813 and his death. He painted popular anecdotal genre, including historical and literary subjects, in a decorative and light manner. He was a friend of Walter Scott, for whom he illustrated many of the Waverley Novels, and a great friend of and correspondent with John Constable. His published life of Constable (1843–5) is still a standard work.

132. The Grosvenor family
The Grosvenors are surrounded by their magnificent collection of pictures, including works by Van Dyck and Velasquez. This nineteenth-century version of the conversation piece shows Leslie's ability to capture the expressions, gestures and ethos of polite society. It was exhibited at the Royal Academy in 1832.

Wyndham Lewis (1882–1957)
Of prosperous Anglo-American parents, Lewis attended the Slade (1898–1901) and travelled in Europe, settling in London in 1909. He showed in the first three Camden Town Group exhibitions (1911–12) and in Roger Fry's second Post-Impressionist Exhibition (1912–13) before briefly joining the Omega Workshop. The Italian Futurists Marinetti and Severini visited London, firing Lewis to produce an English response: with Kate Letchmere he founded the Rebel Art Centre and produced *Blast* No. 1, 1914, and No. 2, 1915. A friend of Ezra Pound and T. E. Hulme, polemical writing was always vital to him. He organized the Vorticist show and decorated the 'Vorticist Room' in the Restaurant de la Tour Eiffel in 1915, before joining the army in 1916. A war artist from 1917, he returned to exhibit in 1919, and with Group x in 1920. He painted and wrote prolifically until he lost his sight in 1951.

190. A battery shelled
His major work as a war artist, it was commissioned by the Imperial War Museum. It is an uneasy synthesis: his pre-war Vorticist principles of dynamic, mechanistic construction dominate the major part of the painting, but are interrupted by the three realistically represented figures at the left. Futurist ideas, as translated into Lewis's art, led Vorticism to virtual abstraction by 1914, in works like *Red duet* and *The crowd*, and it seems that the impact of the war shook his commitment to abstraction. The scene of destruction is, nevertheless, vividly conveyed in the jagged, disturbed angularities plunging across this large canvas.

John Linnell (1792–1882)
Linnell, like William Mulready, was a pupil of John Varley, whose students, according to Linnell, 'were constantly drawing from nature'. Linnell concentrated on landscape painting throughout his career, although he was also a skilful portraitist. He patronized William Blake, whom he met in 1818, commissioning from him the *Book of Job* illustrations, and it was through Linnell that Samuel Palmer met Blake. Linnell helped the young Palmer, but their relationship turned sour after Palmer's marriage to Linnell's daughter, Hannah. Linnell was strongly religious in a nonconformist way, and his best-known works are of hayfields and North Downs woodlands—he went to live at Redhill in 1852—which express the fruitful nature of the earth.

120. The river Kennet, near Newbury
This is a more finished and detailed painting than Delamotte's (*Plate 119*), but it expresses the same kind of fidelity to the simple natural scene. Apart from the difference of handling, which in this painting is precise, clear and highly worked up, it shows an interest in rural activity similar to Constable's work of the same period.

James Lobley (1829–88)

A little-known genre painter from Brighton, Lobley exhibited from 1865 at the Academy, the Society of British Artists and elsewhere. His subjects are mostly of scenes in church, archly titled: '*Ancient and Modern*' (R.A. 1871) and *The first of the congregation* (R.A. 1874). He may have known the artists of the Cranbrook Colony in Kent, which included genre painters like John Calcott Horsley and F. D. Hardy. *The free seat* by Lobley is in the Birmingham City Art Gallery.

145. The dole

Possibly exhibited at the Academy in 1867, Lobley's painting shows the poor being given loaves inside Stowe Church, Lincolnshire, whilst some prosperous middle class people look on.

Philippe Jacques de Loutherbourg (1740–1812)

De Loutherbourg was born in Strasbourg but was trained in Paris. He came to England in 1771, already a successful and well-known artist, and in 1773 began his career as a stage designer and scene painter, a profession taken up by a number of landscapists in the eighteenth century, including George Lambert. In 1781 he opened his *Eidophusikon*, an experimental miniature theatre which featured depictions of natural phenomena such as sunsets and storms, aided by the use of artificial light and theatrical effects. De Loutherbourg's landscapes exploited the taste for the Sublime and the Picturesque, and influenced the later landscapes of Gainsborough, but they have an artificial stage-set quality when set against the paintings of overwhelming natural forces by Turner.

94 and 103. Coalbrookdale by night

The Industrial Revolution subject matter is unusual in de Loutherbourg's work. Coalbrookdale fascinated artists in the late eighteenth century because of its combination of scenic beauty with the 'horrific sublime' of its iron works. De Loutherbourg here shows the same fascination with artificial light and its dramatic possibilities as was expressed in the work of Joseph Wright of Derby (*Plates 95 and 96*).

Laurence Stephen Lowry (1887–1976)

Lowry was born in Manchester and studied at Manchester and Salford schools of art. He always lived in the Manchester area and painted almost exclusively street scenes of northern towns. He was elected an associate of the Royal Academy in 1955 and an academician in 1962.

198. An organ grinder

Lowry created a highly personal naïve style, which did not change, for the depiction of a peopled urban industrial landscape. The little figures silhouetted against the harsh streets evoke a feeling of greyness and desolation, where the individual appears to have no hope of breaking away from the drab background of terrace houses and factory chimneys.

Conroy Maddox (born 1920)

In 1937 Maddox worked in Paris with the Surrealist Group, whom he continued to visit until the war, exhibiting meanwhile in England. He joined the English Surrealist group in 1940, and published Surrealist writings like *Infiltrations of the marvellous* and *Kingdom come*. He began teaching at Birmingham University in 1945, and contributed to *Message from Nowhere* by E. L. T. Mesens. He developed his technique of écremage in 1947, and from 1955 continued to paint and lecture on Surrealism in London. In 1967 he collaborated on the Exeter Surrealist Festival, and showed at Zwemmer's (catalogue introduction by Mesens). He was associated with the Chicago Surrealists in 1970, and showed at the Hamet, London, in 1971 and 1972.

205. Passage de l'Opera

Maddox is the only English Surrealist who has continued unswervingly on a Surrealist path, with collages, écremages, oils, drawings and writing. De Chirico's architectural perspectives, Magritte's strange confrontations of bowler-hatted man with adjusted reality, and Ernst's collages were his starting points. From them he has established territory of his own: here, the long bare vista, a favourite Maddox device, penetrates the picture space peopled with enigmatic figures, but, Maddox has written, 'a painting can become an environment that has the sufficiency and interior logic of a situation that does not lend itself to any explanation'.

John Martin (1789–1854)

Martin came to London in 1806 and his first great success was *Joshua commanding the sun to stand still upon Gideon*, exhibited at the Royal Academy in 1816. After this he painted a series of large historical landscapes, partly inspired by the early works of Turner, such as *The destruction of Sodom* of about 1805 (Tate Gallery). His pictures contain tiny figures set in landscapes which suggest vast height, depth and distance and often portray geological catastrophes of cosmic proportions. They are almost caricatures of Burke's ideas of the Sublime and prefigure the Hollywood biblical epics of Cecil B. de Mille. Known as 'Mad Martin', he was also a mechanical inventor, devising amongst other things, an ambitious yet convincing plan, which was not adopted, for London's water supply and sewage disposal.

108. Belshazzar's feast

This painting was exhibited at the British Institution in 1821 as an illustration to *Daniel*, chapter v, and was a tremendous success. The stages of the biblical drama are shown as a continuous scene, reading from left to right; first the writing on the wall, followed by Daniel's interpretation and prophecy of the death of Belshazzar and the overthrow of the Chaldean empire. The suggestion of vastness by the depiction of tiny figures and the repetitive features of the architecture are typical of Martin's work, and they showed to great effect in the strong chiaroscuro of the mezzotint engravings which followed the painting in 1826 and 1832.

John Everett Millais (1829–96)

Millais entered the Royal Academy Schools at the unprecedented age of eleven, exhibiting from 1846, and he was to end his successful and highly professional career as president of the Royal Academy. His academic art training and technical mastery always set Millais apart from Hunt, Rossetti and the other artists with whom he founded the Pre-Raphaelite Brotherhood, although he continued to produce carefully observed and tightly executed works in a Pre-Raphaelite manner until 1857. After his marriage to the former Mrs Ruskin, his work became freer in handling and more sentimental in subject matter and among his later works are many society portraits and popular fancy pictures of children.

137. Mariana

This picture was exhibited, untitled, at the Royal Academy in 1851 with the following lines from Tennyson's poem, *Mariana*:

> She only said, 'My life is dreary—
> He cometh not' she said;
> She said, 'I am aweary, aweary—
> I would that I were dead.'

Many Pre-Raphaelite paintings illustrated love poetry or themes of love and blighted passion. Also typical of Pre-Raphaelite painting is the detailed accuracy found in this picture. The stained glass was painted from the windows in Merton College Chapel, and Millais bought velvet and draperies from which to paint.

John Minton (1917–57)

Minton studied art at St John's Wood Art School and in Paris in the late 1930s. After the war he travelled widely in the Mediterranean and the West Indies. He taught at Camberwell, the Central School and the Royal College of Art. He was an accomplished illustrator of books as well as a landscapist in oil and watercolour.

208. Street and railway bridge

Minton belongs to the generation of artists who, influenced by the work of Graham Sutherland, pursued realism but combined it with a simplification of shapes and forms which derives from the work of Picasso and Braque. In this painting can be seen an interest in different surface textures which is found also in the paintings of John Piper (*Plate 204*).

Monogrammist HE (working 1569)

7. Elizabeth I and the three goddesses

The identity of the monogrammist remains unsolved; the style of the three goddesses—less attractive than the more naturalistic treatment of the queen and her attendants—suggests strongly the influence of Franco-Flemish Mannerism. The theme of the Judgement of Paris has here been reinterpreted to flatter the queen, a device not uncommon in Elizabethan literature; the three goddesses, Juno, Minerva and Venus, are overcome with shame as the queen, who unites all their virtues, takes on the role

of Paris and awards the apple or golden orb of state to herself. In the background is a distant view of Windsor Castle. The painting is a good example of the elaborate symbolism with which poets and painters glorified the queen.

Albert Joseph Moore (1841–93)

A younger brother in an artistic family, Moore was exhibiting at the Royal Academy by the age of fifteen, but stayed only briefly at the Academy Schools, later travelling and working in France and Rome. Moore's early Old Testament paintings were Pre-Raphaelite in style, but on returning to England in 1863, his increasing interest in colour and design was reflected in decorative murals for houses by the architects William Nesfield and Norman Shaw. His later paintings, based upon numerous nude and draped preliminary figure studies, are exclusively of posed, frieze-like figures in classical drapery, often in similar or repeated compositions enabling him to examine various colour harmonies. Moore was a close friend of Whistler, defending him at the libel trial against Ruskin, and like Whistler he substituted a symbol for his signature and gave his paintings oblique titles which have only an incidental reference to the subjects.

174. Portrait of a girl

This small unidentified portrait shows Moore's concern with the formal relationships of colour and design characteristic of the Aesthetic movement.

Jacob More (1740–93)

More is a relatively little-known painter today and few of his paintings now survive. He first trained in Scotland and went to Rome in 1773, where he stayed until his death. He specialized in classical landscapes in the style of Claude, but introducing an element of the Sublime to suit contemporary taste. He was a popular artist in his day and was one of the few British landscape painters to be patronized by Italians.

82. Self-portrait

This portrait was painted for the gallery of artists' self-portraits in the Uffizi. It shows the artist painting in the open air, though it is difficult to see from this picture how More could have balanced his canvas and it is clearly an idealized conception of the artist at one with nature. It was quite usual for British artists in Italy from Richard Wilson in the 1750s onwards to sketch and draw outside, but it is not certain how widespread the practice of painting in oils in the open air was at this time, although there is some evidence for it. Painting in oils direct from nature became more common in the early years of the nineteenth century.

John Hamilton Mortimer (1740–79)

Mortimer has been placed with Barry, Romney and Fuseli as one of the early Romantic artists. He had aspirations to be a History painter and won the first premium at the Society of Arts in 1764 with his *St Paul preaching to the Ancient Britons* (High Wycombe, Guildhall). He was most successful with his charming

conversation pieces in the style of Wheatley and Zoffany and, on the other side of the coin, with his 'horrible imaginings', bandits and gruesome monsters clearly based on the etchings of Salvator Rosa. His quixotic, rollicking temperament combined with his weird and often harrowing subject matter, earns him a place as a Romantic *avant la lettre*, though even his darkest subjects are treated in a fastidious and decorative style, and his work altogether lacks the psychological intensity of Fuseli.

89. Banditti fishing

Mortimer's upbringing at Eastbourne, where his father was a customs official, is reflected in his frequent depiction of coast scenes. This, in conjunction with his fascination for bandits in the style of Salvator Rosa, accounts for the fanciful nature of this painting—a sort of English eighteenth-century equivalent to Neapolitan seventeenth-century genre.

William Mulready (1786–1863)

Mulready attended the Royal Academy Schools between 1800 and 1805 and began his career as a landscapist. By 1816, when he was elected Royal Academician, he had established himself as a successful genre painter with his scenes from schoolboy life. During his later career his subject range expanded to include literary painting, nudes, book illustrations and scenes of inventive and original genre. His technique, which anticipated the Pre-Raphaelites in its use of a white ground, showed an increasingly meticulous finish, precision of line and glowing intensity of colour.

113. First love

A contemporary critic wrote of this painting, exhibited at the Royal Academy in 1840; 'A sweet story shortly told . . . what a volume of thought is produced by this single passage of life.' Compared with his earlier comic schoolboy scenes, crowded with numerous small figures in the tradition of Wilkie, Mulready here introduces a greater range and earnestness of subject allied to a more elevated style. The composition is filled by a few large figures, academically drawn and given a weight and elaboration of pose previously considered appropriate for religious or history painting.

Alfred Munnings (1878–1959)

Munnings studied at the Norwich School of Art and later in Paris. He exhibited at the Royal Academy from 1898, was elected an academician in 1925 and was president of the Royal Academy from 1944 to 1949. He settled at Dedham in 1918, after painting some war scenes, commissioned by the Canadian government. For the *avant-garde* he was an arch reactionary with no room for any of the developments in twentieth-century art and so simply irrelevant to their life; for the conservative lay public he was a vocal, if eccentric, expounder of common sense in the face of an art world gone mad.

188. The arrival of the gypsies at Epsom Downs for Derby Week

Munnings's early works, such as this picture painted in 1920,

have a strong draughtsmanship combined with fluent brushstrokes which show the influence of Augustus John. Paintings of gypsies, fairs and race-meetings were amongst his stock-in-trade subjects, just as they formed a large part of the work of his contemporary, Laura Knight (1877–1970).

Daniel Mytens (about 1590–1647)

Mytens was born in Delft; he was in London by 1618 where he obtained the patronage of the Earl of Arundel. From 1624 he received a pension from James I and in 1625 became official painter to Charles I. He probably left London in 1634 having been outclassed by Van Dyck from 1632. Compared with the work of his predecessors at the Stuart court, Mytens's portraits are distinguished by a new elegance and grandeur of design, more painterly brushwork and a surer sense of form.

13. Thomas Howard, Earl of Arundel

Probably painted by 1618. Compared with the elegance of Plate 24 the portrait still retains a hint of Jacobean stiffness. The Earl of Arundel was both a great collector and patron of living artists. Mytens shows him pointing with his Earl Marshal's baton to the sculpture gallery at Arundel House, where he kept some of the collection of Roman sculpture that he had brought back from Italy in 1614.

24. George Villiers, 1st Duke of Buckingham

The Duke of Buckingham was an important collector of pictures with a particular interest in the work of Venetian painters. The portrait shows the new sophistication and assurance that Mytens introduced into English portraiture.

Paul Nash (1889–1946)

After periods at Chelsea and the Slade, Nash had his first one-man exhibition in 1912, and an exhibition of watercolours by Paul and his brother John in 1913 attracted the interest of Roger Fry. Now married, he served in the First World War, and from 1917 to 1918 was a war artist, while continuing to exhibit in London. From 1921 Nash lived in and around Romney Marsh, a close friend of Ben Nicholson, an association which resulted in the formation of Unit One in 1933. A successful exhibition at the Leicester Galleries in 1928 prompted a change of style, but he exhibited continuously for the rest of his life. He lived in Hampstead and Oxford until he again worked as a war artist from 1940 to 1945.

202. Totes Meer

Nash's anger and despair at war and the destruction it brought to his beloved landscape is evident in this sea of wrecked enemy planes, painted in 1940–1. His work in both wars was amongst his best, particularly so in the second, when the external crisis pulled him out of his problematic Surrealist phase into this far more powerful and effective work. The function of the war artist as propagandist gives him an awkward role: Sutherland reflected with total honesty the London bomb damage; Nash's enemy planes rise above a mere propaganda exercise to a statement, deeply felt, on the nature of war. The wings and

fuselages, blue-grey in the cold moonlight, fall into a rhythmically lapping wave of destruction breaking over the ochre land.

Christopher Richard Wynne Nevinson (1889–1946)

Nevinson studied at the Slade School from 1908 to 1912 and later in Paris, where he shared a studio with Modigliani. He was influenced by Cubism and Futurism and his most original paintings, such as *The arrival* (about 1913–14; Tate Gallery), were done just before the beginning of the First World War when Wyndham Lewis's Vorticist group was active. As a war artist he successfully fused his knowledge of Cubism and Futurism with a more conventional realism. After the war his works became softer and more Impressionist in technique, but they lack the unity and bite of his early paintings.

192. La Mitrailleuse

Painted in 1915. The Futurist and Vorticist passion for modernity and machines and stark angular steely forms is here employed by Nevinson to underline their destructive power and the tragic nature of the subject matter. The inhumanity of war in the trenches depicted here can be contrasted with the attitude of romantic jingoism in Lady Butler's *'Scotland for Ever!'* (*Plate 169*).

Ben Nicholson (born 1894)

Nicholson, the son of William Nicholson and Mabel Pryde, who were both painters, studied at the Slade School (1910–11). During the 1920s he lived in Cumberland and London, as well as visiting Cornwall. In 1933 he became a member of Association Abstraction-Création in Paris. He was a leading spirit of the Seven and Five Society in the 1920s and 1930s and was a member of Unit One from 1933 to 1935. He lived in Cornwall from 1939 until 1958, when he moved to Switzerland, where he now lives. Nicholson has been in the forefront of developments in British art since the 1920s and has been both immensely aware of contemporary developments on the Continent and at the same time strikingly original in his own work.

211. Feb 28–53 (vertical seconds)

Painted, as its title indicates, in 1953, this work admirably expresses Nicholson's ability to combine a taut, nervous line with a fastidious sense of colour, both of which contribute to the creation of pictorial space. The background has a textured surface with warm grey colouring which appears to be part of the substance of the support, as if the painting was done on a rectangular block of stone. The curved lines in the design, which reminds one to a certain extent of the work of Braque, are vestigial echoes of the jugs of a still-life motif.

Isaac Oliver (about 1565–1617)

Oliver, a French artist, was brought to England in 1568 by his father, a Huguenot refugee, and he learned the art of miniature painting from Nicholas Hilliard. He probably travelled abroad in 1588, and in 1596 was in Venice. In 1604 he was appointed limner to Anne of Denmark and later to Henry, Prince of Wales. His style is more realistic than Hilliard's, his use of light and shade more pronounced, and his colours more subtle and less translucent.

11. Frances Howard, Countess of Essex and Somerset

The sophisticated and elegant treatment of the drapery perhaps suggests the influence of Italian Mannerism. The detail is more precise and less free than in the work of Hilliard, and the subtlety of Oliver's colour is here clearly apparent in the differing shades of pearly grey.

John Opie (1761–1807)

Opie was the son of a Cornish carpenter, was trained in secret by the satirist John Wolcot ('Peter Pindar') and sprung on the London art world in 1781. Although primarily a portraitist, at the Royal Academy in 1784 he exhibited a genre subject entitled *The schoolmistress* which owed much to Rembrandt and Netherlandish genre painting of the seventeenth century. It was a new, if isolated, departure in British painting, looking forward to Wilkie and the nineteenth-century school of Incident. Opie was best in his portraits of old people and children.

81. The Brodie family

Opie was influenced like many of his contemporaries by the technique of Reynolds, with its thick impasted highlights and dark shadows, made rich by bitumen, which is technically unsound because it never dries properly, blistering and cracking after a few years. He was eminently successful in capturing the natural charm of children; they appear less sugary than those of Reynolds.

Samuel Palmer (1805–81)

Palmer was a precocious artist and first exhibited at the Royal Academy in 1819. Through Linnell he met William Blake in 1824 and was his most important follower, particularly inspired by Blake's illustrations to Thornton's edition of Virgil's *Eclogues* (1820–1), where the landscape element is emphasized. Between 1826 and 1835 Palmer worked and lived at Shoreham, in Kent, amongst a group of artists called 'The Ancients', painting innocent yet richly textured landscapes, replete with Christian symbolism and meaning. After he married Hannah, Linnell's daughter, in 1837, his landscapes became more conventional yet still highly wrought, and at the end of his life he was working with some of his youthful visionary intensity on illustrations to Virgil's *Eclogues*.

115. Hilly scene

The enclosed valley of Shoreham inspired Palmer to create an intensely personal visionary world, suffused with his knowledge of the Bible and Milton. The smallness of these pictures and sepia drawings, with their enlarging of landscape detail such as ears of corn and leaves, vividly expresses Palmer's imaginary world and shows the influence of early German art, especially wood engravings, a new source of inspiration to British painters.

Palmer's works have influenced Stanley Spencer and Graham Sutherland and the Romantic escapism of British painting in the 1940s.

Victor Pasmore (born 1908)

Pasmore was educated at Harrow and then studied painting at evening classes at the Central School. In the early 1930s he experimented with Fauvism, Cubism and abstraction, but turned to a lyrical realism in the late 1930s when he helped to found the Euston Road school in 1937, painting views of the Thames at Chiswick and Hammersmith. In 1947–8 he turned decisively to abstraction and in the early 1950s to paintings with three-dimensional elements. By this time he had begun to formulate his ideas of the fusion of painting, sculpture and architecture as part of an all-embracing visual environment. He was appointed consulting designer for parts of Peterlee New Town in 1955. From 1954 to 1961 he was senior lecturer and master of painting at the Department of Fine Art, Durham University.

207. Evening, Hammersmith

Under the influence of Whistler, Turner and the Impressionists, Pasmore evolved a style of academic realism at a time when the Euston Road school was reacting against the abstract and Surrealist developments of British art in the 1930s. But the linear design of the tree branches looks forward to his abstract work of the early 1950s, and many of his Thames-side paintings, done in the early 1940s, carry the seeds of his later purely abstract designs.

Joseph Noel Paton (1821–1901)

Paton studied at the Royal Academy Schools and he won prizes in the Houses of Parliament competitions in 1845 and 1847. But he worked subsequently mainly in his native Scotland, although he exhibited at the Royal Academy. He painted historical and mythological subjects, concentrating after 1870 on religious works in a somewhat cold academic style, but he is best known for his 'fairy' pictures, executed in a highly detailed manner.

163 and 165. The quarrel of Oberon and Titania

This painting of 1849 depicts the same subject as the slightly later work by Dadd (*Plate 162*). We find the same detailed realism, but Paton's work is less dense and 'close-up' than the picture by Dadd. There is more air and space and a more conventional sense of rhythm and design in the composition. Both pictures show the influence of Daniel Maclise's clear-cut realistic style.

Robert Peake (working 1580–1619)

Robert Peake became established as a portrait painter in the 1580s. In 1607 he became Serjeant Painter and most of his work was done in the service of Prince Henry before 1610. His linear style continues the tradition of Hilliard before this was superseded by the more realistic approach of Isaac Oliver and Gheeraerts.

21. Henry, Prince of Wales, and Robert Devereux, 3rd Earl of Essex

Probably painted about 1606–7. The composition and colouring are both Hilliardesque. Henry, Prince of Wales, stands triumphantly over a dead stag; in the background is an enclosed deer park. The painting expresses the Stuarts' enthusiasm for the chase which was to be given more poetic form by Van Dyck (*Plate 22*).

John Piper (born 1903)

Piper studied at the Richmond and Kingston schools of art and at the Royal College of Art (1928–9). He visited Paris in 1933 where he met Braque and Léger. He was a member of the Seven and Five Society and in the middle 1930s painted a number of abstract compositions. He married Myfanwy Evans, who started *Axis* (1935–7), a magazine of abstract art. By 1938 Piper had returned to representation, concentrating on a personal evocative interpretation of architectural subjects. He was an official war artist from 1940 to 1942 and has worked as a stage designer.

204. St Mary-le-Port, Bristol

Scenes of war damage, such as this picture painted in 1940, were, by a strange irony, ideal material for Piper, who had already developed a personal style for depicting 'picturesque decay' in architecture in the late 1930s. Although this painting shows Piper's interest in abstract design, inspired partly by the work of Léger and Braque, it also betrays his interest in the literary or associational qualities of architecture.

Edward John Poynter (1836–1919)

Poynter visited Italy in 1853 where he met Frederick Leighton and was inspired by his conception of a new academic art of classical excellence. He studied in Paris under Gleyre in the 1850s and there met Whistler. Back in London in 1866, he became Slade professor in 1871. In a career full of honours he was also director of art at the South Kensington Museum and eventually director of the National Gallery (1894–1906) and president of the Royal Academy. His art, grounded in his belief in the value of academic figure drawing, was an example of the establishment art found throughout Europe in the second half of the nineteenth century.

153. On the temple steps

Exhibited at the Royal Academy in 1890, this painting is an example of the classical subject tinged with the exotic and the sentimental which so appealed to the late Victorian public. Although today we can clearly see it as a gentle form of escapism, this artful depiction of classical subjects was seen at the time by many as the epitome of taste and beauty.

Henry Raeburn (1756–1823)

By the age of twenty-one, Raeburn had become an established portrait painter in Edinburgh. Although he visited Italy (1785–7) and London twice, the first time in 1785 when he met Reynolds, Raeburn was content to remain in Edinburgh as the

leading Scottish portrait painter with a large clientele in Edinburgh fashionable society. George IV knighted him on a visit to Edinburgh in 1822 at a time when Scottish life and culture, aided by the Romantic novels of Walter Scott, had become a subject of interest and fascination in England.

109. Sir John Sinclair

Probably painted about 1794–5, this is one of the grandest and most Romantic of Raeburn's portraits. Raeburn's technique is just as dashing as that of Lawrence, but it has a tougher more masculine bravura about it with thick, almost square-edged slabs of paint unerringly expressing form and contour.

Allan Ramsay (1713–84)

Ramsay was born in Edinburgh, the son of the author of *The gentle shepherd*. He visited Rome in 1736–8 and again between 1754 and 1757. Ramsay's success as a portrait painter was established in London in the early 1740s, when he was still working in the style of Hudson. But he was aware of the work of contemporary French artists, such as Nattier and Perroneau, and Italian artists, such as Batoni, and he brought to British portraiture a new softness and relaxed naturalism, which shows itself especially in his portraits of women.

79. Mrs Bruce of Arnot

Painted about 1765. The delicate rendering of the pink dress and the lace shawl is typical of Ramsay at his best and shows the influence of French painters on his style after his second visit to Rome.

Joshua Reynolds (1723–92)

Born at Plympton in Devon, Reynolds was apprenticed to Thomas Hudson in London in 1740, under whom he studied for three years. In 1749 he went to Italy, where he spent most of his time in Rome studying Raphael and Michelangelo, but he also visited Venice, returning to England in 1752. In the 1750s and 1760s he established his reputation as the leading portrait painter in London and in 1768 was made the first president of the Royal Academy. His *Discourses*, delivered at approximately yearly intervals to the students of the Royal Academy, provided a summing up of the Renaissance academic art theory, and formed part of his aim to bring British art into the mainstream of the European tradition.

73 and 74. Laurence Sterne

Reynolds surpassed himself in the depiction of intellectuals and men of letters, in whose company his own wit and learning flowered. In this portrait of the author of *A sentimental journey* and *Tristram Shandy*, Reynolds achieved that penetration into mind and character, expressed through a typical pose, which marks him out as one of the finest portraitists of any age.

77. George, Prince of Wales

Exhibited at the Royal Academy in 1787, this painting displays all the opulence of Reynolds's grand manner. The columns in the background are a recurring element in such portraiture from Van Dyck to Lawrence, and the negro page, sumptuous colour and rich impasto all show Reynolds's debt to what he called the 'Ornamental Style' of Venetian painting, especially Paolo Veronese.

78. Lady Betty Foster

Lady Betty Foster was the second wife of the 5th Duke of Devonshire and it was also her second marriage. A late portrait, painted in 1787, this shows Reynolds's ability to capture a delightfully intimate informal mood in his portraits of pretty women.

99. Lady Worsley

Lady Worsley here wears a riding habit adapted from the uniform of her husband's regiment, the Hampshire Militia. The pose and composition bring to mind the full-length portraits of Van Dyck, whilst the landscape background reminds one of the way in which Gainsborough often set his figures against a natural scene. The picture was exhibited at the Royal Academy in 1780.

Sebastiano Ricci (1659–1734)

Ricci was born at Belluno; he studied in Venice where he was influenced by Veronese and Luca Giordano. He worked in many cities in Italy and in Vienna before arriving in England in 1711 or 1712, when he was patronized by the Duke of Portland and Lord Burlington. In 1716 he returned to Venice with his nephew, the landscape painter Marco Ricci. The sophisticated ease and fluency of Sebastiano Ricci's work were qualities new to painting in England; and with Pellegrini he is the supreme exponent of Rococo decorative painting in this country.

44. The Triumph of Galatea

The original square open-well staircase of Burlington House had walls and ceiling decorated by Ricci; this was dismantled in 1815 and rearranged. The *Triumph of Galatea* and *Diana and her nymphs* now hang on the present staircase. The ceiling painting is still *in situ* in the council chamber, while the third wall painting is on the ceiling of the present assembly room. Ricci's style here shows a fusion of ideas from Veronese, Luca Giordano and Annibale Carracci.

Ceri Richards (1903–71)

Born near Swansea, Richards's Welsh roots were always important to him, though he lived much of his life in London, coming to the Royal College in 1924. His love of music and poetry supplied many of his themes, and while painting was his major activity, he also drew, made lithographs, and constructed wood reliefs and collages. A member of the London Group in 1937, he taught successively at Cardiff, Chelsea, the Royal College, and the Slade, was a trustee of the Tate Gallery from 1958 to 1965, and showed at the Venice Biennale in 1962. Since his death, memorial exhibitions have been arranged by the Welsh Arts Council, 1973, and at the Edinburgh Festival, 1975.

201. The female contains all qualities

The 1936 London International Surrealist exhibition gave Richards, like Armstrong, the visual language he needed: above

all, for Richards, there was Miró. Here, elevated on a pedestal, the generously-endowed female towers over her admiring male, all typical of Richards's biomorphic forms, slipping into near-abstraction at times, yet whether landscape or figure study, Trafalgar Square or a female nude, always retaining its hold on the figurative. Colour was also vital to him: rich turquoise blues accented with crimson were a favourite combination and set him apart from the more subdued tonalities of contemporaries like Nash and Armstrong.

George Richmond (1809–96)

Richmond studied at the Royal Academy Schools, where he met Samuel Palmer. Together with Palmer and Edward Calvert (1799–1883), he was one of a number of followers of William Blake. Although his early work was influenced by the visionary nature of Blake's art, he later became more conventional and was a successful portrait painter.

112. Abel the shepherd

An early work, influenced both by Palmer and Blake. The close fusion of landscape and figure is characteristic of this stage in Richmond's career, creating an intense pastoral mood and a feeling of womb-like security. The large moon is a device also found in the work of Palmer (*Plate 115*) and Calvert.

Bridget Riley (born 1931)

A Londoner, student at Goldsmiths and the Royal College, contemporary of Richard Smith and Peter Blake, Riley taught and worked in advertising, seeing the important American post-war painting show at the Tate Gallery in 1956. From 1959 she taught in art schools, travelled, notably in Italy, gaining recognition in the early sixties as a major creator of Op art. Her first one-man show, 1962, a John Moore's prize, 1963, and significant European and American exhibitions culminated in the Grand Prize at the Venice Biennale in 1968. She helped organize SPACE, providing artists with cheap studios in London, where she continues to live exhibiting at the Rowan Gallery. Arts Council retrospectives were held in 1971 and 1973–4.

221. Fall

Riley has stated that her concerns are with light and movement, and, more recently, with colour; the interaction between these elements and with the individual perceiving them constitute Riley's version of what is called Op art. She makes the initial study herself, allowing intuitive processes to intervene in her calculations, then studio assistants take over the actual work on the finished painting, an unexpected revival of the old *atelier* system. In this painting of 1963 the wavy lines create the effect of vibration and movement over the whole painting.

George Romney (1734–1802)

Although Romney was primarily a portrait painter, his heart was in History painting and there are numerous drawings by him in a bold sketchy style of mythological and literary subjects. 'This cursed portrait painting,' he complained, 'how I am shackled with it.' He never exhibited at the Royal Academy. After 1781 he became infatuated with Emma Hart, later Nelson's mistress, and painted many portraits of her.

80. The Gower family

The picture was painted in 1776–7, when Reynolds was producing his most classical and Historical portraits and when Romney himself was fresh from his experience of classical sculpture in Italy (1773–5). So this can be called a Neo-Classical portrait, with its emphasis on a frieze-like composition, classical draperies and the tactile qualities of classical sculpture. But the children are presented with charm and informality. This group portrait can be compared with the equally charming *Brodie family* by Opie (*Plate 81*), which is more in the tradition of Reynolds's sentimental 'fancy pictures' of children.

Dante Gabriel Rossetti (1828–82)

Born of Italian parents in London, Rossetti had a lifelong obsession with his namesake, Dante. Impatient with the artistic training at the Royal Academy, he left to be apprenticed to Ford Madox Brown and became a founder-member of the Pre-Raphaelite Brotherhood. Rossetti, as both poet and painter, often based his works on his own writings, which associates him with William Blake, of whom he was an early admirer. His poetic vision is more akin to the work of the Symbolists of the 1890s, for whom he was a major source of inspiration.

157. The day dream

Commissioned in 1879 by Constantine Ionides, this painting was developed from a drawing of Jane Morris completed before 1872. Jane, the wife of William Morris, was an important model for many of Rossetti's later works, and he evolved a distinctive type of female beauty from an exaggeration of her features.

Peter Paul Rubens (1577–1640)

Rubens was born at Siegen in Westphalia. From 1600 to 1608 he was in Italy, where he lived in Mantua, Rome and Genoa. In 1603 he visited Spain. He returned to Antwerp in 1608 and in 1609 became painter to the Brussels court of the Archduke Albert and the Infanta Isabella. In 1628 he made a second visit to Spain; in 1629 to 1630 he visited London as envoy to Charles I and was knighted and given an honorary M.A. by the University of Cambridge. He executed the canvases to decorate the ceiling for the Banqueting House in Whitehall in Antwerp between 1630 and 1634; this is the most significant surviving work inspired by the patronage of Charles I. In the last years of his life, 1636–40, he worked on the decorations for Philip IV's hunting lodge near Madrid.

19 and 20. Landscape with St George and the dragon

With characteristic brilliance and virtuosity, Rubens has managed to include portraits of Charles I as St George, patron saint of England, and Henrietta Maria as the rescued princess, in a landscape which has an imaginary view of London and the Thames in the background, the whole executed in a dramatic Baroque style with numerous incidental figures. It was painted in London in 1630, but Rubens sent it to Flanders 'to remain as a

monument to his abode and employment here'. After his return to Antwerp he probably enlarged the picture, and it soon made its way into Charles I's collection.

26. Sketch for the central panel of the Whitehall ceiling
This is the earliest known sketch of a series connected with the Whitehall ceiling. The centre of the panel is a study for the apotheosis of James I, which was to occupy the centre of the ceiling. Rubens then added sketches of ideas for the four oval compartments, all of extraordinary spontaneity. At the top and bottom are the friezes of putti, which were to occupy the longer sides of the ceiling. The sketch provides a glimpse of Rubens's creative processes and is remarkable, at this early stage, for its assurance, spontaneity and completeness.

27. General view of the Banqueting Hall, Whitehall, with ceiling
Rubens's ceiling, which is steeped in the Venetian tradition of decorative painting so loved by Charles I, celebrates the Divine Authority and the peace and wisdom of the reign of James I; Rubens applied to a Protestant heretic monarch the kind of elaborate allegory with which he had served the Catholic cause.

John Singer Sargent (1856–1925)
The son of a Philadelphia doctor, Sargent was born in Florence and when young travelled extensively in Europe, studying in Rome, Florence and Paris. He first exhibited at the Paris Salon of 1878. In 1886 he settled in London and began to build up a reputation as a fashionable portrait painter, although he also painted landscapes. His dashing and fluent technique prompted obvious comparisons with Lawrence; and, with the later Philip de Laszlo (1869–1937), he is the last in the line of portrait painters in the grand tradition which stretches back to Van Dyck.

179. Mrs Carl Meyer and her children
This is one of Sargent's most opulent portraits. The painting of the satins, velvet and tapestry-backed settee shows great verve and also the extent to which a large portrait, showing the whole figure, depends for its effect on the painting of drapery and accessories. This is as true of a full-length portrait by Gainsborough, Lawrence or Van Dyck as it is of Sargent's work. Exhibited at the Royal Academy in 1897, a critic wrote; 'The dominating picture of the whole Academy is unquestionably the portrait of Mrs. Carl Meyer.'

Samuel Scott (about 1702–72)
Scott first started painting marine views in the style and tradition of Van de Velde, and in 1732 he worked with George Lambert in painting views of East Indies settlements. He settled in Twickenham in the 1750s and retired to Bath in 1765.

55. The Tower of London
It was not until Canaletto's arrival in London in 1746 that Scott started painting views of the Thames, for which he is best known. His later work is strongly influenced by Canaletto, though it has also a breadth and mastery of tone which makes

him one of the finest view painters of the eighteenth century. There are a number of versions of this composition.

William Bell Scott (1811–90)
Associated with the Pre-Raphaelites, Scott was a poet as well as a painter and contributed poems to the short-lived Pre-Raphaelite periodical, *The Germ*. Coming to London in 1837 he entered for the Houses of Parliament competition, and was in 1843 appointed master of the Government School of Design in Newcastle. Here he helped James Leathart to form his fine collection of Pre-Raphaelite paintings. He came back to London in 1864.

161 and 164. Iron and coal
This is the last in a series of paintings illustrating the history of Northumbria, painted for Wallington Hall (1857–61). Its preoccupation with modern industrial life and the hard physical strain of manual labour, as well as its detailed realism, curiously prefigures the social realism of the state art of Soviet Russia in this century.

William Scott (born 1913)
Born in Greenock, brought up in Northern Ireland, Scott came in 1931 to study first sculpture then painting at the Academy; he lived and travelled in Cornwall, France, Italy and Brittany until war forced him back to Somerset and art school teaching, interrupted by four years of war service. After his allegiance to French art, increasing abstraction was confirmed by a visit to New York in 1953: he met Pollock, Rothko and Kline, and exhibited there from 1954. Critical recognition led to selection for the São Paolo Bienal, 1953, a major mural commission, 1958, first prize John Moores, 1959, exhibitions abroad, Ford Foundation artist in residence, Berlin 1963, and monographs published in 1963 and 1964. He still lives in Somerset; a major retrospective at the Tate in 1972 included a catalogue commentary by Scott.

209. Frying pan, eggs and napkin
Studies of simple kitchen implements were Scott's main theme, even as he withdrew to the point of abstraction where his representations became merely rudimentary, formal allusions to pots and pans. Their shapes, here in 1950 clearly represented, symbolize the male and female elements, erotic implications not denied by Scott, though he declines to explain further. His typically uncluttered, cleanly organized surface is concerned with juxtapositions of colour and form, and the references to Purism in the uptilted table and stark formality of flattened planes are here particularly emphatic.

William Scrots (working 1537–54)
William Scrots, who arrived in England in 1545, succeeded Holbein as the King's Painter and retained this position until 1553. He had previously been court painter to Mary of Hungary, Regent of the Netherlands, and he brought to England an up-to-date style of Mannerist court portraiture. Very little is yet known about his oeuvre.

8. Henry Howard, Earl of Surrey

Painted about 1550, this is a commemorative portrait; Surrey was executed in 1547. The four known versions of this painting are now considered to be variants, on canvas, of a lost documented original on wood. The use of the full-length portrait formula—which derives ultimately from a north Italian type—the glossy fabrics and sophisticated classical architecture are characteristic of the fashionable refinement with which Scots revitalized English court portraiture.

Jan Siberechts (1627–1703)

Siberechts was a Flemish painter who arrived in England between 1672 and 1674. His style shows the beginnings of a departure from a strictly topographical tradition. He painted views of country houses and of English scenery.

45. Landscape with a view of Henley-on-Thames

The scenery here is obviously British, but the composition and particularly the style of the animal and figure group and the way in which the trees are painted reveal Siberechts's Flemish origins. It is an interesting attempt on the part of a foreign artist familiar with Dutch landscape and with Rubens to come to terms with English scenery.

Walter Richard Sickert (1860–1942)

Born in Germany of Anglo-Danish parents, Sickert was brought up in London and at seventeen was an amateur actor. In 1879 he met Whistler and two years later went to the Slade, leaving in 1882 to become Whistler's assistant, a job which introduced him to Paris, Oscar Wilde, Degas, and regular painting trips to Dieppe. Now in the first of three marriages, Sickert was based in London, and exhibited in 1884 as 'pupil of Whistler'. In 1887 he showed in Brussels with the *avant-garde* 'Les xx', and in 1888 joined the New English Art Club, from which he finally resigned in 1917. With a great taste for a good battle and a quixotic enterprise, Sickert set up a succession of drawing and painting schools with himself as master, most of which had only a brief life. The Fitzroy Street Group formed in 1907, followed by the Camden Town Group in 1911, with Sickert, Gore and Gilman joined by Duncan Grant, Wyndham Lewis and others.

178. La rue Pecquet (St Jacques)

During the nineties, Sickert's use of colour had mellowed to its familiar plummy tones and here he strokes it on to the canvas with dash and vigour, leavening the sombre mass of the church with the streak of bright sunlight along the road and carrying the eye precipitately in through the twin black slots of the door—the focus of the painting. Impressionist and freely applied though his paint was, structure was always a major preoccupation for Sickert. Monet's Rouen Cathedrals lie behind Sickert's variations on St Jacques, but it is Degas and Cézanne who answered his technical problems.

183. Ennui

The title, hinting darkly at a deep-seated malaise in the couple's relationship, recalls Victorian themes and Sickert's Whistlerian apprenticeship (even Whistler had succumbed to the anecdote

with an etching called '*Weary*'). Sickert had always been in love with the theatre, above all with music hall, and since 1890 had painted evocative scenes of audience, stage and orchestra pit; perhaps with *Ennui* there is an element of the theatrical tableau, dramatic tension skilfully deployed, heightened by the brown bulk of the man filling the foreground and pushing the bored figure of the woman both literally and metaphorically back into the corner. Painted in about 1913–14, like his *Camden Town murder* of about 1907, it relates most directly to Degas's similar scenes of the 1870s.

Matthew Smith (1879–1959)

It was not until 1905 that Matthew Smith escaped first his family's business then design at Manchester art school and reached the Slade for two years, followed by a year in Brittany. Moving to Paris, he attended Matisse's school for its final month and returned to London the next year. Marriage, travel, and the First World War intervened before he was elected to the London Group in 1920. He painted in England and France, lived in Provence in the thirties and worked with consistent style and brilliance of colour; he was saluted by the publication of a Penguin monograph in 1944, and a Tate retrospective in 1953.

195. Fitzroy Street nude no. 2

One of a pair, and his first major paintings, they had the distinction of being rejected by the London Group—perhaps because of their raw, almost violent, colour. Matthew Smith is tagged as the 'English Fauve', and though this is true as far as it goes, he was nevertheless able to manipulate colour with the control essential if it was not to become overpowering. His debt to Matisse is clear in the serpentine line of the figure, emphasized by the broad lines acting as perimeters to generously-applied areas of colour—a human equivalent to the sinuous forms in *Lilies* (1913–14, Leeds), one of his most beautiful still-lifes.

Gerard Soest (died 1681)

Gerard Soest was a Dutch artist who had probably arrived in this country before the execution of Charles I; he was said to be nearly eighty when he died. His serious and realistic style, which was less overwhelmed by an exposure to Van Dyck than that of Lely, contrasts sharply with the ornate and flamboyant portraits produced by the latter's many followers.

40. Sir Richard Rainsford

The impressive gravity of the painting and the harmony of warm greys, silvers and cool scarlets are characteristic of Soest's style.

Andrea Soldi (about 1703–71)

Soldi came to England in about 1736 and enjoyed considerable success as a portrait painter, together with the French artist, J. B. Vanloo. The popularity of their elegant and sophisticated Continental style was resented by Hogarth; and Ramsay in 1740 claimed he had triumphed over them. But Soldi, despite a

period in the Fleet Prison for debt in 1744, continued to make a living, producing some particularly fine portraits of other artists, such as his *Roubiliac* (Dulwich College Picture Gallery and the Garrick Club) well into the 1750s. His 'light and airy' style, however, suffered in the 1760s in competition with the new Grand Manner of Reynolds and Romney.

71. Catherine Havers
The painting dates from the late 1740s, when Soldi was painting his finest portraits. The treatment of the fur muff, the lace bodice and the grey satin dress shows his ability to suggest the textures of different materials. Catherine Havers stands before a drawn curtain revealing a performance of the Italian *commedia dell'arte*. This precursor of the modern pantomime was very popular in England in the first half of the eighteenth century.

Solomon Joseph Solomon (1860–1927)
After study at the Royal Academy Schools, then with Cabanel in Paris and finally at the Munich Academy, Solomon began exhibiting from 1881 large mythological and Old Testament scenes. The majority of his later works were portraits, though during the First World War he applied his art to the study of camouflage technique.

154. Ajax and Cassandra
This is another example of the classical revival in the last third of the nineteenth century. Here the emphasis is on size and a kind of sublime energy paralleled in the work of Watts (*Plate 156*) and earlier found in the work of Fuseli (*Plate 88*). It was exhibited at the Royal Academy in 1886. Large pictures, which by reason of the hanging policy of the Academy in the middle years of the nineteenth century were 'skied' and thus difficult to see and rarely produced for the exhibitions, became more common after 1869 when the Academy moved to Burlington House, where, because of the abolition of the 'line', they could be hung lower down on the walls. The 'line' was a ledge which ran round the galleries in Somerset House and Trafalgar Square about eight feet above the floor. The pictures of academicians were hung 'on the line', just below this ledge, where they could be best seen.

Stanley Spencer (1891–1959)
Spencer was born at Cookham, in Berkshire, a Thames-side village, where his father was the parish organist and a devout Christian. He studied at the Slade from 1909 to 1912 and served in Macedonia in the First World War. He resigned from the Royal Academy in 1932 but was re-elected in 1950. In the Second World War he painted a series of pictures of ship-building on the Clyde (Imperial War Museum). The combination of his childhood love of Cookham and reading the Bible gave to his art a highly personal quality which is both spiritual and earthy at the same time. His work was also influenced by the paintings of Masaccio, Fra Angelico and Bruegel.

186. Self-Portrait
The openness to sensation and the visionary eyes in this self-portrait, painted in 1913, are strikingly reminiscent of the self-portrait of Samuel Palmer of about 1828 in the Ashmolean Museum, Oxford. Both artists shared a strong attachment to a particular place, for Palmer, Shoreham, and for Spencer, Cookham, which appeared to them as an earthly manifestation of Christian truth.

191. Wounded arriving at a dressing station, Smol, Macedonia, 1916
Painted in 1919, this picture shows Spencer's concentration in his war paintings on the everyday life of soldiers behind the front line. Although it has a documentary quality, the figures are monumental and have that odd bulkiness which Spencer gave to all his human and animal forms. Spencer's major depiction of the First World War is in the Burghclere Memorial Chapel, which he decorated between 1927 and 1932.

193. Christ carrying the Cross
Painted in 1920, the house depicted was his own in Cookham and the ivy-covered cottage was his grandmother's. The picture shows Spencer's linking of the life of the village in which he lived with the joy he felt in the Christian story. 'It was joy and all the common everyday occurrences in the village were reassuring comforting occurrences of that joy.... I had as a child no thought than that Christ had made everything wonderful and glorious and that I might be able later on to join in that glory.'

Philip Wilson Steer (1860–1942)
From Gloucester School of Art Steer went to Paris, studying at the Académie Julien and the École des Beaux-Arts, 1882–4. The Impressionists he saw in Paris—above all Monet—profoundly influenced his work once he was back in London and as it developed at Walberswick in Suffolk and on the north French coast. He showed at the Royal Academy from 1883, and joined the New English Art Club in 1886; an exhibitor in the Goupil Gallery's 'London Impressionists', 1889, he had a one-man show there in 1894. After 1900 he remained in England, making regular painting trips into the country, and taught at the Slade for the last forty years of his life.

176. The bridge
Previously thought to have been at Étaples, *The bridge* was painted in 1887 probably at Walberswick, for years Steer's favourite English haunt. There is still much of Whistler in the paint, thinly skimmed on to the canvas, and in the horizontally-structured composition, but by 1889 when he probably began *Girls running, Walberswick*, one of his best-known paintings, his studies of sun and light-saturated beaches were rising successfully to Monet's example. His interest in figure studies, many of them nudes in the tradition of Boucher and even Rubens, lapsed after 1900 when he looked increasingly to Turner and Constable for landscape studies.

Ian Stephenson (born 1934)
Stephenson is a native of Northumbria and studied art at King's College in the University of Durham between 1951 and 1956. Since he came to London in 1959, apart from a sojourn in the North Country from 1966 to 1970, he has worked in Chelsea. He has exhibited regularly since his student days. Stephenson has

always worked in a stippled style which coincides with his understanding of English painting. He has said; 'I love the tradition of an albion art and really my paintings have more to do with Constable's *snow* than Tobey's *white writing*.' Throughout the sixties his work became larger in scale and more dense in surface texture, often employing more than one canvas to a picture. In 1970 Stephenson shared a retrospective exhibition with the works of the early Victorian artist John Martin.

219. Parachrome

This picture, painted in 1964, is ambiguous in the way that it alternates between easel painting of the past and the all-over modernity of the artist's later series of large sectional canvases painted horizontally. The flat on the floor technique of painting recalls the Abstract Expressionism of Jackson Pollock, who worked in America in the late 1940s and early 1950s. In Stephenson's work, however, the delicately massed effect of the spray technique has none of the violent expression of Action Painting. His style 'conceals and reveals' the richest variety of marks. *Parachrome* is complex and mysterious in its meticulous details. Stephenson shares with Francis Bacon a concern for creating an ordered picture out of a method of painting which has some elements of chance and accident. Although their imagery is focused at a different level of reality, they are in their own ways portraying time, depicting movement, and extending the frontiers of painting. In common with many modern painters, however different their methods or their imagery, he is as concerned with the process of painting as with the finished work.

Alfred Stevens (1817–75)

Stevens went to Italy in 1833, where he studied for nine years. He was a sculptor, designer and decorator as well as a painter. His best-known commission was the Wellington Monument in St Paul's Cathedral, on which he started work in 1858, although it remained unfinished at his death. He was a brilliant draughtsman and his studies in red chalk are arguably the finest figure drawings done in Britain in the nineteenth century.

149. Mrs Elizabeth Young Mitchell and her baby

A charming and poignant study of a mother and child which shows Stevens's unerring grasp of the human form. Both mother and child were ill when the picture was being painted in 1851, and Mrs Mitchell died before it was finished.

Marcus Stone (1840–1921)

Having decided as a child to become a painter, Stone learnt from his artist father and friends, and at seventeen showed the first of his annual exhibits at the Academy. A friend of many writers—Bulwer Lytton, Dickens, Wilkie Collins—he illustrated *Our mutual friend* and *Great expectations*. Stone lived in Melbury Road, Kensington, near Leighton and Fildes, and had known many artists of his father's generation like Maclise, Dyce and John Phillip. Elected associate of the Royal Academy in 1876 and academician in 1886, he was enormously successful and commanded high prices; a biography by Alfred Lys Baldry was the *Art Annual* for 1896.

177. Two's company, three's none

Exhibited in the Academy of 1892, the subject is an episode in what became Stone's long-running serial of young love—*In love* (1888), *The first love-letter* (1889), *A passing cloud* (1891), and, in 1893, the happy ending, *Honeymoon*. Invariably set around 1800–20, the glamorous occupants of his paintings drift through storybook gardens filled with blossom, and one, as here, will gaze out at the onlooker, inviting us into the narrative. The situations are often humorous, the characters perplexed, but his public was comforted that a solution would always be found in next year's summer show.

George Stubbs (1724–1806)

Stubbs was born in Liverpool and first made his living as a portrait painter. After a visit to Italy in 1754, to convince himself, it has been said, that 'Nature is superior to Art', he published his *Anatomy of the horse* in 1766, based on a minute and detailed study of dissected carcases. In the 1760s, now based in London, his reputation as a painter of sporting pictures and especially horses was established. In the 1770s he painted in enamels on Wedgwood plaques. At the end of his career he undertook a series of large portraits of horses for the *Turf review*. His work provides the consummation of the sporting painting tradition in direct descent from John Wootton

48 and 67. The Duke of Richmond's racehorses exercising at Goodwood

Painted for Charles, 3rd Duke of Richmond, about 1760–1, soon after Stubbs's move south from Lincolnshire, where he had been working on his studies of dissected horses. This painting is thus one of the first by which Stubbs established his reputation as a fashionable sporting painter. The curiously static quality of the racehorses, intensified by Stubbs's fastidious sense of rhythm, reminds one of the works of James Seymour (1702–52), a lesser artist, but one who had been successful as a painter of racehorses.

66. Lord and Lady Melbourne, Sir Ralph Milbanke and John Milbanke

This painting was possibly exhibited at the Society of Artists in 1770. It can be seen as a variation of the popular conversation piece genre, with a clear emphasis on the three quite different horses. Stubbs's works of this kind celebrate the happy world of country life, good breeding—both human and animal—and sporting pursuits, which were part of the golden age of the English aristocracy. It is sharply distinguished from the urban turmoil and decadence depicted by Hogarth.

68. Mares and foals

Stubbs painted at least nine pictures of brood mares, or mares and foals. This one was painted for Charles, 2nd Marquis of Rockingham, in 1762, and is the only one without a background, like Stubbs's portrait of *Whistlejacket*, now on loan to the Iveagh Bequest, Kenwood, which was painted for the same patron. Stubbs immortalized this series of brood mares and foals by his sure sense of anatomy combined with an exquisite feeling for rhythm and interval.

69. Pumpkin with stable lad
Stubbs painted several versions of the same horse being ridden at Newmarket, one for the late *Turf review* series. As in many of Stubbs's paintings, the landscape has a curiously frozen and static feeling, and this stillness is echoed not only by the horse, but also by the pose of the stable lad. It gives the picture an icon-like quality which reflects the importance attached to horses and horse breeding by many of the English upper classes at the time.

Graham Sutherland (born 1903)

Sutherland studied at Goldsmiths College from 1920 to 1925 and amongst his early works are etchings of landscapes, partly inspired by Samuel Palmer. In the 1930s he exhibited with the New English Art Club and the London Group. He exhibited at the 'International Surrealist Exhibition' in 1936. During the Second World War he was an official war artist, painting bomb damage, Cornish tin mines and limestone quarries. Since the war he has achieved an international reputation and his work has been exhibited throughout Europe. He has painted religious subjects and he designed the huge tapestry of the *Seated Christ* for Coventry Cathedral. In landscape, he has been particularly associated with Pembrokeshire, where the romantic inlets and oddly shaped prehistoric standing stones have stimulated his interest in weird, evocative and menacing landscape forms.

203. Devastation, 1941: an East End street
Sutherland's paintings and drawings of bombed London streets are somewhat similar in style to the work of John Piper (*Plate 204*), but they are harsher and more forbidding. Although the forms are realistic, the colours and light and shade are emotionally expressive.

218. Portrait of Lord Goodman
Lord Goodman was chairman of the Arts Council from 1965 to 1972. Sutherland's portraits combine an academic realism and sure draughtsmanship with an uncompromising penetration into character. He is one of the finest British portraitists of this century, and one of the most controversial, as the mixed reaction to his portrait of Churchill (1954–5) demonstrated. Probably his best known portrait is that of Somerset Maugham (1949; Tate Gallery), which, in its ability to catch a characteristic pose, is in the tradition of Reynolds's portrait of Laurence Sterne (*Plate 73*).

James Thornhill (1675/6–1734)

Thornhill came from an old Dorset county family. He was possibly working for Verrio at Hampton Court from 1702 to 1704 and in 1706 he painted his first major decorative work, the Sabine Room at Chatsworth, in the style of Verrio and Laguerre, but with a surer sense of painted architecture in perspective. His two major commissions were the Upper and Lower Halls at Greenwich (1707–25) and the dome of St Paul's (1715–17), the latter in grisaille. He was knighted in 1720, the first English-born painter to be so honoured. The turning point in his career came in 1722, when he was passed over for the decoration of Kensington Palace, the commission going to

William Kent. He spent his last years making three sets of copies of the Raphael Cartoons.

43. Sketch for the ceiling of the queen's bedchamber, Hampton Court
The ceiling, originally of the Prince of Wales's bed-chamber, now the queen's bed-chamber, was painted by Thornhill in 1714–15. The oil sketch is executed in a free style which shows Thornhill's sound grasp of painted architectural decoration. It depicts Leucothoë restraining Apollo from entering his chariot. In the coves are oval portraits of George I, Prince George, Caroline, Princess of Wales, and Prince Frederick. The conventional allegorical figures of slaves round the edge of the central design derive from the work of Annibale Carracci in the early seventeenth century on the ceiling of the Farnese Gallery, Rome.

Peter Tillemans (1684–1734)

Peter Tillemans, an Antwerp painter, was brought to England in 1704. His first employment was in copying old masters. Later he became an antiquarian and topographical draughtsman. He was a popular painter of country seats, houses and hounds. He had a wide repertory and in his later years did many views of Newmarket.

47. Mr Jemmet Browne at a meet
By family tradition the setting is at Riverstown, County Cork. Tillemans is amongst the first of those painters to immortalize the country life and sporting pursuits of the English upper classes. The tradition continues throughout the eighteenth and nineteenth centuries and survives in the twentieth century in the work of Alfred Munnings and his followers.

Jacques Joseph Tissot (1836–1902)

Born in Nantes, Tissot studied with Flandrin in Paris where he met Whistler and Degas. He began to paint modern life subjects in the 1860s, and his success in this field was confirmed after he settled in London in 1872. Although Tissot refused Degas's invitation in 1874 to exhibit at the first Impressionist exhibition, he was influenced by these artists, particularly by Manet, while retaining his distinctive polished finish and the hint of anecdote in his subject matter. Despite Ruskin's criticism that his works were 'mere coloured photographs of vulgar society', Tissot continued his stylish paintings of society until his return to Paris in 1882.

152. London visitors
Tissot's subjects of modern life have a fastidious clarity which is partly inspired by the paintings of Degas and Manet. This painting was exhibited at the Royal Academy in 1874, and one reviewer complained of its 'arctic frigidity'. It shows the steps of the National Gallery with St Martin-in-the-Fields in the background and two boys in the uniform of Christ's Hospital School. The woman looks out of the picture at the spectator, subtly involving him in the scene, inviting him to invent some story or narrative which might explain the ordinary yet curiously enigmatic incident which is taking place.

Joseph Mallord William Turner (1775–1851)

Turner started his career as a watercolourist in the Picturesque tradition of Edward Dayes and Thomas Girtin. He travelled to the Continent in 1802, the first of many trips to Germany, France, Switzerland and Italy, which last he first visited in 1819. His *Liber studiorum*, published in mezzotint from 1806 to 1819, categorized different kinds of landscape. Turner's output was immense and the range of his subject matter wide, though it almost always took landscape form. He had a remarkable capacity for capturing the atmosphere of a particular topographical location as well as investing it, in his finished paintings, with complex associations of a literary and intellectual nature. In his later work his intense preoccupation with light and colour gives his work an almost abstract quality, but in fact he never lost his overwhelming concern to depict the phenomena of nature.

118. Tabley Lake
Commissioned from Turner by Sir John Leicester, an important patron of British artists, in 1808. For paintings of the same park by Richard Wilson and James Ward, see Plates 116 and 117. When the painting was exhibited at the Royal Academy in 1809, a critic wrote; 'The views [there was another by Turner] of Sir John Leicester's seat, which in any other hands would be mere topography, touched by his magic pencil have assumed a highly poetical character.'

104 and 106. Dido building Carthage, or the rise of the Carthaginian Empire
This is one of the most ambitious paintings of Turner's early maturity, when he was flexing his artistic muscles in rivalry with and imitation of the much venerated painter of the seventeenth century, Claude Lorrain. It was Turner's wish that this picture should hang beside the *Seaport: Embarkation of the Queen of Sheba* by Claude, as it now does. In fact the differences, as well as the similarities, are striking. The romantic bustle and preoccupation with size and grandeur in Turner's work, and the fairly thickly painted paint surface, are in contrast to the clear, limpid, liquid peace of Claude's painting.

107. Ulysses deriding Polyphemus
Exhibited at the Royal Academy in 1829, this is one of the completest and most complex of Turner's mythological landscapes. The bright and highly keyed colour is typical of his work in the 1820s and probably derives from his first experience of Italian light in 1819. Ruskin greatly admired this painting.

130. Interior at Petworth
Turner painted a number of interiors at Petworth, both in oil and body-colour on blue paper, all in a very free and sketchy manner. The artist stayed at Petworth frequently in the late 1820s and 1830s, as a guest of his most important patron, the 3rd Earl of Egremont, whose free and easy hospitality was enjoyed by other artists including Constable. This painting has the bright reds, yellows and greens of an almost Expressionist colour scheme and it may represent Turner's reaction to the news of Lord Egremont's death in 1837.

Unknown artist

17. Knole House, Kent: Grand Staircase
The painted decoration of about 1605 is in stone colour which is intended to imitate plasterwork. The style of the allegorical figures and of the strap-work and grotesques is derived from prints by Netherlandish artists, a common source of inspiration in the late sixteenth and early seventeenth century.

Antonio Verrio (about 1639–1707)

Antonio Verrio was probably born at Lecce in southern Italy. In the later 1660s he was working in Toulouse and was in Paris by 1671. He came to England in 1672, and from 1675 until the 1688 Revolution he was employed by the Crown, largely at Windsor. During the next ten years he undertook private commissions, amongst them Chatsworth and Burghley. In 1699 he returned to royal service and the most important commission of his later years was Hampton Court. Verrio brought to England a theatrical Baroque illusionism; Charles II was anxious to follow the fashion for decorative painting established at the court of Louis XIV.

42. The Heaven Room, Burghley House, Lincolnshire
Verrio here employed his favourite device of painted colonnaded walls; his handling of *trompe-l'œil* is masterly and the figures seem to stride forward into the room. The subjects, depicted with some humour, are, on the ceiling an Assembly of the Gods, and on the walls Mars and Venus caught in Vulcan's net, Neptune and his court and Bacchus, and Vulcan's forge.

Edward Wadsworth (1889–1949)

Wadsworth studied art and engineering in Munich in 1906, then was at the Bradford School of Art and the Slade from 1908 to 1912. He was associated with Wyndham Lewis and the Vorticists. He was a member of many *avant-garde* groups, from the London Group and the New English Art Club to Unit One. He executed mural decorations for the liner, *Queen Mary*, in 1935. Wadsworth produced a wide range of styles, including Vorticist abstraction, biomorphic abstraction (abstract forms which have an appearance of biological life, amoeba-like), Surrealism and realistic painting. Almost all his paintings are concerned with marine and nautical objects or scenes, or forms derived from his knowledge of nautical life.

200. The beached margin
This picture was painted at a time when Wadsworth was using marine and nautical forms to create a kind of seaside Surrealist still-life effect—the starfish, ropes and simplifications of nautical instruments are recurring elements in his work in the 1930s. The objects are painted with a clear definition which reflects his interest in machinery and engineering.

Edward Matthew Ward (1816–79)

Ward trained at the Royal Academy Schools and in Rome at the Academy of St Luke, where he won the silver medal for historical composition. He studied fresco for a short time

under Cornelius in Munich before returning to London in 1839. His Royal Academy exhibits were popular with the Victorian public, who responded to his brightly coloured paintings of anecdotal incident, often drawn from seventeenth- and eighteenth-century history and literature. Awarded a prize in the 1843 competition for the decoration of the Houses of Parliament, in 1855 he painted eight scenes from British history in the corridor leading to the House of Commons.

167. The royal family of France in the prison of the Temple

Unlike the Bonington (*Plate 166*), this painting depends for its success on the emotional and anecdotal appeal inherent in the historical situation, which is heightened by Ward's varied and detailed treatment of facial expression, and brought closer to the sympathy and imagination of the viewer by his careful rendering of homely details such as the queen's sewing box and the child's toys.

James Ward (1769–1859)

Ward started his career as an assistant to his brother, the engraver William Ward, but, his sister marrying George Morland, he started to paint. His first major success was his *Fighting bulls with a view of St Donat's Castle* of 1803–4 (Victoria and Albert Museum), an imaginative pastiche of Rubens's *Château de Steen* (National Gallery), whose technique influenced Ward's work considerably. Despite a successful career as an animal and landscape painter up till the 1820s, Ward was a troubled artist, with aspirations to paint grand historical subjects, and little is known of his works in the 1830s and 1840s.

117. Tabley Lake

Ward was aware of the fact that Wilson and Turner (*Plates 116 and 118*) had already painted Tabley when this picture was commissioned by Sir John Leicester. 'I have had to tell a story', he wrote to his patron, 'that has been told before so beautifully as to make me tremble.' Characteristically, Ward includes a 'Young White Bull, the Adonis of my picture'. His capacity to invest his animals, especially bulls and horses, with a quasi-human primitive nature shows him as developing one of the strains in Stubbs's art and making it overtly Romantic. Ward was the creator of the Sublime animal, which was sentimentalized later by Landseer.

125. John Levett out hunting in the park at Wychnor

Ward was friendly with the Levett family, who commissioned a number of paintings from him. It is noticeable, even in this relatively conventional sporting painting, that Ward gives to the horse an intense, impassioned, almost human expression.

George Frederick Watts (1817–1904)

Watts was a delicate child and he suffered from ill-health throughout his life. Yet he was an enormously hard worker, continually wrestling with vast projects and high moral ideas. After winning a prize in 1843 in the competition for the decoration of the Houses of Parliament he went to Italy and

stayed with Lord and Lady Holland. Thenceforward he was always looked after, largely by Mr and Mrs Thoby Prinsep at Little Holland House in London, but he did not receive widespread recognition as a painter of allegorical and mythological subjects, which were often coloured by his personal vision and symbolism, until the 1880s. In 1886 he married for a second time, having been briefly married previously to Ellen Terry, and settled at Compton, near Guildford, where his house is now the Watts Gallery.

148. John Stuart Mill

Watts had a steady success with his portraits, which are amongst the finest done by a British painter in the second half of the nineteenth century. They are never grandiose or theatrical in the manner of Lawrence or Sargent, yet they stand as masterpieces because of their penetration into character. Their simple format is reminiscent of the photographic portrait studies of Julia Margaret Cameron. A replica of this portrait is in the National Portrait Gallery.

156. Paolo and Francesca

This painting is a version of the composition exhibited at the British Institution in 1848. The British Institution held exhibitions of contemporary artists' works and old master paintings in the nineteenth century. The design of this picture was influenced by a painting of the same subject by Ary Scheffer, but it shows Watts's love of large figures presented in unusual poses. The subject demonstrates his overwhelming concern with moral issues—the two lovers, because of their sin, float forever through eternity.

Benjamin West (1738–1820)

West was an American-born artist who travelled to Italy in 1760 and settled in London in 1763. His *Death of General Wolfe* (1771) was extremely successful and led to his appointment as History Painter to George III. It set the trend for a more narrative and realistic depiction of events from contemporary history, which had not in itself previously been considered as a proper source of subjects for serious painters. West was president of the Royal Academy from 1792, with a short break, until his death. He painted both in the Neo-Classical and Romantic vein a wide range of subjects, religious, mythological, ancient, medieval and modern history as well as illustrations to literature and portraits.

93. Apotheosis of Nelson

West painted this picture as a frontispiece for Clarke and McArthur's *Life of Nelson*, published in 1809. Nelson, killed at the Battle of Trafalgar in 1805, was a great national hero and West clearly decided to treat the subject in the grandest allegorical vein, with the figure of Nelson like the dead Christ of a *Pietà*. The composition is the same as that of the central panel of his project for a monument to Nelson which was never executed. This painting contrasts with his more realistic portrayal of the *Death of Nelson* (Liverpool, Walker Art Gallery), which is rather on the lines of his *Death of General Wolfe*.

James Abbott McNeill Whistler (1834–1903)

Brought up in America and Russia, Whistler visited England in 1847; three years at West Point, then six months in the United States Coastal Survey taught him etching and decided him to become an artist. From 1855 he studied in Paris academic studios, and made friends like Du Maurier, Poynter, Fantin-Latour, Legros and, most important, Courbet. He moved to London permanently in 1859, exhibited at the Academy, 1860–72, and caused a sensation at the Salon des Réfusés, Paris 1863, with *The white girl*. Increasingly influenced by Japanese art in the sixties, he decorated the Peacock Room for F. R. Leyland in 1876–7. *The falling rocket*, exhibited 1877, was ridiculed by Ruskin; Whistler sued and won a farthing damages. Bankrupted, he travelled between Venice and London in the early eighties with his pupils Sickert and Menpes. The 'Ten o'clock' lecture, 1885, presidency of the Society of British Artists from 1886, and publication of *The gentle art of making enemies*, 1890, filled his last years.

150. Nocturne in blue-green

First exhibited in 1871 as 'Harmony in blue-green—Moonlight', Whistler changed the title when Leyland suggested 'Nocturne' for his moonlight studies of the Thames. This is probably the first of these, which occupied much of the 1870s. Whistler was delighted with the musical allusion, not only because of its aptness for the poetic mood and subtle tones of the paintings, but because it enraged his legion of critics. His paint is laid in liquid sweeps across the width of the panel, accented by the few vertical marks; according to Courbet, Whistler always 'made the sky too low, or the horizon too high', but Whistler's placing of the horizontal bands of river and shore used Japanese formulae with daring and imagination.

172. Symphony in flesh colour and pink: Mrs F. R. Leyland

Mrs Leyland was painted in 1873, immediately after Whistler's earliest and greatest portraits, of his mother (1871–2) and of Thomas Carlyle (1872–3). Her portrait is a subtle fusion of Whistler's twin gods, Velasquez and Japanese art: the delicate rose and white dress was chosen to harmonize with her rich auburn hair, a theme picked up in the Japanese sprays of blossom at the left; the placing of the figure in a simple shallow space and the tall narrow canvas are from Velasquez. She was the first of many beautiful women of whom Whistler painted superb and sympathetic portraits: amongst her successors were Lady Meux (1881; Frick Collection, New York), Lady Archibald Campbell (1884; Frick Collection, New York), and Mrs Whistler (1886; Glasgow).

David Wilkie (1785–1841)

Born in Fife, Wilkie's earliest knowledge of art was from engravings after seventeenth-century Dutch cabinet pictures, and when he arrived in London in 1805, after brief study in Edinburgh, he had already assembled the basic ingredients of the incident-packed, highly finished peasant genre scenes with which he quickly made his reputation. Journeys to Italy and Spain in 1825 inspired him to extend his range of subjects to include history paintings and portraits. His canvases became larger, darker and more loosely painted. These later works, though he never lacked patrons, caused a drop in his popularity. In 1840 Wilkie travelled to the Holy Land hoping to collect material from direct observation for biblical painting, but he died at sea on the return journey.

134. Chelsea Pensioners receiving the London Gazette Extraordinary of Thursday, June 22nd 1815, announcing the Battle of Waterloo

The Duke of Wellington ordered a Waterloo subject from Wilkie in 1816, but the artist was allowed to pick an incident which suited his own talents. The painting was not completed until 1822, when it was the most popular picture at the Royal Academy. In showing the reaction to the great event of the Battle of Waterloo, rather than any heroic action, Wilkie was able to produce a *tour de force* of realistic anecdotal detail. The result is a picture that could have been painted by Hogarth in an optimistic and sentimental mood.

141. The penny wedding

An example of Wilkie's most popular manner, this picture depicts a Scottish rural marriage festivity, where each guest was expected to contribute towards the feast. Despite the clearly realistic nature of painting, Wilkie has added a touch of charm and elegance to the scene to appeal to the London audience, who liked to view such low-life customs through a haze of sentiment. Frith's modern life subjects (*Plate 142*) were, in fact, considered more 'real'. The Prince Regent, a collector of seventeenth-century Netherlandish painting, bought this work from Wilkie in 1819.

Richard Wilson (1714–82)

Wilson started his career as a portrait painter as well as a landscapist, and it was not until his relatively long stay in Italy (1750–57/8) that, encouraged by Claude-Joseph Vernet and Zuccarelli, and inspired by Italian light and scenery, he dedicated himself to landscape. On his return to England, topographical views of country houses, sublime landscapes in the manner of Salvator Rosa, and repetitions of his Claudian Italian views brought him success. But in the late 1760s and early 1770s his popularity waned, largely because his idea of the importance and independence of landscape as an art precluded compromise with patrons. He died in poverty, but within thirty years of his death his reputation as the first great British landscape painter was being established.

58. Kew Gardens: The ruined arch

This painting, exhibited at the Society of Artists in 1762, was entitled the *Villa Borghese* in the etching by Thomas Hastings of 1822 and it is one of the most Italianate of Wilson's English landscapes. It was perhaps one of the pictures shown to George III in the hope that he might purchase it, but the king considered the price too expensive for a landscape and was anyway more pleased with the lighter style of Zuccarelli, and so Wilson failed to secure royal patronage.

116. Tabley House

This was painted probably in about 1774 for Sir Peter Leicester, whose son was later to commission landscapes of Tabley from Turner and Ward (*Plates 117 and 118*). Compared with Wilson's paintings of country houses done just after his return from Italy, such as the views of Wilton and Croome Court, and indeed with the paintings of Tabley by Turner and Ward, the architectural or topographical features are reduced to a minimum. All the emphasis is on the landscape and the sky. It was this complete commitment to landscape, and often quite unspectacular landscape in Britain, which accounts both for Wilson's importance in the history of British art and for his lack of success in his own lifetime.

Christopher Wood (1901–30)

Wood studied art in Paris at the Académie Julien in 1921, before travelling widely in Europe. During the 1920s he became closely associated with Ben Nicholson and at the end of the decade he painted landscapes and harbour scenes in Cornwall and Brittany. The figures in his landscapes often take on the curious significance of dream images. His short life was tragically ended when he was killed by a train at Salisbury.

197. Boat in harbour, Brittany

Christopher Wood, like Ben Nicholson, was affected by the texture, colours and forms of Cornish buildings and landscape. Wood also worked in Brittany, with its similar landscape and architecture, and this picture was painted in 1929. Unlike Nicholson, however, Wood was not drawn towards abstraction, but towards a childlike and naïve vision, partly inspired by the paintings of the retired fisherman, Alfred Wallis.

John Wootton (about 1682–1764)

Wootton was a pupil of the Dutch artist, Jan Wyck, and his sporting subjects derive from the Netherlandish tradition which Wyck practised in England. By 1714 Wootton was established as 'ye horse painter' in a great era of horse breeding, but he was also a landscapist of considerable gifts, who was in demand for pastiches of Gaspard Dughet and Claude at a time when seventeenth-century classical landscape was overwhelmingly popular. George Vertue noted his success, saying that he was 'well esteemed for his skill in Landskip painting amongst the professors of Art and in great Vogue and favour with many person of ye. greatest quality'. He provided decorative sporting pictures for Althorp, Longleat, Welbeck and Badminton.

46. Lady Henrietta Harley hunting with harriers

Lady Harley was the daughter of the Duke of Newcastle and inherited her family's passion for horses. Lord Harley, a great admirer of Wootton, owned about forty sporting pictures, portraits and landscapes by the artist.

Joseph Wright of Derby (1734–97)

Wright was trained, like Reynolds, under the fashionable portrait painter, Thomas Hudson, in London in the 1750s, and he exhibited at both the Society of Artists and the Royal Academy, as well as visiting Italy (1773–5). Wright is almost unique in the eighteenth century, however, in making a provincial town, Derby, the centre of his activity; and indeed his preoccupations and interests were wider and more up-to-date than those of most London painters. He knew the leading figures of the scientific, intellectual and industrial circles in the Midlands and expressed in his paintings a wide range of interests, literary as well as scientific, which make him a true son of the European Enlightenment.

83. Robert Shore Milnes

A fine example of Wright's grand portrait style, painted about 1771–2 and exhibited at the Society of Artists in 1772. Milnes is dressed as an officer in the Royal Horse Guards. The landscape background is painted in Wright's characteristic manner, with a surface texture that resembles rough stone. Wright painted pure landscapes, both Italian views and scenes in the Peak District, and another distinctive landscape background appears in his masterpiece in portraiture, the group portrait of Mr and Mrs Thomas Coltman of about the same date.

95. A philosopher giving a lecture on the orrery

This painting was exhibited at the Society of Artists in 1766, and with Wright's *Experiment on a bird in the air pump* (Tate Gallery), documents that dissemination of interest in astronomy, science and physics which coloured the intellectual life of the Midlands at this time. The orrery was an instrument which demonstrated the movement of the planets round the sun, which is here represented by a lamp, the source of light in the picture, and, typically in Wright's work, concealed behind a figure. The figures, which are mostly portraits, show that diverse psychological involvement in the drama of the scene which is characteristic of Wright's depiction of contemporary subjects.

96. An iron forge

Wright's great contribution to the history of art is his concern for the accurate and scientific observation of the effects of artificial light. Although this was also a feature of the work of Caravaggio and his northern followers in the seventeenth century, Wright almost always chose vividly contemporary subject matter to illuminate. The *Forge* is just such an example, although it also echoes, with the typical complexity of Wright's art, such Renaissance iconography as the forge of Vulcan.

William Frederick Yeames (1835–1918)

Son of a British consul in Russia and Germany, Yeames lived in London from 1848, studying under Scharf, and then in Italy from 1852 to 1858. His forte was historical genre, and he showed many tableaux from English history, exhibiting from 1859 at the Academy, Society of British Artists, British Institution and even the Grosvenor Gallery. A member of the St John's Wood Clique with Leslie, Marks, Storey and Fred Walker, Yeames was enormously successful with his contemporaries with paintings like *Amy Robsart* (R.A. 1877; Tate Gallery) and *Defendant and counsel* (R.A. 1895; Bristol).

168. 'And when did you last see your father?'

After Millais's *Bubbles*, the most popular of all Victorian genre paintings, this subject was prompted by the artist's nephew. A child, Yeames wrote, 'of an innocent and truthful disposition, . . . it occured to me to represent him in a situation where the child's outspokenness and unconsciousness would lead to disastrous consequences', hence the Civil War confrontation between the Cavalier boy and Cromwell's troops. The anecdote assumed heroic proportions in Yeames's skilful hands: his audience read the painting and, enthusiastically ensnared in the narrative, longed to know more. He had already been made an associate in 1866—with the showing of his *chef-d'œuvre*, he was duly elected academician in 1878.

Johann Zoffany (1734/5–1810)

Zoffany, born in Germany, came to London in about 1760 and by 1762 was working for the actor, David Garrick, for whom he produced a number of theatrical conversation pieces which established his reputation. He was patronized by the Crown—his group portrait, *Queen Charlotte with the two elder princes* (Royal Collection), depicted the quiet domestic felicity which was characteristic of George III's family life and by which, anticipating Queen Victoria, the king changed the image of the monarchy. Zoffany went to Florence in 1773 to paint the Tribuna of the Uffizi for the queen. He visited India from 1783 to 1789.

65 and 70. A view in Hampton Garden with Mr and Mrs Garrick taking tea

Probably dating from the early to mid 1760s, this painting was commissioned by Garrick and hung in his dining parlour. Garrick sits at tea with his wife; his brother George fishes. It is a charming example of the conversation piece genre, with, for Zoffany, an unusually dominant landscape element. Hampton and Twickenham and such Thames-side places were fashionable retreats at this time from the hurly-burly of London. David Garrick (1717–79), as well as commissioning theatrical conversation pictures from Zoffany in particular, was an enlightened patron of the arts. He purchased Hogarth's *Election* series (*Plates 60 and 64*).

Bibliography

THE FOLLOWING is a short list of general books on the history of British art. Useful fuller bibliographies can be found in the books marked with an asterisk. No attempt has been made here to deal with individual artists, a valuable list of books on these appears in E. K. Waterhouse's *Painting in Britain 1530–1790*. At the end is a brief list of exhibition catalogues, often containing new and valuable information, covering British art in the period dealt with by this book.

Early source material and literature

GEORGE VERTUE: *The Vertue Notebooks*, published in the Walpole Society, Oxford, Vols XVIII, XX, XXII, XXIV, XXVI, XXIX, XXX

HORACE WALPOLE: *Anecdotes of Painting in England*, 4 vols, 1762–71, revised and annotated edition by Ralph N. Wornum, 3 vols, London, 1888. Vol. V, *Anecdotes of Painting in England* (1760–95), edited by F. W. Hilles and P. B. Daghlian, Yale, 1937

EDWARD EDWARDS: *Anecdotes of Painters . . . in England . . . intended as a continuation to the anecdotes . . . by the late Horace, Earl of Orford* (Horace Walpole), London, 1808

ALLAN CUNNINGHAM: *The Lives of the Most Eminent British Painters, Sculptors and Architects*, London, 1829–33

SAMUEL REDGRAVE: *A Dictionary of Artists of the English School . . .*, 1874, revised edition, London, 1878

RICHARD AND SAMUEL REDGRAVE: *A Century of Painters of the British School*, first published, London, 1866, 2nd edition, London, 1890, new edition, London, 1947

More recent literature

C. H. COLLINS BAKER AND M. R. JAMES: *British Painting*, London, 1933

ROGER FRY: *Reflections on British Painting*, London, 1934

R. IRONSIDE AND J. GERE: *Pre-Raphaelite Painters*, London, 1948

JOHN ROTHENSTEIN: *Modern English Painters*, 3 vols, London. *Sickert to Smith*, 1952; *Lewis to Moore*, 1956; *Wood to Hockney*, 1974

E. K. WATERHOUSE: *Painting in Britain, 1530–1790*, London, 1953, 2nd edition, 1962, 3rd edition 1969

NIKOLAUS PEVSNER: *The Englishness of English Art*, London, 1956

DAVID PIPER: *The English Face*, London, 1957

*M. WHINNEY AND O. MILLAR: *English Art, 1625–1714*, Oxford, 1957

*T. S. R. BOASE: *English Art, 1800–1870*, Oxford, 1959

*E. CROFT-MURRAY: *Decorative Painting in England, 1537–1837*, 2 vols, London, 1962, 1970

DAVID IRWIN: *English Neoclassical Art. Studies in inspiration and taste*, London, 1966

GRAHAM REYNOLDS: *Victorian Painting*, London, 1966

QUENTIN BELL: *Victorian Artists*, London, 1967

ALAN BOWNESS: *Recent British Painting*, London, 1968

*ROY STRONG: *The English Icon: Elizabethan and Jacobean Portraiture*, London, 1969

TIMOTHY HILTON: *The Pre-Raphaelites*, London, 1970

LUKE HERRMANN: *British Landscape Painting in the Eighteenth Century*, London, 1973

*DAVID PIPER (editor): *The Genius of British Painting*, London, 1975

DAVID AND FRANCINA IRWIN: *Scottish Painters at Home and Abroad 1700–1900*, 1975

Recent exhibition catalogues

Nicholas Hilliard and Isaac Oliver, Victoria and Albert Museum, 1947, 2nd edition, 1971

Decade, 1890–1900, Arts Council, 1967; *Decade, 1910–20*, Arts Council, 1965; *Decade, 1920–30*, Arts Council, 1970; *Decade, 1940–49*, Arts Council, 1972

Romantic Art in Britain. Paintings and Drawings 1760–1860, Detroit Institute of Arts, 1968

La Peinture Romantique Anglaise et les Préraphaelites, Petit Palais, Paris, 1972

The Age of Charles I, Tate Gallery, 1972/3

Landscape in Britain, c. 1750–1850, Tate Gallery, 1973/4

British Sporting Painting, 1650–1850, Arts Council, Hayward Gallery, 1974

Acknowledgements

THE FOLLOWING PLATES are reproduced by Gracious Permission of Her Majesty the Queen: 5, 7, 19, 20, 21, 28, 98, 141, 142, 143

The publishers are grateful to all museums, institutions and private collectors who have given permission for works of art in their possession to be reproduced.

Photographs have been kindly supplied by the following:
Bristol City Art Gallery: 105
British Council: 217
A. C. Cooper: 34, 35, 91
Courtauld Institute of Art: 8, 17, 39, 41, 89, 95, 132, 159, 160
Edward Croft Murray: 42
Department of the Environment: 27
Hazlitt, Gooden and Fox: 108
Kasmin Ltd: 220
Marlborough Fine Art: 215
Mellon Centre for British Art: 45, 144, 158
Benedict Nicolson: 83
Phaidon Press Archives: 1, 6, 9–10, 12–15, 18, 22–6, 31, 46–8, 50–1, 54, 57–8, 61–5, 67, 69, 70–1, 75, 77–8, 81–2, 84–8, 90, 92–4, 96–7, 100, 103–4, 110, 114–16, 118, 119, 124, 125–6, 128–31, 133, 135–7, 140, 145, 147, 153, 155, 161–2, 164–5, 169, 171, 174–5, 177, 179–80, 194, 206, 211, 213
Roland, Browse and Delbanco: 185, 210
Royal Academy: 40, 44, 68, 132
Scottish National Portrait Gallery: 81
Tate Gallery: 29, 87, 162, 209
Victoria and Albert Museum (Crown Copyright): 11, 127
All other photographs were generously provided by the owners of the works reproduced.